SEURAT

SEURAT

Richard Thomson

PHAIDON · OXFORD

To my Parents

Phaidon Press Limited, Littlegate House, St Ebbe's Street, Oxford, OX1 1SQ

First published 1985
© Phaidon Press Limited 1985

British Library Cataloguing in Publication Data

Thomson, Richard
 Seurat.
 1. Seurat, Georges Pierre
 I. Title
 759.4 ND553.S5

ISBN 0–7148–2287–6

Printed in Great Britain by Blantyre Printing and Binding Co. Ltd., Glasgow

Frontispiece: Maximilien Luce, *Seurat*, cover of *Les Hommes d'aujourd'hui*, no.368, 1890.
Paris, Bibliothèque Nationale.

Contents

Acknowledgements

Over the past few years I have discussed Seurat with more people than I can possibly mention here. I thank them all, remembering in particular my conversations with Sally Medlyn, Martha Ward and Professor Robert Herbert, who kindly helped track down some vagrant drawings. Three friends read the text, and I am very grateful to John House, Paul Smith and Richard Tilston for their specialist remarks; they will not agree with all my arguments, and any errors that remain are mine alone. My gratitude also goes to the staff of the many museums who have made their Seurat material available to me, and especially to the curators at the Louvre and the Kröller-Müller Museum, Otterlo; Richard Brettell and his colleagues at the Art Institute of Chicago were most generous to me in July 1982. I have been kindly received by many libraries, notably the Bibliothèque Nationale, Paris, the Taylorian and History of Art Department Libraries, Oxford, the Courtauld Institute and Victoria and Albert Museum Libraries, London, and the John Rylands University Library, Manchester. An Area Studies Grant from the University of Manchester much facilitated a period of research on this book in the Lent Term, 1981. At Phaidon Press I owe my thanks particularly to Peg Katritzky and Bernard Dod.

My greatest debt is to my family: to Rupert, and to Belinda for listening and moderating. Nothing could give me more pleasure than to dedicate this book to my parents, Ian and Mary.

Richard Thomson
Heaton Moor, March 1984.

Introduction

Although Georges Seurat's career as an independent artist lasted barely a decade, he must be regarded as one of the most significant talents of late nineteenth-century French painting. Indeed, for the five years between the exhibition of *La Grande-Jatte* in the spring of 1886 until his early death in 1891, Seurat's example dominated avant-garde art in Paris. The 1880s was recognized by contemporaries as a decade of great excitement and innovation and is regarded today as one of the most salient periods of aesthetic change over the past century. To have forged a new visual language in such challenging circumstances, and while only in one's late twenties, was a remarkable achievement.

The usual account of Seurat lays most stress on the technical and formal aspects of his work: the development of the pointillist touch, the theories of divided colour and linear direction. Such an argument insists on seeing Seurat in terms of an advance from and a reaction against Impressionism. This book pursues a broader interpretation. Accepting the importance of technique and theory in his work, it explains his career more in terms of the academic canons by which he was trained and of the new Symbolist concepts which he adopted than by spurious notions of 'Post-Impressionism'. Above all, the book's aim is to arrive at an account of the meaning of Seurat's pictures. He understood that for contemporary painting the vital subject was the modern metropolis, and his images are still almost unchallenged in their acute and efficient synthesis of urban life.

Seurat was a Parisian. He was born in Paris and died there; his family belonged to the Parisian bourgeoisie. He was trained in Paris as a painter and based his career as an artist in the city. He drew the subjects of his major figure paintings from the capital and its suburbs, and his ideas were formed by, and contributed to, the intellectual life of the city. Seurat's selection of Parisian themes for these canvases seems to fit into conscious groupings; his first large exhibition pictures, *Une Baignade* and *La Grande-Jatte*, depicted scenes of daytime leisure in the city's western suburbs, for example, while later paintings like *Le Chahut* and *Le Cirque* dealt with indoor, nocturnal entertainment. These pictures not only represent different parts of Paris, different Parisian publics, but they also manifest distinct phases of formal and technical development, indicative of the intricate interrelationship between form and content in Seurat's work.

The contemporary meanings of Seurat's imagery were very complex, and they shifted with both the aesthetic and the political climate of the 1880s. In painting, Impressionism was ousted from its avant-garde position; in literature, the new Symbolist ideas challenged Naturalist exactitude; in politics, the Left established itself as a permanent force. To understand Seurat's work we need to situate it within the fluctuating intellectual and social currents of the day and this is what I have tried to do.

Seurat's harnessing of colour theory to the requirements of modern painting was of undoubted importance for other artists both during his lifetime and well into the twentieth century, and this gives great weight to the analysis of his technical accomplishments; after all, Seurat himself was convinced of the value of his innovations. While recognizing the crucial role of technique and theory in his art — and gratefully acknowledging my reliance on the scholarship of R.L. Herbert and W.I. Homer in these matters — I have chosen to concentrate on Seurat's subjects, in order to explore a neglected field of study closer to the interests of recent art history.

The obstacle to any comprehensive study of Seurat is the nature of the material: imbalanced, disjointed, with something of the man's own intractability. Take the pictures. Seurat's output in the 1880s was formidable. He left six large-scale figure compositions, twenty-four major marines, some twenty other substantial canvases (mainly landscapes but including figure paintings such as the small version of *Les Poseuses* and the *Jeune Femme se poudrant*), around 150 small paintings (some canvases, but predominantly oil sketches on wood panels), and some 250 drawings, most of them carefully wrought. Prior to the mid-1880s we need to provide the small-scale work with a plausible chronology, establishing a

pattern of technical progress and defining the nature of his subjects. From the mid-1880s onwards the character of the formal innovation and the identity of his images is apparently recognizable, but only if we are content with superficial readings. Our efforts to reach a deeper understanding are hardly helped by direct biographical or documentary material. In striking contrast to so many of his contemporaries Seurat himself is a shadow. We know when his pictures were exhibited, we can find out which Society's dinners he attended; but there is scant information of a more personal, more revealing kind. A short note on theoretical concepts, a handful of letters are all we have: no full correspondence, no diaries, no account books, no table-talk transcribed by a disciple. The historian makes use of what is available, and the skeleton of Seurat's circumscribed life can be reconstructed. But to put flesh on those bones we must turn to the letters, journals and memoirs of his colleagues. Further than that, to arrive at an account of the meaning of Seurat's pictures we must match the visual vocabulary he developed with the languages of colleagues and contemporaries. Attempting to situate Seurat in the artistic and ideological discourses of Paris in the 1880s and to decipher his imagery by means of related codes involves constructing a historical pattern from diverse sources: the exhibition review, the Naturalist novel, the political column, backstreet slang, the Symbolist poem, the up-to-the-minute cartoon or caricature. The very fact that such oblique but illuminating material needs to be brought into play serves to remind us that, for all the brevity of his career, Georges Seurat was an artist of challenging complexity and sophistication.

1 The Seurat Family

The bourgeois family

Georges-Pierre Seurat was born in Paris on Wednesday 2 December 1859, his parents' belated third child.[1] We know little about the Seurat family, but there is sufficient evidence to give us an idea of the domestic climate in which young Georges grew up, and of the family's position in mid-nineteenth-century Parisian society. Seurat's mother (1828-99) was herself a Parisienne. Born Ernestine Faivre, she was related to an old Parisian family called Veillard, and in the eighteenth century there had apparently been sculptors in this family. Both her father and grandfather had been jewellers. She was married in January 1845 and had two children in rapid succession; Emile-Augustin was born in June 1846 and Marie-Berthe in November the following year. Mme Seurat seems to have been a docile, retiring woman. It is probably safe to assume that she devoted much of her time to the regular domestic tasks of the bourgeois housewife, and no doubt the weight of bringing up the children fell on her. Seurat's drawing of her (Plate 1), made in about 1883, shows the middle-aged woman preoccupied with her sewing, fingers pinched to clasp the needle. Seurat made no attempt to characterise his mother by her surroundings or her belongings, rather he allowed his subtle observation of her composed and withdrawn mien to encapsulate her character. He picked out her strong and regular features – which he inherited — and the precision with which she cared for her person and her chores, aligning her careful parting, firm nose and dextrous gesture to create an image of determined, undemonstrative diligence.

Her husband, Chrysostome-Antoine Seurat (1815-91), had been born in Donson, in the Département of the Aube, some 150 kilometres to the east of Paris. He had come to the capital as a young man, and for sixteen years, from 1840 to 1856, he worked as a *huissier* — a legal official — at the Public Tribunal of the Seine in La Villette, an independent commune on the north-east outskirts of the city. M. Seurat obviously did well at his job, and he was able to retire at an early age. Well en-

trenched in the middle echelons of the bourgeoisie, he apparently continued to insist on being addressed as 'Monsieur l'Officier Ministériel'. It was no doubt this sort of attitude that led Seurat's friend Edmond Aman-Jean, who would have first met the retired *huissier* as a teenager in the mid-1870s, to remember him in later years as 'the classic bourgeois type'.

Seurat's parents cannot have had a very satisfactory marriage, for Seurat *père* seems to have spent little time with his wife and children at the family's Paris apartment. He bought a suburban house — 8, boulevard du Midi — in Le Raincy, a large village some ten kilometres to the north-east of Paris, with easy access by railway to the city, for a short journey from the station at Le Raincy would have taken him to the Gare de l'Est, only a few steps from the family apartment in the boulevard de Magenta. M. Seurat preferred to keep to himself at Le Raincy, where he spent his time gardening and, more eccentrically, indulging in private and unauthorised religious observance, saying mass in his house with his gardener as server. Perhaps in connection with this bizarre religiosity, he collected pious images, woodblock *images d'Epinal* and other cheap prints of the kind that would later interest his son.

On Tuesday evenings M. Seurat performed what Paul Signac referred to as his 'devoir conjugal' and dined with his family in Paris. As a result of a hunting accident he had lost an arm, which had been replaced with a mechanical substitute. This device gave rise to odd behaviour at the dining table, as Signac recalled: 'At mealtimes he screwed knives and forks into the end of this arm, which enabled him to carve legs of mutton, fillets (of beef), poultry and game with speed, verve even. He positively juggled with these sharply pointed weapons, and when I was sitting next to him, I was terrified for my eyes. Georges paid no attention to these music-hall performances'.[2] Indeed, Seurat once drew his father at a meal and ignored these disconcerting antics (Plate 2).

Seurat's conception of his father is markedly different from his slightly later drawing of his mother, and one senses that these differences were ordained by tempera-

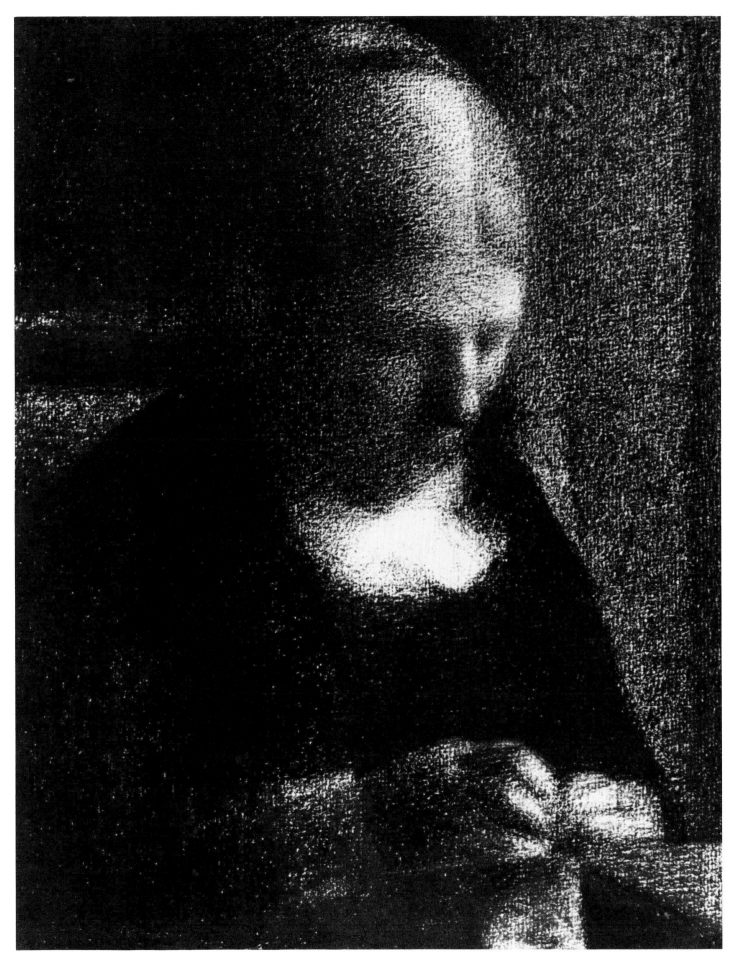

1. *Broderie (Mme Seurat). c.*1883. Conté crayon, 31.2 x 24 cm. New York, Metropolitan Museum (DH 582).

mental relationships rather than mere change in drawing style. The figures in both drawings fill up much the same proportion of the picture space and are involved in regular daily activities, but there the similarities end. While the drawing of Mme Seurat is carefully observed and recorded, Seurat merely generalizes his father, content to depict a stolid presence but unable to give his sitter any palpable personality. M. Seurat was indeed a contradictory individual. On the one hand he was the archetypal bourgeois, with his monotonous routine, suburban villa and dreary marriage, and yet on the other he had an eccentric independence of character. Several of M. Seurat's traits — his secretive and distant behaviour, his preference for isolation rather than co-existence with others, his tedious insistence on duly earned status — were inherited by his son Georges.

The bourgeois son

Georges Seurat was a difficult man to get to know. We have no revealing evidence about his childhood, but fortunately, many people who knew him as an adult recorded, either in formal obituaries or in later recollections, their reminiscences about his character. The remarkable feature about these anecdotes and memories is their consistency, and also the fact that they seem to go only a short way in penetrating Seurat's personality; even to his friends and colleagues there was something unfathomable about Seurat. 'We had to break a lot of ice before we were able to get through to one another,' wrote the Belgian poet Emile Verhaeren about their first meeting, in the summer of 1886. Only in the following year, when Verhaeren visited Seurat's studio, did the artist truly relax in his intelligent and enthusiastic company.[3] Charles Angrand, one of the very few to remain on reasonably friendly terms with Seurat for an unbroken period (in Angrand's case from about 1884–5 until Seurat's death), remembered how even at the sympathetic social gatherings in Signac's studio that took place in mid-decade, Seurat listened in silence unless someone asked him a direct question.[4]

Perhaps the most striking instance of Seurat's obsessive insistence on privacy was his attitude to his mistress, Madeleine Knobloch, and their child. It seems that their relationship began in 1888 or 1889, and on 16 February 1890 she gave birth to a son whom Seurat acknowledged, giving the child his own names in reverse: Pierre-Georges. Few, if any, of his friends knew about Madeleine, let alone the baby, and his family was kept entirely in the dark. His mother only knew of her son's mistress and child two days before Seurat's death, when they accompanied the critically ill artist to his parents' apartment.[5] He may have wanted to shield Madeleine and himself from ironic comments that his intellectual friends might make about his working-class mistress, and his strict bourgeois upbringing might have made him hide his small family from his parents. What-

ever his reasons, Seurat guarded his private life with fanatical secrecy.

But for all this personal privacy, Seurat came to lead an active public life, especially after his paintings brought him into prominence. In later chapters we will see him playing a substantial rôle in the avant-garde circles of the 1880s, and his part was a complex one. It is perhaps curious that a man of such distant and defensive personality allowed himself to become involved in the bruising politics of the Parisian art world. Angrand recalled him at the organizational meetings of the Société des Artistes Indépendants at the Café Marengo, which Seurat rarely missed: 'He used to sit smoking, silent and attentive.' No doubt this apparently passive person attended out of a sense of duty, of loyalty to his colleagues, in order to cast his vote. There was something rigidly proper about Seurat's make-up. He also had a strong commitment to his own interests,

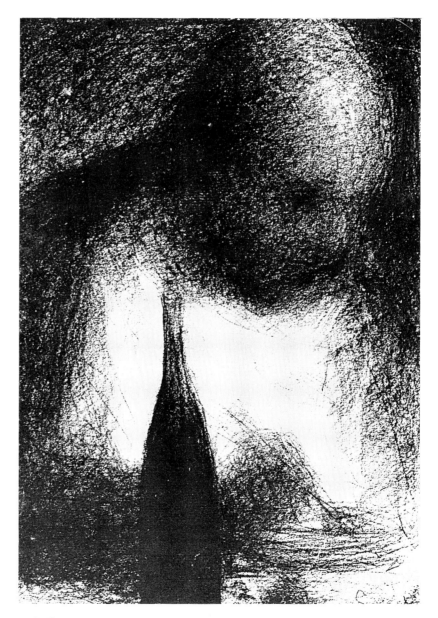

2. *Le Dîneur. c.*1882–3. Conté crayon, 31.7 x 22.7 cm. Private collection (DH 600).

though not in a materialistic way. He was always insistent on the recognition of his status, and he was ever anxious about being misinterpreted or, worse, undervalued. The recollections of Signac and Angrand agree exactly on this point: 'He was somewhat taciturn, except when he was talking about *his* method.' 'He took obvious pleasure in talking about the state of painting — above all about *his* method.' Seurat was determined to reap due credit for his painterly innovations, and this determination, as we shall see, was most tiresome for his colleagues. He even subscribed to a press-cutting agency in order to keep an eye on his public position, and he could be humourless and pedantic in his detailing of facts. Indeed, in a letter to the critic Félix Fénéon, written in 1890, Seurat showed himself to be tediously accurate: '...out of the 30 articles calling me an innovator I count you six times ...' (see Appendix I). At moments like this one remembers that Seurat was the son of 'Monsieur l'Officier Ministériel'.

A more attractive element, recognized by Signac and Angrand in their remarks, is Seurat's deep commitment to painting, his professionalism. Seurat constantly observed his surroundings, incessantly testing his own concepts about the analysis of light on the world around him. Angrand remembered walking back into Paris from a day's painting in the suburbs with Seurat, probably during the spring of 1888 when they were both working on the island of the Grande-Jatte: '... we would leave the end of the island by the 'Artilleryman's' ferry, which for two *sous* took us across to the boulevard de Courbevoie, recently created along the river bank. Trees had just been planted there, and Seurat took pleasure in proving to me that the green treetops against the grey sky were haloed in pink.' And Signac recounted that Seurat would often have only a snack for lunch, a croissant and a bar of chocolate, in order not to waste valuable time.[6] A description of Seurat and his working habits published in 1890 by an anonymous writer — who was nevertheless acquainted with the artist and had apparently visited his studio — stressed his industry and application: '... he works six days a week, like a labourer, from nine o'clock in the morning until seven o'clock at night, in that modest, well-lit studio on the boulevard de Clichy which is stripped of all bric-à-brac, where the studies brought back from a stay by the sea or in the fields radiate in their white frames.'[7]

To this acquaintance Seurat seemed to be a man of single-minded simplicity, but to Signac who knew him closely from 1884, 'he was extremely complex; he had a love of contradiction'.[8] Some of the qualities that made Seurat so complicated, so hard to get to know — his evasiveness, his obliqueness, his touchiness — can be found in the few of his letters that survive, a curt correspondence with a telegraphic expression. Here is an extract from a letter to Signac, written in August 1887, while Seurat was in Paris working on *Les Poseuses*:

'...Painting on gesso desperate. Can't understand any-

thing any more. Everything makes a mess — tedious work.

I'm not seeing anybody.

Verhaeren hasn't deigned to give me any news of our pictures.

He really is surprising.

One sentence (on page 8 — Fernand Khnopff) left me wondering for a long time...

Weather mild. Nobody in the streets in the evening (Province).

Slight spleen.

From 22 August to 18 September, 28 days.'[9]

It is a sparse communication; one might expect Seurat to expatiate more to a close friend on the problems he was encountering with his painting or on his mood, but he merely hints. His analogy between Paris in August and provincial monotony is made by a single word in parenthesis, his reference to compulsory military training merely by dates. Verhaeren, who in a pamphlet on the Belgian painter Khnopff had appeared critical of Neo-Impressionism, has been found out — Seurat even gives the page number — and is quietly castigated for disloyalty. Seurat's speech, as well as his letters, was clipped — his only known remark about his elder brother, an unsuccessful playwright, was 'he likes good suits'[10] – and he expressed himself in an oblique, ironic fashion. He only implied meanings, expecting others to decode his cryptic pronouncements for themselves, and we do well to remember this when we approach Seurat's art.

On the surface Seurat's behaviour and appearance were a model of bourgeois rectitude. He dined at home with his mother every evening, and always wore a top hat and black suit for openings and committee meetings, which led Degas to dub him 'le notaire'.[11] His appearance was distinguished; in later years Kahn compared him to an Assyrian king and Aman-Jean to Donatello's Saint George, while the sculptor Carabin talked of him as 'an apostle,... with a Christ-like head'. The accuracy of Angrand's description of Seurat is attested by Luce's portrait of the artist, drawn in 1890 to accompany Jules Christophe's short biography in *Les Hommes d'aujourd'hui* (Frontispiece): 'He was good-looking, with a straight nose, a broad forehead and heavy eyelids; his full beard was a dark brown colour with tawny tufts. His whole appearance was one of calmness. He had stature and presence.'[12]

The family and bourgeois Paris

The Seurat family's changing circumstances provide vital information about the artist's social experience and status. The family interweaves with the complex evolution of mid-nineteenth-century French society: the movement of population from provinces to capital, the dislocation of Paris during the years of rebuilding and the subsequent redistribution within the city's class structure, the critical choice for the upward-moving bour-

geoisie of a locality consistent with its class identity, the growth of the Parisian suburbs.

As we have seen, Seurat's father was a provincial who migrated to Paris with his two brothers, presumably in the belief that the city would give him a more prosperous future than the countryside. Tens of thousands did the same in mid-century France, provoking twin social crises of rural depopulation and urban overcrowding; indeed the population of Paris doubled between 1831 and 1851.[13] M. Seurat seems to have done better than his brothers. As a *huissier* he was a civil servant, a member of the establishment, while one of his brothers was a shopkeeper and the other an office employee. M. Seurat was able to retire at the age of forty-one. Perhaps this was encouraged by his accident or an advantageous marriage; we do not know. He does not, however, seem to have been unseated for any political reasons, as his tenure as *huissier* at La Villette, from 1840 to 1856, ran without apparent interruption through three régimes, from the Orléans monarchy via the Second Republic into the Second Empire.

M. Seurat managed to forge himself a place in the Parisian bourgeoisie. Not only was he well enough off to retire early, but he was able to provide for his children. Georges Seurat was comfortably off; circumstantial evidence suggests that he received a monthly allowance of 400 francs during the 1880s — the average industrial worker might expect 150 francs.[14] Above all, he had no need of a job that would interrupt his painting, and he was under no pressure to sell his work, which left him scope to experiment.

The rise in the Seurat family's social status is clearly revealed in their changes of address. Seurat himself was born at 60 rue de Bondy, a street on the eastern side of the city centre near the Place de la République. Rue de Bondy was an undistinguished street; to the south three theatres backed on to it, and to the north it lay in unpleasant proximity to the bustle of the Porte St. Martin market. Shortly after Seurat's birth the family moved to 110 boulevard de Magenta.

Although in physical terms the move was only a matter of several hundred yards it must have represented appreciable social progress. This boulevard was constructed as part of the massive rebuilding of Paris in the 1850s and 1860s, planned by Baron Haussmann under the aegis of the Emperor Napoleon III himself. The motives behind the rebuilding were varied, mixing practical considerations, such as the pressing need for modern systems of sewerage and water supply, with political ones, notably the autocratic régime's craving for the prestige of such major public works and its determination to diminish the potential of urban unrest. Massive changes were necessary because, in essence, the population of Paris — swelled by the immigration of provincials like M. Seurat and his brothers — had outgrown the city's facilities. The boulevard de Magenta was built as part of a system to ease the traffic in the eastern half of the city. It ran past the two stations in the north-east,

the Gare du Nord and the Gare de l'Est, to the Place de la République. From there the boulevard Voltaire led eastwards to the Porte de Vincennes, while the rue Turbigo drove towards the city centre, linking Paris's main market, the huge, newly constructed Les Halles, with the outer boulevards. The rue Turbigo, completed in 1867 and running only a few blocks south of the rue de Bondy, is a good example of how the rebuilding could serve political as well as practical purposes, for it completed the destruction of the old hotbed of insurrection around the Conservatoire des Arts et Métiers.[15]

These new streets disrupted old working-class quarters, and along them were erected the monotonous and regimented façades of bourgeois apartments. Zola described these changes in progress in *L'Assommoir*, set during the Second Empire: 'The boulevard de Magenta, coming up from the heart of Paris, and the boulevard Ornano, going off towards the country, had torn a gap in the old wall — a huge demolition, two great avenues, still white with plaster ... It was an immense crossroads leading to the far horizon along endless thoroughfares, swarming with people, who disappeared in the chaos of construction work. But among the tall new apartment blocks, plenty of rickety old houses were still standing; between façades of carved masonry yawned black holes, gaping kennels, exposing their wretched windows. Beneath Paris's rising tide of luxury, the squalor of the faubourg broke through and besmirched this brand new city, being so hastily thrown up'.[16] By the 1870s, when Seurat was in his teens, this process of change was over and the boulevard de Magenta was a busy thoroughfare and an established middle-class quarter.

Seurat's father was also able to afford the house at Le Raincy, in the north-eastern outskirts of Paris. In the mid-1880s Le Raincy was characterized as a place of 'comfort and relative prosperity'; its shops were equal to those of the inner-city rue Saint-Denis, and it was inhabited by 'bankers, businessmen, stockbrokers, civil servants'.[17] Le Raincy, then, was comparable to a respectable bourgeois quarter in Paris, and M. Seurat shared his suburban comforts with fellow bourgeois. How fitting it was that M. Seurat, whose own origins were rural, should choose to cement his bourgeois status with a house in the semi-rural suburbs. By the 1880s contemporaries were noting that the population of Paris, of which 'a third part only was born in the city itself, evinces a more and more strongly marked tendency to spread itself out in the surrounding country'[18], and M. Seurat had his place in the pattern.

The politics of the Seurat family and their reactions to political events are unknown, except for the fact that during the Commune of 1871 they took refuge at Fontainebleau.[19] This was the orthodox bourgeois precaution, and it matches the other evidence in establishing the family's respectable, unexceptional, but nevertheless shifting position in mid-nineteenth-century Parisian society, making gradual progress to the middle echelons of the bourgeoisie.

2 *The Education of the Artist*

Initial training

Seurat drew as a child, as we all do. While still a boy, family tradition tells us, he was encouraged in his drawing by his mother's brother, Paul Haumonté-Faivre (1821–69), who owned a substantial fancy goods shop, 'Au Père de Famille', at 48 avenue des Ternes.[1] Seurat's childhood drawings, such as *Man Walking his Dog* or *Man with his Hands in his Pockets*,[2] are unremarkable, but they do show us that from the earliest stage he preferred simple poses — in these two cases profile and frontal — rather than the vigorous movement that we find in the boyhood drawings of, say, Toulouse-Lautrec.[3] By his mid-teens Seurat obviously took his drawing seriously, and he seems to have embarked on an informal programme of copying the objects that attracted his attention. He made a copy, for example, of Aimé Millet's vast statue *Vercingetorix*, exhibited at the Salon of 1874,[4] and a drawing of a reclining nude, dated 1875, was taken from a lithograph of the 1820s or 1830s in the style of an artist such as Achille Devéria.[5]

It is not clear from whom Seurat received encouragement after the death of his uncle. His mother may have provided support. She seems to have had some taste for the visual arts; in the mid-1880s she commissioned a small painting from Camille Pissarro, and even collected some Chéret posters,[6] but these initiatives may well have been stimulated by her son. Another possible source of encouragement was Léon Appert (1837–1925), a manufacturer in the glass industry who had married Seurat's elder sister. Little is known of the contact between the two men, but Appert won a gold medal at the Universal Exhibition of 1878 for his work as a 'manufacturer of optical and coloured glass', and was well enough respected in his field to serve on the jury at the subsequent Universal Exhibition, in 1889.[7] Appert's work would have required a knowledge of optics and colour theory, and it may well have been he who introduced his artistically inclined brother-in-law, twenty years his junior, to the writings of Chevreul and others.

In 1875, aged fifteen, Seurat left school and enrolled at the local municipal drawing school at 17 rue des Petits-Hôtels, a small street very near his home, running between the boulevard de Magenta and the Place de la Fayette.[8] The teacher there was Justin Lequien (1826-82), once the runner-up in the Prix de Rome for sculpture,[9] but a minor figure by any account. It was at this school that Seurat made his first important friendship, with Edmond Aman-Jean (1859-1936). Aman-Jean, whose family's business — haulage on the northern canals — had been ruined in 1870, was an orphan, and he had been brought up in Paris by two uncles.[10] The same age, Seurat and Aman-Jean remained close friends through their student days and beyond.

There is little direct factual evidence to bring to bear when analysing Seurat's four years as an art student — at the municipal school and later at the Ecole des Beaux-Arts — from 1875 to 1879. None of his reactions to his teaching have survived, and one suspects that a substantial proportion of his student work was destroyed, perhaps by Seurat himself. Only some two dozen life drawings exist, for instance, a small number for four years of intensive training. Nevertheless, about a hundred drawings in all — copies, studies from life, and early compositions — are known from this period, as well as a handful of paintings; enough to give us an outline of Seurat's career as an art student.

Art school training in France during the nineteenth century was rigorous and standardized, and Seurat went through most of its stages. The regular practice in municipal art schools and private teaching ateliers was for the young artist to begin with the mastery of line, drawing first from engravings. Initially he would draw from prints representing idealized fragments of the body, using these models to practice accuracy of imitation. Indeed Aman-Jean recalled that Lequien 'taught us to outline noses or ears with precision from lithographed models', and one such drawing by Seurat survives.[11] Other such *modèles de dessin* would include engravings after recommended Old Masters, and only once this stage had been satisfactorily completed — with its emphasis on fluent and accurate transcription of contour —

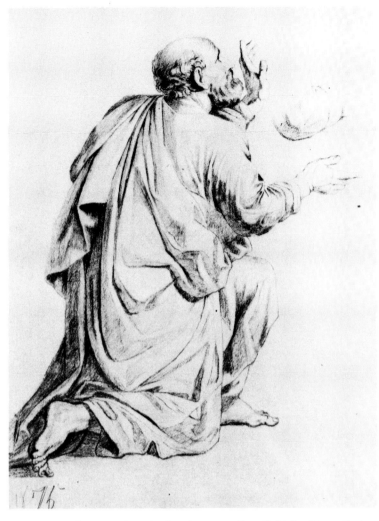

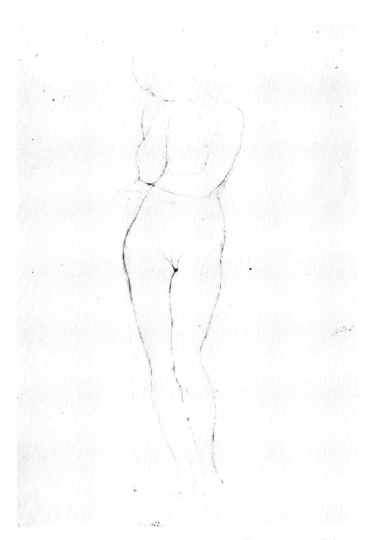

3. Copy after Poussin's *Ordination*. 1875. Pencil, 52.2 x 38 cm. Paris, private collection (DH 224)

4. Copy after Ingres's *Stratonice. c.*1876. Pencil, 30 x 21.5 cm. Private collection (DH 236).

would the student be allowed to draw *à la bosse*, after casts of antique sculpture, to practice modelling the volumes of a three-dimensional object.[12]

Seurat's drawing after a figure from Poussin's *Ordination* (Plate 3), made in 1875, is a good example of a copy after an engraving. He had obviously been deemed able to pass beyond purely linear copies, and here he practised applying shading to the pattern of the drapery, revising the drapery of the elbow in a subsidiary passage, with a studious but rather stiff result. Engravings gave students convenient access to works of art they would never see in the original; *Ordination* was then, as now, in the collection of the Duke of Sutherland. Although Poussin was a conventional academic model of the period, the copy after *Ordination* is of particular interest because Seurat selected such an ordered composition to copy, symmetrical, with a strong central image.

Seurat's copying was not done entirely from engravings, however. Of his four copies after Raphael at least one was from an Alinari photograph of a drawing in Vienna.[13] And he also copied in the Louvre, for the drawing after Holbein's *Sir Richard Southwell*, made about 1877–8, is after neither the painting in the Uffizi nor the preliminary drawing at Windsor but an oil copy

in the Louvre's collection.[14] Seurat probably made more copies than we now know — some thirty drawn copies after Renaissance or later works of art have been identified[15] — but enough survive for us to see certain preferences in his choices. He was wary of dramatic movement or gesture, and these features are only found in his copies after Raphael, such as a flying angel from the Chigi Chapel decorations (DH 255), and Puget's *Milo de Croton* (DH 286). He showed little interest — at least in the surviving copies of the mid-1870s — in painters celebrated for their use of colour; his copies after Bellini, Titian and Pontormo are only small heads on a single sheet (DH 263). The artists that Seurat favoured were those who laid stress on line, such as Holbein, and on balanced composition, such as Poussin; in short, those characterized by qualities of discipline and sobriety. Ingres, after whom Seurat made no fewer than eleven copies, mainly after drawings or reproductions of drawings rather than paintings, united these elements. The copy after a drawing for Ingres's *Antiochus and Stratonice* (Plate 4) is noteworthy in that Seurat did not draw the figure draped as she appears in the dramatic painting. Instead he drew from a reproduction of one of Ingres's preliminary studies, following Ingres's own

5. Copy after a fragment of the Parthenon Frieze, 1875. Pencil, 48 x 63.2 cm. Private collection (DH 220).

rehearsal of the contours for the figure of Stratonice.

Seurat's drawings after antique sculpture are mostly undated, and it is not possible to be precise about the order of their execution. One of the earliest, from the Parthenon frieze (Plate 5), is dated 1875 and was made from a cast at Lequien's school; the shading is rather heavy and clumsy, especially around the heads, feet and hooves. A drawing of a male figure (DH 297) is another copy after the Parthenon frieze, and such work reminded students that the forms of antique sculpture were still central to the classical canons of nineteenth-century French art.[17] Indeed, the continuing relevance of this knowledge of the antique for Seurat can be detected in later paintings such as *La Grande-Jatte* and *Les Poseuses*. On several occasions Seurat drew the same cast from different angles,[18] and this was the case with the famous sculpture *Antinoüs* (Plate 7), which he drew from a version in the Louvre no fewer than five times.[19] Drawn about 1876, Seurat's *Antinoüs* is still somewhat unrelaxed. The internal shading, handled more delicately than in the copy after the Parthenon frieze, is kept to a minimum, and one can make out corrections to the figure's left leg and right-arm, perhaps by Seurat's teacher.

One of Seurat's life drawings (DH 265) is dated '27 Oct. 1877' and another *Standing Male Nude* (Plate 6), '77', so by that year at least he had graduated from casts to the model. *The Standing Male Nude* demonstrates how Seurat's draughtsmanship had advanced. The figure is modelled by a crisp contrast of light and dark, and the forms unified by a confident bounding contour. It was drawings such as this that Seurat would have had to submit in order to graduate to the Ecole des Beaux-Arts, but even at that more advanced level Seurat had to per-

sist with life drawing, a point proved by the survival of at least one *académie* inscribed with the name of his teacher Lehmann.[20]

Lehmann's atelier and the Ecole des Beaux-Arts, 1878–79

It was the traditional step to advance from a private teaching atelier or municipal school of art to the Ecole des Beaux-Arts, and the young artist's aim once there would be to attain the coveted Prix de Rome. Records indicate that Seurat entered the Ecole des Beaux-Arts in February 1878 and that he was admitted to the painting class on 19 March, placed 67th out of 80 pupils; this rapid promotion suggests that his drawing was judged to be of suitable standard. At the end of the summer term, 1878, Seurat was placed 73rd. In the following year he did better, and on 18 March 1879 he was placed 47th in his class of 80. Seurat's name last appears in the Ecole's records on 22 March 1879; the documentary evidence thus points to only one year's attendance.[21]

Seurat entered the class of Henri Lehmann (1814–82), who is usually given short shrift by authors on Seurat. This is not entirely just, and Lehmann is due more consideration. In the 1870s he was enjoying the twilight of a successful career and an interesting life. Born a German, in 1831 he had settled in Paris and studied under Ingres, and at his Salon début four years later he won a second-class medal. He became a French citizen in 1847. Lehmann spent two long periods in Italy between 1838 and 1842, and at this time his friends included the critic Sainte-Beuve, the artist Chassériau and the poet de

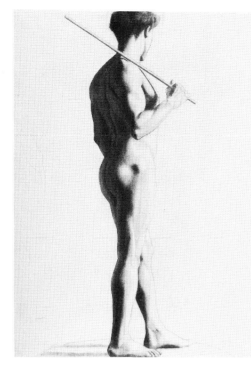

6. *Standing Male Nude*. 1877. Black chalk, 60.3 x 46.3 cm. Private Collection (DH 268).

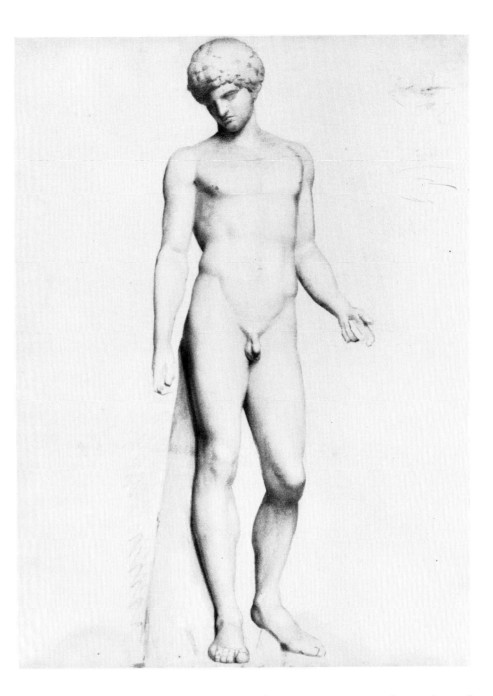

7. *Antinoüs*, *c*.1876. Conté crayon, 62.5 x 49.2 cm. New York, Joan and Lester Avnet (DH 249).

Vigny. He was on intimate terms with Franz Liszt and the Comtesse Marie d'Agoult.

Lehmann's marriage in 1851 made him a man of means, and from mid-century the progress of his career carried him unostentatiously to the top of his profession. Elected a member of the Institut — the senior body of the French cultural establishment — in 1864, he served as its Vice President in 1867 and President the following year. In October 1875 he was nominated as a Professor at the Ecole des Beaux-Arts. These prestigious appointments were paralleled by his career as a decorator of public buildings. He had received his first commissions to decorate Parisian churches in the 1840s, and these were followed by important decorative schemes in the Hôtel de Ville and Palais du Luxembourg during the 1850s. In 1874 he was honoured with a commission for decorations in the Panthéon, which he was forced to turn down on grounds of poor health.[22]

Seurat's professor, then, was a respected member of the establishment, and he represented a particular viewpoint in the senior echelons of the art world. There is no doubt of his commitment to the classical tradition — in 1864 he founded the Prix Henri Lehmann at the Institut for its encouragement — nor of his devotion to Ingres. He had been a close friend of his former mentor; indeed, in 1880 he painted a posthumous portrait of Ingres and left it in his will to the Ecole des Beaux-Arts. Among the professors at the Ecole in the late 1870s Lehmann was the only ex-pupil of Ingres (Cabanel and Gérôme had been taught by Picot and Delaroche respectively) and it is likely that he saw his function to be the continuation of Ingres's doctrines.

Lehmann's teaching adhered to Ingres's example, but to the Ingrist canon of suave linearity and high finish, his own painting added the fresh quality of dynamic movement, often accompanied by emphatic gestures as

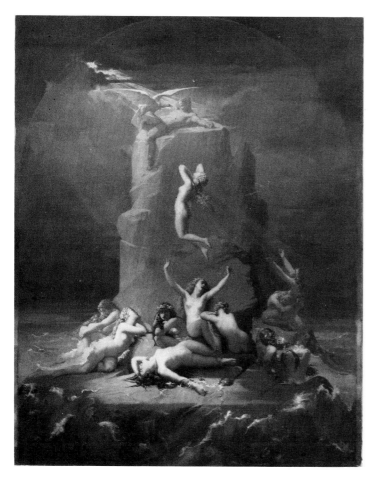

8. Henri Lehmann, *The Oceanides Grieving at the Foot of the Rock where Prometheus is Chained*. 1850. Canvas, 251 x 193 cm. Gap, Musée Departemental des Hautes-Alpes.

in his *Oceanides Grieving at the Foot of the Rock where Prometheus is Chained* (Plate 8), bought by the state from the Salon of 1850–1 and on public display in Paris during Seurat's lifetime.[23] Here Lehmann counterpointed the static nude of Ingrist convention with flying figures, and attempted — not altogether successfully — both to enliven and to unify his composition with insistent diagonals. His drawings are finally of higher quality than his paintings, but he was nevertheless an artist of impact and individuality, for all his conservative allegiance to Ingres.

The comrades and contacts Seurat made in Lehmann's atelier included some young artists who were to become close friends. Aman-Jean followed Seurat into Lehmann's class in August 1878, and stayed at least until July 1880, when he was awarded an honourable mention in an atelier competition.[24] And it was there that Seurat met Ernest Laurent (1859–1929), Alphonse Osbert (1857–1939) and Alexandre Séon (1855–1917), all of whom would form part of Seurat's circle of artistic contacts in the 1880s. Despite the fact that these friends were to follow more conventional careers than Seurat — Laurent went on to win the Prix de Rome in 1889 — they were among the significant young artists of the

decade, and their relationships with Seurat need to be taken into account.

Two other pupils of the Ecole in the late 1870s would cross Seurat's path during the next decade. One was the mysterious Théo Wagner, who, owing to the fact that his contemporaries knew little about him except that he was both a practising artist and a circus clown, became something of a legend in his own lifetime.[25] The other was the poet Jules Laforgue (1860–87). A recently published manuscript by Laforgue — notes written about 1880–1 for a novel, *Un Raté*, that was never completed – shows that Laforgue had inside knowledge of life at the Ecole, and particularly of Lehmann's atelier. Laforgue's elder brother Emile passed through the Ecole in the late 1870s, and it is possible that Jules followed him, perhaps on an informal basis for his name appears on no register.[26] Seurat may not have actually known Laforgue, as he did Wagner, at the Ecole, but nevertheless Laforgue's manuscript provides fresh and intriguing evidence about the training that all these young artists received.

None of Seurat's reactions to Lehmann or his teaching have survived, but it is still possible to piece together a picture of this crucial phase of his career. Lehmann's reputation at the Ecole des Beaux-Arts was a mixed one in Seurat's day. As a teacher he scored conventional successes — his pupil François Schommer won the Prix de Rome in 1878 and another, Georges Truffaut, was runner-up two years later[27] — and yet there is evidence of some unrest in his atelier. A group of his pupils even informally approached Manet to ask if he would teach them, a step implying that Lehmann's supervision and aesthetic were considered outmoded.[28] One contemporary, Victor Fournel, writing shortly after Lehmann's death, recorded that he took his teaching most seriously, but that with his respect for discipline he was upset by the students' pranks. Even Fournel, who was sympathetic to Lehmann, was forced to admit that he found it hard to stimulate his pupils, a point corroborated by Aman-Jean.[29] It may well have been Lehmann's insistence on Ingres's example that appeared to his students limited or retrogressive. Laurent recalled that he constantly invoked Ingres in his teaching, and Lehmann apparently taught from the paintings by Ingres in the Louvre, using *The Apotheosis of Homer* as an example of 'the equilibrium of masses'.[30]

It was perhaps in response to Lehmann's dictates that Seurat made a careful copy (Plate 9) of the female figure in Ingres's *Roger Rescuing Angelica* (1819; Paris, Louvre). Seurat went about this copy in the most scrupulous fashion, first producing a drawing of Angelica, and then a more resolved painted version.[31] It is interesting to see Seurat's own concerns in the copying process, for he ignored the bizarre imaginings of the hippogriff and Roger's armour to concentrate on Ingres's expressive stylization of the female figure.

From Laforgue's account we gather that on trips to the Louvre Lehmann reportedly encouraged students to study Poussin and Lesueur, stalwarts of seventeenth-

century French classicism. When it came to copying Rubens he warned: 'Take him in small doses as you would a beneficial poison,' and he even destroyed a pupil's copy after Sebastiano Ricci in a fit of anger.[32] Such prejudices tally with the contemporary assessment that Lehmann favoured drawing above colour.[33] Lehmann's inability to move with the times is witnessed by his attitude to what he apparently saw as his students' over-enthusiasm for plein-air sketching. When students brought him such work he would say: 'Oh! yes, I know it's the thing to do nowadays, but first of all work as the Masters did, in studio lighting; when you've left the Ecole you'll do as you please'.[34] Lehmann was thus at his most *retardataire* when it came to painting and the use of colour, and this was unlikely to satisfy students such as Aman-Jean, Laurent and Seurat. For at this time, as Aman-Jean later recalled, 'we were enthralled by the theory of complementary colours'.[35]

The morality of art and the elevated subject

From the outset of his career Seurat was imbued with a grave and deliberate sense of both the purposes and practices of his profession. In 1890 he recorded, in an important letter to Félix Fénéon that summarised his career to date, that he had been interested in finding 'an optical formula' for painting since 1876 (Appendix I). In October 1875, as he recalled in the same letter, he had solicited from a M. Aviat a three-page manuscript of Corot's comments on art: clear evidence of Seurat's precocious interest in the notional foundations of painting. And in one of the very few direct references to his period at the Ecole des Beaux-Arts, made in that letter, Seurat said that he had read 'Charles Blanc at college.' By this he meant Blanc's *Grammaire des arts du dessin*, published in 1867, a large volume of both theoretical and practical ideas on the visual arts. Blanc's text was central to the intellectual bases of Seurat's work, and it remained important to him throughout his career; Gustave Kahn, who did not meet Seurat till 1886, remembered that 'his knowledge of Charles Blanc was unequalled'.[36]

As we consider this formative stage of Seurat's career it is important to mention Blanc's view of the artist's role. 'The artist is duty bound to remind us of the ideal, in other words to reveal to us the fundamental beauty of things, to discover their eternal character, their pure essence', he wrote, and to extract these qualities from their 'tangled and obscure form' in nature. Blanc added that 'painting has a moral effect on us because it moves us and because it can arouse in us either noble aspirations or beneficial regret.'[37] He saw the artist's role as ordering nature into an elevated form of expression, and argued that embodied in this was a tacit but distinct moral function. One should remember that Lehmann's work too often tackled subjects of didactic moral significance. His public commissions, unlike the timeless Arcadias of Puvis de Chavannes or the historical reconstruc-

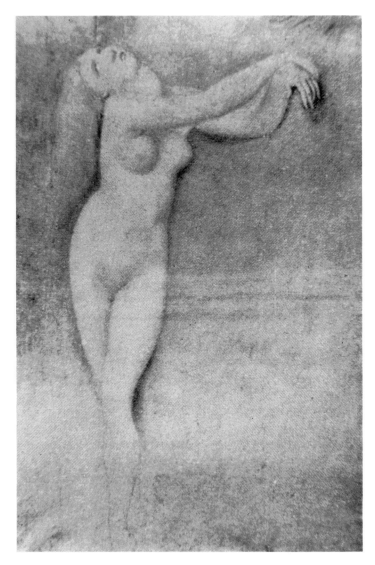

9. Copy after Ingres's *Roger Rescuing Angelica*. c.1878. Black chalk, 43 x 28 cm. Private collection (DH 315).

tions of Jean-Paul Laurens, dealt with allegorical themes of moral import. During 1872 and 1873, for example, he painted *Law Prevailing over Force* (Plate 84) for the Ecole de Droit, and this was exhibited at the Salon of 1876.[38] Thus both Seurat's intellectual mentor and his teacher at the Ecole laid stress on the ability of painting to transmit moral concepts, a lesson not lost on the young artist.

While we have scant evidence of Seurat's activities at the Ecole des Beaux-Arts, we know that he continued to draw from life, and he would have been expected to apply himself to both painting and composition. Although little work has survived from this time, Seurat's own compositions already indicate significant characteristics and interesting choices of subject. Independent designs in oil were considered a comparatively late stage in an artist's training, but Seurat had begun to plan such subjects in drawings by 1876. An important group of drawings, some dated 1876 and others 1877, give the most coherent insight into Seurat's early compositions. Executed on sheets of similar dimension (approximately 24 by 32 centimetres), these six drawings,[39] with their

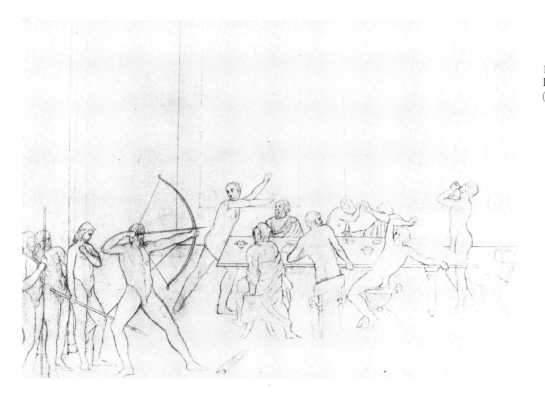

10. *Ulyssees and the Suitors*. 1876.
Pencil, 23 x 32 cm. Location unknown
(DH 223).

linear, unmodelled figures and frieze-like compositions, have frequently been compared to Flaxman's designs, which were certainly admired by conventionally trained artists of the period.[40] This group was obviously a significant undertaking for the young Seurat, and their subject-matter in particular has been unfairly neglected. At least two of these drawings have been incorrectly identified. One, titled *The Trial of Iphigenia* by de Hauke, in fact represents Ulysses recognized by his nurse Eurycleia,[41] and another, which de Hauke catalogued as *Séparation*, is taken from the *Iliad*, and shows the heralds of Agamemnon leading Briseis from the tent of Achilles.[42]

It comes as no surprise to find Seurat taking subjects from Homer. *Ulysses and the Suitors* (Plate 10) has always been recognized as drawn from Book 22 of the *Odyssey*, and Homeric themes were frequently selected as subjects for the Prix de Rome.[43] Although the choice of material was entirely typical of Seurat's conservative training, the specific incidents that he illustrated bear further scrutiny. Often the design of these drawings is divided into two distinct portions, as in *Ulysses and the Suitors*. And if these drawings are composed around polarities, this is only better to serve the narrative content, for the motifs Seurat chose were scenes of alienation, faction, even aggression.

At the Ecole students would be set subjects for which they prepared small oil sketches, to practise both composition and basic painting procedures. According to Laforgue Lehmann ordained conventional themes such as Daphnis and Chloë or Perseus and Andromeda.[44] Two such efforts by Seurat have survived, both entirely predictable subjects. *Jupiter and Thetis* (DH 5; present location unknown) of c.1878–9 repeats the subject of a famous picture by Ingres (1811; Aix-en-Provence, Musée Granet) that Seurat would have known from engravings. It is also consistent with Seurat's contemporary enthusiasm for Homer, for the painting depicts Thetis pleading with Jupiter to avenge her son Achilles's loss of Briseis, the preceding incident in the *Iliad*. Seurat's other early composition is usually titled *Bather by a Curtain* (Plate 11). This is inaccurate, for the motif has a specific subject, and represents *Truth Emerging from the Well*. This image was common in late nineteenth-century France, and one could cite many examples of it, by artists as different as Félicien Rops, Frédéric Chevalier and the sculptor Henri Chapu.[45] Seurat's version, probably painted about 1879, can be readily identified as a *Truth* when placed alongside Paul Baudry's treatment of the theme (Plate 12), a variant of which was exhibited at the Cercle Volney in 1880.[46] Although Seurat has neglected the mirror, emblematic of accuracy, he would nevertheless have been aware of the specific allegorical associations: the nude personification of Truth, and the well, symbolic of creative resources, from which she emerges.

Although Seurat's academic training failed him in certain respects — notably neglecting to stimulate further the interest he had in colour — it did provide him with a sound basis from which to launch his independent career. He had received a solid grounding in draughtsmanship, and his taste for stylish linearity and disciplined design had been allowed to flourish. He had been taught the gradual procedures by which one approached mastery of one's art and carefully prepared one's work. And Seurat had been trained, as we have seen, to rehearse imagery that carried moral overtones. All these lessons would remain with him to the end of his career.

Military service, 1879–1880

Seurat seems to have left the Ecole des Beaux-Arts in the Spring of 1879, when he was last registered. It is not clear why he left. Laurent later recalled that he, Seurat

11. *Truth Emerging from the Well. c.*1880. Board, 31 x 21.5 cm. Private collection (DH 4).

12. Paul Baudry, *Truth Emerging from the Well. c.*1880. Canvas. Location and dimensions unknown.

and Aman-Jean were greatly impressed by the Fourth Impressionist Exhibition held that year from 10 April to 11 May.[47] This exhibition may well have been one factor in Seurat's gradually increasing awareness that there were exciting artistic possibilities outside the academic tradition, but on its own this experience can hardly have led to his departure. Indeed, it took him almost half a decade to come to terms with certain Impressionist principles. Seurat probably left the Ecole because he felt he had little more to learn there. He certainly was not opting out of the established art world; some years later, in 1883 and 1884, he was dutifully submitting work to the annual Salon.

Both Seurat's whereabouts and his activities during 1879 are extremely uncertain. It is often stated that, at this time, he and Aman-Jean shared a studio in the rue de l'Arbalète, in south-east Paris, but the address given for Aman-Jean in the Salon catalogues of both 1879 and 1880 is 133 quai de Valmy, to the north-east of the city.[48] Seurat's arrangements remain a mystery. The very few paintings that survive from this period, such as *Madame B., Cousin of the Artist* (*c.*1879, DH 2; Wash-

ington, Dumbarton Oaks), suggest highly finished, un-exceptional work.

This phase was destined to be a short one, for in November Seurat was called up for compulsory military service under the conscription laws of 1872. He was fortunate in having to serve for only one of the usual four years. The rules decreed that certain university diplomas — perhaps Ecole des Beaux-Arts qualifications counted — or the passing of a preliminary exam could shorten the period of service, provided another exam was passed prior to demobilization and 1,500 francs paid in lieu of service.[49] Seurat grasped an opportunity only available to a conscript from a prosperous family, for l,500 francs was equivalent to the annual wage of a Parisian factory worker.[50] By contrast, the less privileged Maxmilien Luce, later to become one of Seurat's Neo-Impressionist colleagues, was called up in the same class of conscripts. He had to serve eighteen months before the helpful intervention of the painter Carolus-Duran alleviated his military obligations, and it was only in September 1883, after the requisite four years, that he was fully demobilized.[51]

13. *Brest Sketchbook: Women; Studies of Hands. c.*1879–80. Pencil, 14.5 x 23.3 cm. Cambridge, Mass., Fogg Art Museum (DH 342).

Seurat served from November 1879 till November 1880 with the 119th Infantry Regiment at Brest.[52] Despite the obligations of military training and discipline he managed to sustain his artistic interests, reading David Sutter's serialized articles on Greek art (see Chapter 3) and continuing to draw, if not to paint.

During this period of conscription, Seurat filled a sketch-book — the so-called 'Brest sketch-book' — of 56 sheets, measuring approximately 15 by 24 centimetres. It has since been dismembered, and several of the sheets chopped up, but a specific character can still be attributed to these drawn observations. At first sight the drawings are merely cursory jottings, but in fact Seurat was cultivating a sophisticated grasp of silhouette. Sheets such as *Women; Studies of Hands* (Plate 13), a typical page from the *carnet*, show how he was keen to reduce the figures, posed in profile, to their essential traits. And a few of these drawings – *The Cobbler* (Plate 14) among them – are more adventurous, experimenting with angles of vision and *mis-en-page*. It is with these sheets that we first begin to sense a distinct personality in Seurat's burgeoning draughtsmanship as the artist, with rigorous logic, sharpened his skills at isolating the simplest and most essential formal features.

It is often thought that Seurat's year of military service forced him to look for his subject-matter in the world around him, and that the pages of the Brest sketch-book signify an abrupt switch of allegiance to the depiction of everyday life. This argument is oversimplified. The quickly drawn sketch (or *croquis*) of everyday scenes and figures was an absolutely standard practice among nineteenth-century artists, and it was encouraged, as an informal method of observation, by academic theory.[53] There is no reason to doubt that Seurat sketched such subjects before his months in Brest, and the adept notation of the sketch-book suggests that he was well versed in the practice. Nevertheless, there is still a studious quality about these drawings, the sense of the artist keeping his hand in.

The subjects are most varied. There are one or two nudes, probably posed casually in barrack-rooms,[54] and usually showing only isolated limbs. Seurat frequently drew hands, often using his own left one as a model.[55] Many sheets include several figures, and sometimes these *croquis* seem to represent scenes of markets or of garrison life, the latter often treated in coloured crayon.[56] More frequently, however, it seems that each figure was rapidly observed individually, that the drawings were never intended to cohere into groups, and that Seurat chose particular types because for some reason they interested him. He became especially skilled, for instance, at tracing the profile of contemporary women's costume.[57]

After his year's military service Seurat was demobilized, and he returned to Paris on 8 November 1880. It must have been at this juncture that he shared a studio with Aman-Jean; the 1881 Salon catalogue gives the latter's address as 32 rue de l'Arbalète.[58] Traversing the rue Mouffetard and running parallel to the Bièvre river, flanked by tanneries, this street was in a working-class quarter of tenements, workshops and small factories. Perhaps the two young artists chose the area because it was cheap; it was certainly the furthest Seurat ever had a studio from his parental home, and this might have been a gesture of independence. We do not know how long this informal artistic community — on occasion Laurent joined them — was to last, and at some point in the early 1880s Seurat seems to have had a studio at 19 rue de Chabrol, just off the boulevard de Magenta and parallel to the rue des Petits-Hôtels where he had studied under Lequien.[59] Back in Paris, his art school training and period of conscription behind him, Seurat could embark on his independent career.

14. *The Cobbler. c.*1879–80. Pencil, 10.3 x 12.5 cm. New Haven, Yale University Art Gallery (DH 332).

3 The Early Drawings and Paintings, 1880-1883

The development of a drawing style

On returning from military service in November 1880 Seurat set to work. It is no longer possible to argue that for a long period, even until 1883, Seurat devoted himself almost exclusively to drawing.[1] He did not paint much at first, perhaps until mid-1881, but from then on painting and drawing held more or less equal roles in his production. However, he made more rapid and immediate progress as a draughtsman — inevitably, as he had had more practice in the medium — and it is on the development of his drawing that we should concentrate first.

R.L. Herbert, on whose work the study of Seurat's drawings is now founded, has established that Seurat's mature style of draughtsmanship was 'formulated probably by late 1881, and for a certainty by 1882'.[2] Some 60 or 70 sheets can be roughly dated to within Seurat's first year after demobilization, and they testify to his steady progress and chart his metamorphosis from competent student to creator of 'the most beautiful painters' drawings there are', as Signac later claimed.[3] The phases through which Seurat's drawings passed during these months can be distinguished easily enough, especially if we focus on one particular motif, the seated figure of a woman sewing, which Seurat treated frequently.

Woman on a Bench (Plate 15), drawn in black chalk, must date from late 1880 or early 1881. It maintains as its essential structure the angular linearity that Seurat had evolved while on military service, and, like the drawings made at Brest, it emphasizes profile and outline. Over this linear base Seurat experimented with a very disciplined diagonal hatching, similar to the handling used in the coloured crayon drawings that he made at this time. Here, without the distraction of colour, Seurat's efforts to regiment the distribution of tone were not entirely successful. The darker and more heavily shaded areas push forward rather than recede, and this drastically distorts the modelling effects that Seurat sought. Nevertheless, *Woman on a Bench* is important because it demonstrates Seurat's determined search for a

drawing style based on tonal relationships and shows the (here rather excessively) methodical manner in which he went about his experiments. About 40 more sheets of similar size, probably from the same sketching block, utilize a closely related style of hatching. Several of these also depict seated women in interiors,[4] but other drawings indicate the range of Seurat's observation over the short period he worked in this manner; one sheet, for example, depicts a bootblack, and another two women apparently in church.[5]

A second drawing of a woman sewing, made some months later, shows Seurat's progress. *Woman Sewing; Picture on the Wall* (Plate 16) is of particular interest because it is unfinished; Seurat rarely left drawings in this state, and the sheet provides important evidence of his development. It retains the angular substructure of his earlier drawings, though this is looser and less in evidence than in earlier sheets. Over this he has played his conté crayon, in places (for example, along the right edge) with diagonal hatchings still reminiscent of *Woman on a Bench* and elsewhere (on the nearly completed head) with a more smudged and scumbled touch. The design was thus still conceived around a linear structure, and not purely as a tonal whole. But, despite its incomplete state, the *Woman Sewing* is a more successful drawing than *Woman on a Bench* because Seurat has dared to simplify. He has not tried to model every shift of tone, but, removing details, has simplified the motif into broad zones and begun to build his forms by value, by relative lightness and darkness.

Seurat arrived at his mature style of draughtsmanship during 1882, if not late the previous year. Another drawing of a *Woman Sewing* (Plate 17) was inscribed by the artist '18 Juillet 1882', and it demonstrates his complete confidence in his new handling, with its delicate gradations from light to dark and back again, its willingness to allow the white paper a suggestive role, and its rich tenebrism. For the great majority of his mature drawings Seurat worked with conté crayon on Michallet paper. R.L. Herbert's classic description of how these media were used has not been bettered: 'Conté is a medium

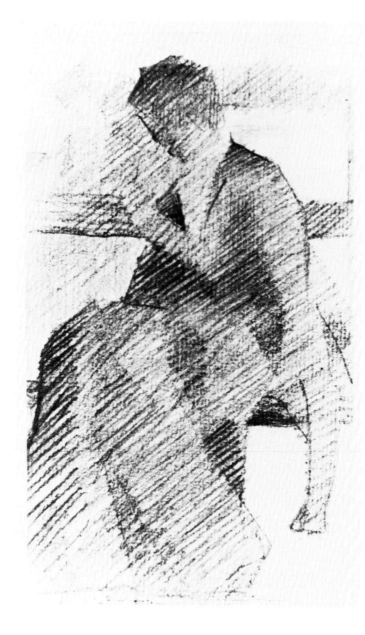

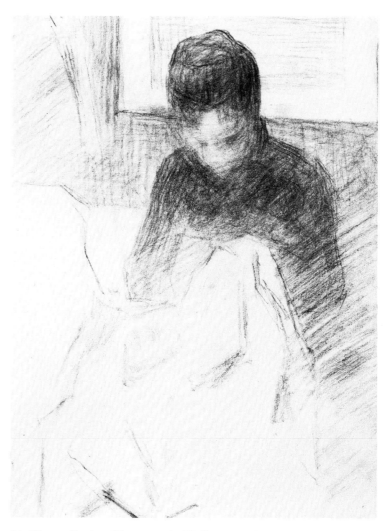

16. *Woman Sewing: Picture on the Wall. c.*1881. Conté crayon, 23.1 x 18.1 cm. Manchester, Whitworth Gallery (DH 446).

15. (left) *Woman on a Bench. c.* 1880–1. Black chalk, 16.5 x 10.4 cm. University of East Anglia, Sainsbury Centre (DH 403).

hard and greasy crayon which has certain advantages over charcoal. It is easier to handle, since it does not crumble or smudge, and the degree of darkness is directly proportionate to the pressure used. It is nonetheless soft enough to leave its mark no matter how lightly applied. In the original its more opaque and lustrous blacks distinguish it from the matte and chalky blacks of charcoal. Michallet was a particular brand of "Ingres paper" (so named because it was favoured by that great master of drawing) Seurat always used. It is a thick rag paper, milk-white when fresh but a creamy off-white after exposure to the air. Under a microscope its myriad tufts can be seen to project from the surface in little comma-shaped hooks. When Seurat lightly stroked the surface, the hooks caught the crayon here and there, leaving the valleys between them untouched. As a result, his greys are truly three dimensional, with the white showing between the touches of dark, and no matter how smooth when viewed from a distance, they are full of little wisps and irregularities which are a joy to discover when close to the eye'.[6]

With these tools Seurat generated a novel form of draughtsmanship. One can see in the 1882 *Woman Sewing* (Plate 17) how line plays little or no part; the figure has no edges, but is bound into a tight tonal relationship with its surroundings. The sheet is thus conceived not as a group of separate but interlocking shapes defined by lines, but in terms of gently modulated tones modelled by the fall of light. The drawing is a coherent totality, in which every square inch of the sheet plays its part. The artist's role, as Seurat tacitly envisaged it in such drawings, was not to conjure up images by improvisatory graphic gestures, but to construct an ensemble that was unified by tone alone.

What is remarkable about this development as a draughtsman is not merely Seurat's age — and to have perfected a fresh manner of drawing when only 22 is a considerable achievement — but the rigorous and critical consistency with which he saw it through. Take a sheet like *The Harvester* (Plate 18). Dated 1881, it was probably, given its subject, made during the summer of that year. It is a strong and striking drawing, but contains

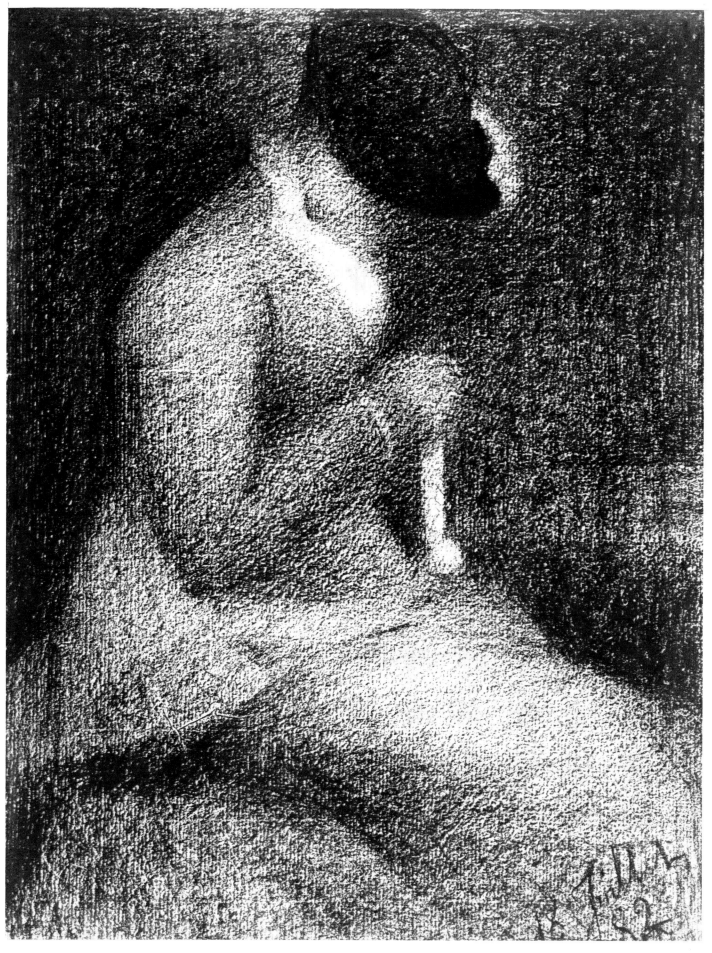

17. *Woman Sewing*. 1882. Conté crayon, 31 x 23.5 cm. Cambridge, Fogg Art Museum (DH 512).

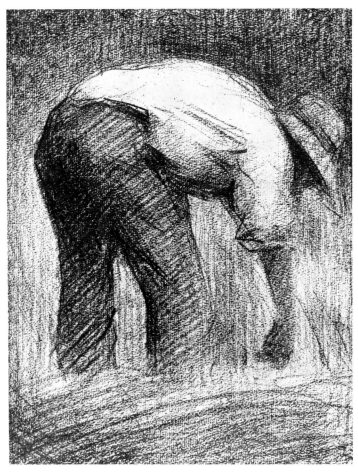

18. *The Harvester.* 1881. Conté crayon, 30 x 24 cm. Private collection (DH 456).

19. *Stonebreaker and Other Figures, Le Raincy. c.*1881. Conté crayon, 30.7 x 37.5 cm. New York, Museum of Modern Art (DH 463).

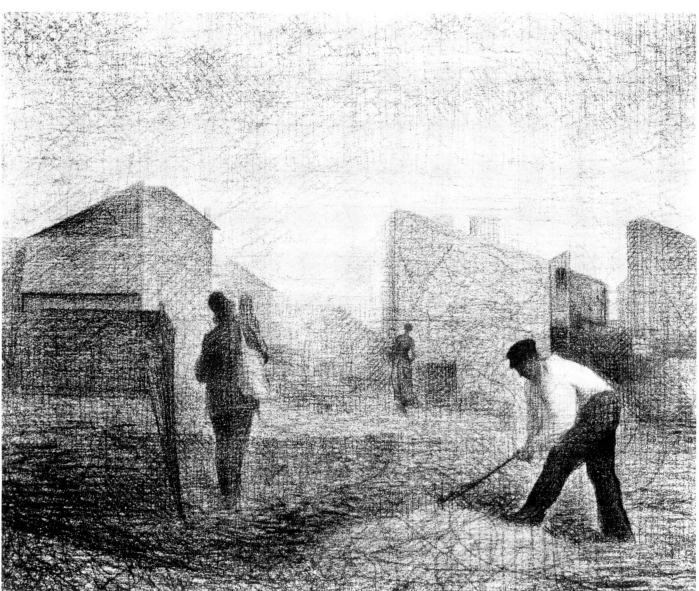

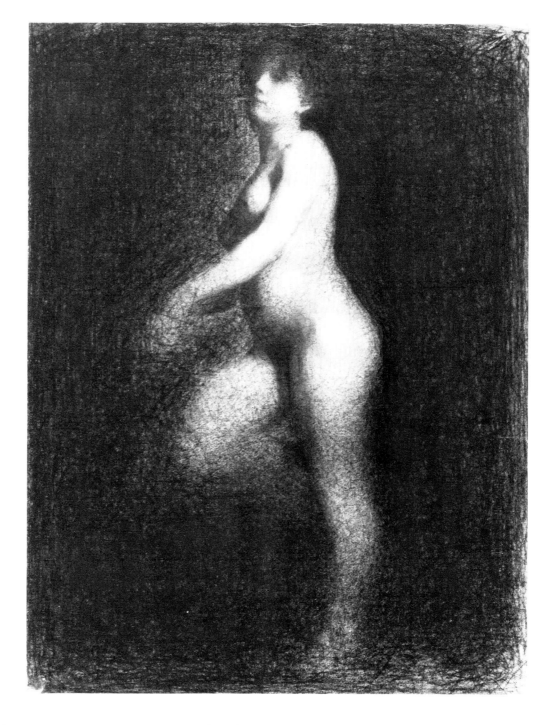

20. *Standing Female Nude. c.* 1881–2. Black chalk, 48.6 x 33.6 cm. London, Courtauld Institute Galleries.

flaws that must have impelled Seurat to continue his search for a unified style of drawing, involving none of this sheet's compromises. For in *The Harvester* the modelling of the trousers, although the hatching has been applied with respect for the fall of light, is inconsistent with the subtle modelling of the outstretched arm. And whereas the edge of the arm is dissolved by the light, the equivalently lit contour of the back is not. In settling for nothing less than unity and consistency in his drawing Seurat gave early evidence of his intellectual rigour and the consistent logic of his experimentation.

Nowhere is Seurat's willingness to experiment more clear than in one of the few multi-figure motifs he made as he perfected his drawing style. *Stonebreaker and other Figures, Le Raincy* (Plate 19), with its angular linear underdrawing and hatched shading, must also date from 1881. It was evidently not drawn from life, for its atmosphere is strikingly unnaturalistic and it bears all the hall-

marks of an early studio composition; indeed, a ruled pencil line around all four edges suggests that Seurat was planning size precisely rather than letting the image develop organically. The hatching creates a grid-like effect, most noticeable in sky and foreground, against which the figures are set. The drawing has some curious and unsatisfactory features, such as the illegible form to the left, and the geometric and at times spatially bizarre shapes are reminiscent of some of Lehmann's water-colours of Pompeii, which Seurat might have seen.[7] *The Stonebreaker* is an important example of Seurat's early efforts to produce an architectonic composition incorporating several figures, but it was a direction which he preferred not to pursue for some time.

Alongside the restless experimentation, Seurat also followed more conventional practice. He seems still to have drawn from the model, for instance. One such sheet survives (Plate 20), its style consistent with a date

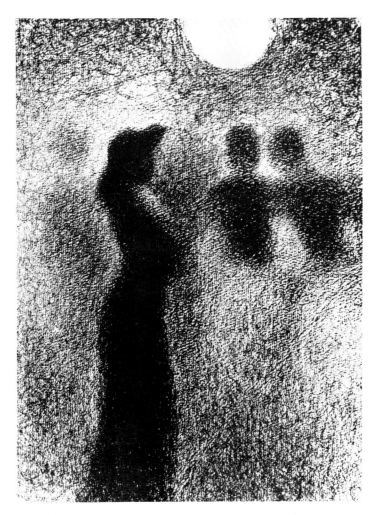

21. *Promenoir. c.*1883. Conté crayon, 29.5 x 22.5 cm. Private collection (DH 499).

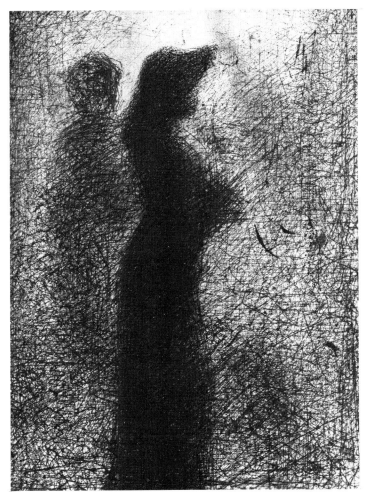

22. *Promenoir. c.*1883. Pen and ink, 27.5 x 20.5 cm. Wuppertal, Von der Heydt Museum (DH 498)

of c.1881–2. Its attribution to Seurat has been doubted, although upheld by Herbert.[8] We know too little about the early drawings of Aman-Jean and Laurent, the friends with whom he was working at the time, to give the sheet to either of them, and Seurat's hand seems evident enough. The model's arms and knee rest on a chair which the artist has left out, in 'a pose typical of the academic model',[9] and this feature, combined with the uncharacteristic use of stump on breasts and belly, gives the sheet a conventional character. But Laurent recalled that in the early 1880s Seurat and he often drew by lamplight, a thoroughly unacademic practice, and this sheet could well have been made in such circumstances.[10] The pose of this *Standing Nude* was adumbrated in an outline drawing,[11] and Seurat did make use of such preparatory sketches on occasion. For example, the drawing known as *Promenoir*, made about 1883,[12] exists in two versions (Plates 21, 22), one an ink sketch roughly mapping out the main silhouette, the other a carefully crafted conté drawing with additional figures.

Although by 1882 the principal characteristics of Seurat's mature drawings had been established, it would be wrong to assume that his draughtsmanship conformed to a simple formula. His handling gradually changed as the years passed, in both texture, finish, and density of tone.

But even in 1882 and 1883, a period when Seurat drew intensely and produced some of his finest sheets, he varied his expressive effects in subtle ways. *The Gleaner* and *Man with a Pick* (Plates 23, 24) have much in common; both set the stooping figure, engaged in an agricultural task, against the skyline, and both were drawn about 1883 on almost identically sized sheets. *Man with a Pick* is heavily shaded, while in *The Gleaner* the ground is described by agitated, wispy strokes. The execution of each is quite appropriate, for in the former it gives a sense of the heaviness of the soil that the man is breaking up, and in the latter the texture hints at stubble. Even the different heights of the horizon act effectively to set the mood of the work Seurat depicts, for the more open, airy space of *The Gleaner* corresponds to the lighter task. It was with such drawings that Seurat taught himself to match his his execution and distribution of forms with the meanings he wished to convey.

Drawing in the tenebrist tradition

By 1882 Seurat had developed an evocative and personal style of drawing, sensitive enough to record subtle changes of light, flexible enough to achieve varied ef-

fects, and economical enough to give his forms the gravity and considered construction that he sought. These were significant steps for a young artist and were obviously not ones that could be taken unaided. Although too little evidence survives to establish any precise pattern of collaboration, it must be the case that Seurat's friendship with Laurent and Aman-Jean, and perhaps with other ex-students of Lehmann, acted as an important stimulus. It was in their company that he drew by lamplight and read Leonardo's treatise with its important views on chiaroscuro; both these experiences — one practical, the other theoretical — must have contributed to the rapid progress of his drawing. And there were stylistic precedents for the type of tonal draughtsmanship that Seurat perfected to which we must now turn, for they tell us a great deal, not only about his drawing but also about his taste and his attitudes to art.

In the early 1880s Seurat's taste broadened to embrace Rembrandt, an artist for whom he seems to have shown no appreciation as a student. He cut thirteen reproductions of Rembrandt etchings from an article published in *Le Figaro* on 8 April 1882,[13] and added them to a collection of reproductions and popular prints, as well as some of his own early drawings, that he formed in the 1870s and early 1880s and kept throughout his life — the so-called Seurat Folio.[14] There was at this period great interest in seventeenth-century Dutch art, and especially that of Rembrandt, whose work was reassessed in important contemporary publications such as Eugène Fromentin's *Les Maîtres d'autrefois* (1876) and Henry Havard's *La Peinture hollandaise* (1881). Indeed, the article

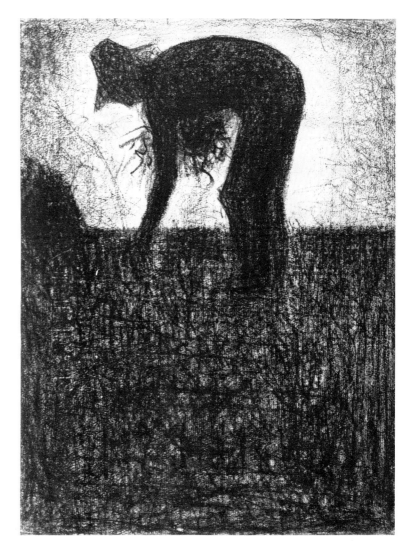

23. *The Gleaner. c.*1883. Conté crayon, 32 x 24 cm. London, British Museum (DH 559).

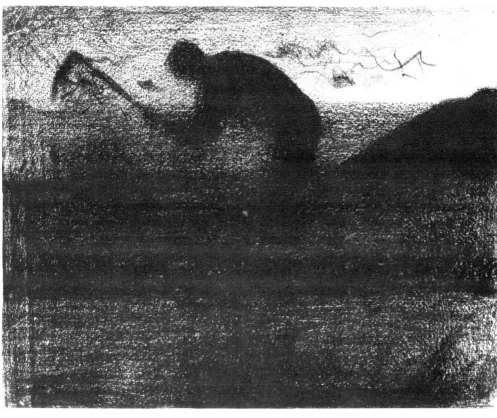

24. *Man with a Pick. c.*1883. Conté crayon, 24 x 31 cm. Private collection (DH 552).

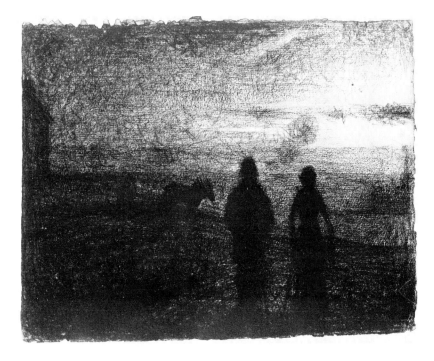

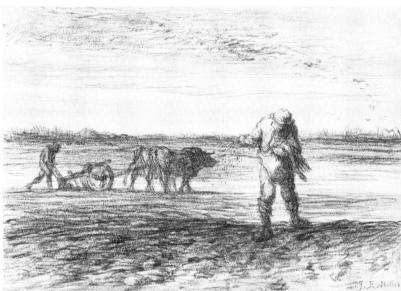

25. *Ploughing* c.1882. Conté crayon, 27.5 x 32 cm. Paris, Louvre (DH 525).

26. Jean-François Millet, *The Sower*. c.1850–1. Black chalk, 14.6 x 21.2 cm. Oxford, Ashmolean Museum.

from which Seurat cut his reproductions was occasioned by the appearance of Eugène Dutuit's *L'Oeuvre complète de Rembrandt*, in which all Rembrandt's etchings were illustrated. Rembrandt was much admired for his chiaroscuro — Havard, for instance, praised his 'transparent and luminous' shadows and his ability to simplify by lighting only the salient elements of his design[15] — and Seurat clearly studied his work for such effects. It has recently been pointed out that the somewhat blurred reproductions of Rembrandt's prints that he collected would have been almost more relevant to his researches than the original etchings, and he may well have made the most of what such printing defects could teach him.[16]

The Seurat Folio also contained a reproduction after Millet, from whose work Seurat was to learn much. Following Millet's death in 1875 his work had been widely dispersed via various sales,[17] and in 1881 his friend Sensier's important biography, *La Vie et l'oeuvre de Jean-François Millet*, was published with ample illustrations; the Barbizon master's work was thus readily available for Seurat at this crucial stage of his career. Millet had developed in his pastels and especially in his black chalk drawings a combination of vigorous forms and strong compositions, often handled in impacted dark tones. The formula Millet used in drawings such as *The Sower* was one Seurat adopted, as comparison with *Ploughing*, a sheet of about 1882, shows (Plates 25, 26). The younger artist purloined several of Millet's stock devices: the emphasis is on the horizon, pitched at mid-point on the sheet to give a sense of maximum space, emphasized by lighter bands of tone where earth and sky meet, broken off-centre by dark figures. And yet in Seurat's hands Millet's imagery of hard agricultural labour can take on an ironic character, for in *Ploughing* the work in the fields is watched by an elegant couple, the woman holding a parasol.

Millet was only one — albeit the most important — of the modern artists to whose work Seurat could have turned as he sought for example and justification in the development of his tonal drawing style. Several of Seurat's older contemporaries drew extensively in charcoal or rich black chalk — Bonvin, Lhermitte and Lebourg, for instance — and their examples no doubt encouraged Seurat's progress.[18] One of Lebourg's drawings must suffice to show how close Seurat's draughtsmanship could come to such artists. Lebourg exhibited ten drawings at the 1879 Impressionist Exhibition, which Seurat attended. One of them was entitled *Reading (Evening)*,[19] and this may well have been the sheet now known as *Portraits of the Artist's Wife and Mother-in-Law* (Plate 27). But while such a drawing might set a precedent for tenebrist subjects, comparison with sheets by Seurat such as the portrait of his mother (Plate 1) indicates how much further Seurat was prepared to take the process of simplification, removing the naturalism still so insistent in Lebourg's drawing and replacing it with more concentrated grandeur and greater delicacy of touch.

Other artists whose work Seurat would have known not only made similar tonal drawings in charcoal or black chalk but also duplicated such images in lithographs,[20] and both Fantin-Latour and Redon should be taken into account. Several of Fantin-Latour's earlier lithographs dealt with interior subjects derived from the example of seventeenth-century Dutch genre painting, and Seurat's images of women sewing can be compared both to Fantin-Latour's lithographs of such themes (Plate 28) and to such paintings as Vermeer's *The Lace-Maker*, purchased for the Louvre in 1870. We will return to Redon, and also to Daumier, whose lithographic caricatures Seurat would surely have known,[21] in due

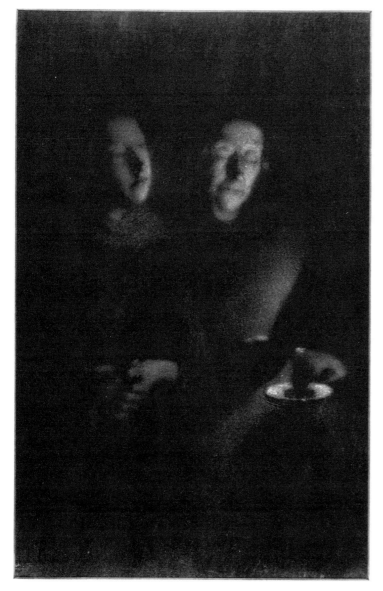

27. Albert Lebourg, *Reading (Evening)*.
1879. Black chalk, heightened with white,
43.5 x 28.3 cm. London, British Museum.

course. The point is that in Paris circa 1880 Seurat had available to him a wide variety of stimuli, in the form of reproductions, drawings and prints, that could serve to encourage the development of his draughtsmanship. All these sources, be they Rembrandt etchings, contemporary lithographs or the tonal drawing of Naturalist artists, have in common one element: they were alien to the academic canons by which he had been trained.

Why did Seurat lavish so much attention on his drawing in the months that followed his demobilization? There was something logical, strategic, in his decision. Unlike his friends, he was prepared (and financially able) to bide his time before making any claim for status as a painter. Again, it was sensible for an artist of Seurat's ambition and intellectual discipline to hone his drawing before applying its lessons to painting. Drawing is more convenient than painting; its results can be gauged more rapidly. And Seurat returned from his period of conscription during the winter. The first months that he had for making up lost time would have been uncongenial for plein-air sketching in oils, and the other genres that he might have used for winter practice in studio painting — portraiture, still-life — were of little interest to him. Drawing is also an appropriate medium for the analysis of one's environment, for the preliminary observation of motifs, and Seurat used the years 1881 to 1883 to develop his drawing and simultaneously explore the subjects of the everyday scene. Finally, Seurat must have felt a sense of achievement and confidence at establishing a personal manner so rapidly; no wonder his earliest exhibits were large-scale drawings, when the work he was producing was demonstrably of such high quality.

Seurat's concentration on drawing — and one should never forget that this was not to the exclusion of paint-

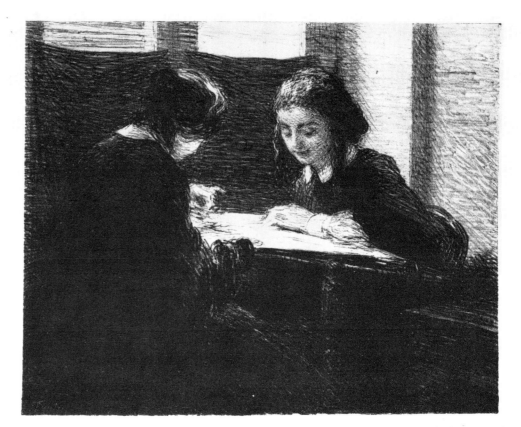

28. H. Fantin-Latour, *The Embroiderers*.
1862. Lithograph, 27 x 40.7 cm. London,
British Museum.

ing — is, however, paradoxical in relation to his academic background. On the one hand he continued the approach that he had been taught: that the vigorous exercise of graphic procedures would ease painterly problems later, that mastery of tone should precede the use of colour. On the other, his chiaroscuro, tonal drawing was contrary to the strict linearity in which he had been instructed as a student.

Such tensions between the conservative and the progressive were at the heart of Seurat's creative temperament. Nowhere is this more apparent than in *Une Baignade* (Plate 97), which was his first major exhibition picture, shown in the spring of 1884. It is, as we shall see, a conventional picture in many ways and Seurat's researches as a draughtsman had a direct impact on its execution; yet it was rejected by the Salon jury, perhaps because it was considered too 'modern', too divorced from the precepts of the Ecole des Beaux-Arts.

Painting: theorists and mentors

At the same time as he was advancing his abilities as a draughtsman Seurat was also making progress with his painting. In discussing his development as a painter prior to *Une Baignade* we need to analyse his theoretical interests as well as his actual painting and the sources from which it sprang. In dealing with Seurat's painting during these early years two particular issues arise. The first is the problem of chronology, for these early pictures are very difficult to date. He dated none himself and exhibited no painting until 1884, and we are hardly helped here by his friends' scant recollections; hence we have to proceed on stylistic grounds alone. The old myth that Seurat drew before he started to paint seriously suggests that, when the painting began, there was a flurry of work and rapid progress, but in fact there was a rather more steady advance. The second issue is the interrelationship of theoretical and stylistic sources. Happily, the work that arouses the discussion of such complex and cerebral matters is, for all its modesty of size and ambition, among the freshest and most challenging ever produced by a young painter.

It should come as no surprise that Seurat felt a strong commitment to what he saw as the scientific 'rules' of painting. To discover immutable and logical laws by which to discipline one's work was a challenge to a man of Seurat's probing and persistent temperament. And the intellectual tenor of the period, rooted in the Positivist notion of the ultimate comprehensibility of the material world through scientific progress, encouraged such researches. From at least the 1860s, much writing about the arts had emphasized the factual, 'scientific' foundations of creativity; Charles Blanc's obituary of Delacroix had stressed the artist's knowledge of 'the mathematical laws of colour' and Zola in the preface to the second edition of his novel *Thérèse Raquin*, published in 1868, declared that the book's aim was 'scientific'.[22]

Such ideas were still current in the late 1870s and early 1880s, the period of Seurat's intellectual formation. In 1880 Zola published *Le Roman expérimental*, in which he tried to draw analogies between the scientist and the novelist, and in one of the texts Seurat read at this time, David Sutter's articles 'Les Phénomènes de la vision' (serialized in *L'Art* in 1880), the writer agreed that '... laws hinder neither the spontaneity of invention nor of execution, despite their absolute character ... science removes all uncertainties and permits complete freedom of movement.'[23] Seurat was never to let his theoretical researches dominate his creative temperament, but much of his work concentrated on a determined effort to codify the principles of painterly practice. It was the painter's duty, he felt, to found his art on these principles.

Fortunately, in the letter he wrote to Félix Fénéon in June 1890 (Appendix I), Seurat gave a precise account of his earlier reading. In this letter he emphasized that the main thrust of his theoretic interests had been, from his student days, a search for 'an optical formula', centred on what he defined as 'the purity of the spectral element'. Between 1876 and 1884, he recalled, he had read much on colour theory in pursuit of this goal, beginning with Blanc's *Grammaire des arts du dessin*, which he had read at the Ecole des Beaux-Arts. Through Blanc's book he learnt of Chevreul's laws of colour and also about Delacroix's ideas, which he then followed up in Blanc's other writings about the artist.[24] Seurat mentioned that his attention had also been drawn to the views of both Corot and Couture, and that he had been struck by the work of Monet and Pissarro. In early 1880, while on military service, he had read Sutter's articles, and he had tackled Rood's *Modern Chromatics* (first published in 1879) when it was translated into French in 1881.[25] With the aid of Seurat's very specific reminiscences scholars, notably W.I. Homer and R.L. Herbert, have been able to provide thorough accounts of the development of his theoretical interests.[26] It is worth stressing that the list the artist gave to Fénéon is dense with references to painters whose work and opinions he had studied. The idea that Seurat's art was dependent on textbook principles is entirely wrong; first and foremost he was a painter.

Indeed, the texts that Seurat read were not so much complicated scientific volumes as convenient synopses of optical and chromatic theories aimed at the general reader or even specifically at the practising painter. Seurat never explicitly stated, for example, that he had read Chevreul's book itself, a complex treatise written as a result of the scientist's experiments while in charge of the dyeing workshops of the Gobelins tapestry factory and dealing in some detail with subjects, such as optics and chemistry, of which Seurat's knowledge can only have been rudimentary. The letter rather suggests that Seurat gathered the fundamental rules established by Chevreul from the summary given in Blanc's book. Blanc's *Grammaire* itself can hardly be considered a

scientific text, for it is a lengthy and fascinating hotch-potch of Blanc's own aesthetic tenets, surveys of import-ant areas in the visual arts such as architecture and print-making, and accounts of theoretical and artistic ideas that particularly interested him. But Blanc did give 'a brief résumé of Chevreul's law of simultaneous contrast of colours, which in its simplest form stated that com-plementaries, when juxtaposed, mutually intensify each other; when mixed, however, they destroy each other'.[27] These findings gave Seurat valuable advice. In order to obtain greater brilliance and luminosity in his painting he would have to keep his colours separate. This would allow the complementary colours (the primaries red, yellow and blue have as their respective complementaries green, violet and orange) to exalt each other, thus en-hancing the chromatic effect of the painting. Seurat had to develop an appropriate brushwork to respond to the theory of optical mixture ('mélange optique') that Blanc extrapolated from his understanding of Chevreul's pre-cepts and Delacroix's paintings. Blanc remarked that 'separate touches of pigment will tend to form more pure and vibrant colours in the observer's eye than would be formed by the more traditional mixing of pigments on the palette'.[28] Much of Seurat's activity as a painter between his demobilization and 1883 involved experimentation with complementary colours and the search for a suitable brushwork.

Blanc's *Grammaire* was thus extremely important for Seurat; as Herbert has pointed out, Seurat's 'subsequent readings were either confirmations or scientific exten-sions of what Blanc says in his eclectic summaries'.[29] In 1881 Seurat was able to read the translation of Rood's *Modern Chromatics*, which as well as being more up-to-date in scientific data than Chevreul, must have been particularly attractive to Seurat as it was written with painters specifically in mind. Rood's chief contribution to Seurat's understanding of colour theory would have been his distinction between colour-light and colour-pigment, which, in brief, explained that, as paint cannot exactly emulate the qualities of light, the painter should not expect his medium to act in the same way as colour does in natural circumstances.

Rood's book also gave practical advice. He was him-self an amateur painter, and recommended artists to practise colour effects in oil sketches, using large brush-strokes on small surfaces. This was an encouragement to Seurat to utilize the traditional oil sketching procedure taught at the Ecole for experimentation in colour, not just as an exercise in natural observation. Rood also published a colour-wheel of 22 colours, which Seurat copied, and such a device enabled the artist to read off instantly the correct complementary pairings.[30] Seurat's letter to Fénéon also mentioned reading Sutter's articles in *L'Art* early in 1880. Sutter's ideas tallied with many of Seurat's concerns. As we have already seen, Sutter stressed the value of scientific principles to artists, and he reiterated the standard views on colour theory. He also put forward some interesting ideas about the moral or symbolic qualities of various colours, which may have had an impact on Seurat at a later date.[31] In sum, Seu-rat's reading was undoubtedly thorough — he copied out passages from several of these texts — but it was essentially practical, limited in scope to writings that could help him as a painter.

Although on the evidence of his copies Ingres was the artist Seurat most admired at the Ecole, he was also impressed by Delacroix's work, and this enthusiasm matured in the early 1880s as his interest in colour grew. Aman-Jean remembered how Seurat had particular re-spect for Delacroix's paintings in the church of Saint-Sulpice (Plate 221), and they used to go and study them together. The reminiscences of friends like Signac and Kahn, close to Seurat in the second half of the decade, prove that Seurat's admiration for Delacroix continued till the end of his life.[32] It may well have been Blanc who aroused this passionate interest, for Seurat's ability to cite chapter and verse to Fénéon suggests very thorough study of Blanc's writings on Delacroix.

Blanc identified a number of characteristics in Dela-croix's work to which Seurat would have responded: his knowledge of the 'rules' of colour, his ability to inject a modern spirit into classical forms, and his skill in co-ordinating and unifying large works.[33] If these last two qualities were ones to which Seurat would later aspire, first he settled to learning what he could from Delacroix about the ground rules of painting, and he went about this in an empirical fashion. Notes survive from several occasions in 1881 — 23 February, 6 May, 11 November — when Seurat made rapid sketches and took colour notes from paintings by Delacroix that he saw on display at the galleries of Parisian art dealers.[34] Seurat particularly interested himself in complemen-taries; the notes he made on *The Fanatics of Tangier* (1836–8; Minneapolis Institute of Art) in February remark on the contrast of complementary red and green in the central flag, for example (Plate 31). It was on such juxtapositions that Seurat was to focus in his own early paintings.

While Delacroix was undoubtedly the primary paint-erly influence on Seurat in the early 1880s, the young artist looked to other senior figures whose reputations were high in mid-century. As we saw earlier, while still a student he had copied some notes on painting dictated by Corot.[35] Corot's remarks are generally rather conser-vative, emphasizing tone over colour, but there were opinions to interest Seurat, notably the stress on har-monious ensemble and the concentration on a single luminous point in the picture. Seurat also mentioned in his letter to Fénéon that he had studied Couture's pre-cepts on colour at the time of the Couture retrospective exhibition, held in 1880. He did not make it clear, how-ever, whether he had simply looked closely at the paint-ings on exhibition or actually consulted Couture's two books on painting technique.[36] But it has been argued that in alternating the exposed canvas with layers of scumbled impasto and working on red-brown grounds

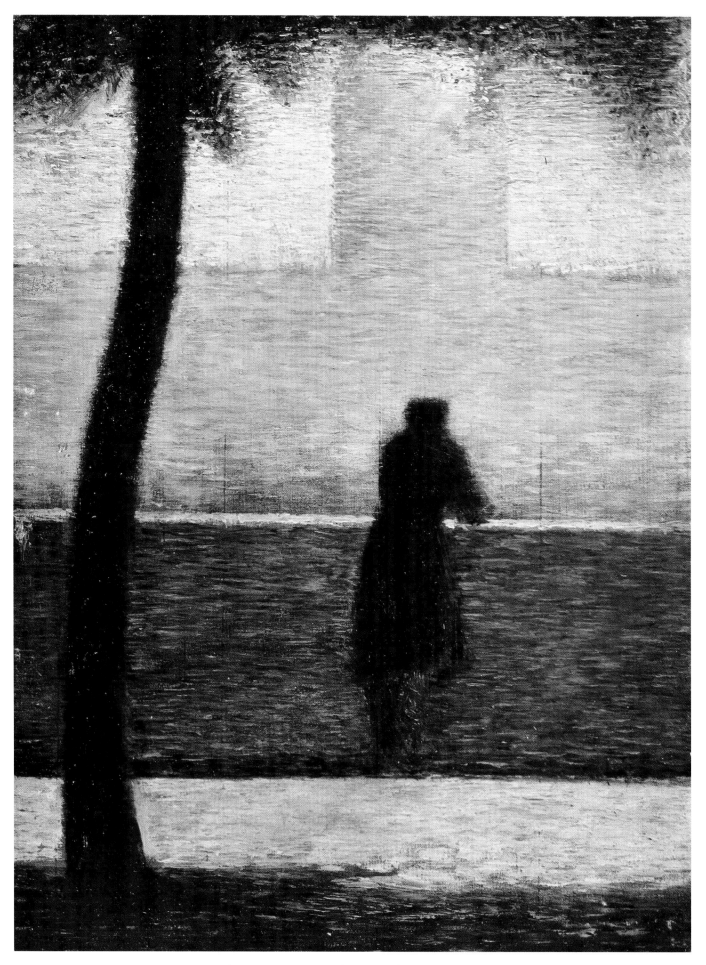

29. *Man Leaning on a Parapet. c.*1881. Panel, 25 x 16 cm. New York, Metropolitan Museum (DH 12).

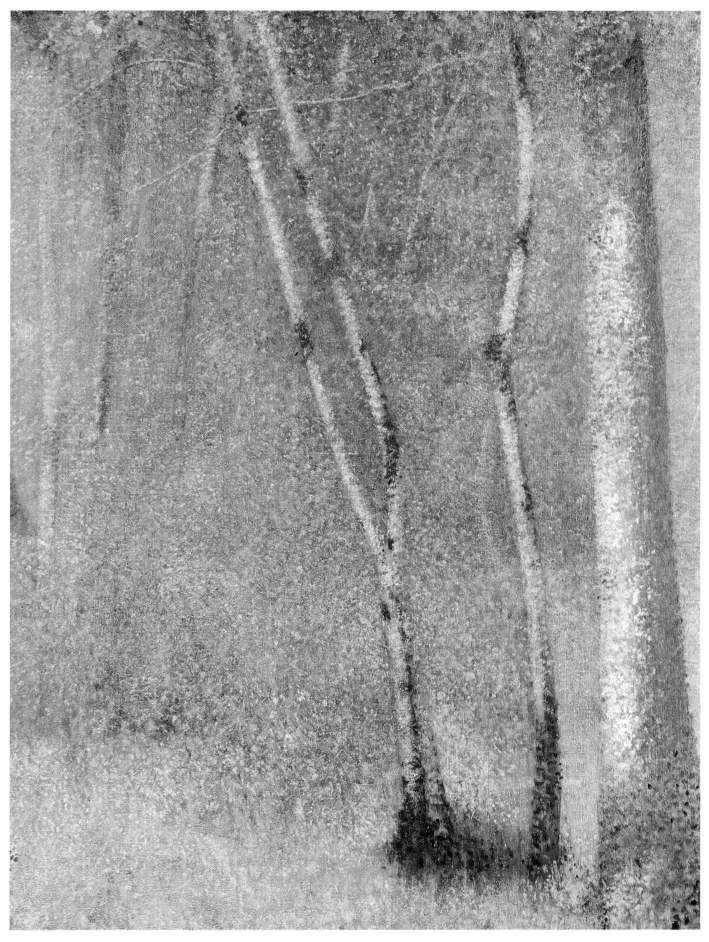

30. *The Forest at Pontaubert*. 1881. Canvas, 78 x 63 cm. Saltwood Castle, Mr. and Mrs. Alan Clark (DH 14).

31. Copies and notes after Delacroix's *Fanatics of Tangier*, 1881. Pen and ink, 22.5 x 31 cm. Private collection (DH 386).

in many early paintings, Seurat was in line with the recommendations of Couture's teaching.[37]

A fourth painter to whom Seurat turned during this formative phase was to have a more lasting influence on him. Puvis de Chavannes, who reached the age of 60 in 1884, had a long career behind him, but only during the previous decade had he begun to gather much substantial critical support. The mural paintings on the subject of the childhood of Sainte Geneviève, executed for the Panthéon between 1874 and 1878, had been well received, and over the next few years a sequence of successful municipal mural commissions and highly personal easel paintings exhibited at the Salon finally established his reputation.[38] As a result Puvis began to gain a following among young painters, especially dissatisfied students from the Ecole des Beaux-Arts, who found in his work — characterized by simplified drawing, disciplined design and subdued tones, all ordered towards total decorative effect rather than highly polished finish — a formula that upheld French classical traditions while remaining refreshingly apart from sterile academic ordinances. About 1880 Puvis began to take pupils on an informal basis, and a number of young painters passed through his atelier, receiving advice on their work and helping Puvis with his studio chores.[39]

Puvis held a particular attraction for ex-students of Lehmann. During the early 1880s Séon, Osbert, Seurat, Aman-Jean and Laurent all had some kind of relationship with him, either as admirer, pupil, or even assistant. There is insufficient evidence to establish precisely what personal contact Seurat and Puvis had. Aman-Jean's son reported that Seurat and his father helped Puvis square up drawings for the *Sacred Wood* (Plate 119), exhibited in 1884, while Herbert has argued that Seurat and Puvis may never have met.[40] But given Seurat's serious and long-standing respect for Puvis's work and the fact that so many of his friends were in (sometimes close) professional contact with the elder artist, it is most unlikely that they did not know each other. Seurat's regard for Puvis at the very outset of his independent career is quite certain. At the Salon of 1881 Puvis showed his *Poor Fisherman* and Seurat made a casual copy of it (Plates 32, 33), the first proof of a visual relationship which would involve varied responses from Seurat for several years to come.

The painter at practice

At the same time as he was digesting these books and articles, and studying the remarks and pictures of these artists, Seurat was hard at work painting. Of the eighty or so paintings that come before *Une Baignade* and its preparatory material, some three-quarters are small oils executed on wood panels rather than on canvas. The panels Seurat used — he referred to them as *croquetons* (little sketches) — generally measure some 16 by 24 centimetres and were in fact cigar-box lids. These were particularly suitable for the artist's purposes, being easily transportable and requiring no special treatment such as sizing. Equally, the red-brown of the wood provided an ideal warm ground for the landscape motifs that predominate as the subject of these panels.

Too often writers on Seurat forget that these early

32. Pierre Puvis de Chavannes, *The Poor Fisherman*, 1881. Canvas, 155.5 x 192.5 cm. Paris, Louvre.

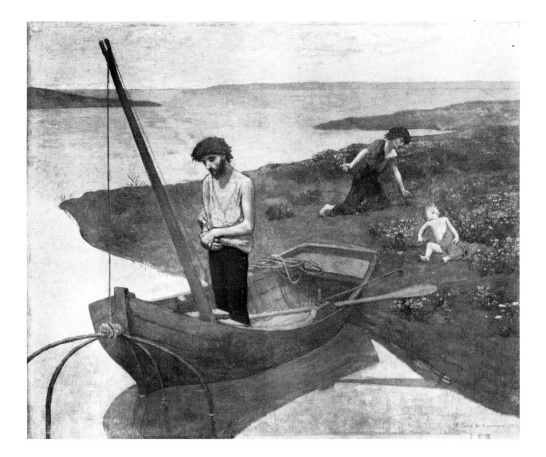

33. Copy after *The Poor Fisherman*. c.1881. Panel, 16.8 x 25.4 cm. Paris, Mme Huguette Berès (DH 6).

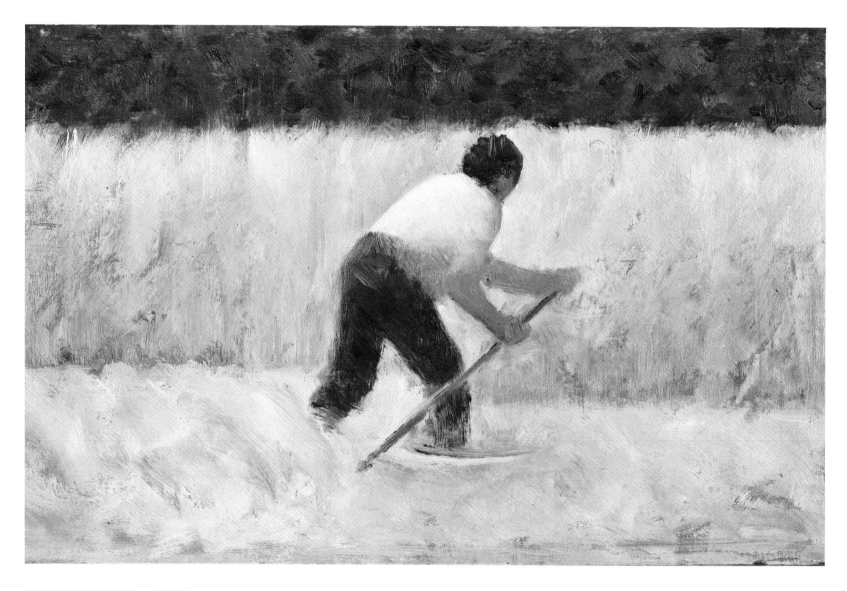

34. *The Mower. c.*1882. Panel,
16.5 x 25 cm. New York,
Metropolitan Museum (DH 58).

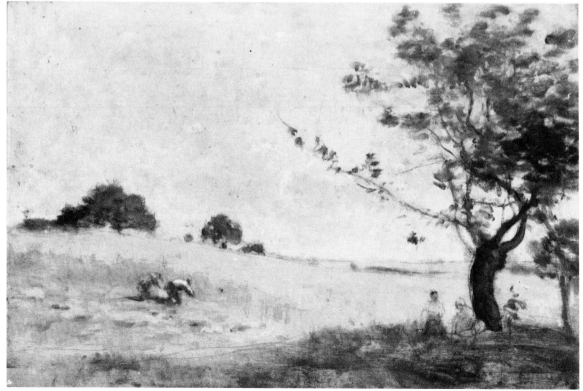

35. Camille Corot, *Harvesters in
Picardy. c.*1850–60. Panel,
25.5 x 37 cm. Private collection.

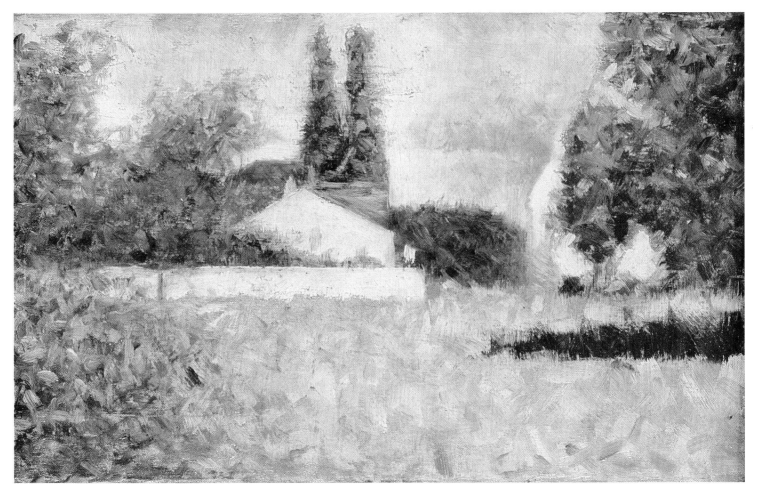

36. *Houses amongst Trees.* c.1883. Panel, 16 x 25 cm. Glasgow Art Gallery and Museum (DH 56).

landscape sketches were by no means an exceptional activity on the artist's part; they belong to a well-established tradition of taking *études* from nature, a tradition enshrined in academic theory. At the beginning of the nineteenth century the great theorist of Neo-Classical landscape, Valenciennes, had established that an essential part of a landscape painter's work was the execution of rapid oil sketches out of doors, in order to refine the artist's responses to natural effects. Valenciennes's writings were still consulted in mid-century, and his recommendations were standard practice.[41] Even Lehmann, for all his apparent caution about excessive plein-air work, made such *études* himself. So did Puvis de Chavannes, and if Seurat visited Puvis's studio he would have seen his small landscape studies.[42]

From the beginning of his career as an independent painter Seurat concentrated on three main problems: the application of the laws of colour, controlled handling of paint, and disciplined composition. The endeavours are evident in *Man Leaning on a Parapet* (Plate 29), one of his earliest paintings of the isolated urban figure that was to be such a *leitmotiv* in his work.[43] This painting is particularly difficult to date because so little comparative or documentary material survives from this stage of Seurat's career. Although it is usually dated c.1881, Herbert has proposed on the evidence of the drawing style in

two unpublished notebooks that the painting was executed prior to Seurat's military service. However, the existence of several preliminary drawings for *Man Leaning on a Parapet*, including a pastel made in diagonal hatchings similar to drawings of early 1881 (Plate 37), suggests that although the painting may have been begun in 1879 it was probably taken up again after Seurat's demobilization.[44] The picture already shows a compositional relationship typical of Seurat, as the natural forms of tree and figure both echo each other's undulations and are silhouetted against the stark geometry of the city. The distribution of colour shows his preference for an arrangement in bands, and the parallel scheme of brushwork represents an early attempt to produce a systematic handling. Complementary colours are used in a very tacit fashion, within an essentially tonal structure. *Man Leaning on a Parapet* was a cautious, if auspicious, start to Seurat's career as an independent painter.

The predominant genre in Seurat's painting until 1883 was of course landscape, and taking this theme we can follow his stylistic progress. Seurat made frequent painting trips with Aman-Jean to places like Ermenonville, Chalis, Survilliers, Mortefontaine and Barbizon, and once the two friends travelled along the Seine as far as Rouen and Saint-Martin de Bocheroille.[45] They also worked near Paris, in outlying suburbs such as Saint-

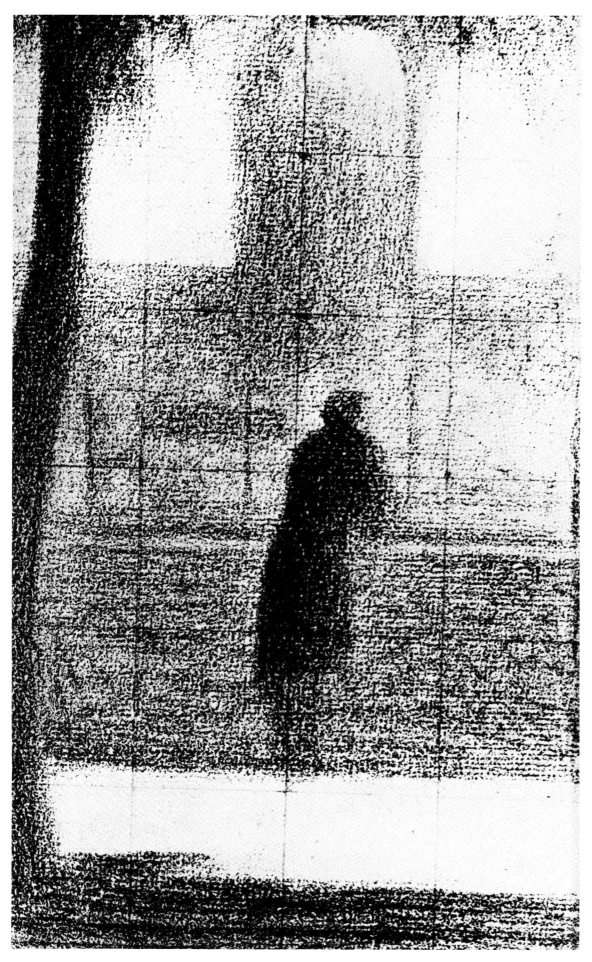

37. Study for *Man Leaning on a Parapet. c.*1881. Pastel, 24.4 x 15.8 cm. Paris, private collection (DH 459).

Ouen, Aubervilliers and Ville d'Avray. In 1881 the two young painters spent a couple of months at Pontaubert in Burgundy, a place they may well have chosen because it had been much frequented by Daubigny and, particularly, Corot.[46] It is significant that several of the sites that Seurat visited at this period were associated with Corot, notably Mortefontaine, Barbizon and Ville d'Avray. The most important painting that Seurat produced at Pontaubert was a *sous-bois* picture (Plate 30), which is very close to a number of similar motifs by Corot. In works such as *The Banks of the Cousin* (c.1840–5; Paris, Louvre) Corot also opted for a canvas of vertical format, bringing natural forms up towards the picture plane to form a strong *repoussoir*, and excluding the sky in order to give the spectator a sense of immersion in the forest. Seurat's combination of green, earth and silver tones is Corotesque, but the dabbed touch is not, and this has stimulated some argument. Some scholars believe that the canvas was reworked in later years by Seurat in the pointillist technique, but, as Herbert has pointed out,[47] the dappled marks that the artist used here were probably learnt from the painters of the Barbizon school; it is particularly reminiscent of the late work of Théodore Rousseau. *The Forest at Pontaubert*, while indicating yet again Seurat's experiments with touch, is in essence a delicately painted essay in the manner of mid-century landscapists.

The paintings that can probably be assigned to the following year, 1882, show some developments, though again Seurat's work invites comparison with that of Corot. *The Mower* (Plate 34) shares certain characteristics with the modest landscape sketches that Corot made to observe natural effects. The older artist's *Harvesters in Picardy* (Plate 35), for instance, allows the warm wood panel to be glimpsed through the paint surface, a trick Seurat frequently used. In such sketches Corot's brushwork only defined the essentials, and the simplified design, arranged around clear zones, served as an ideal vehicle for a reduced colour structure, as Corot felt it necessary to fix only the fundamental chromatic relationships. These were lessons in the use of the oil sketch for purposes of both observation and experimentation that Seurat could well learn, and in *croquetons* such as *The Mower* they were put into practice. But Seurat ventured more than Corot, reducing his motif to the bare minimum, setting the figure against three schematic bands of colour. His use of complementaries to give extra vibrancy was still at a rudimentary stage in *The Mower* and other panels that probably belong to 1882. *Angler in a Moored Boat* (Plate 38), for example, is painted in rather drab local colours, with white rather than the brighter colours of the prism used to heighten the overall tone. But both these panels show an advance in Seurat's actual handling, for both utilize — albeit in partial fashion — the criss-cross or *balayé* (literally 'swept') stroke that was to form the cornerstone of Seurat's painting technique in 1883 and 1884.

By 1883 the *balayé* stroke had advanced beyond this

incipient stage. In *Houses among Trees* (Plate 36) this criss-cross handling occurs across almost the whole of the panel; it is softened in the sky and abandoned for a flatter application on the white walls. And with — or perhaps it would be more accurate to say following — the full adoption of this technique, Seurat was able to incorporate a more sophisticated treatment of complementaries. Here the use of violet in the shadows and the setting of oranges against the blues testify to a growing confidence in the treatment of colour. This progress is most clearly evident in a group of canvases Seurat executed in 1883. Painted on a larger scale and on a more 'permanent' support than the *croquetons*, these canvases — some ten in all[48] — can perhaps best be understood as a phase during which Seurat finalized the technical methods he had developed over the preceding two years prior to embarking on his first major composition. *Horse and Cart* (Plate 39) exemplifies this phase. Seurat first established the chief zones of local colour, and then over this structure applied *balayé* strokes with an emphasis on complementary relationships, especially yellow and violet, blue and orange. The extra vividness provided by the divided colour gives the painting a striking, sunlit effect while simultaneously enlivening a placid image conceived around precise spatial intervals.

The pattern of Seurat's development as a painter outlined above can only be an approximate one, however. Even Seurat's progress was not so deliberate as such a scheme suggests, and there are paintings that are extremely difficult to situate, either because they represent an experiment slightly outside the main thrust of his researches or because one can argue equally well that they belong to one year or another. An example of the former case is a canvas known as *Suburb* (Plate 42), dated by Dorra/Rewald (following Fénéon's estimate) to 1882 and by De Hauke to the next year.[49] The dabbed application of paint on this lightly covered canvas looks forward to Seurat's later pointillist manner, and this encourages acceptance of the later date. But in his notes on Delacroix's *The Fanatics of Tangier*, taken in February 1881, Seurat remarked on 'the blue of the sky and the white of the walls and the orange-tinted grey of the clouds'.[50] *Suburb* exactly emulates these colour relationships, as well as the strong contrasts of value in Delacroix's painting. Given that in 1881, with *The Forest at Pontaubert*, Seurat was testing a dabbed touch and that by 1882 he was moving gradually towards the *balayé* handling, it may even be that *Suburb* is a painting of 1881, or 1882 at the latest.

It is just as hard to be precise about panels such as *Man Painting his Boat* (Plate 43). The tonal structure, relying on a strong admixture of white, and the scant use of complementaries point to 1882, but the confident and overall *balayé* stroke to the following year. These problems emphasize both the complexity of Seurat's development and also the vivacity and variety which he brought to his programme of determined experimentation with the fundamental principles and practices of his art. By

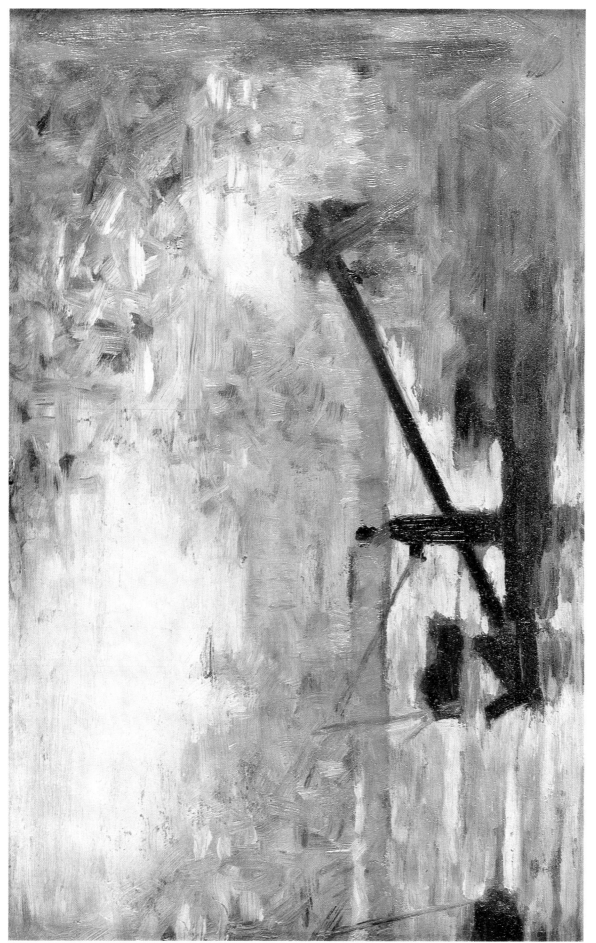

38. *Angler in a Moored Boat. c.*1882. Panel, 16 x 25 cm. London, Lady Aberconway (DH 64).

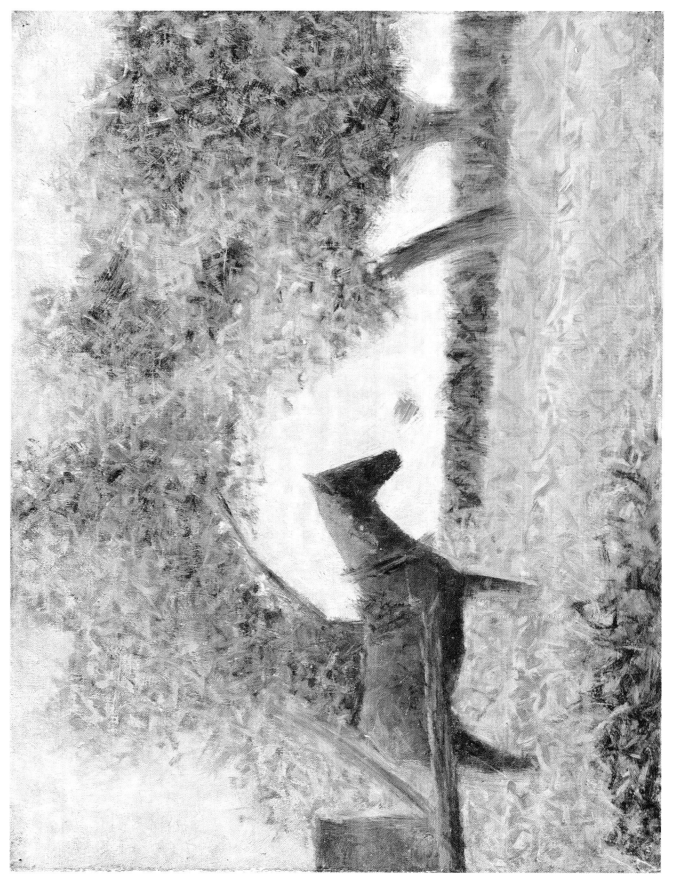

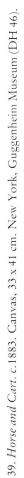

39. *Horse and Cart. c.*1883. Canvas, 33 x 41 cm. New York, Guggenheim Museum (DH 46).

40. *Man with a Hoe. c.*1883. Panel, 16 x 25 cm. From the collection of Mr and Mrs Paul Mellon (DH 30).

1883 he was starting to achieve remarkable results.

The great majority of Seurat's early paintings, the essays he made between demobilization and 1883, are landscapes, which with very few exceptions show spring or summer scenes; autumn and winter were not seasons that appealed to Seurat. This observation raises crucial questions which are, finally, unanswerable, owing to lack of biographical evidence. Nevertheless, even their posing casts light on the character of his art. If he painted hard during the summer, one could assume that over the winter months he concentrated on drawing. In other words, perhaps there was a cycle in Seurat's work from the very outset of his independent career, a division of the year between summer and winter activities. Certainly some *croquetons* and drawings seem closely related, and there may well have been a more considered relationship between the two media than writers on Seurat have yet taken into account. *Man with a Pick* (Plate 24), for example, recalls a *croqueton* in the Mellon Collection (Plate 40). In this instance the artist might have rehearsed the profile pose and banded design in a winter drawing, and then tackled the motif several months later under the chromatic conditions of summer light. Or, alternatively, some of Seurat's paintings, perhaps the canvases rather than the panels, might have been painted in his studio over the winter. If this was the case, and Seurat worked from empirical evidence gathered in

sketches made over the summer, such a procedure foreshadowed his practice in mid-decade. Further, it suggests that Seurat saw experimental studio work and direct observation of nature as separate but tandem activities. Such an attitude would imply that even at this stage in his career Seurat did not set absolute store by the Naturalist principles of precise and direct transcription of observed reality. And this points to another paradox in Seurat's work, to a disjunction between his theory and practice. For, despite his stated aim to recreate for painting chromatic effects consistent with colour's natural laws, the actual look of his pictures — their insistent *balayé* brushwork, their emphatic zonal divisions, their pared-down forms — is already fundamentally unnaturalistic.

This raises a second point: the effect of Impressionist landscape painting on Seurat's early pictures. Seurat's letter to Fénéon recalled that he was 'struck by the intuition of Monet and Pissarro.' He admitted an influence, though in a rather casual fashion given the detail into which he went to explain his other theoretical and painterly debts. Signac later insisted that Seurat's early work was developed independently of any Impressionist influence, though this might be seen as propaganda. (Such a claim gave Seurat an early status distinct from Impressionism, while giving Signac credit for later introducing him to it.) After the visit to the exhibition of

1879 that Laurent, years later, claimed to recall there is no specific evidence of any contact between Seurat and Impressionist artists or even paintings until 1884.[51] He might have seen the Impressionist exhibitions in 1881 or 1882, and Durand-Ruel held one-man shows by Monet, Renoir and Pissarro during 1883.

Impressionist painting was certainly available for Seurat to study, and he himself admitted his interest in two artists whose work was widely exhibited at the time. It would be rash to claim that Monet's and Pissarro's paintings had absolutely no impact on Seurat, but the circumstances need to be put into perspective. The oil sketches that he was making at this time were in tune with academic recommendations, and up to 1881 he was not producing work that was significantly more advanced than that of mid-century landscape painters like Corot. The progress made in 1882, it could be argued, coupled Seurat's previous practices with the advice of Rood. The study of Monet and Pissarro would have encouraged Seurat's use of bright, even divided, colour in his landscapes, but it did not necessarily provide more than justificatory stimulus.

Perhaps Seurat's earliest assimilation of Impressionist example was not from a painterly but rather from a compositional point of view. His drawing *House on a Hill* (Plate 41) of *c*.1883, for example, is reminiscent of Monet's paintings of the Customs officer's cottage at Varengeville — several of which were exhibited at Durand-Ruel's in 1883 — with their craggy horizons and the building crammed towards the upper left corner.[52] And Seurat's magical little panel *The Anglers* (Plate 47), executed in 1883, also surely owes a debt to Monet. Monet's *Anglers on the Seine at Poissy* was in the Durand-Ruel show, and a drawing after a reduced version was illustrated in *L'Art Moderne* in April 1883. Seurat seems to have borrowed Monet's current interest in a high angle of vision, looking down on the motif of fishermen from so steep an angle that the picture is denied a horizon. Such a device was surely too typical of Monet at the time and so alien from anything Seurat had done before for the similarity to be coincidental.

Perhaps the two culminating pictures among Seurat's early paintings are *Woman Seated on the Grass* and *Seated Boy in a Meadow*, both of 1883 (Plates 48, 44). With these slightly ungainly pictures he began to focus on the figure as the major compositional element. A high

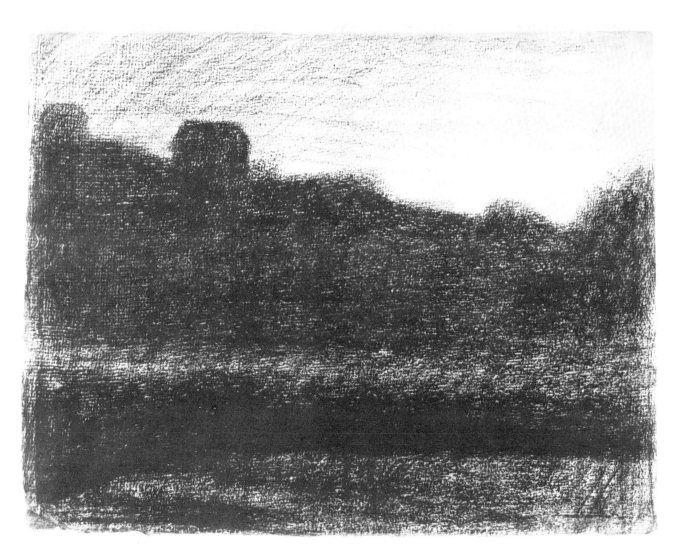

41. *House on a Hill. c.*1883. Conté crayon, 24.7 x 31.5 cm. Rotterdam, Boymans-Van Beuningen Museum (DH 538).

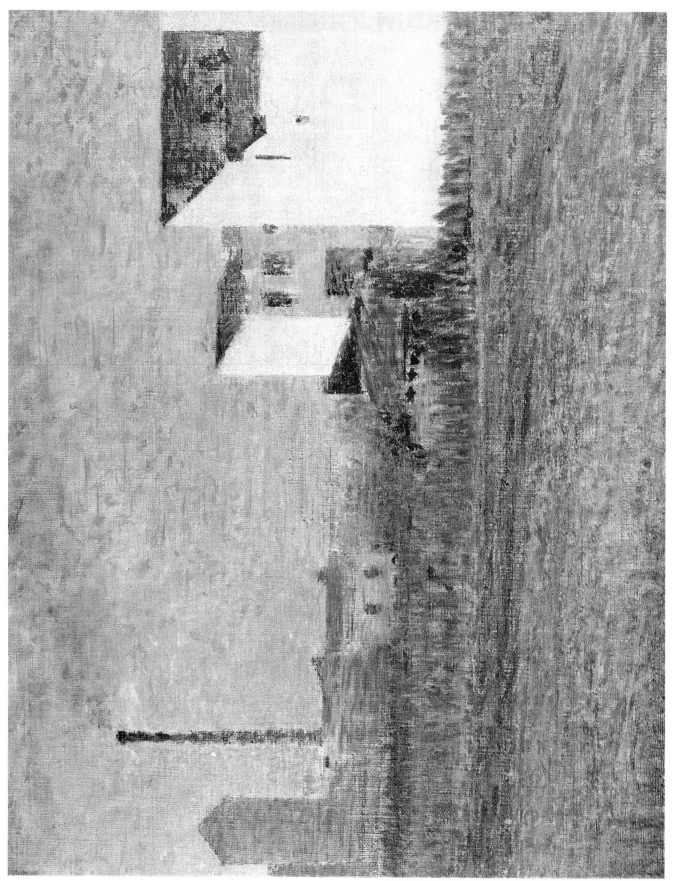

42. *Suburb*. c.1881–2. Canvas, 32.3 x 41 cm. Troyes, Musée (DH 75).

43. *Man Painting his Boat.* c.1882–3. Panel. 15.8 x 24.7 cm. London, Courtauld Institute Galleries (DH 66).

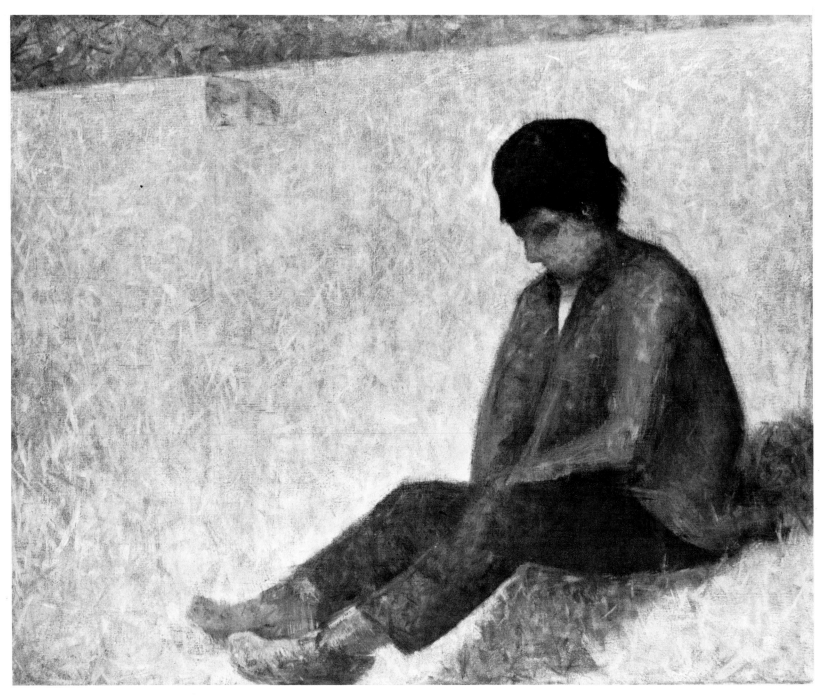

44. *Seated Boy in a Meadow*. 1883. Canvas, 63.5 x 79.6 cm. Glasgow Art Gallery (DH 15).

horizon was used to minimize the landscape features, though the pictures are obviously set out-of-doors, as the artist studied effects of sunlight on and around the figures. The *balayé* handling of such paintings is often compared with Pissarro's contemporary work (Plate 45).[53] Seurat's brushwork may owe something to the older painter, but his application of colour is much more systematic and sophisticated than Pissarro's. Seurat's two paintings were not intended as naturalistic scenes of rural life, though. Their static quality, lack of detail and the economic drawing of forms promote the idea that he had reached a more mature appreciation of Puvis, and that he was now assimilating the crucial simplifications of Puvis's recent work. Paintings like *The Prodigal Son*

(Plate 46) may occupy entirely different iconographical territory to Seurat's figures, but already by 1883 he had grasped Puvis's prime contribution to contemporary art: reduction of the formal components for increased effect of the ensemble. In *Woman Seated on the Grass* and *Seated Boy in a Meadow* Seurat for the first time combined his most developed concepts of colour, application of paint and articulation of human form. These two figures, although in themselves neither direct preparatory works nor resolved canvases of exhibition status (they were not shown in his lifetime), represent significant experiments which, once concluded, put Seurat on the threshold of his first major figure composition.

45. Camille Pissarro, *Seated Peasant Woman*. 1883. Canvas, 60 x 73 cm. Paris, Galerie Schmit.

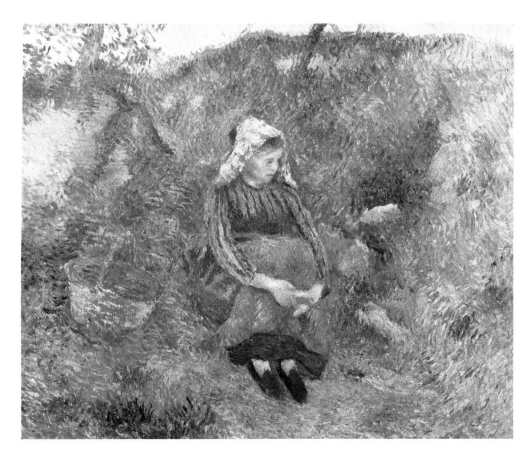

46. Pierre Puvis de Chavannes, *The Prodigal Son. c.*1879–82. Canvas, 106.5 x 146.7 cm. Washington, National Gallery of Art.

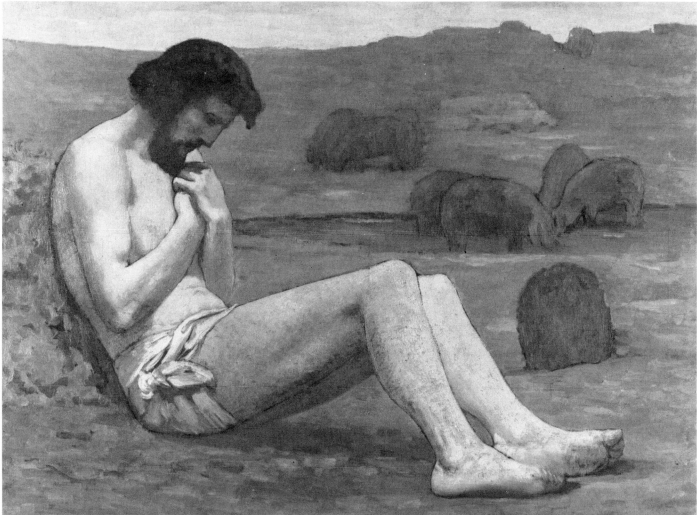

47. *The Anglers*. 1883. Panel, 15.7 x 24.4 cm. Troyes, Musée (DH 78). Lent to the 1886 Impressionist exhibition by Léon Appert.

48. *Woman Seated on the Grass*. 1883. Canvas, 38.1 x 46.2 cm. New York, Guggenheim Museum (DH 59).

4 *Rehearsing the Subject*

Other than the occasional painting trip into rural France, the bulk of Seurat's work both as a painter and as a draughtsman in the first five years after his demobilization was done close to his base in Paris. Although his studios and accommodation were near the city centre, most of his subjects between late 1880 and mid-1886 were taken from the city's suburban environs.

The societies of the suburbs

Throughout the mid-nineteenth century France's population shifted, moving from country to city. In 1843 only 24 per cent of the population lived in cities, whereas by 1888 this had swelled to 35 per cent. Many had been drawn to Paris, attracted by the work provided by increasing industrialization and by the rebuilding programme carried out under the Second Empire. This increase was slackening off by the early 1880s; between 1876 and 1881 the Parisian population grew by 280,217 (one eighth of the city's total), but from 1881 to 1886 there was a gain of only 75,527.[1] Nevertheless, the suburbs of Paris were still feeling the effects. Prior to the rebuilding, pre-1850, the city's population, of all classes, was concentrated in the very centre. Haussmann's new streets had destroyed many traditional working-class *quartiers* and forced their inhabitants out of the city centre, a process aided by the substantial rise in rents which followed the revamping of much inner-city property.

This dramatic redistribution of the population of Paris was inevitably a political issue, and in the early 1880s it was widely discussed in the press. To Otherin d'Haussonville, writing in the conservative *Revue des Deux Mondes* in 1881, the rent-rise rather than the rebuilding was the prime cause,[2] while the Left saw the rebuilding as a deliberate stratagem to remove the poorer classes from central Paris. As Jules Vallès argued in *Gil Blas* the following year: 'Haussmann pushed back the people by opening up the new streets to daylight and sanitation, which are not made for the poor. It is on the frontiers of

the city, even outside, that the workers eke out their sad and sombre existence'.[3]

Initially this redistribution of the population had concentrated the working classes in areas such as Montmartre, Belleville and La Villette, beyond the ring of outer boulevards but still within the encircling band of fortifications (see map: Plate 49). In 1860 these areas were incorporated within the city's administrative structure, a recognition of Paris's sprawling growth. The relocation of the city's population was, of course, along lines of class, and this sharpened political tension; by 1871, the year of the Commune and its bloody repression, it was clear that 'class war was written in the geography of the capital'.[4] If, by the early 1880s, the population of Paris itself was not growing as fast as it had, this was not the case with the suburban towns and villages outside the fortifications. These were now taking the strain. Seurat's friend the writer Jean Ajalbert was brought up in Levallois-Perret, near Clichy, and he remembered as a child in the 1860s how meadows where cattle and goats grazed stretched from the fortifications to the river: 'before 1870 Levallois-Perret didn't count as suburb'.[5] By the late 1880s Levallois had 35,649 inhabitants, and other outer suburbs had expanded to a similar size; Saint-Denis had a population of 48,009, Boulogne of 30,084.[6] The Right viewed several of these outer suburbs and their 'floating, miserable, embittered population' with suspicion; in any future social unrest they might challenge Belleville and Montmartre for 'the sceptre of revolution'.[7]

It would be misleading, however, to suggest that the outer suburbs, the subject of so much of Seurat's early work, were all populated by such dangerous, potentially revolutionary inhabitants, that all were based on the same economic or class structure, that all had the same relationship with Paris. North of the fortifications, and the ring of wasteland (or 'zone') that skirted them, the suburbs were predominantly proletarian and industrial. 'To the north, the huge working-class communes, bristling with workshops and factories, begin fifty or a hundred metres outside Paris, beyond the zone. The parapet

49. Paris and Its Environs. 1881. From K. Baedeker, *Paris Handbook for Travellers*, 1881 edn., between pp.280 and 281.

is bordered by filthy shanties, put together from sardine boxes and packing canvas. In them live tribes of rag-pickers and hobos. Further away the tall, narrow tenements begin again, interspersed with the red rooves of industrial buildings and factory chimneys', wrote Robert Bernier in 1886. The south, he continued 'is more bourgeois; it is an area of impeccable properties, well scrubbed and dazzlingly smart'.[8]

Ease of communication and distance from the city counted for a great deal in establishing the character of the outer suburbs. Clichy, to the north-west, was conveniently placed for barge traffic on the Seine and situated on the main railway between Paris and the Normandy coast; inevitably it became an industrial suburb with a working-class population. Clamart, to the southwest, was quite different. One writer in 1883 described it as 'not yet truly country, or still suburb'. Not on the railway, it was too far from Paris for easy commuting and not distant enough for those wanting to get right away. At places like Clamart the 'bourgeois tone dominates', with 'little stone houses that the retired employee

aspires to; … it is the modern *aurea mediocritas*'.[9] By contrast, the *haute bourgeoisie* could afford to live further out, in well-heeled suburbs with larger houses. 'The smart stockbroker has his villa at Chatou, Ville d'Avray, Maisons-Lafitte or Saint-Germain', reported one book in 1882; 'it is not chic to have one's country retreat at Pantin or at Courbevoie.'[10]

There were various pressures and stimuli on the young artist to choose the Parisian suburbs as the thematic core of his early work. One looks immediately for an ideological reason, but until at least 1884 there is negligible factual evidence to guide us. No doubt Seurat would have been aware of current debates about 'La Question Sociale', debates in which the problems of working-class life loomed large (and the suburbs held a crucial place in this discourse), but there is no evidence yet of which newspaper he read, which views he might have upheld. It seems that — again until 1884 — his circle of friends was limited; as far as we know it included, other than his family, only young colleagues from the Ecole like Aman-Jean and Laurent. Such

company — a bourgeois family, Aman-Jean a staunch Catholic — was likely to have been conservative rather than radical.

There is, however, evidence concerning the views of other young men of Seurat's generation, who later became his friends. They seem to have been fascinated by the suburbs — initially, at least — from an aesthetic rather than from a political position, for by 1880 the Parisian *banlieue* was a well-established theme in the Naturalist canon, both in literature and the visual arts. Jean Ajalbert, who made a substantial reputation in the mid-1880s for his poems based on observations of the poor and destitute on the outskirts of the city, recalled that it was the poetry of François Coppée that opened his eyes to the tawdry beauty of the suburbs.[11] In his introduction to Ajalbert's first volume of verse, *Sur le Vif*, published in 1886, Robert Caze evoked a conversation with the poet in which Ajalbert talked of a 'delicate melancholy pastel' of a suburban scene by Jean-François Raffaëlli and explained that he wanted his writing to operate as a verbal equivalent to such pictures.[12] And Jules Laforgue also saw the suburbs through the lens of Naturalist painting. 'When I've got the "spleen"', he wrote to Gustave Kahn in February 1881, 'I go into the sad suburbs to listen to barrel organs and contemplate living pictures by Guillemet and Raffaëlli'.[13]

Several of Seurat's friends — Aman-Jean, Signac and Kahn among them — remembered his admiration for Naturalist novels, especially those by the Goncourt brothers,[14] and it is possible that Seurat's initial stimulus to adopt suburban themes came from such writing. The first major Naturalist novel to deal with the Parisian working classes and the conditions of their life in the suburbs was the de Goncourts' *Germinie Lacerteux*, published in 1865. The aristocratic de Goncourts, whose politics were, if anything, royalist, justified their attempt to bridge an ideological divide between themselves and their subject-matter by invoking Positivist notions of factual accuracy and social research;[15] *Germinie Lacerteux* was far from being a work of social criticism. This veil of aestheticism and objectivity was still in place — just — around 1880, as a younger generation of Naturalist novelists, notably J.-K. Huysmans, also took up suburban subjects. Several of the prose pieces Huysmans published in 1880 under the title *Croquis parisiens* dealt with the *banlieue* theme. In 'La Bièvre', a piece describing one of the south-east suburbs, Huysmans claimed to admire the ravaged industrial landscape because of 'the pitiful charm that a desolate corner of the city has for me ... Ultimately, the beauty of a landscape stems from melancholy'.[16]

In another of the *Croquis parisiens*, 'View from the Fortifications of Northern Paris', Huysmans made metaphorical play with the suburban poor and their animals — a nursing mother and a goat, a beggar and some mongrels — and stressed the motif of dirt: tar, smoke, dust and sweat.[17] Nevertheless, lodged within his deft Naturalist descriptions is an awareness that

the character of the suburban landscape was a changing one, and that changes were imposed by external forces. Around 1880 the language used by Naturalists like Huysmans and by Seurat's own contemporaries was essentially one of sensibility rather than politics; 'spleen' and 'melancholy' belong to an aesthetic, not a political vocabulary. Among the writers and artists of the first years of the decade such was the dominant attitude towards the suburbs, and it may well have been this uncommitted approach that first attracted Seurat.

There were other stimuli that led Seurat to work in the outskirts of Paris at this time, stimuli that were more immediately related to his practice as a painter. It seems to have been a regular habit for young artists to make sketches in the western suburbs.[18] In working out there with friends from the Ecole like Aman-Jean Seurat was following the custom of contemporary art students; this would be typical of the unexceptional side of his character, especially in the early 1880s. There were reasons of convenience for such a practice. With so many studios in Montmartre, the northern and western suburbs were well placed for plein-air sketching trips, and this would have been true for Seurat, who by 1883 had settled into a studio at 128bis, boulevard de Clichy.

It is also important to remember that the suburbs of Paris — or, to be more specific, certain areas and certain aspects of their daily life — had been depicted in recent French painting before Seurat and his generation matured in the mid-1880s. Even *faubourgs* populated by the working classes and industrial sites could be found in canvases exhibited at the official Salon early in the decade. In 1881 Jean Béraud, for instance, showed a painting entitled *Montmartre* (present location unknown), its motif an unprepossessing street corner in a proletarian *quartier*. The following year Henri Gervex exhibited his *Bassin de la Villette*, a painting of stevedores unloading coal barges commissioned as part of his decorations for the local town hall, the Mairie of the 19th Arrondissement in the staunchly working-class north-east of the city.

Other paintings represented suburbs outside the fortifications, even the industrial areas to the north-west, as did E.-J. Delahaye's *Gasworks at Courcelles* (1884; Paris, Petit Palais). Indeed, some reviewers of the Impressionist shows in the 1870s had noted that artists such as Monet and Sisley were in fact suburban rather than landscape painters. 'Ultimately, it is not true nature that they have been looking at,' wrote Charles Bigot in 1877, 'rather the kind of nature that one glimpses sporadically from the city or in its outskirts'.[19] Thus in painting suburban subjects in the early 1880s Seurat — and his colleagues of mid-decade, Signac, Angrand, Dubois-Pillet and others — were hardly covering novel thematic territory. They would have to find in the suburbs a new modernity pertinent to the 1880s.

The impact of one particular artist does need to be taken into account here, a man who established himself as the specialist painter of the *banlieue*. Jean-François

50. *The Watering Can in the Garden at Le Raincy. c.*1882. Panel, 24.7 x 15.3 cm. From the collection of Mr and Mrs Paul Mellon (DH 57).

Raffaëlli won the position in the early 1880s by culti-
vating friendships with Naturalist writers such as Huys-
mans, currying favour with radical politicians such as
Clemenceau, and by exhibiting his work widely. Settling
at Asnières in the late 1870s, he began to concentrate on
depictions of life in that locality. His two submissions to
the Salon of 1879 were little liked, except by Huysmans,
and in 1880 and 1881 he exhibited large groups of work
at the Impressionist shows. In 1884 he held a one-man-
show of some 150 works which was a resounding suc-
cess, and the following year he returned to the Salon to
continue his now well-entrenched career. Seurat would
certainly have known his widely exhibited oeuvre.

Raffaëlli's paintings and pastels were based on his
thorough knowledge of the particular vicinity of As-
nières and its neighbouring communes. His titles were
often precise — *Quai de la Seine at Asnières*, *The Clichy
Tollgate* — and here was a specificity from which
a young artist could learn. He was also exact in his
depiction of class and of activities preordained by class.
He categorized two groups of work at his one-man-
show 'Portraits-Types de Gens du Bas Peuple' and 'Por-
traits-Types de Petits Bourgeois', and his staffage of
ragpickers, quarrymen, retired soldiers and shopkeepers
kept to his brief; he did not depict the smarter suburban
population and their pursuits of promenading and sail-
ing. Raffaëlli's work fell into identifiable configurations.
His genre scenes, often groups with an overt narrative
content, were unlikely to have interested Seurat. But his
landscapes were more challenging. Raffaëlli was pre-
pared to depict frankly the detritus-strewn panoramas of
the suburban wasteland, marked here and there by tele-
graph poles, railway lines, factories and unfinished hous-
ing (Plate 51). And as a variation on these motifs he
would place a figure against such a backdrop, the better
to evoke the alienation and destitution of the industrial
suburbs: these were configurations with which to ex-
periment.

In 1880 Huysmans wrote about such pictures: 'here at
last is expressed the poignant, splenetic character of
these landscapes, the plaintive delights of our suburbs!'[20]
This is the vocabulary of sensibility we noted earlier, but
critical responses to Raffaëlli developed through the
decade. By 1886 critics were pointing out the accuracy
with which he recorded the class structure of the sub-
urbs, 'made up of well-to-do *petit bourgeois* and half-
starved wretches, proprietors and ragpickers, honest
people and cut-throats, all leading their lives in the prox-
imity of the wasteland.'[21] In 1889 Octave Mirbeau saw
Raffaëlli's quintessential suburb as a place 'which is no
longer city and which is not yet countryside, where
nothing ends and nothing begins, where people [are] the
flotsam of social misfortune: circumscribed bourgeois
existences, shady businesses, nocturnal loiterings, pro-
letarian debasement'.[22] This is the language of political
awareness and unrest, and it is indicative of the changing
tenor of the decade, more specifically of the way in
which the depiction of the Parisian suburbs was seen

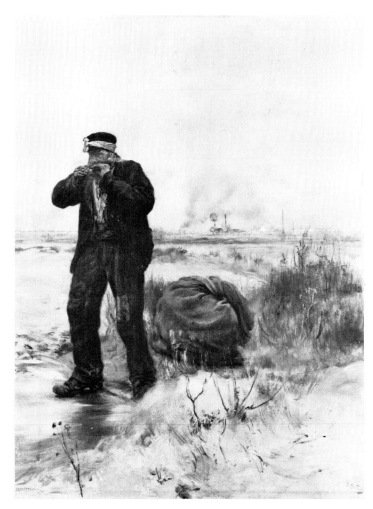

51. Jean-François Raffaëlli, *Ragpicker Lighting his Pipe. c.*1880.
Canvas, 77 x 59 cm. Nantes, Musée des Beaux-Arts.

in a political light and became in itself an increasingly
ideological matter. Seurat's lengthy commitment to sub-
urban subjects, from 1881 to 1886 and beyond, was in-
trinsically related to this discourse.

Prior to *Une Baignade* and the studies made for it,
Seurat painted some eighty canvases and panels, and the
distribution of subjects among them gives some indi-
cation of his thematic concerns during this first phase of
independence. Some fifty are of ostensibly rural subjects,
showing figures in the fields, often at work, and land-
scapes. About twenty seem to depict explicitly suburban
motifs, factories, quaysides and typical *banlieue* housing.
Fewer than half a dozen are of the inner city, often of
specific sites such as the Tuileries Palace or the rue
St. Vincent. Such a proportion would appear to argue
that between, say, 1881 and 1883 Seurat was a landscape
painter, even that he was rehearsing a career as a peasant
painter. Closer analysis suggests that this is far from the
case. Although he did make a few trips deep into rural
France, there is every likelihood that many of these early
paintings, which look so like conventional landscapes,
were in fact executed in the outer suburbs. Different
kinds of evidence seem to support this. Seurat was very
much the domestic Parisian, his studios rarely far from
home. One should be wary of the titles now given to

many of Seurat's early pictures; many were added after his death by friends. But when there is hard evidence for a title it frequently proves the suburban contention. One early panel, now in the Metropolitan Museum, New York (DH 7), depicts a river and a distant ridge. But it is not, in fact, a pure landscape; in 1935 Aman-Jean remembered it had been painted about 1881 at Saint-Ouen, two kilometres north of the Parisian fortifications. Thus from an early stage Seurat was working in the suburbs, and many of the paintings and drawings of this period, such as *Houses amongst Trees* (Plate 36) and *Tree-trunk and House* (Plate 52) place the buildings in a tidy relationship with the landscape which is more redolent of the *faubourg* than the farmyard.

The north-eastern suburbs

Seurat certainly worked around Le Raincy, to the north-east of the city, where his father owned a property. Le Raincy lies in the hilly Forêt de Bondy region, and in the 1880s the whole area was undergoing considerable change. Louis Barron asked sadly in 1886: 'How could one give the name "forest" to the small, enclosed woods — with notices saying "Hunting Prohibited" — that one comes across from place to place between a country seat, an inn, a workshop or a beer garden? ... Speculation was rapid, so people built, chopped down, cut back, to left and right, without rhyme or reason, according to caprice or haphazard allocation: villas, smallholdings, shoots resulted, mixed up in the most incoherent fashion.' He described how Montfermeil had become 'expanded, embellished, bourgeois',[23] and other writers mentioned the same symptoms. Gustave Geffroy, for instance, in the radical newspaper *La Justice* in 1885, gibed about how a vicious local murder would disturb the middle-class sobriety of Villemomble, with its 'flower gardens, white houses and gilded gateways'.[24]

But to suggest that these villages had simply become dormitories for the Parisian bourgeoisie would be to oversimplify the pattern of change. As Barron noted, the area was now inhabited by 'a heterogeneous population of villagers, artisans and Parisians'. The vicinity's rural character was under threat, but it still maintained its local population, who made much of their living by supplying Paris with the produce of their market gardens. The Plateau d'Avron was particularly rich, with vineyards, apple orchards and fields of asparagus, strawberries, and cabbages under cultivation.[25] The Forêt de Bondy was popular with Parisians not only as a place to settle but also to visit as a Sunday trip from the city. Such visitors were from the working-class *arrondissements* to the east of Paris as well as from bourgeois quarters.[26] In sum, this area where Seurat often worked between 1881 and 1883 was a varied and shifting community.

Seurat exercised a great deal of selection in his representations of the outer suburbs. Evidently he noted

possibilities that were not immediately realized in painting. An example of this is a drawing of a drummer (DH 442; Paris, private collection) which is inscribed: 'Montfermeil 1881 parades saltimbanques Place des Maronniers'. This proves Seurat's early interest in popular entertainment, but at this juncture it also serves to indicate what he would not paint. There is little obvious concern with the parties of Sunday visitors in the early images of the outer suburbs. Nor is there for the bourgeois population who used places like Le Raincy as dormitory towns, though in oil sketches and drawings Seurat tackled their houses often enough (Plates 50, 53). Seurat's representations of these buildings and their gardens somehow fail to establish a specific identity. Uninhabited and generalized, they do not signify with the accuracy that Signac was able to give his *House under Construction* (Plate 54), which concisely shows the erection of a tidy *petit-bourgeois* villa next to a cottage and its rambling outhouses. Similar images by Seurat have the character more of the painterly exercise in colour and brushwork than the observation of a social reality.

52. *Tree-trunk and House.* c.1881–2. Conté crayon, 30.3 x 24.3 cm. Paris, Louvre (DH 546).

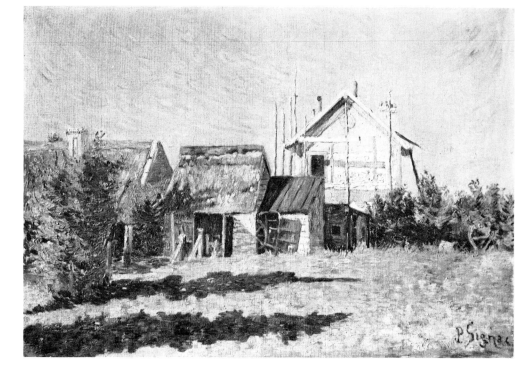

At this same time Seurat painted and drew a substantial number of images of men and women working in the fields and breaking stones. These motifs are frequently compared to those of Millet, whom Seurat certainly admired, but the links can be exaggerated. Paintings like *The Stone-Breaker* and *Farm Women at Work* (Plates 55, 56) echoed Millet's skill in giving a sense of monumentality on a small scale, but certain features suggest that Seurat had looked at other artists too. The fusion of particular work and anonymous worker, locked tightly into unified picture surfaces, recalls some of the paintings Corot made in the 1830s and 1840s, such as *The*

Paving of the Road to Chailly (c. 1830–5; Memphis, Dixon Art Gallery). Seurat's images also differ from Millet's in the evidence they give about labour in the fields. On occasion Millet detailed not just the work but also the context in which it took place; the meaning of *The Gleaners* (Plate 57), for example, is made both by the three foreground women and also by the economic and class relationships established between them and the labourers and overseer in the background. Seurat's *Farm Women at Work*, so often compared to *The Gleaners*, is a very different image, for all the similarities of pose. Seurat was just sufficiently accurate about what his

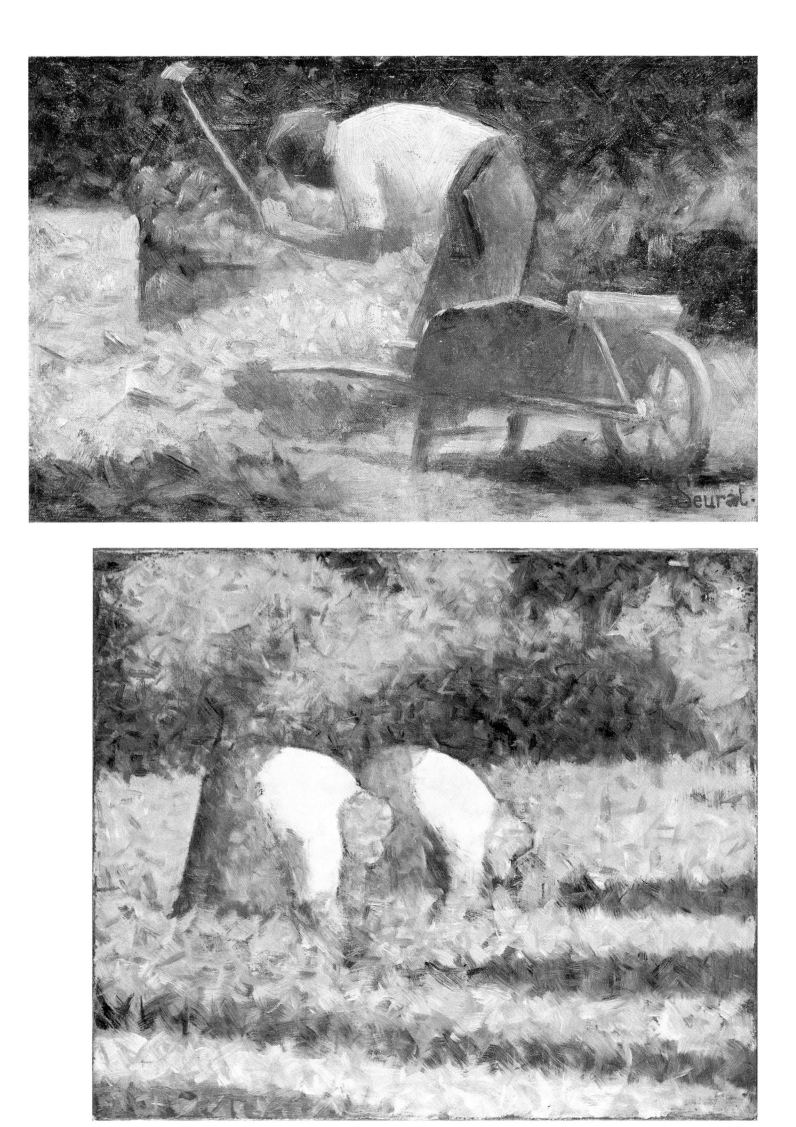

57. Jean-François Millet, *The Gleaners*. 1857. Canvas, 83.5 x 111 cm. Paris, Louvre.

58. *The Ragpicker*. c.1882. Conté crayon, 24 x 31 cm. Formerly in the Paul Signac Collection (DH 520).

women are doing; they are not gleaning, but weeding in a market garden. There is no background; their task is shown, but their position in society is not investigated. The rural labourers in the Le Raincy area must have existed in a curious limbo at this time, being neither truly peasant nor proletarian. But in 1883 Seurat was still only exploring such ambiguities, and he had not yet found the means to orchestrate them.

Lack of evidence — either from documentation or from the images themselves — makes it impossible to gauge exactly the balance of Seurat's commitment to one suburban locality or another during the three years between 1881 and 1883. He seems still to have been painting market gardening motifs, probably in the Le Raincy area, in 1883, pointing to a persistent interest in such subjects. Simultaneously he worked in the north-western suburbs — we have traced a Saint-Ouen panel from 1881 — and only as the concept of *Une Baignade* began to gestate in the summer of 1883 did his attention focus specifically on that side of Paris.

The north-western suburbs

The suburbs to the north-west of Paris were in marked contrast to those in the north-east. The region around Le Raincy was hilly, cultivated, and still with a semblance of woodland. To the other side of the city the terrain was much flatter, more monotonous. This stretch of the Seine increasingly had the character of an industrial artery, and communes like Saint Denis, Saint-Ouen and Clichy, suburbs just beyond the fortifications, were heavily built up with factories, gasworks, marshalling yards and tenement accommodation for the work force. Otherin d'Haussonville described the Plaine Saint Denis as 'foul and hideous, … with its rubble roadways strewn with broken bottles, its vegetable gardens sprinkled with liquid manure, its piles of garbage, and its filthy clothes hanging from its washing lines'.[27] On the other side of the river were places such as Asnières, Colombes and Courbevoie, which were becoming dormitory towns. The north-west was also an area in the process of change, but the identities of its constituent localities had begun to take definite shape.

Seurat did not see the suburbs with the statistical eye of a sociologist or the precise objectivity claimed by Naturalist novelists like the de Goncourts and Zola. A number of his early drawings of subjects from the industrial suburbs tried out the configurations of other artists, as Seurat sought for a pictorial syntax. *The Ragpicker* (Plate 58), for example, recalls Raffaëlli's off-centre placement of the isolated figure in a wasteland, set against a dreary horizon, while Seurat's use of the arch in *Road near a Railway* (Plate 59) is an essay in a motif for urban scenes used at least since Canaletto. On occasion such drawings are rather difficult to read. One sheet, traditionally known as *Factories by Moonlight* (Plate 60), shows what appear to be on close inspection not factory chimneys but telegraph poles, and the form to the lower right is not a building but a fence. That title, of course, was given after Seurat's death, but the ambiguous legibility, the deliberate crepuscular deceit were his.

Provocative analogies for such representations lie not so much in the visual arts as in literature. Huysmans's *Les Soeurs Vatard*, published in 1879, described a house near a railway line on the outskirts of the city: 'Almost opposite the window the rooves of a cluster of jerry-built houses, whose lower floors disappeared into shadow, were silhouetted against the darkness, which became

59. *Road near a Railway. c.*1882. Conté crayon, 24 x 30 cm. Private collection (DH 472).

60. *Suburban Landscape. c.*1883. Conté crayon, 22.9 x 30.5 cm. New York, Metropolitan Museum (DH 536).

61. *The Rue Saint-Vincent, Montmartre: Spring.* c.1884. Panel, 25 x 16 cm. Cambridge, Fitzwilliam Musem (DH 104).

62. *Lucerne at Saint-Denis*. 1885. Canvas, 65 x 81 cm. Edinburgh, National Gallery of Scotland (DH 145).

63. *The Ruins of the Tuileries Palace*. *c*.1882. Panel, 16 x 25 cm. Geneva, Galerie Jan Krugier (DH 13).

less dense as one looked up. Then, cramped between the hoardings and the shanties, allotments of cabbages and some trees, the railway line led off into the distance ...'[28] In Jacques Le Lorrain's *Nu* of 1888 a train is described passing through the suburban marshalling yards at night: 'One's eye wandered, following the lines of waggons, immobile, crouched like heavy and exhausted animals. Occasionally the grating of a wheel or a brief blast of a whistle broke the silence; dull red warning lights broke through the shadow, blood-coloured, flickering. The wide track, flooded wih uncertain light, was gloomy in places, with menacing depths of shadow, like the giant city in the distance, already coming to life beneath the sinister eyes of the streetlights.'[29] Seurat's images parallel a certain kind of naturalist writing, not necessarily in direct description but rather in a shared use of devices — in particular the nocturnal effect — to distort scale and reality, to give ordinary objects and environments an epic, even metaphorical quality. There is, however, an equivocation in the use of such an idiom. The great beauty of these drawings is much enhanced by their lack of precision. Take *Group of People* (Plate 64). We see figures in front of a factory setting, but how many? What are they doing? Who are they? These seem to be the drawings of an artist who is testing motifs, cataloguing observations, experiencing locales to which he is unaccustomed. The suburban drawings of 1881 to 1883 are concerned with locating a new modernity; they are not yet about inventing one.

As Seurat's experience of the area accumulated, so his depictions of the suburban landscape gained in precision. By 1884, drawings of such motifs dropped out of his repertoire, except as studies for major canvases, and his paintings of the *banlieue* grew in confidence and specificity. This process is most evident in *Une Baignade*, *La Grande-Jatte* and their preparatory works, but it is also apparent in his smaller, independent paintings. Whereas early panels such as *Man Painting his Boat* and *The Anglers* (Plates 43, 47) are, for all their quality, essays in observation, *Lucerne at Saint Denis* (Plate 62), painted in 1885, has a different status. There is a picturesqueness here, to be sure, but there is also a precise categorization of the suburban landscape. The scene is practical and neat; in the foreground is a field of lucerne, grown for fodder and ready for harvest, while the wall restrains the fringes of the town. Seurat painted the frontier of city and country, stressing the co-existence between them. The landscape is man-made, the buildings constrained by a wall planners can shift at will, the field cultivated to feed the city's horses. Nevertheless, the precision of such a painting reminds one of how much Seurat's work in the north-western suburbs left out, for he rarely focused on factories, workshops or tenements. They lurk in gloom or distance, beyond what this bourgeois artist saw as the limits of his work.

Seurat was not prepared to paint pictures of social realism like those submitted to the Salon by Gervex and Delahaye. Where those painters depicted actual labour,

Seurat only represented the environments where work was done, generalized industrial zones. His imagination was moulded by bourgeois constraints, and yet it traded in ambiguity and irony; in the early 1880s, as he discovered his unpreparedness to come to terms with the proletarian and industrial side of the suburban landscape, he found an appropriate theme in an aspect of the *banlieue* he could better comprehend, the world of the leisured bourgeoisie.

A few cityscape motifs prove that at this period Seurat also worked in the centre of Paris. In these instances, in line with the traditions of the genre, he often dealt with identifiable sites. He painted at least one customary artist's haunt, the rue St.-Vincent (Plate 61) 'adored by painters, so picturesque and so sad', wrote his friend Rodolphe Darzens in 1889[30] — and, again following convention, he also produced a picture of the same street at a different time of the year (DH 70; Switzerland, private collection). Two drawings of the Place de la Concorde under snow (Plate 65) once more adhere to a well-known location, and their motif of lonely winter Paris was not infrequent in contemporary poetry.[31]

The *croqueton* of the ruins of the Tuileries (Plate 63), the palace of both Louis-Philippe and Napoleon III, gutted by fire during the suppression of the Commune in May 1871, is exceptional in such company. Its associations were unavoidable, and they hint at a nascent political awareness on the artist's part; in Jules Valles's words, the Tuileries was the 'classic terrain of civil war'.[32] Immediately after the Commune the ruins had been treated by painters of the Right as an allegorical motif — for instance in Meissonier's canvas (1871; Compiègne, Musée National) — and throughout the 1870s artists tended to ignore them as an eyesore, which Monet did in his *View of the Tuileries Gardens* (1876; Paris, Musée Marmottan). Painting the Tuileries at all was a political gesture, and Seurat chose to represent the ruins head on. This was surely more than merely the depiction of a landmark before it was destroyed;[33] it was an acknowledgement that Parisian buildings and sites had ideological associations.

The Parisian type

During the early 1880s Seurat also explored the depiction of the figure, mainly in his drawings. The major emphasis of these drawings was on the single figure type taken from the life of the city. This manner of documentary observation had a long tradition in the graphic arts, and prints by or after Callot and Annibale Carracci witness how established a mode of representation it was by the seventeenth century. The types conventionally treated in these cycles of prints — such as Edmé Bouchardon's *Etudes pris dans le bas peuple, ou les cris de Paris* (1737) — were usually drawn from the lower classes, and the images were often accompanied by a verse or slogan particularizing what the figure sold or

64. *Group of People. c.*1883. Conté crayon, 24 x 31 cm. Paris, Louvre (DH 550).

65. *Place de la Concorde, Winter. c.*1883. Conté crayon, 23.2 x 30.7 cm. New York, Guggenheim Museum (DH 564).

67. *The Orange-Seller*. 1881. Conté
crayon, 31 x 24 cm. Paris, Louvre
(DH 450).

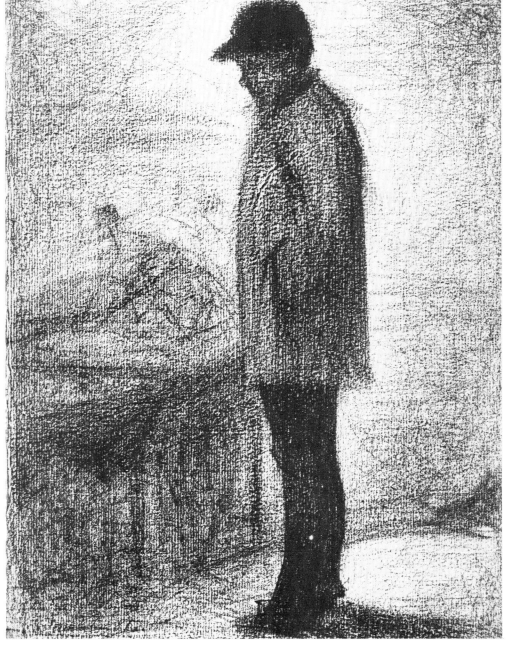

66. Honoré Daumier, *The Man Hired
to Applaud (Le Claqueur)*. 1842. Litho-
graph, 23.9 x 19.2 cm. Reproduced in
Le Charivari, 13 Feb. 1842.

made. This tradition carried on into the final quarter
of the nineteenth century; Bertall's *La Comédie de notre
temps* (1874) included many pages of street-vendor
types and their cries.[34] The tradition widened during
the nineteenth century to include bourgeois and petit-
bourgeois types as well, as can be seen in the caricatural
series *Types français*, published by Daumier and Traviès
in *Le Charivari* (1835–6), and in such later series as *Les
Français peints par eux-mêmes*, which began in 1839 and
continued for a number of years.

It was from this fund of graphic imagery that Seurat
learnt many of the devices which he used to make his
own inventory of Parisian types. The predominant con-
ventions of the idiom were to depict the lone figure with
just sufficient detail of physiognomy, pose, costume and
accessory for the spectator to recognize his or her social
identity (Plates 66, 68). A scantily indicated urban back-

drop would be added to provide supplementary evi-
dence. Such a procedure was a visual language develop-
ed to codify the city, and Seurat rapidly adopted and
mastered it, as his *Orange-seller* (Plate 67), dated 1881,
proves. The majority of Seurat's drawings of individual
types — that is, once more, those not related to particu-
lar paintings — were made between 1881 and 1884, but a
few sheets, such as *The Sweeper* (Plate 69), which Her-
bert dates to c.1887–8, suggest that Seurat found this
synthetic method of observation of constant value; it
formed the cornerstone of his work as a figure painter.

Seurat was not alone among his contemporaries in his
use of the type tradition, which was a commonplace in
contemporary painting as well as in the graphic arts, and
was accepted by spectators as an intrinsic part of their
pictorial vocabulary. Successful artists such as Roll and
Bastien-Lepage regularly exhibited paintings of single

figure types, often on a large scale, at the Salon in the 1880s, taking their models from both urban and rural life. Raffaëlli's figure subjects centred on the type, too. The public instantly recognized this — the critic of *Le Gaulois* immediately responded to his work at the 1880 Impressionist show as 'types, like sweepers, traders in old clothes, ragpickers, road menders and elderly men'[35] — and it was a dialogue that Raffaëlli encouraged; we have seen how he categorized two of the sub-sections at his one-man show in this way. In 1889 Raf-

faëlli published an album of drawings, entitled *Les Types de Paris*, accompanied by short descriptive passages by well-known writers such as Maupassant, Huysmans and Richepin. Such collaboration is indicative of literary interest in this kind of codification, as can be seen in much contemporary writing, from Huysmans's *Croquis parisiens* (with five pieces on types) of 1880 to Mallarmé's telegraphic *Chansons bas* of 1892.

Although Seurat's drawings belong within a continuing convention, distinctions must be made between his

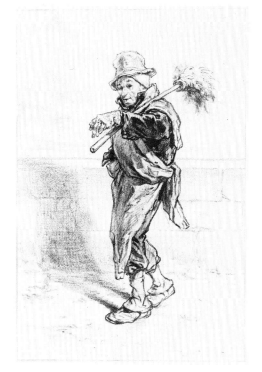

68. Gavarni, *The Sweeper*. 1858. Lithograph, Baltimore Museum of Art. From *Physionomies parisiennes*.

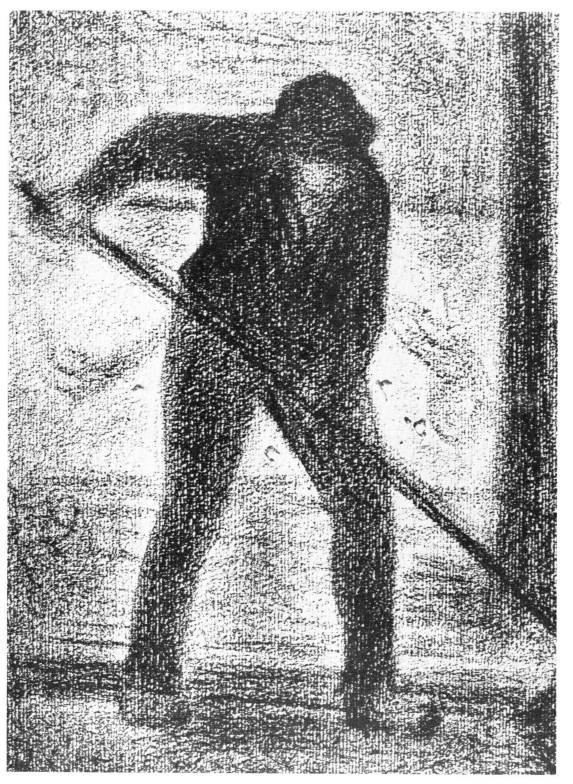

69. *The Sweeper. c.* 1887–8. Conté crayon, 31 x 24 cm. Formerly Félix Fénéon (DH 560).

and others' use of this code. Despite the persistent alliance between type imagery and the graphic arts, despite the extent to which his drawing was indebted to graphic media, especially lithography, despite the suitability of his figure drawings for publication, Seurat seems never to have made a print. His drawings of types were part of a private codification of Paris. They operated in a more refined fashion than the Salon paintings to which they bear superficial resemblance. Blanchon's *A Porter at Les Halles* (Plate 70), exhibited in 1884, is explicit; the porter, identified by his characteristic hat, stands vigorous inside the Parisian central market, while behind him we see a cross-section of the market's activities and even another porter demonstrating how their loads were car-

ried. This was a documentary approach, whereas Seurat's drawing (Plate 71) eliminates background to a stage beyond even the summary indication standard in prints, leaving us to recognize the figure by his costume alone, and relying on power of draughtsmanship to give a sense of the man's muscular build.

One can make similar points about *Woman leaning on a Parapet* by the Seine (Plate 72) and Adan's *Autumn Evening* (Plate 73), shown at the Salon of 1882. Again it is clear how close Seurat's motifs could come to middle-of-the-road contemporary art, and the two images share a composition and a melancholy reverie. However, he was able to evoke the mood by much more subtle means; while Adan was dependent on all the resources

70. E-H. Blanchon, *A Porter at Les Halles*. 1884. Location and dimensions unknown. From *Catalogue illustré du Salon*, Paris, 1884, p.78.

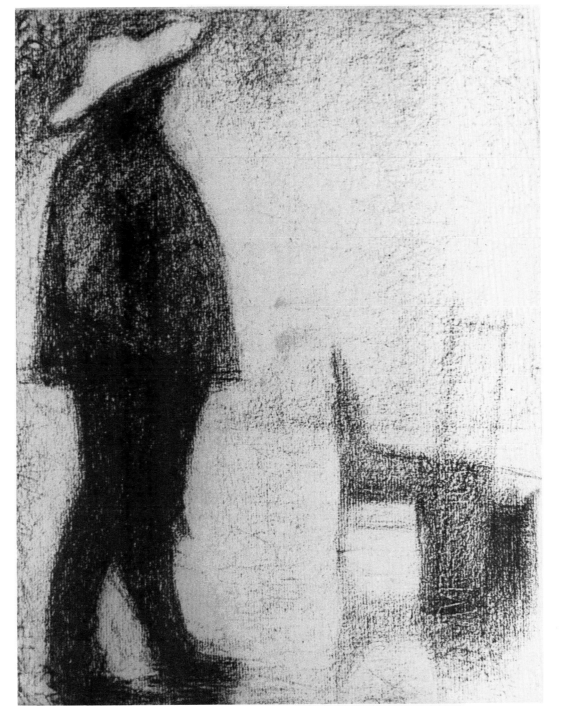

71. *A Porter at Les Halles. c.*1882. Conté crayon, 30.2 x 22.5 cm. Private collection.

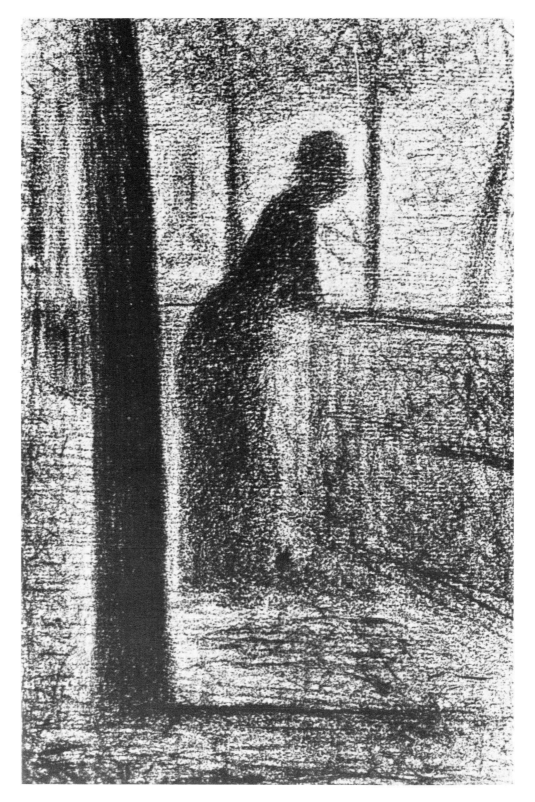

72. *Woman Leaning on a Parapet by the Seine.* *c.*1882. Conté crayon, 23 x 15.5 cm. Private collection (DH 462).

73. L-E. Adan, *Autumn Evening.* 1882. Canvas, 150 x 215 cm. From *Catalogue illustré du Salon*, Paris, 1882, p.219.

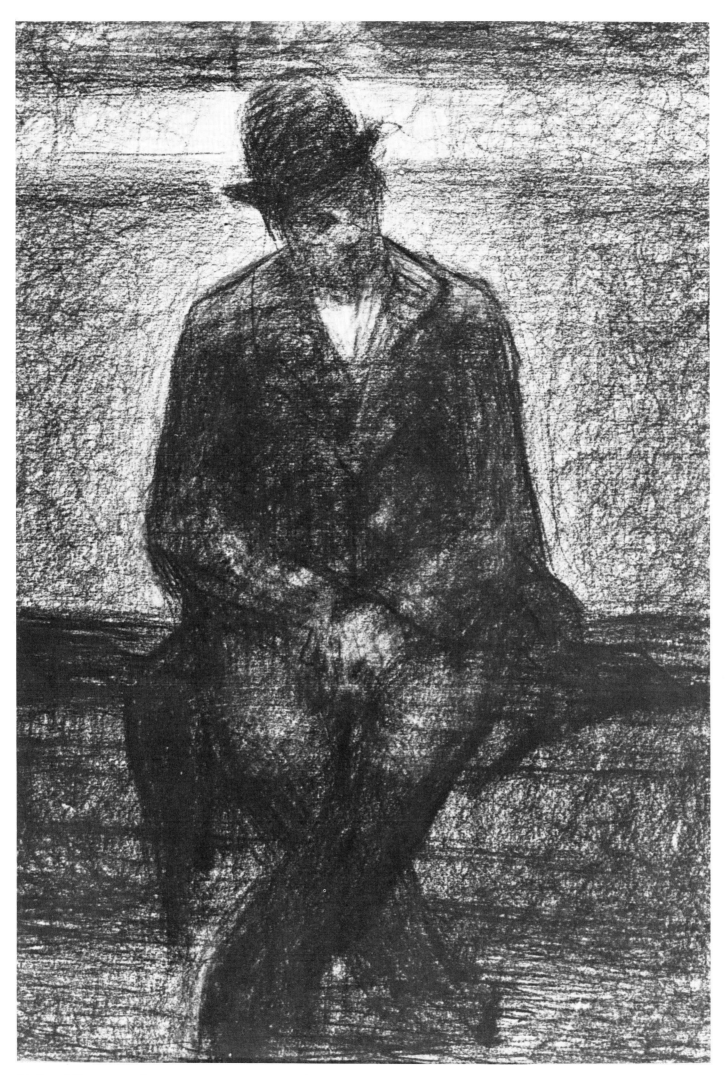

74. *Seated Man. c.*1883. Conté crayon, 31.1 x 20.7 cm. Budapest, Museum of Fine Arts (DH 514).

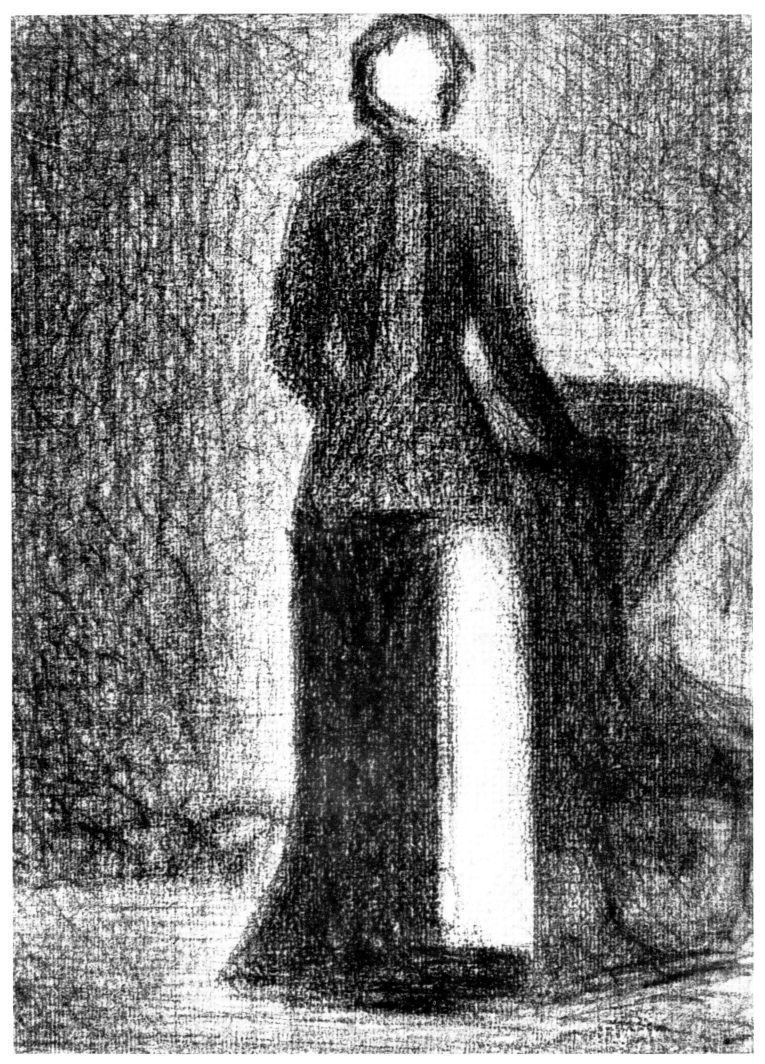

75. *The Wet-Nurse (Le Bonnet à Rubans). c.*1882. Conté crayon, 31 x 25 cm. New York, Mr. and Mrs. E.V. Thaw (DH 485).

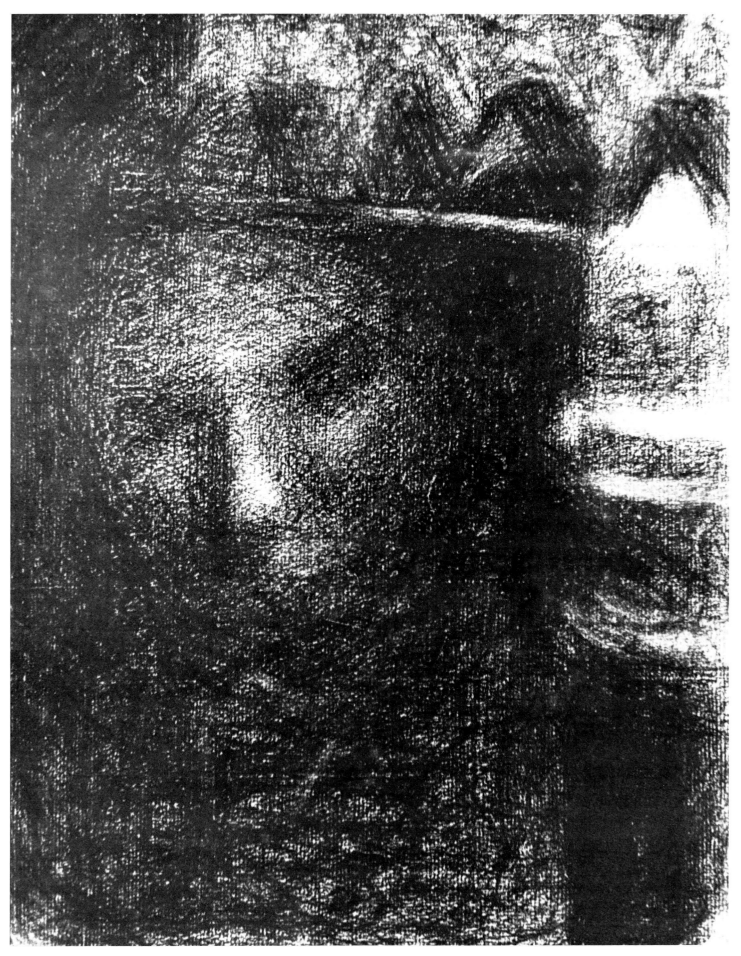

76. *The Lamp. c.*1883. Conté crayon, 30.5 x 24 cm. Private collection (DH 578).

of detail, colour and title, Seurat reduced his motif to a very simple tonal configuration. Here was one of the crucial lessons that Seurat's drawing of types taught him: how to strip a figure of all but the essential accessories, how to synthesize human form to a bare minimum. It was a procedure founded in popular imagery, consonant with the methods of caricature, and it was an idiom around which multi-figure paintings might be built.

These drawings served another purpose, teaching Seurat to locate, with a most effective simplicity, a type's position in the economic and class structure of modern Paris. By means of the clothes they wear and the tasks they perform Seurat isolated the social status of his figures and he divided his observations between the working classes — the porter from Les Halles, the streetsweeper, the orange-seller — and the bourgeoisie — the angler (DH 457), for instance, or the many sheets of elegantly dressed women. Sometimes he so reduced the identifying elements that types have since been miscast; the drawing of a seated man now in Budapest (Plate 74) surely does not represent a tramp but, with his *chapeau melon*, a *petit bourgeois* – a clerk perhaps, or a shopkeeper.

In other instances Seurat deliberately depicted a juxtaposition of classes, as in *Ploughing* (Plate 25), where two bourgeois onlookers watch work in the fields. (The drawings of rural figures do not register as precisely as their city counterparts, perhaps because the traditions of type imagery were essentially urban and because their costume did not lend itself to classifiable simplification.) There are other drawings in which he was ambiguous about class identity and thus about juxtaposition. *Promenoir* (Plate 21) is a case in point: the two hatless girls wearing aprons to the right are evidently working-class, but the woman in tight dress and smart bonnet might be either a bourgeois lady or a prostitute. Seurat's sense of irony and ambiguity could be used to give an image a sense of anxiety and dislocation.

The traditions of type imagery assumed that the spectator would apply his own associations to the figure depicted, associations about role or place in society, associations of fact or myth. Seurat's emphasis on working-class types must have been accompanied by an awareness of the lives they led. Rules for street-sweepers, for example, decreed that they begin work at 3 a.m. in the summer and 4 a.m. in winter, and work till 4 in the afternoon.[36] Both the artist and the public at the 1888 Indépendants exhibition, where Seurat's drawing (Plate 69) was shown, would have known that it represented one of the most menial tasks in the metropolis. Seurat frequently drew wet-nurses, identifiable by the long ribbons streaming down from their bonnets (Plate 75). These women worked in unfortunate conditions; the typical *nourrice* was a country girl who, after an unintended pregnancy, would be forced to leave her baby and travel to Paris, to earn a living feeding a bourgeois woman's child. For some commentators they were figures of fun — Maupassant called them cows — but to

77. Odilon Redon, *A Mask Tolls the Funeral Knell*. 1882. Lithograph, 15.8 x 19.2 cm. No.3 of *To Edgar Poe*. London, British Museum.

others they were alienated and exploited; one writer considered their fate a kind of prostitution.[37]

It would be imprudent to attribute any overt ideological position to Seurat on the basis of his drawings of such types, but his thorough rehearsal of this mode of representation in the early 1880s made available to him a publicly understood visual vocabulary, well capable of conveying ideological meaning, for the pictorial statements of his later figure paintings. And the predominance of proletarian types in his drawings must be due not only to the traditions of such imagery but also to a conscious sympathy, not without political undertones, on Seurat's part.

One final thematic trend, oblique yet insistent, insinuated itself into Seurat's early work. This is an element of mystery and enigma. It manifests itself primarily in drawings, notably in the interiors he occasionally drew. *The Lamp* (Plate 76) is one of such curiosity, a beautiful drawing that reads as a dimly illuminated face and yet almost like a king's head with a displaced crown. In its disjointed legibility the drawing is reminiscent of Odilon Redon's contemporary lithographs, with their bizarre juxtapositions of the real and the fantastic (Plate 77). Like Rembrandt, Seurat had an imaginative capacity that could make magic from a mundane interior. Such suggestive qualities were appealing to the literary

78. *Through the Grill of a Balcony.*
*c.*1883–4. Conté crayon, 31.6 x 24 cm.
Private collection (DH 586).

mind — Huysmans owned *Condolences* (Plate 79) and lent it to the Eighth Impressionist show in 1886 — and it comes as no surprise that once he began to exhibit Seurat found many defenders amongst young Symbolist writers.

During his first half-decade as an independent artist Seurat researched a broad range of subjects, centred on the twin themes of the Parisian *banlieue* and the urban type. At this stage of his career his treatment of the suburb was both evocatively perceptive and yet still tentative, with the specific — the regular treatment of certain locales, for instance — dominated by the ambiguous and the circumscribed: the illegibility of images, the reluctance to represent proletarian Paris in focus. With his drawings of types Seurat depicted the human figure as an anonymous urban motif, which nevertheless signified a particular rank or function in the metropolitan class structure. Until 1884 at least, Seurat was training himself in the appropriate skills to become a painter of modern Paris.

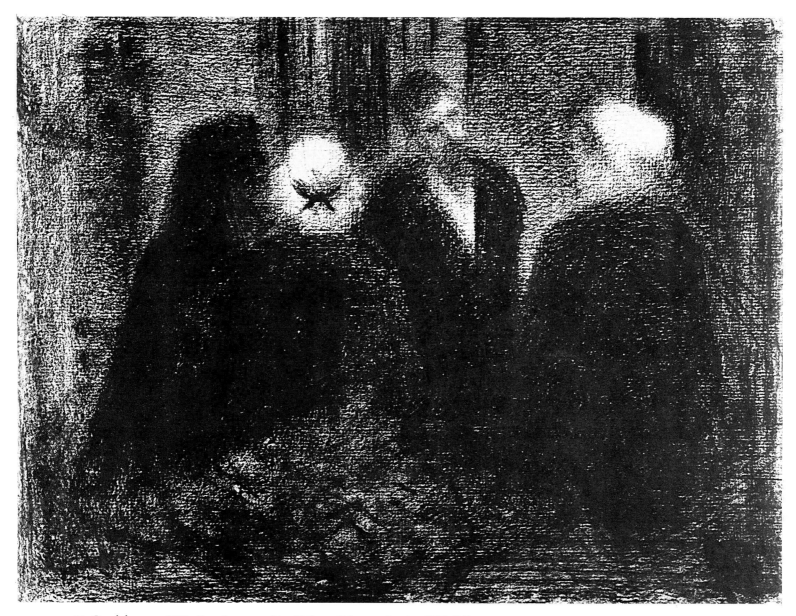

79. *Condolences. c.*1885. Conté crayon, 24 x 31.7 cm. Private collection (DH 655).

5 Une Baignade and its Aftermath, 1884-1886

The Lure of the Establishment

Up to 1883 Seurat's work was, in essence, exploratory. His early years of independence formed a conscious period of rehearsal and experiment, as he developed a highly personal drawing style, investigated the laws and application of colour, attempted various kinds of brushwork and explored a range of subjects, at the core of which was modern Paris and its suburbs. Seurat's deliberate stealth — made possible by his private means — contrasted with his friends, who made their public débuts earlier.

Aman-Jean first showed a portrait drawing at the Salon of 1879, and exhibited regularly thereafter, for the first few years with portraits; Laurent's début was in 1882. Seurat shared their company and ambitions; he rented a studio with Aman-Jean in the early 1880s, and they all drew together.

The group of friends also posed for each other. Both Seurat and Osbert posed late in 1883 for Laurent's *Scene by the Brook*, a painting of one of the Sunday performances at the Concert Colonne which he was preparing to exhibit at the Salon the following year (Plates 81, 82). Aman-Jean sat for Seurat's grandest drawing (Plate 80), a life-size image caught in a profile position reminiscent of Holbein's *Erasmus* (1523; Paris, Louvre). The young artist was shown painting — marks by the crook of the elbow indicate that Seurat meant to include a palette but left it out to maintain the integrity of the profile — and the drawing provides an excellent example of Seurat's ability to create a telling and sensitive portrait. He was obviously pleased enough to send it to the Salon of 1883, and it attracted some sympathetic critical attention; Roger Marx, a young critic of his own age with an eye for new talent, described it as 'an excellent study in chiaroscuro, a drawing of merit which does not strike one as the work of a mere débutant'.[1]

By the time Seurat made this modest Salon début Laurent and Aman-Jean were already producing paintings of some ambition. At the Salon of 1883 Laurent exhibited a picture derived from Richardson's eighteenth-century novel *Clarissa Harlow*; the following year he changed subject dramatically with his modern concert scene. Aman-Jean's *Saint Julian the Hospitaller* of the Salon of 1883 was also inspired by literature — one of Flaubert's *Trois contes*, published in 1880 — and its combination of 'biblical' figures in a 'modern' landscape was evidently indebted to the recent work of Jean-Charles Cazin, notably *Tobit and the Angel* (Lille, Musée des Beaux-Arts) and *Hagar and Ishmael* (Tours, Musée des Beaux-Arts), both shown at the Salon of 1880. This dependence on Cazin was only a passing phase. Aman-Jean's *Saint Geneviève* (Plate 83), exhibited at the Salon of 1886, set an allegorical figure against the Paris skyline in much the same fashion as Lehmann had done in his mural for the Ecole de Droit, *Law Prevailing over Force* (Plate 84). He prudently held to tried formulae as he sought recognition in the Salon.

For all the uncertainty of their subject-matter, by mid-decade Seurat's closest friends had become regular and substantial Salon exhibitors. Laurent's ambitions went further. In 1883 he entered a competition to decorate the town hall of Saint-Maur-des-Fossés, a suburban commune to the south-east of Paris, with a design based on divisionist principles. Puvis saw his entry and gave him advice and encouragement.[2] The following year Laurent presented a scheme for the town hall of Courbevoie, which was shown with fifty others — including one by Alexandre Séon, another friend of Seurat's — at the Ecole des Beaux-Arts. Roger Marx, reviewing the competition and arguing that the best decorations for a modern town hall should be 'powerful and significant allegories based on realistic forms', admired Laurent's work for being 'as fertile in promise as in inexperience'.[3]

Seurat does not seem to have been involved in these competitions, but he would have known about his friends' participation, and the existence of these projects may have helped him to decide in 1883 that his first major canvas should be of a suburban subject; it is perhaps no coincidence that *Une Baignade* was set only a few hundred metres downstream from Courbevoie. A

81. Ernest Laurent, study for *Scene by the Brook (Beethoven op.68)*. Black chalk, 24 x 27 cm. Paris, Louvre.

82. Ernest Laurent, *Georges Seurat* (study for *Scene by the Brook*). 1883. Black chalk, 39 x 29 cm. Paris, Musée National d'Art Moderne.

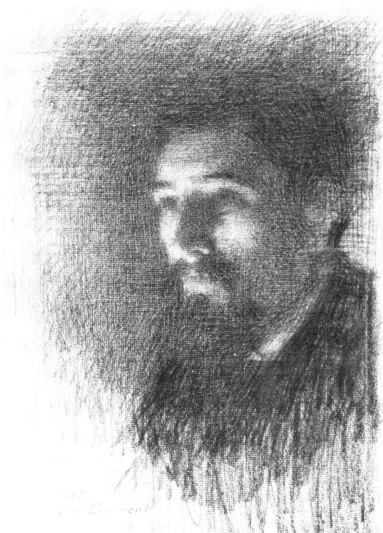

80. (opposite) *Aman-Jean. c.*1883. Conté crayon, 62.7 x 47.5 cm. New York, Metropolitan Museum (DH 588).

83. Edmond Aman-Jean, *Sainte-Geneviève*. 1885. Canvas, 74 x 105 cm. Brest, Musée des Beaux-Arts.

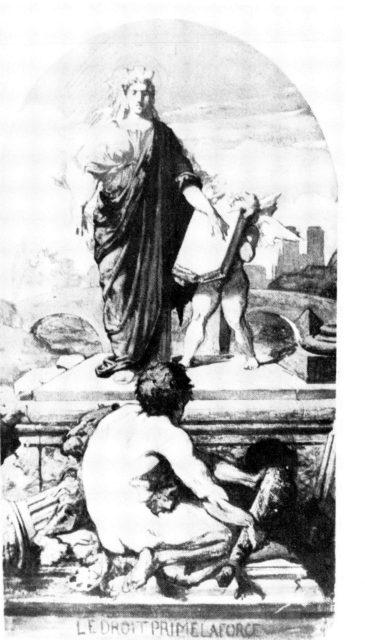

84. Henri Lehmann, study for *Law Prevailing over Force. c.*1872–3. Conté crayon, watercolour and gouache, 43.4 x 24.5 cm. Paris, private collection.

85. (opposite) *The Painter at Work. c.*1884. Conté crayon, 30.7 x 22.9 cm. Philadelphia Museum of Art (DH 602).

further suggestion that Seurat may have envisaged a future as a painter of monumental public decorations is a drawing of this period, often said to be a self-portrait, which represents an artist painting such a work from a step-ladder (Plate 85). Whether the sheet represents Seurat or not, it is typical of many drawings of the period which posed famous painters of mural-scale pictures in this fashion,[4] and it encapsulates the position of Seurat and his colleagues at this time: conventionally trained young painters with ambitions to make a reputation at the Salon and as decorators of public buildings.

Une Baignade, Asnières: recasting academic convention

By 1883 the crucial elements in Seurat's professional life were in harmony — the mechanics of his craft, his researches into modern subjects, the challenge of his colleagues — and he embarked on the masterpiece intended to establish his artistic stature, *Une Baignade, Asnières* (Plate 97). Seurat set about the preparation of the painting with a thoroughness and conviction typical of both his character and his training, producing fourteen small

painted panels and nine drawings as preliminaries for the final canvas.[5] It is not certain when this intense period of study began, although scholars usually assume that as the finished painting was exhibited in the spring of 1884 the preparatory work started in the spring or summer of the previous year.[6] However, the internal evidence of at least one panel suggests that the project might have its origins in 1882. The *croqueton* known as *The Two Banks* (DH 79; Glasgow Art Gallery) is handled loosely with very little use of the *balayé* stroke — an execution consonant with that year but not with 1883 — and also depicts trees that are not in leaf, unlike all the other preliminary panels. It may be that Seurat, working in the western suburbs during 1882, hit upon the motif that autumn without in any way intending it to form the basis for a major painting, and, returning to the area the following spring, found that the vista he had already treated could be adapted for his new project. The dating of the preparatory drawings for *Une Baignade* has raised similar problems. Herbert has proposed an approximate date of 1882–3 for some of these sheets, in particular the study now at Yale for the seated boy in the straw hat (Plate 86), without explaining his supposition.[7] While it is difficult to distinguish exactly between drawings made in 1882 and 1883, it is surely implausible that resolved figure drawings of poses clearly destined for incorporation in a major canvas should be executed when the overall concept of the painting had scarcely germinated. While the earliest visualization of the landscape motif later to be used in *Une Baignade* may have occurred in 1882, in every likelihood most of the panels and probably all of the drawings were made during the second half of 1883; indeed, some of the drawings seem to have made their appearance very late in the conception and may even belong to early 1884.

Seurat seems to have begun to focus on the *Baignade* project with the landscape panels, and to have started in the middle of the year, because with the exception of *The Two Banks* the trees in all these paintings are in leaf. The earliest of the *croquetons* must be those least like the final composition in design and staffage, and several seem to form what one might call an exploratory group. The *White Horse in the Water* (DH 87; Paris, Renand collection), the *Black Horse and Figures* (DH 85; Paris, private collection) and the *White Horse and Black Horse in the Water* (Plate 88) all fall into this category. They are handled in quite loose strokes — horizontal for the water and elsewhere with a very slack and informal dab, rather than the more deliberate *balayé* touch — and their colouring is light and bright, with attention paid to the careful distribution of complementary colours. Each of these panels concentrates on the river, which spreads across the whole horizon, rather than the bank, and none of their figures, or the horses, were included in the final canvas. The relaxed execution and casual composition argues that they were painted on site, *en plein air*.

Gradually Seurat worked his way towards a more coherent design. Already *White Horse and Black Horse*

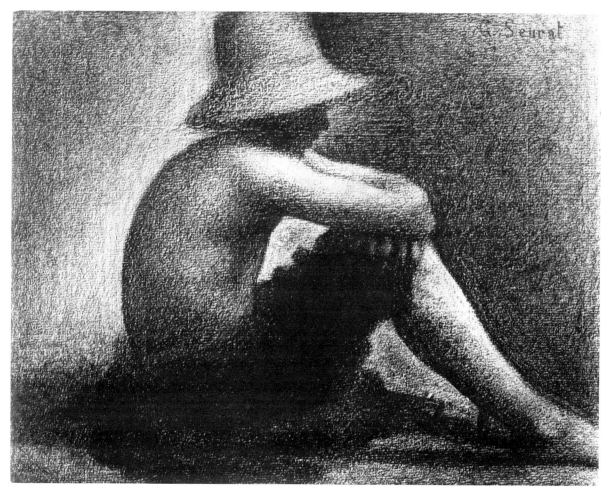

86. Study for *Une Baignade: Boy with Straw Hat Seated on the Grass. c.* 1883–4. Conté crayon, 24 x 30 cm. New Haven, Yale University Art Gallery (DH 595).

87. Hippolyte Flandrin, *Nude Youth Seated on a Rock by the Sea.* 1836. Canvas, 98 x 124 cm. Paris, Louvre.

88. Study for *Une Baignade: White Horse and Black Horse in the Water.* c.1883. Panel, 15 x 24.7 cm. London, Lady Aberconway (DH 86).

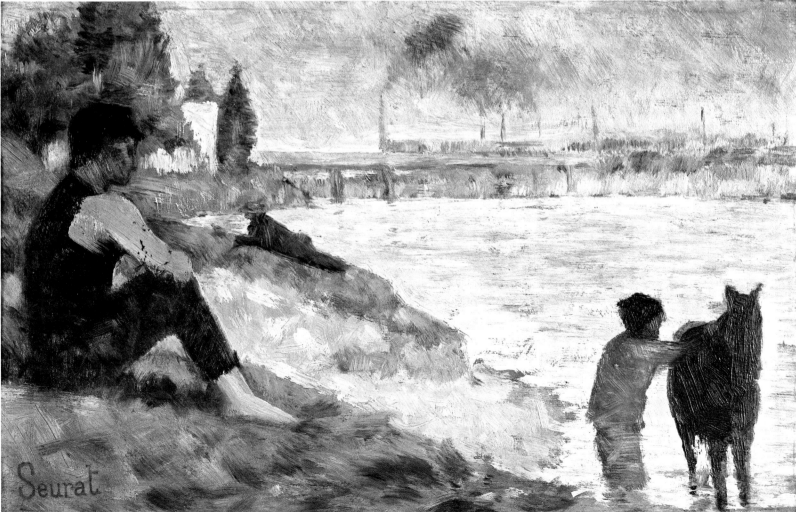

89. Study for *Une Baignade: Seated and Reclining Figures, Black Horse.* c.1883–4. Panel, 16 x 25 cm. Edinburgh, National Gallery of Scotland (DH 88).

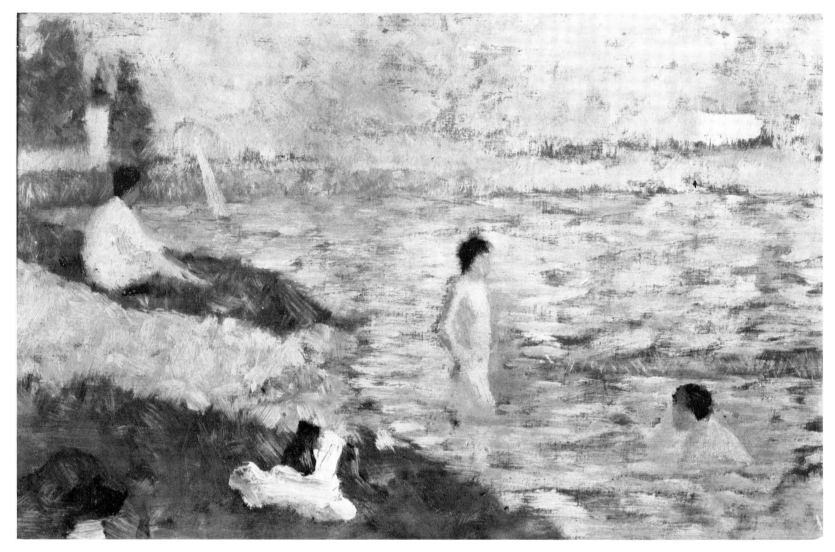

90. Study for *Une Baignade: Figures in the River. c.*1883. Panel, 16 x 25 cm. Paris, Louvre (DH 84).

in the Water achieved greater balance than the earlier panels, and with *Figures in the River* (Plate 90) Seurat went a step further. By this stage he had established more of an equivalence between river and bank, driving the latter into deep space on the left of the picture. The bank also began to play a more important part, for a seated figure and pile of clothes establish horizontal planes, and this profile distribution lends the configuration an air of calm and deliberation. Probably at this juncture Seurat painted two *croquetons* of the landscape motif alone, with no figures but only discarded clothes to act as a marker of space, and now his procedure for the painted panels changed. The Tate version is quite lightly handled and may have been made out of doors (Plate 91); the other (DH 90; formerly Cargill collection), executed in a more controlled *balayé* touch and corresponding more closely to the left side of the finished picture, could have been a revised version made in the studio. In both these Seurat paid more attention to the cityscape on the horizon than he had previously.

A further stage was reached with *Seated and Reclining Figures, Black Horse* (Plate 89) and *Seated Bather* (DH 91; Kansas City, Nelson Gallery), both of which are probably studio works. In these the landscape is well established and certain figures, such as the boy with raised knees and the seated half-naked bather, begin to play the prominent roles they kept in the exhibited painting, and in the Edinburgh panel the horse makes a brief and final return to the scheme.

This account calls into question the effect that Impressionist painting might have had on the genesis of *Une Baignade*. Commentators are divided on this. To Herbert the preparatory oil panels constituted 'a veritable apprenticeship to Impressionism', while other scholars, including Douglas Cooper and Sven Lövgren, consider that Impressionism had little impact — surely the more justifiable view.[8] The very nature of Seurat's conventional and intensive preparatory process — small oil sketches made on site, others revised in the atelier, the complex programme of drawing figures and parts of figures, and the assembly of all elements in a complete scheme before work began on the large-scale canvas — was at odds with the apparent transcription of immediate visual sensations at the core of the painting of a Monet or a Sisley. Seurat's procedures belonged to the time-honoured Ecole system, justified by the reading

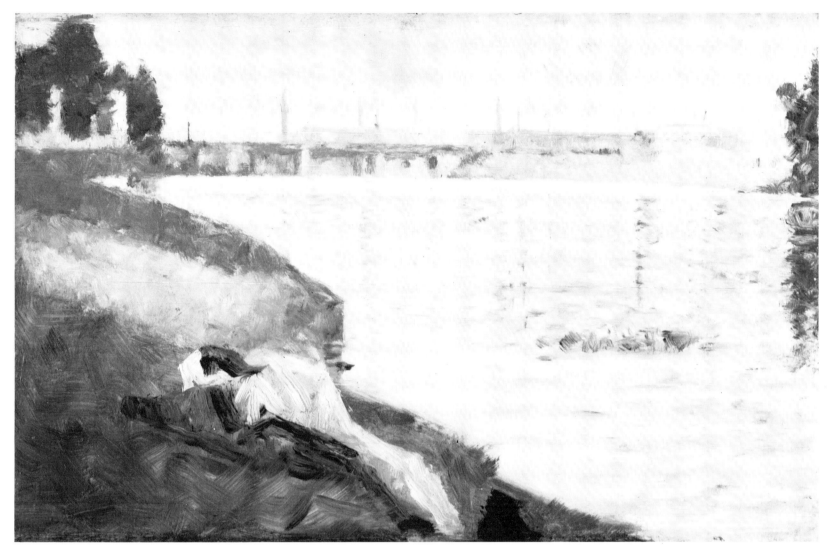

91. Study for *Une Baignade: Clothes on the Grass. c.*1883. Panel, 16 x 24.7 cm. London, Tate Gallery (DH 81).

of texts like Rood, and he employed it to the full. Even the actual handling of the *croquetons* reminds one of a middle-of-the-road artist such as Lépine or Guillemet[9] rather than the Impressionist landscape painters, whose touch was more varied, less systematic. Seurat's colour was clearly more adventurous in these panels than in his earlier Barbizon-inspired pictures, and this no doubt owed something to his experience of Impressionist landscape painting, but his observations of local colour and simple complementary relationships, for all their freshness, still suggest the influence of more moderate mentors, even of the textbook, rather than the extraordinarily subtle and delicate medleys of colour in Monet's work at this time.

The drawings for *Une Baignade* were all made in the studio. This is particularly obvious in a sheet (DH 594; Stockholm, Bonnier collection) made to revise the legs of the figure wearing a straw hat and seated to the left of the final painting; the feet do not rest on grass but on the flat floor of the atelier. Indeed, a drawing for one of the bathing boys has in the background the triangular shape of a collapsible easel, against the straight lines of which Seurat set the undulations of the boy's biceps and

profile (Plate 92). These drawings were made to establish not just the poses but also the value structure of the main figures, and sheets survive for all five. Seurat used the drawing process to refine pose and value simultaneously. Thus there are three drawings for the man reclining in the foreground. This figure was a late addition, brought in from a panel of assorted models (DH 82; formerly Denis collection) and appearing at the last minute in the completed compositional sketch as a substitute for the pile of clothes which had previously fixed the foreground. One sheet (DH 589; Basel, Beyeler collection) depicts this figure full-length, while the other two target on head and shoulder. The Louvre sheet was probably the last of these, as Seurat reduced details such as the creases on the coat, achieving a highly simplified range of values that he transferred directly into the final painting (Plate 94). This confident drawing — almost half the sheet is blank white — must have come very late in the procedure, and it indicates the cross-fertilization between drawing and painting; drawing established form and value, while certain graphic effects even occurred in the painting, here the wispy strokes that appear on the man's shoulder in the canvas.

83

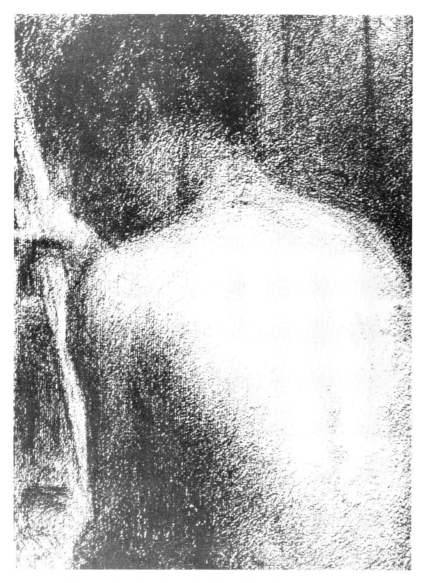

92. Study for *Une Baignade: Nude Figure by an Easel. c.*1883–4. Conté crayon, 31.2 x 24 cm. Paris, private collection (DH 596).

93. J.-A.-D. Ingres, *The Valpinçon Bather*. 1808. Canvas, 146 x 97.5 cm. Paris, Louvre.

The final stage before Seurat began work on the canvas was the panel now in Chicago, in which the resolved configuration made its first appearance (Plate 96). He exhibited this *croqueton* at the Cercle des Arts Liberaux in February-March 1884,[10] heralding the appearance of *Une Baignade* at the Salon a couple of months later, or so he must have hoped. Nevertheless the artist made several significant changes between the compositional sketch and the canvas: the river traffic was altered, the head of the swimming figure to the right removed as it disturbed the balance and added unwelcome movement, both the boy seated on the edge of the bank and the reclining man pushed deeper into the picture space, and — as pentimenti make clear — the dog added over the white coat.

The final sketch also fixed the different zones of brush-strokes; the instinctive scheme of the earlier panels' *balayé* land and foliage with horizontally handled water, was determined as the execution for the full-scale canvas. Again, the technique of 'irradiation' (making artifical and exaggerated value contrasts between object

and background to give the former a strong sense of relief) which Seurat had explored in the drawings was carried through via the compositional sketch to the final painting. Like many of the preceding *croquetons* this panel is quite subdued in colour; complementaries are limited to the use of some violet and dull orange in the grass and more orange in the shaded green area of the water.

Recent technical examination of the Chicago panel has revealed for the first time that prior to painting Seurat scored the wood with a blunt instrument, making two lines that exactly bisected each edge; these lines are visible to the naked eye under the paint surface. The vertical division passes along the centre boy's back, while the horizontal one runs through the ribs and knees of the seated boy to the left.[11] On this simple arrangement of his design into equal quarters Seurat organized *Une Baignade*.

Such a compositional aid is not immediately apparent on the completed canvas. On close inspection, however, a horizontal mark, probably in black chalk, can be made

out running for several centimetres just below the rim of grass that juts out towards the water above where the riverbank has collapsed to centre left. This mark indicates the horizontal axis exactly half-way up the painting. The corresponding vertical axis, which also precisely bisects the canvas, is subtly indicated. Just behind the back of the centrally placed bather there is a change of tone, running vertically through the water and the edge of a rectangular patch of shadow to the right of the distant bridge. This tacit inclusion of a vertical bisection by a value contrast ordained by the distribution of light was part of the vocabulary of classical landscape; Claude used it in several port scenes, including *Ulysses Returning Chryseis to her Father* (c.1648; Paris, Louvre). This vertical played little part in the discipline of Seurat's final design, but the horizontal did, and he made changes in the arrangement of forms to correspond with this axis. The bather seen from behind, for example, was given a more substantial presence than in the Chicago panel, and the top of his head coincides with the horizontal axis.

It is also possible that Seurat used the Golden Section in *Une Baignade*, and Dorra has suggested that the distant waterline was sited on that proportion.[12] This may well be the case — the Golden Section has been, after all, a standard proportional structure in the visual arts since the Renaissance — but it seems clear that Seurat's primary compositional aid was the simpler division into quarters, which he respected but did not follow slavishly.

The overall effect of *Une Baignade* is one of calm, and the composition was contrived to this purpose. The spectator's eye is initially drawn to the horizontal planes, to the lines and forms running across the painting; bridge, ferry-boat, shadows, even the figures' gazes are held in this profile configuration. Nevertheless, against the planar arrangement Seurat set insistent diagonals, and the two banks of the river lead deeply into space. The artist emphasized this depth by pushing the industrial cityscape into a distant haze and by repeating the seated and reclining figures on the left bank. The

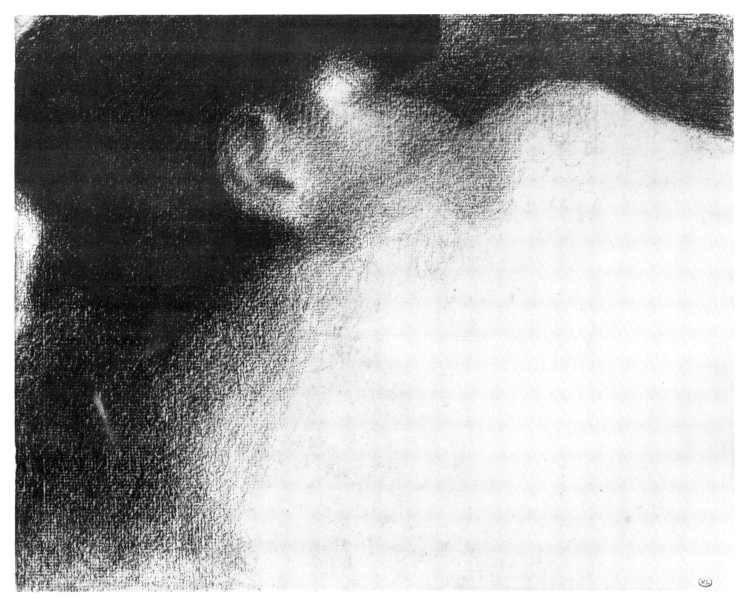

94. Study for *Une Baignade: Reclining Figure*. c.1883–4. Conté crayon, 24.7 x 31.2 cm. Paris, Louvre (DH 590).

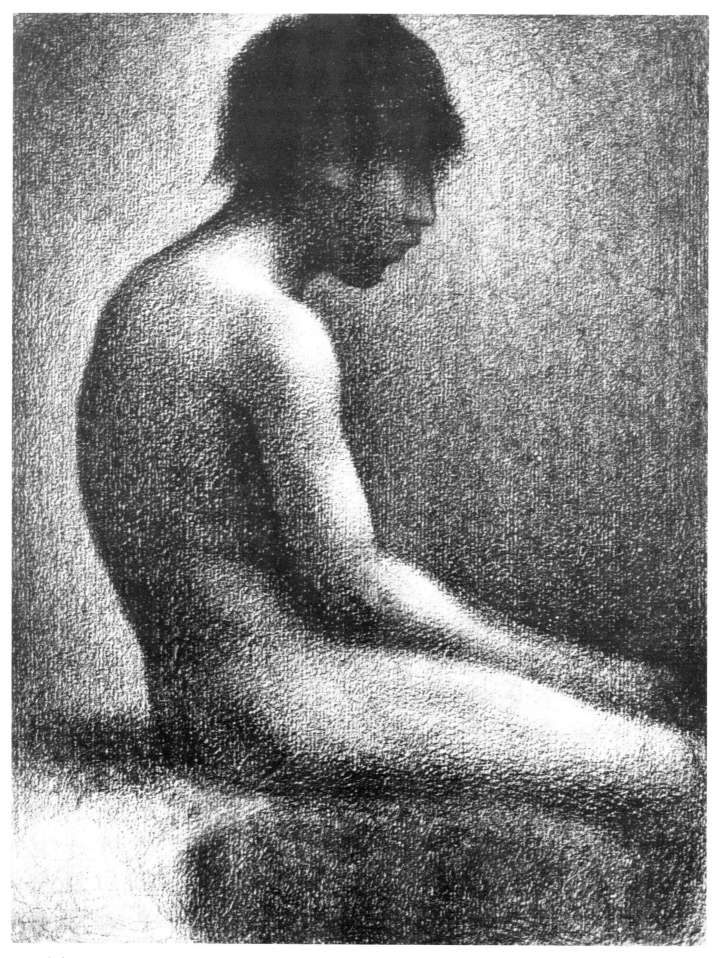

95. Study for *Une Baignade: Seated Youth. c.*1883–4. Conté crayon, 31.5 x 24 cm. Edinburgh, National Gallery of Scotland (DH 598).

disposition of forms, for instance the siting of the two boys in the water parallel to the shore, echoes the diagonal thrust. This diagonal effect is taken up in the poses, too, for the limbs, elbows and knees of the figures, as well as the shadows on them, are frequently ordered around a triangular structure. The design is thus a satisfying balance between planar structure and illusionistic depth. But despite this discipline there is a disparate quality about *Une Baignade*. The preparation of the figures in isolation, the lack of groups, must have contributed to this, and the painting's controlled design and alienated figures ultimately produce a jarring effect at odds with the initial calm.

The general tonality of *Une Baignade* is very blond, and it is a painting that gives out much light. The application of colour, with limited use of complementaries, was not exceptional for the period; the sky, for example, is essentially handled in straightforward blues and whites, and there is only a little reflected colour in the water. In the foliage Seurat mixed some violet, orange and pink with the greens, and in the shadows violet and blue. The figures are also simply executed in flesh tone, with blue in the shadows. In places the transitions are quite abrupt on the figures, as in the central boy, and it is such sharp value contrasts, rather than traditional modelling, that give the figures volume. Seurat allowed the thick weave of the canvas to act as a medium for the modelling (as he utilized the texture of paper in his drawings), having it reinforce contours and shadows, for instance on the neck of the right-hand boy in the water or the face of the seated boy in the straw hat.

The colour became more sophisticated in the later stages of execution. The dog is a case in point. A late addition to the scheme, its warm brown coat reflects green from the grass and includes blue and violet in the shadows. Again, the cushion on which the boy in the straw hat sits was in neither the drawing nor the Chicago sketch, being added at a late stage to alleviate the hole the boy's dark trousers would have made in the chromatic structure; the pentimenti around the buttocks suggest it was put in at the eleventh hour. By contrast the central still-life was settled in a preliminary drawing (DH 593; Connecticutt, Orswell collection) and was simply transposed onto the canvas, where it was executed more delicately, less hastily than the additional items. Seurat's eye for detail did not let him down; he added two yellow flowers at the lower right to warm a dark area, much as the dog served to enliven the other corner. His experiments with brushwork paid off, and *Une Baignade* was handled in the horizontal and *balayé* strokes rehearsed in the panels and other 1883 paintings such as *Woman Seated on the Grass* (Plate 48). This execution adapted itself well to a large scale, for *Une Baignade* measures some two by three metres, a suitable size to attract attention at the Salon or to sustain a painting's presence if installed in a cold public building.

The treatment of colour in *Une Baignade* was, then,

perhaps not so startling for its period as we have come to assume. Puvis counted for something in its rough, matt surface, and the painting's overall blond tonality was not far from the middle-of-the-road *peinture claire* of the early 1880s — Cazin and Bastien-Lepage are once more examples. Limited division of tone might even be admired by an establishment figure and Salon juror such as Puvis, as we saw in the case of Laurent. Seurat's use of colour, with its uninsistent notation of complementaries, was progressive but not revolutionary; indeed, as his own concepts developed he later saw fit to rework certain small passages of *Une Baignade* to complete incidents unresolved in 1884. It was Signac who reported this in 1894, arguing that Seurat muted the painting's colour to make it acceptable to the Salon jury.[13] This was rather missing the point; Seurat had taken his painting as far as he could in 1884. The preparatory processes he had used were completely conventional and the whole compositional conception of *Une Baignade* belonged firmly within a deeply rooted pictorial tradition.

Some indication of how *Une Baignade* was read when on exhibition in 1884 comes with Paul Alexis's statement that 'it's a fake Puvis de Chavannes'.[14] It presumably reminded him of Puvis's recent work in its simplified drawing, matt surfaces and disciplined design, perhaps more specifically because it recalled *Doux pays* (Plate 98), exhibited at the Salon of 1882, in the high horizon broken by a figure just off-centre, the disposition of bank and water, even in details such as the sail to upper right. If in *Une Baignade* Seurat, like Aman-Jean in his reliance on Lehmann or Cazin, was making oblique use of prototypes provided by senior contemporaries, he was also, like Puvis, working within a set of conventions central to the traditions of French classicism, a pictorial vocabulary enshrined in the work of Poussin, one of his most admired models at the Ecole. Indeed, *Une Baignade* follows many of the features defined in such paintings as *The Finding of Moses* (Plate 99), a canvas Seurat would have known: the creation of depth by diagonals, the demarcation of space by successive horizontal planes, the still figures seen in profile which dominate the landscape elements. It is perhaps no coincidence that at the beginning of his *Grammaire des arts du dessin*, which Seurat knew so well, Charles Blanc, defining art as 'the interpretation of nature', gave the example of Poussin transforming the sight of a woman bathing her child in the Tiber into a painting of Moses rescued from the Nile. 'This', he wrote, 'is how a scene of everyday life suddenly becomes raised to the dignity of a history painting.'[15] Blanc's words would have served as ideal justification for precisely the kind of transformation Seurat was attempting to achieve in *Une Baignade*, from mundane observation to disciplined work of art.

At least two of the poses in the painting relate to the same classical tradition. The bathing boy seen from behind was indubitably founded on Ingres's Valpinçon Bather (Plate 93), acquired for the Louvre in 1879; this

96. Study for *Une Baignade: Final Compositional Study*. c.1883–4. Panel. 15.7 x 24.7 cm. Chicago, Art Institute (DH 93).

97. *Une Baignade, Asnières*. 1884. Canvas, 200 x 300 cm. London, National Gallery (DH 92).

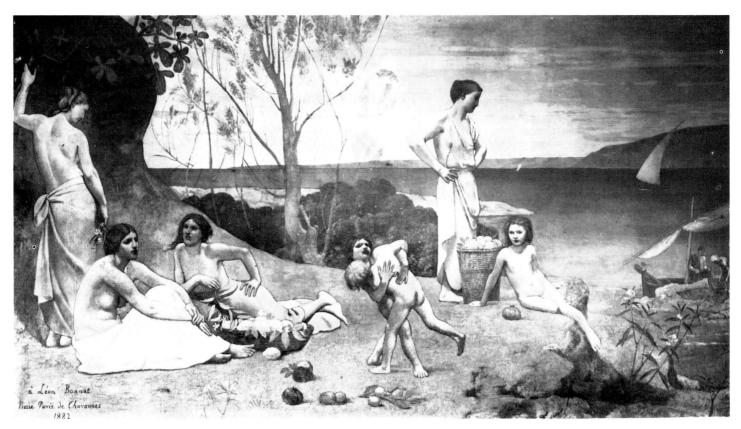

98. Pierre Puvis de Chavannes, *Doux Pays*. 1882. Canvas, 230 x 430 cm. Bayonne, Musée Bonnat. Exhibited at the Salon of 1882.

was a way of paying homage to the artist who had meant most to Seurat as a student. It is often argued that the seated boy in the straw hat (Plate 86) was based on one of the sleeping soldiers in Piero della Francesca's *Resurrection* (c.1463; Borgo San Sepolcro, Palazzo Comunale), but any links between Seurat and Piero are more coincidental than deliberate and have at times been grossly exaggerated.[16] Seurat never travelled to Italy and showed scant interest in Quattrocento art, and while he might have seen reproductions of Piero's *Resurrection* he found this pose much nearer to hand, because it was absolutely standard in the canon of nineteenth-century French academic art. The most famous example of the pose in this context was Hippolyte Flandrin's *Nude Youth Seated on a Rock by the Sea* (Plate 87), executed in 1836, and in the collection of the Louvre by Seurat's day. It also occurred on the left of Lehmann's *Oceanides* (Plate 8), in a painting by Bouguereau of 1884 (*Seated Nude*; Williamstown, Clark Art Institute) and even in contemporary photographs of nude *académies*.[17]

In sum, *Une Baignade, Asnières* is a grand, fresh, yet in many ways rather conservative canvas, which in 1884 may have looked less like a radical new departure than the work of a young artist well versed in conventional procedures, with an eye to modern developments in simplification of drawing and high-key tonal painting. *Une Baignade* was submitted to the Salon of 1884, but was rejected by the jury. We do not know the reason for this. It might have been that the picture was considered too derivative of Puvis — Alexis thought so — or an internal failure: its simplified forms too stark for the expectations of the Salon jury. Perhaps it looked too equivocal a canvas within the art politics of the time, an unacceptable combination of academic recipes and modern handling, contemporary subject and classical configuration. Its refusal marked a turning point in Seurat's career.

The Indépendants and the challenge of new colleagues

A substantial number of canvases were rejected by the Salon jury in 1884. The protestations of disappointed artists led to the formation of the Groupe des Artistes Indépendants, who staged an exhibition from 15 May to 1 July under the auspices of the city of Paris in a temporary building erected as a provisional post office in the Place du Carrousel, near where the Tuileries had stood. It was a spontaneous and rather ramshackle affair, the only coherent principle of which was that there should be no jury. The 402 exhibitors ranged from the most amateur dabbler to artists such as Seurat, well-trained painters whose canvases had fallen foul of the Salon jury. Among them were several who would become friends and collaborators of Seurat, including Paul Signac, Henri-Edmond Cross, Charles Angrand and Albert Dubois-Pillet.[18] *Une Baignade* was badly hung, apparently in the bar, and it received little critical attention.[19]

The Groupe was incompetently and chaotically run, and Dubois-Pillet, an officer in the Republican Guard and part-time painter, was largely responsible for setting

99. Nicolas Poussin, *The Finding of Moses*. 1638. Canvas, 85 x 120 cm. Paris, Louvre.

up a new Société des Artistes Indépendants, legally constituted on 11 June with its secretariat at his studio, 19 quai Saint-Michel. Dubois-Pillet, who used his Masonic connections in bureaucratic circles to aid the Société's arrangements, was occasionally reprimanded for his extramural activities by his military superiors, who were often urged on by disgruntled members of the Groupe des Artistes Indépendants.[20] The Société, an altogether more professional affair, also made the abolition of the jury a central principle, so that any painter was free to show work, the only constraint being a limitation on the number of pictures each artist was allowed to submit to any one exhibition. This emphasis on freedom — Fénéon wrote in 1886 that the Société's goal was 'to allow artists to expose their work freely to public judgement'[21] — was not without political undertones, for the Société was in essence a co-operative. As Jules Antoine claimed in a piece on Dubois-Pillet published in 1891, the Société des Artistes Indépendants was the 'first and the sole manifestation of liberty in art'.[22]

Seurat immediately became involved with the Indé-

pendants and never again submitted work to the Salon. He showed at the first exhibition put on by the Société, which opened on 10 December 1884 and ran on into the following January, once more submitting the portrait of Aman-Jean (Plate 80), the major showpiece among his drawings, plus 'a group of studies framed together, and a remarkably translucent, airy landscape, with the vivid light of a hot summer sun playing upon it'. The landscape was a canvas of *La Grande-Jatte* (Plate 102), and the nine studies were probably panels which had also been executed there.[23] Seurat was showing recent work, the preliminary material for his next major canvas, which he had already had in hand. But before dealing with *La Grande-Jatte* itself, we must examine the changes in Seurat's social and artistic circumstances between the exhibition of *Une Baignade* in the spring of 1884 and of *La Grande-Jatte* two years later.

There can be no doubt that the Indépendants provided a new society for Seurat, a wider and more challenging range of friends and contacts, so that by mid-1886 he belonged to an exciting circle of painters, poets, journal-

ists, art critics and novelists, and was exposed to the full breadth of their radical and stimulating views. Seurat's taciturn nature did not change, of course, but at this stage in his career he began to participate more in artistic society. One finds reports of him, for example, in attendance at the regular dinners of the Indépendants, such as the one held chez Catelain, near the Palais-Royal, on 12 January 1886; Signac, Angrand, Dubois-Pillet, Pissarro and Guillaumin were there, Gustave Geffroy could not come.[24] And although the evidence is thin, Seurat does not seem to have completely abandoned his colleagues from the Ecole – Séon, for one, kept in contact — though their paths increasingly began to divide. Aman-Jean and Laurent both won travelling scholarships in 1885 with the support of Puvis de Chavannes, and visited Italy for lengthy spells.[25]

The most immediately important new friend to Seurat was Paul Signac. Signac was also a Parisian, and came from the same class background. His father had been a well-to-do shopkeeper, running a small saddler's business in the rue Vivienne, near the Bourse, and Signac had substantial private means. By the time his father died in 1880 and he and his mother had moved to live at Asnières (42bis, rue de Paris), Signac had begun to paint, encouraged particularly by seeing the work of Monet. He was largely self-taught, having unsuccessfully tried to coax some tuition from Monet, on whom his painting style, up to about 1885, was substantially based. Before meeting Seurat at the gatherings held to found the Indépendants in the early summer of 1884 Signac, then still only 20, was already on the fringes of Impressionism; his landscapes were painted *en plein air* with a loose touch and the exclusion of earth colours, and Caillebotte had taught him to sail.

Perhaps of crucial importance to Seurat was Signac's personality, which was a contrast and a complement to his own. Seurat was reserved, touchy and distant. Signac was gregarious and ebullient, thriving on a wide circle of friends. He enjoyed organizing, and in the mid-1880s was the dynamo of the Neo-Impressionist group, leaving Seurat the more aloof — and welcome — role as major artist. Signac also had a rumbustuous sense of humour; on one occasion he dressed as a nun for a fake funeral at the Chat Noir cabaret, and wrote art criticism giving fulsome praise to his own pictures under a thinly-disguised pseudonym. He was intelligent and energetic, generous but not without ambitions for his own art, the sort of man always at the centre of things.[26]

Seurat and Signac quickly struck up a friendship, despite the four-year difference in age and their different artistic backgrounds. Although Seurat was the more experienced artist, Signac had his own contributions to make to the relationship. Earth colours still played a part in Seurat's work for *Une Baignade*, and their disappearance from his palette after 1884 was probably indebted to Signac's more explicitly Impressionist experience. Signac's personal knowledge of Asnières and its vicinity was no doubt a substantial help to Seurat. Signac's own

rather makeshift interest in colour theory was galvanized by his friendship with Seurat, and he took his new fascination with typical commitment, even paying a visit — perhaps with Seurat — to Chevreul himself at Les Gobelins.[27] At the age of ninety-eight the chemist was probably of little help.

It was through Signac that Seurat met Guillaumin and Pissarro. Signac had come across Armand Guillaumin, then still a part-time painter specializing in the landscape and industrial suburbs of south-east Paris, working on the *quais* either in late 1884 or early 1885, and was introduced to Camille Pissarro by Guillaumin in April 1885.[28] Seurat must have made the acquaintance of these two veterans of the first Impressionist show soon after Signac, that is by mid-1885, although the actual date is disputed.[29] By this time *La Grande-Jatte* had been completed, and even though it was later re-worked it is worth pointing out that Seurat had to all intents and purposes painted two major canvases before he had even met an Impressionist proper.

Signac also provided Seurat with opportunities to meet colleagues of his own age. From about 1884 he held regular *soirées* at his studio at 20 avenue de Clichy, and it was there that Seurat was able to meet and consolidate contacts with painters such as Angrand and Dubois-Pillet.[30] This was the germ of the future Neo-Impressionist group, beginning with a community of friendship before there was community of style. This broadened circle of painter colleagues provided Seurat with a greater range of conversation, experience and expertise than he had known hitherto; his own painting became logically but conspicuously more adventurous in such a challenging context. And he began to win status among advanced young Parisian painters, who became aware that his work was identifying new objectives. In early May 1886, a few days before the opening of the Eighth Impressionist exhibition, Camille Pissarro, his son Lucien, and Louis Hayet visited Seurat's studio for a preview of the finished *Grande-Jatte*.[31] It was increasingly necessary to take account of Seurat's work.

Signac was interested in contemporary literature, and in early 1882 even published two pieces in *Le Chat noir*, one of them a clever pastiche of Zola.[32] Several writers attended Signac's *soirées*, among them Paul Adam and Henri de Régnier,[33] and Signac was the intermediary between Seurat and a wide circle of literary acquaintances. By 1886 Seurat was to be seen in the haunts of young writers, and Jules Christophe, compiling in 1888 a retrospective account of those who had met in the brasserie Gambrinus at 5 avenue de Médicis 'from 1884 to the autumn of 1886', listed Seurat, Signac and Dubois-Pillet with Gustave Kahn, Jean Moréas, Félix Fénéon, Charles Vignier, Adam, Edouard Dujardin, Téodor de Wyzewa, Ajalbert, Charles Morice, Laforgue and Charles Henry.[34] Some of these — Fénéon and Henry, say — Seurat probably only met after the 1886 Impressionist show, others — such as Laforgue — he may have known earlier. What is clear is that between

100. *The Seine at Courbevoie*. 1885. Canvas, 81 x 65 cm. Paris, private collection (DH 134).

1884 and 1886 Seurat was making a growing number of literary contacts.

The most significant circle of writers to which Seurat had access at this time, probably via Signac once more, was that which met informally *chez* Robert Caze, 13 rue Condorcet, on Mondays. Caze (1853-86) made a living as a journalist, writing novels and prose pieces in a wry Naturalist vein, and in the mid-1880s ran one of the most adventurous literary journals of the period, *Lutèce*. Seurat was certainly a visitor *chez* Caze by 1885, perhaps even as early as late 1884,[35] and they must have become friends, for the artist gave him the final sketch for *Une Baignade* (Plate 96) and a drawing of a saltimbanque. (This drawing was lent to the Impressionist exhibition in 1886 by Caze's widow after Caze had tragically died from wounds received in a duel in February.) Amongst those who met at Caze's *soirées* were Rodolphe Darzens, Moréas, Fénéon, Adam, de Régnier, Alexis, Huysmans, Pissarro, Signac, Guillaumin and Maximilien Luce.[36]

This was a most varied complement. Alexis and Huysmans had both been followers of Zola, and in 1880 had contributed to his *Soirées de Médan*, a group of short stories compiled under his Naturalist banner. By mid-decade Alexis was still unflinchingly loyal to Zola, but Huysmans, especially after the publication of *A Rebours* in 1884, stood increasingly outside the Naturalist camp, writing novels with esoteric and mystical themes. Naturalism still had affiliates among the younger generation. Adam's first novel, *Chair Molle*, was banned by the French censorship and published in Brussels in 1885; it told in clinical detail the life of a prostitute in the towns of northern France, the last chapter of the novel simply duplicating the form of a death certificate. Ajalbert's early verse shared similar Naturalist concerns, trading in accurate reportage of the grimy Parisian suburbs, and owing much to the scrupulously crafted prose of the de Goncourts. The poetry of Moréas and de Régnier, meanwhile, was leaning towards new forms of expression, innovative verse patterns and an oblique, evocative treatment of theme. The middle years of the decade were a period of transition for many young Parisian writers. There was a sense that the Naturalist aesthetic, although still a powerful and productive force, had lost its impetus, and that another aesthetic, a new literary modernity with an emphasis on mood and emotion rather than on fact and documentation, was being generated.[37] Seurat's contacts would have made him aware of the transitional and experimental state of contemporary literature, and discussions between writers and painters no doubt included the visual arts in the discourse of aesthetic change.

Political Pressures in the mid-1880s

The first half of the 1880s was a period of considerable disturbance and unrest in French politics, and this had its effect on contemporary literature and the visual arts.

The Third Republic, established in 1870, had spent its first decade consolidating its position, recovering from the traumatic Franco-Prussian War and the Commune, fending off the threat of the Right in the shape of Legitimism, Orleanism and Bonapartism, and establishing a constitution. By 1879, with a majority in the Senate and a genuine republican, Jules Grévy, as president, the Third Republic seemed secure. But with the following decade came new pressures. The 1880s saw a phase of economic uncertainty and fluctuation, exacerbated by financial disasters such as the crash of the Union Générale bank in January 1882. Although the Republic was firmly established, its supporters were widely spread across the political spectrum, and this led to dissention, rivalry, short-lived administrations and aborted policies; so disparate was its nature that Zola published an article in *Le Figaro* on 27 September 1880 criticizing 'the thirty-six Republics'.[38] Left-of-centre republicans, who had made much of their programmes to ameliorate the conditions of the working classes, proved to be a desultory failure when they were able to achieve power, and the collapse of Gambetta's ministry in early 1882 after only a few months in office signified for many the bankruptcy of the so-called 'Opportunists'.

This state of affairs inevitably gave scope for the new forces of socialism to intervene, and the early 1880s saw a substantial, if gradual, increase in the activities of the Left. A conference at Marseilles in 1879 set up the Federation of Socialist Workers, the first major left-wing initiative for almost a decade, and in the following year those exiled after the Commune were granted full amnesty, which allowed many politicians and activists back into the ring. The legalization of trade unions in 1884 marked another step in the progress of socialist organization. But the Left did not form a united front. By 1883 there were deep divisions between the Marxist-orientated French Workers' Party, led by Jules Guesde, and the more moderate 'Possibilists', Paul Brousse's Socialist Workers' Party eschewing revolutionary rhetoric for a policy of infiltration. And the Left was also active in smaller, more marginal groups such as the anarchists; in 1885, for example, Jean Grave moved his anarchist newspaper *Le Révolté* from Geneva to Paris.[39]

In the face of the debates and propaganda stimulated by the emergence of an organised, if divided, Left it became increasingly difficult for the writer or artist to avert his attention. Nowhere is this more clear than in the novels of Zola. The thrust of his books dealing with working-class subjects in the 1870s — novels such as *Le Ventre de Paris* (1873) or *L'Assommoir* (1877) — was essentially documentary, but by the mid-1880s — in *Germinal* (1885) and *La Terre* (1887) — he had been forced to change. As he wrote to a friend in 1886: 'Nowadays, every time I take up a project I run into socialism'.[40] The wide questions of social reform taxed the contemporary intellectual, and the generation of writers maturing in mid-decade took them into account. Literary and artistic periodicals such as the *Revue indé-*

pendante and *La Vogue*, run by friends of Seurat like Fénéon, Kahn and Adam, felt the need to state their editorial positions, as they did in March 1885 and April 1886 respectively. While distancing itself from party politics *La Vogue's* first issue decreed: 'The social revolution will take place; all these coalitions will only serve to precipitate it. It is crucial that it should happen deliberately and intelligently, unlike the political revolution of the eighteenth century. Cultured and broadminded intellects must unite and analyse the problems without prejudices or *parti-pris*, drawing their inspiration from the most rigorous methods of science and the principle of universal solidarity'.[41]

Young intellectuals, contributing to such periodicals, meeting at the brasserie Gambrinus, had to confront these issues, although, as the piece in *La Vogue* indicates, in mid-decade opinions were flexible; there were no entrenched positions. The commitment of (predominantly bourgeois) artists and writers to radical social reform tended to have a sense of detachment to it, laced with intellectual snobbery. The *Petit Bottin des lettres et des arts*, a satirical compendium of leading figures in contemporary French cultural life compiled by Fénéon, Adam and Moréas in 1886, gave a telegraphic entry for the proletarian Guesde: 'Has difficulty in expressing himself in French'.[42] Nevertheless, by the mid-1880s discussion of 'La Question Sociale' was urgent, and parallels could be drawn between radical reformist views on the social structure and the condition of the working classes and progressive views in the arts. Alexis — friend of Zola and Renoir, Pissarro and Seurat — made such an equation in *Le Cri du Peuple* on 1 May 1885: 'The Impressionists, you see, are about the cleanest there are in the swamp of contemporary painters. They represent in painting exactly what the Naturalists do in literature and the Socialists in politics... Following the general thrust of the century, responsive to science, holding to the truth, they have in common the privilege of scaring the timid and pedantic, disturbing the stability of those who stick to the establishment view, and scandalizing bourgeois stupidity'.[43]

It is impossible to establish exactly Seurat's own political position at this period. His taciturn and secretive nature has left us no written or spoken clue. According to Fénéon, who became a close colleague in the spring of 1886, 'one can assume that he shared the views of his friends, because his literary and artistic comrades and their supporters in the press belonged to anarchist circles, and if his opinions had been opposed to theirs it would have been noticed'.[44] This is arguing by default — an approach no historian prefers — but, while this book will argue that it is possible to recreate a plausible if not complete picture of Seurat's ideological stance through his choice of subjects and imagery, it is worth pursuing Fénéon's oblique point, stressing at this juncture the individuals the painter came to know between the exhibition of *Une Baignade* in the spring of 1884 and of *La Grande-Jatte* two years later.

The friends Seurat made via Signac, Caze and the Indépendants were almost exclusively Left-of-centre. Caze himself had been involved in the Commune, and spent the years between 1871 and 1880 in exile. On his return he wrote for the Opportunist paper *Le Voltaire*.[45] Roger Marx was *Le Voltaire's* art critic, and Seurat was also acquainted with Gustave Geffroy, who reviewed exhibitions for Clemenceau's Radical *La Justice*. Alexis, meanwhile, contributed a regular column on general cultural matters, written in working-class slang under the pseudonym 'Trublot', for the even more left-wing *Cri du Peuple*, an extreme socialist paper run by another ex-Communard, the political novelist Jules Vallès, from October 1883 until his death in 1885.[46] Alexis must have been on good terms with Seurat by at least the spring of 1886, where he reported in his column that he owned three small paintings by Seurat,[47] and the friendship lasted, for in June 1888 *La Vie Moderne* printed Seurat's recent portrait drawing of Alexis (Plate 190).

Although Alexis was the chief artistic voice of *Le Cri* Vallès himself also contributed, even touching on painting: 'If painting doesn't re-immerse itself in the current of new ideas, it had better be careful!'.[48] Such slogans would have been heard in Seurat's circle, for Gustave Kahn remembered that *Le Cri du Peuple* was widely read.[49] Signac was a regular reader, so was Pissarro; Luce, it seems, even knew Vallès personally.[50] The evidence of Pissarro's letters points to the anxieties and fluctuating opinions among politically aware artists. The arrest of Prince Jérôme-Napoléon in early 1883 for suspected conspiracy against the State and his release a month later made Pissarro anxious about a right-wing backlash, while in July that year he castigated radicals such as Clemenceau for trying to gain power on a pseudo-socialist programme.[51] By mid-decade at least Pissarro was reading Kropotkin, knowing his anarchist texts well enough to recommend a particular chapter to a correspondent in December 1885.[52]

Seurat's friends and colleagues responded to these political circumstances, aware of the need for social reform and variously critical or curious, open-minded or committed. In such a context we should be wary of attributing any fixed views to the silent Seurat, but he cannot have been unaware of the climate of opinion in his new circle and what radical, left-wing views he probably held must have been similar to those of his friends at mid-decade, developing and inconsistent.

Staging the Eighth Impressionist Exhibition

By late 1885 plans began to be discussed amongst members of the old Impressionist group for another exhibition, the first since 1882. Pissarro and Berthe Morisot, aided by her husband Eugène Manet, seem to have been the prime movers. From the outset Pissarro argued for the inclusion of Seurat and Signac, and Guillaumin lent a hand. Writing to Pissarro on 30 December 1885 Guil-

laumin reported that 'Degas, who doesn't know — or hardly knows — what Signac's and Seurat's work is like, must have been a bit worried by the reports he's heard … Mme Manet saw our friends' studies last year, and she seems to me to be well disposed in their favour, so if necessary she could calm Degas's fears'.[53] Much politicking took place among the old members of the group as the months passed and plans became clearer. By March 1886 Eugène Manet was very anxious about Seurat and Signac while Degas was reassured. A letter written that month from Pissarro to Lucien described the current position: 'Yesterday I had a stinking row with M. Eugène Manet about Seurat and Signac … To cut a long story short, I explained to M. Manet, who could understand nothing, that Seurat had something new to offer that these gentlemen, for all their talent, weren't able to appreciate. Whereas I myself am convinced that, in due course, the novelty of this method will produce extraordinary results. Besides, I don't give a damn about other artists' appreciation, no matter who they are; I don't accept the idle judgement of the romantics who have every interest in fending off new initiatives. I accept the struggle, that's that … Degas is far more loyal — I told him that Seurat's painting is most interesting. "Oh! I can see that for myself, Pissarro; but it's so big!" Fair enough! — If Degas doesn't see anything there, so much the worse for him; there's a rare quality that escapes him. We'll see.'[54] Pissarro's faith in the new was shared by few others from the earlier exhibitions, for Monet, Renoir, Caillebotte, Sisley and Raffaëlli chose not to participate.

The exhibition was finally staged at the Maison Dorée, in the boulevard des Italiens, from 15 May to 15 June — precisely the same dates as the Salon, at Degas's provocative insistence. The artists fell roughly into three groupings, besides isolated individuals like the new-comer Redon: those working in the established vein of landscape Impressionism, Morisot, Vignon, Guillaumin and Gauguin (the last two particularly close allies at this time); Degas and the artists associated with him since 1879, Mary Cassatt, Forain and Zandomeneghi; and the group around Seurat.[55] This last group seems to have been the result of a conscious effort to attain a particular identity and status. It is unlikely that Seurat himself was active in these machinations — he was a 'guest', and lacked the temperament of a negotiator — that task fell to Pissarro. According to Signac's recollections, Pissarro failed to persuade Degas to accept Angrand and Dubois-Pillet, but managed to secure a single room for himself, his son Lucien, Seurat and Signac,[56] painters whose recent work now had identifiably shared characteristics: a small, regimented touch, an increasing tendency to simplify forms, and the division of tone. To exhibit their works together was a gesture of community, and the identity of this new group was dominated by the example of Seurat, still only twenty-five.

Seurat achieved this status because in his recent work he had established a model for a new manner of painting. This formula was most apparent in *La Grande-Jatte*, much the largest canvas in the exhibition and the centrepiece of the new group's hang. It was exhibited with three marines painted at Grandcamp in the summer of 1885, two of which — *The Bec du Hoc* (Plate 161) and *The Roadstead at Grandcamp* (Plate 162) — hung either side of the large painting.[57] Seurat also showed a smaller canvas (Plate 100) and a panel depicting (Plate 47) riverside suburban subjects, as well as three drawings, one of an interior (Plate 79) and two representing travelling entertainers.[58] This was a carefully calculated selection on his part: biased towards recent work, varied in scale and medium, and providing a synopsis of the subjects now foremost in his mind.

6 La Grande-Jatte, the 'Manifesto Painting'

The preparatory work

After the exhibition of *Une Baignade* Seurat began work on his next major project. According to Signac, for some six months Seurat went daily to the Grande-Jatte, an island (or eyot) in the river Seine to the north-west of Paris between Clichy and Courbevoie (see map, Plate 120)[1]; as the preliminary studies and final picture all show fine weather one might assume, say, June to October 1884. The letter Seurat drafted to Fénéon in June 1890 (see Appendix I) gives an approximate chronology: it mentions that a study (Plate 102) was exhibited at the Indépendants in December 1884, continues "1884–1885. Grande-Jatte composition. 1885 studies at the Grande-Jatte and at Grandcamp", and mistakenly adds that the main canvas was taken up again in October 1886. Another version is fuller and probably more accurate:[2] "1884, Ascension day: Grande-Jatte, the studies and the *picture*" (Seurat's emphasis). No doubt Seurat was so specific about dates in order to establish the priority of his researches. In·claiming that work on *La Grande-Jatte* itself (Plate 118) began in late spring 1884 — Ascension Day fell on May 22 — Seurat was attempting to fix its inception as early as he could, hard on the heels of *Une Baignade*. He seems to have exaggerated. A project as complex as *La Grande-Jatte* needed extensive preliminary work before the canvas could be properly started, and, as we shall see, the internal evidence of the preparatory studies points to a more graduated development than Seurat implied. The canvas was ready to be shown at the second exhibition of the Société des Indépendants, planned for March 1885, but this was cancelled. The letter continues that the canvas was reworked after the trip to Grandcamp in 1885 and exhibited in May 1886. Within this pattern it is feasible to construct some approximate guidelines for the intricate genesis of *La Grande-Jatte*, without attempting the impossible task of establishing precisely in what order the preparatory drawings and paintings were executed.

While similar in some ways to *Une Baignade* — the subject-matter drawn from the north-west suburbs, the figures arranged in a riverside landscape — Seurat's new project was more ambitious. It would have a larger staffage and, in contrast to *Une Baignade*, would be structured around groups. And, as we shall see, these figures were to carry amplified meaning. Seurat therefore paid even more scrupulous attention to the preparatory procedure. Three subsidiary canvases were used, and some thirty panels produced, along with about twenty-six drawings.[3] Despite the intensity of this preparation and the size of the final painting — almost the same as *Une Baignade* — the project was executed with speed. Given that it was ready to be shown by March 1885, Seurat had completed a canvas of two by three metres, with some fifty figures, in less than a year.

Once more Seurat began with oil sketches painted on small panels *in situ*, as he attempted to fix his motif. It was the method that had served him well with *Une Baignade*, and it was again effective, for the evidence of the surviving *croquetons* suggests that he was soon able to establish the essential configuration of the landscape. The *View of the Background with Several Figures* (Plate 101) is one of this group of sketches, painted presumably during the late spring or early summer of 1884. Its mixture of horizontal and *balayé* strokes is reminiscent of the *Baignade* panels of the previous year, but in general the touch is lighter and the depiction of natural forms looser, involving some informal integration of colour contrasts: yellow sunlight and violet shadows, for instance. With its shaded foreground and lit middleground, and its emphatic *repoussoir* tree to the right, the design closely obeys the conventional formulae of classical landscape. At this stage the figures played a minimal role as markers of scale and planes; they were executed in a summary fashion with no observation of detail. Half a dozen or more panels, all probably painted on the island, would appear to belong to this initial stage,[4] and they share similar characteristics: loose brushwork, zonal arrangements and casual placement of figures.

As Seurat's conception of the landscape became clearer he also began to use drawings to fix the motif. Two

101. Study for *La Grande-Jatte: View of the Background with Several Figures.* c.1884. Panel, 15.5 x 24.1 cm. New York, Metropolitan Museum (DH 117).

large sheets were made as detailed studies for the trees at the centre (Plate 103) and right (DH 620; private collection). The finest of these is the grand drawing now in Chicago, executed in a light touch with careful attention to shading. It is exact and specific; a vertical mark near the centre established the placement of a jetty contained in the final painting, and the main tree was diligently observed, especially the almost anthropomorphic undulations of its trunk and the twisting parting of its branches.

In December 1884 Seurat exhibited the first preparatory canvas (Plate 102; Whitney collection). In this painting the landscape was well on the way to resolution, and it is likely that the picture had been completed during the summer, the culmination of the early sketches made *sur le motif.* Seurat had earlier made use of strong contrasts of light and shade falling on the ground to divide recession into a series of planes; the *Horse and Cart* (Plate 39) is a case in point. The foreground of the Whitney canvas was forcefully divided in such a way, with the open swathe of grass halved by the sweep of shadow, which so effectively marked the frontal plane

that the *repoussoir* tree was no longer necessary. But in this landscape Seurat also contrived to attain the depth he wanted for his large painting — depth he needed to incorporate the large staffage required by the subject — and this was achieved in part by the picture's main diagonal, the river bank, but also by the corridor- or avenue-like effect that he orchestrated to rear right by a step-by-step disposition of light and shade reminiscent of previous panels such as the Rue Saint-Vincent (Plate 61).

As the landscape elements fell into place, Seurat increasingly turned his attention to the figures and their role in the scheme. The so-called *Petite Esquisse* ('Small Sketch': Plate 104), seems to mark the first of a series of concerted efforts to explore the complement of figures. Here the setting was informally treated, and certain poses and dispositions tried out. The *Petite Esquisse* indicates already that the final painting would have a profile emphasis, while a *repoussoir* feature would be provided by a tall standing figure to the near right; the classical discipline was to continue. General complementary colour relationships were respected, but the *Petite Esquisse* is a study of composition rather than colour, a

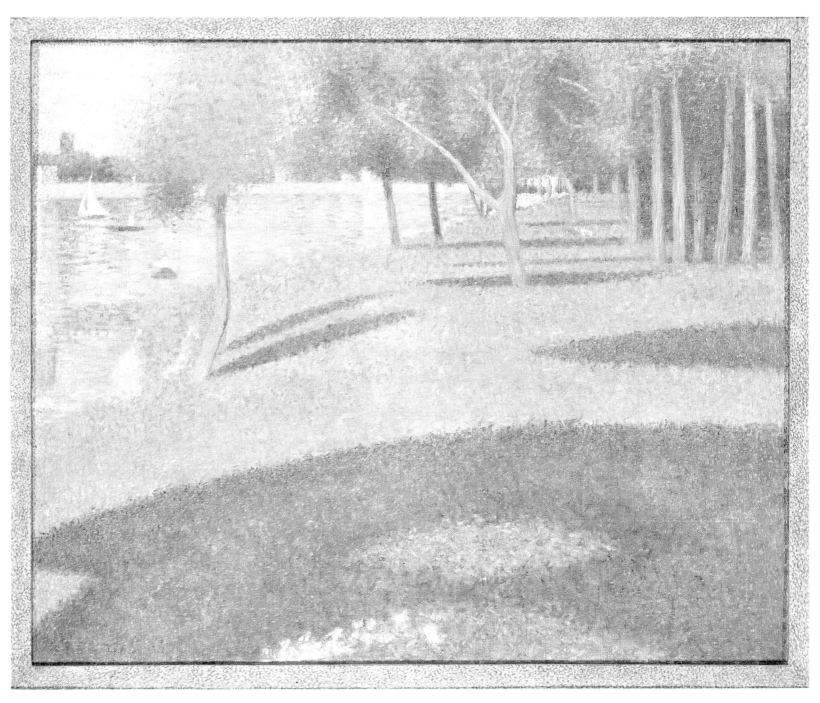

102. Study for *La Grande-Jatte: Landscape*. 1884. Canvas, 64.7 x 81.2 cm. Private collection (DH 131).

'rather tight and self-conscious studio painting'.[5] With other panels painted in the studio — such as *Centre and Left Sections* (DH 127; Zürich, Bührle collection) and *Centre, Middle Distance* (DH 121; Brookline, Cunningham collection) — Seurat moved closer to the complete arrangement.

Seurat's exploration of the figures involved also the increasing use of drawings and led him to modify his landscape. One sheet repeated the motif of the Whitney canvas, but adapted its arrangement slightly (Plate 105). If the figures were to be caught in profile they would need a wide stage, and this drawing increased the intervals between natural objects to give greater breadth. With this subtle alteration of format, and with the details of the shoreline, Seurat began to make final decisions. One crucial feature of this landscape drawing is that Seurat was establishing the fundamental proportions around which he would order his painting. Small marks on the edges of the sheet show that he intended the upper side of the foreground shadow — which in *La Grand-Jatte* itself lies on a Golden Section[6] — to act as a fixed element of the structure, and another mark on the top edge indicates the half-way point; the picture was to revolve around a horizontal Golden Section and a vertical bisection.

Seurat worked on the individual figures that were to fill this stage in both drawings and panels. From the outset he had intended to include the profile of a female

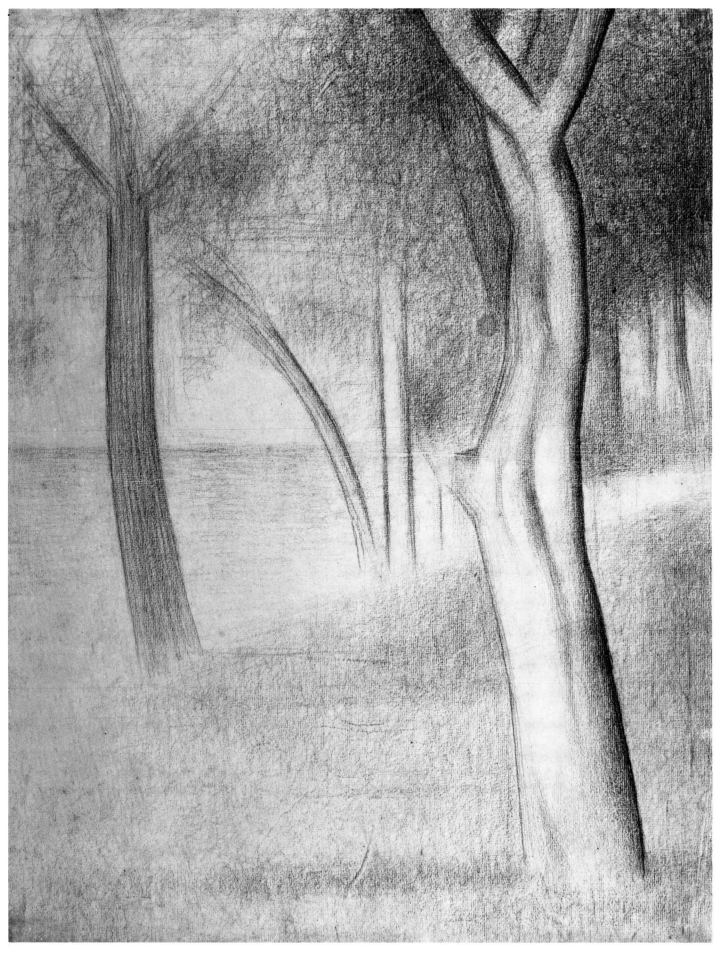

103. Study for *La Grande-Jatte: Trees on the Bank of the Seine*. *c*.1884–5. Conté crayon, 62 x 47 cm. The Art Institute of Chicago (DH 619).

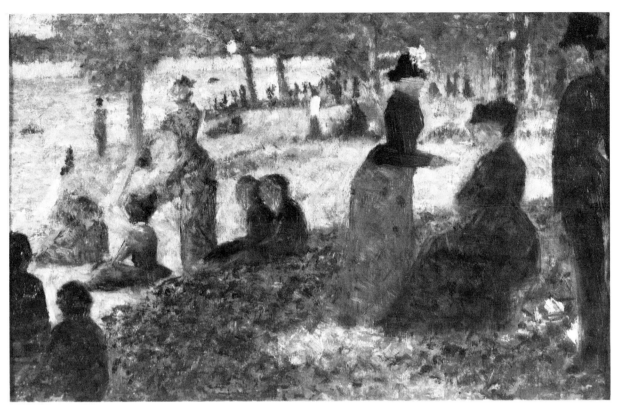

104. Study for *La Grande-Jatte: Petite Esquisse. c.*1884–5. Panel, 15.2 x 24.7 cm. The Art Institute of Chicago (DH 128).

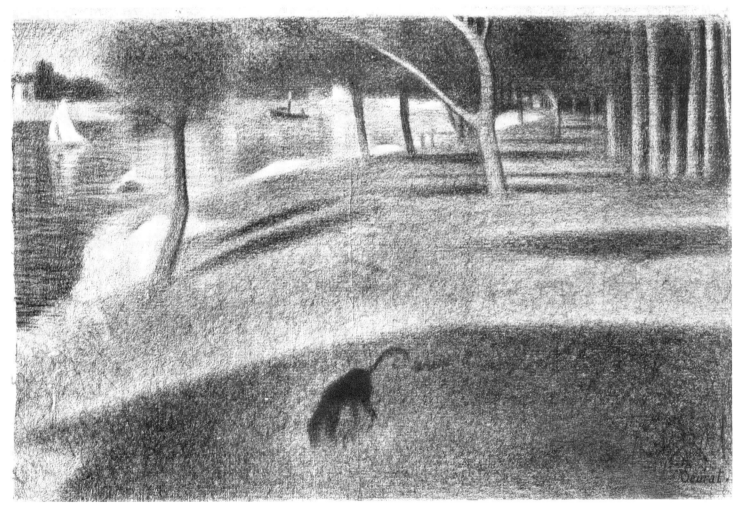

105. Study for *La Grande-Jatte: Landscape with Dog. c.*1884–5. Conté crayon, 40 x 60.2 cm. London, British Museum (DH 641).

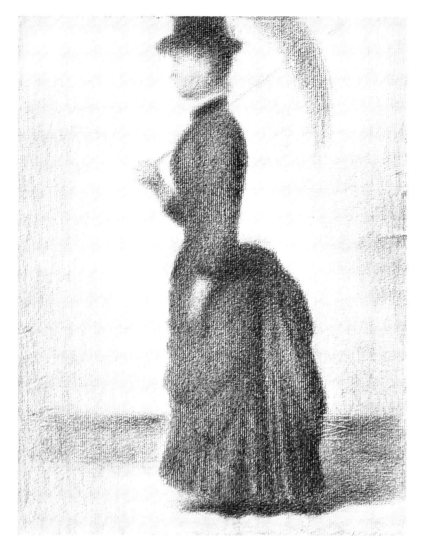

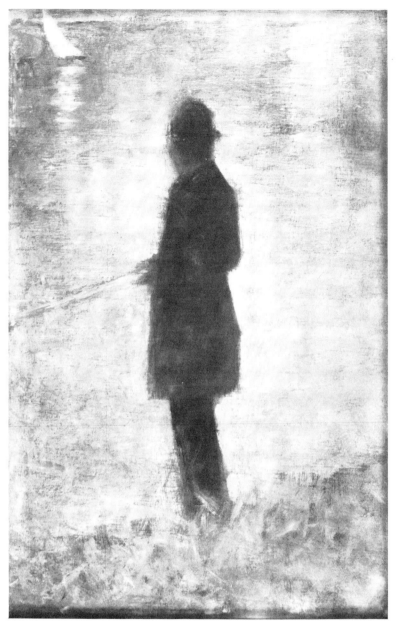

106. Study for *La Grande-Jatte: Woman with a Parasol. c.*1884. Conté crayon, 41.2 x 24 cm. New York, Museum of Modern Art (DH 625).

107. Study for *La Grande-Jatte: An Angler. c.*1884. Panel, 24 x 15 cm. London, Lady Aberconway (DH 115). Probably intended for *La Grande-Jatte*, but discarded prior to the *Esquisse d'Ensemble*.

figure in a fashionable bustle — this was noted as early as the *View of the Background* (Plate 101) — and several early drawings (Plate 106: DH 623; Paris, Rothschild collection: DH 624; Paris, Pellequer collection), perhaps dating from as early as mid-1884, investigate such a pose. All these sheets treat drapery very literally, and indeed one of them (DH 624) is a drapery study alone; such a procedure was, of course, standard academic practice.

These earliest figure drawings for *La Grande-Jatte* already suggest how Seurat would treat his personnel: individual facial features were not to count, clothes would signify role, class and status, frozen formality was to predominate. It seems that the earliest painted figure studies were for those who would populate the riverbank: a very sketchy panel of a man and woman angling (DH 114; Indianapolis Museum of Art), one of a woman (DH 113; formerly Von Hirsch collection) and another of a man fishing (Plate 107). These would undergo sub-

stantial transformation before the picture was completed; the female figure would, via a drawing (Plate 108), become one of the most sophisticated and detailed of the whole staffage, and the man would cease to be an angler and become instead a solitary spectator of the river traffic. Much more work needed to be done on the figures, not only on their placement and grouping but also the associations of their identities, interrelationships and accessories.

Seurat refined his earlier compositional ideas in a canvas that largely prefigured the final picture, now referred to as the *Esquisse d'Ensemble* (Plate 117). While no absolute date or place in the preparatory sequence can be established for this painting, it is perhaps most likely that it was painted after — possibly not long after — the Whitney canvas (Plate 102), thus late in 1884. The *Esquisse d'Ensemble* goes further than the landscape in the breadth of its *balayé* stroke and in the use of colour contrasts, and in both these elements it prepared the

ground for the final painting. *Balayé* strokes were used over the whole *Esquisse*, even the figures, with the exception of some vertical touches in the tree trunks and horizontal marks used for about half the surface of the water. The colour relationships were developed further too, to gauge their suitability for the main picture. The zonal arrangement of local colour decided in the landscape canvas was retained, but the *Esquisse* incorporated within it a much more sophisticated respect for colour relationships in both the light and shade, establishing contrasts that would remain much the same in *La Grande-Jatte* itself. The *Esquisse d'Ensemble* is a bright painting, the strongly lit areas such as the grass treated in intense local colour — various mid- and light greens — touched with pale blue and muted orange; the deeper green patches of shaded grass were dabbed with dark

and mid-blues, and violet. The *balayé* of the figures was also interwoven with strokes of complementary colours; thus the local deep blue and violet of the couple at the right were infiltrated by orange marks. The *Esquisse d'Ensemble* served both the conventional academic purposes of the oil sketch to register the chief colour relationships and to identify the fundamental composition structure. In it Seurat also mapped out the complement of figures for the first time. Nevertheless, there were still many adjustments to be made between this preliminary canvas and the completed *Grande-Jatte*, changes that involved probably the most intense period of drawing.

The drawings made at this late stage in the preparatory process were, of course, all executed in the studio, with the possible exception of five sheets of studies for

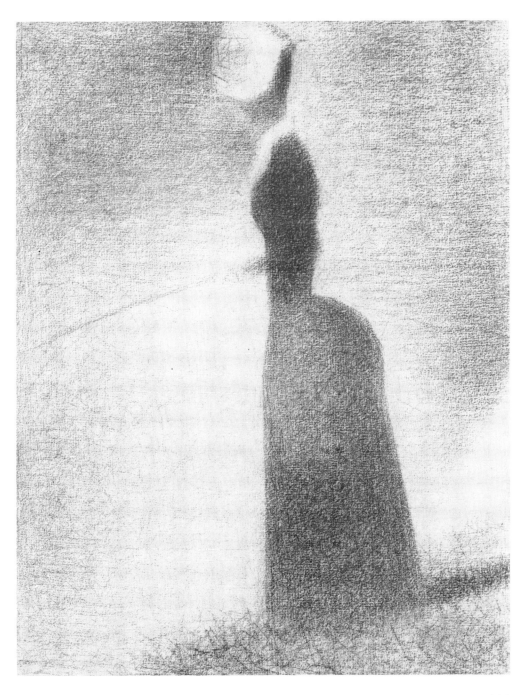

108. Study for *La Grande-Jatte: Woman Angling*. *c*.1884–5. Conté crayon, 30.7 x 23.7 cm. New York, Metropolitan Museum (DH 635).

109. Study for *La Grande-Jatte: Seven Monkeys. c.*1884–5. Conté Crayon, 30.2 x 23.3 cm. Paris, Louvre (DH 639).

the monkey, which may well have been drawn at the Jardin des Plantes[7] (Plate 109). All the drawings were made with a particular placement within the overall conception clearly in mind, and even sheets which appear to depict isolated figures were not without indications of their situation within the whole. This is the case with *Seated Young Woman with a Parasol* (Plate 110), a study for the central seated figure, which includes a light band of shading adjacent to her bust that corresponds to a shadow on the grass in the landscape. The delicate tonal modelling and disturbing, almost spectral anonymity of this figure recur in *The Child in White* (Plate 111), also from the middle of the picture, and once more the drawing does not merely focus on the representation of an individual but also on contingent elements, here the mother whose hand the child clasps and again shaded areas to which the figure will relate in the final painting.

The drawings made at the later stages have different qualities from those made earlier, notably an increased simplification. This is apparent in *Man Standing by a Tree* (Plate 112), which contrasts abruptly with the greater naturalism of previous landscape drawings, such as the sheet of trees now at Chicago (Plate 103). *Man*

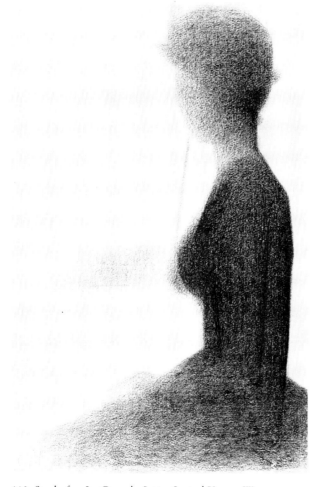

110. Study for *La Grande-Jatte: Seated Young Woman with a Parasol. c.*1884–5. Conté crayon, 47.7 x 31.5 cm. New York, Museum of Modern Art (DH 629).

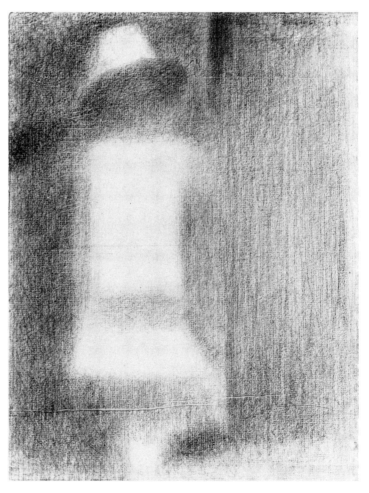

111. Study for *La Grande-Jatte: The Child in White. c.*1884–5. Conté crayon, 30.5 x 23.3 cm. New York, Guggenheim Museum (DH 631).

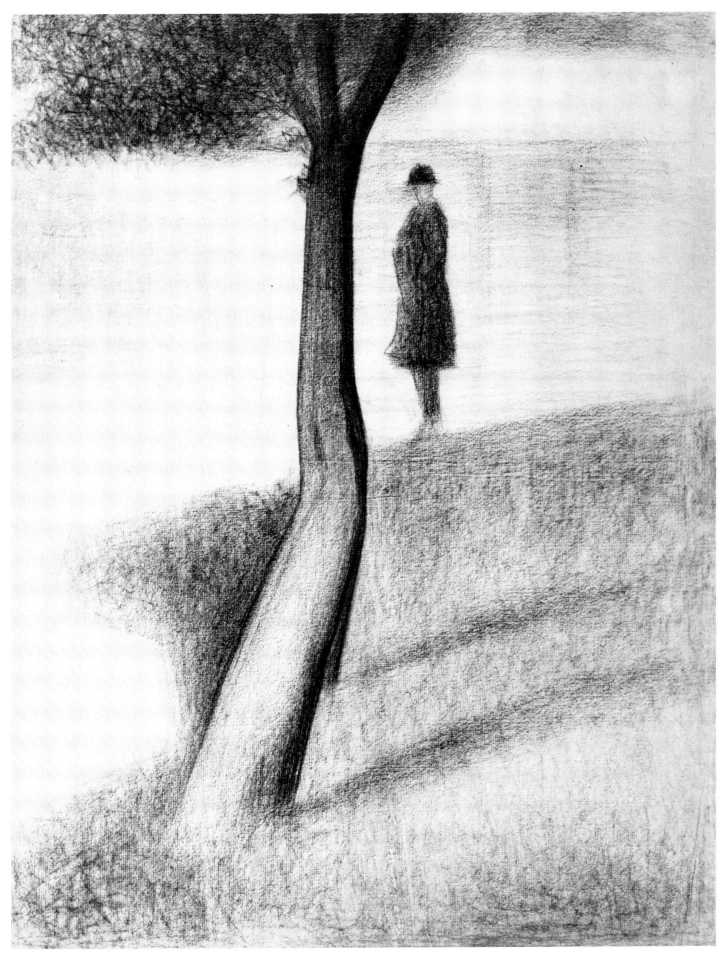

112. Study for *La Grande-Jatte: Man Standing by a Tree*. c.1884–5. Conté crayon, 61 x 46 cm. Wuppertal, Von der Heydt Museum (DH 616).

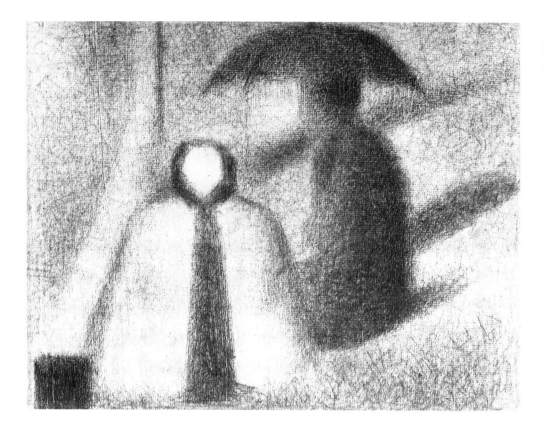

113. Study for *La Grande-Jatte: La Nounou (The Wet Nurse)*. c.1884–5. Conté crayon, 22.9 x 30.5 cm. Buffalo, Albright-Knox Art Gallery (DH 630).

Standing by a Tree gives further evidence of the complexities of Seurat's compositional manoeuvrings. Possibly executed prior to the *Esquisse d'Ensemble*, the sheet shows twin shadows cast by two tree trunks. While in both the *Esquisse* and *La Grande-Jatte* itself there is only one tree on the shore at the left, the two shadows were retained because they aided the illusion of the bank sloping down towards the river. This drawing must have come into play between the two paintings, for this lone figure — reminiscent of the earlier *Angler* (Plate 107) — did not occur in the *Esquisse* but does appear in the final painting.

La Grande-Jatte was the first substantial painting by Seurat in which groups of figures had a major role, and several drawings and paintings were executed to investigate the way they would interlock within the composition. The *Esquisse d'Ensemble* had established that beneath the tree to the left would be seated a wet-nurse and her companion. A common figure from the earlier drawings of types, the nurse, although schematically treated, was recognizable by the ribbons on her bonnet. But the drawing for this group (Plate 113) carried the conception much further, tidying up the two figures, giving them greater presence, marking on the nurse's back the precise tonal shifts and the fall of the ribbon that could be transferred intact on to the main canvas. The group was also carefully situated in relation to its neighbours in the design; the shadows on the ground were scrupulously noted, and the black square to the lower left of the sheet is in fact the top hat of the man seated closer to the frontal plane.

Two other drawings of groups served the right side of the picture. The sheet now at Northampton, inappropriately catalogued by de Hauke as *Les Jeunes Filles* (Plate 115), in fact represents the two seated women and the little girl to the extreme right, and it was the group's third incarnation. The motif of the original panel (DH 129) was transformed by the inclusion in the *Esquisse d'Ensemble* of the standing couple in the foreground, and this drawing set out to specify the relationship between these two units of the composition. To the left of the drawing the standing woman's back and bustle act as a kind of buttress, behind which are ordered the pram and the three figures, arranged with more space between them than in the *Esquisse*. Another change from the preliminary canvas is the inclusion in the drawing of an open parasol, which also intrudes into the final painting.

The most significant example of these drawings of groups must be *The Couple* (Plate 116). Once more it is impossible to ascertain whether the drawing came before or after the *Esquisse*: possibly immediately before, given the absence of the accessory of the monkey and a heavier handling of the conté crayon than on the very latest sheets. Nevertheless, *The Couple* played a vital role in the final preliminary stage because, marked for enlargement, it was almost a cartoon for the right side and is intimately related to the third preparatory canvas, *The Couple and Three Women* (Plate 114). In the drawing the landscape is lightly but precisely defined, and the emphasis is on the two promenaders who were to be crucial to the composition — and to the meaning — of the final painting: acting as a *repoussoir* on the right, establishing immediately the sequence of parallel planes that were to dominate the entire design,

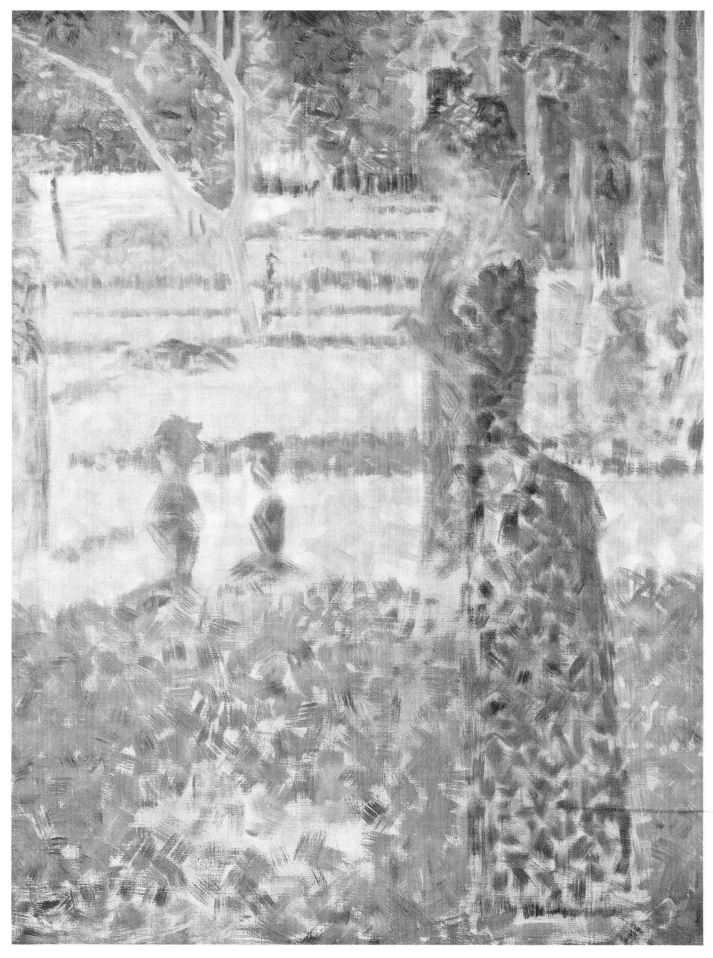

114. Study for *La Grande-Jatte: The Couple and Three Women*. *c.*1884–5. Canvas, 81 x 65 cm. Cambridge Fitzwilliam Museum, (on loan from the Keynes Collection, King's College, Cambridge) (DH 138).

115. Study for *La Grande-Jatte: Two Women and a Girl. c.*1884–5. Conté crayon, 23.3 x 30.5 cm. Northampton, Mass., Smith College Museum of Art (DH 633).

and insisting on the spectator's attention. Seurat marked the drawing at measured intervals on the left, right and lower edges, dividing the sides into four and the bottom into three equal sections. He squared up a larger canvas according to these divisions and on it painted *The Couple and Three Women*; the squaring is still visible beneath the loosely applied, slab-like brushwork. The squares Seurat measured out corresponded to half-metre units on the final canvas, and he adapted the natural elements of the landscape to relate to these proportions, for the lower rim of the patch of shade on which the two women and child sit at the extreme right comes exactly midway down the vertical edge of the picture. Equally the verticals of this system run through three emphatic axes: the figures of the central woman with the child, the right-hand seated girl (with a posy in the final picture), and the female promenader on the gentleman's arm. This canvas, simply executed around a colour range of the three primaries and three complementaries, represented the resolved right-hand side, the penultimate step from which the main canvas could be completed.

Although Seurat claimed to have begun work on the main canvas by May 1884 he can hardly have started even the initial lay-in of broad areas of local colour until the Whitney canvas was completed, and it may be safest to suppose that the large painting only got underway over the summer. During the months that followed Seurat worked on arrangements of figures, perhaps interspersing this procedure with bouts of work on the major painting as individual motifs or passages became more resolved. The final few months before *La Grande-Jatte* was ready for the Indépendants in March 1885

would in all likelihood have been spent on the main canvas itself, and it is to the execution of the final painting that we must now turn.

The painting itself

Seen from a distance *La Grande-Jatte* (Plate 118) gives an illusion of deep space, despite the right-to-left configuration of the foreground. Seurat achieved this sense of space in several ways. First, he placed the spectator in a foreground of deep shadow, and the eye is drawn into the picture stage by stage, in a dark–light progression that gradually leads into a light, bright distance. Second, he concentrated the movement in the distance, the boats on the river or the couple strolling to the upper right, and this contrasts with the foreground planes, which are predominantly still, and with the centre, which is pulled closer to the spectator by the advancing couples of the mother and child and the two soldiers. The little girl in white followed Corot's prescription of a light accent in the centre of a picture.[8] Third, the little girl's mother, situated almost exactly on the central vertical axis, acts as the meeting point of two vital diagonals — one running from the group in the left foreground to the couple strolling into the distance at the right, the other from the pair of promenaders at the lower right, via the man playing the horn, to the lone figure standing on the bank — which emphasize the thrust into depth.

The balance between horizontal foreground planes on which the predominant figures are sited and diagonals

116. Study for *La Grande-Jatte: The Couple. c.*1884–5. Conté crayon, 31.3 x 23.8 cm. London, British Museum (DH 644).

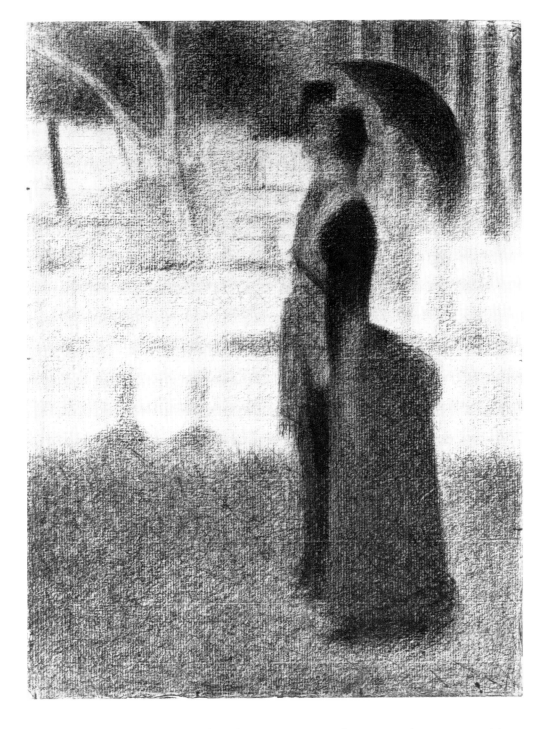

leading into depth, combined with a strongly lit middle ground, belonged to the well-tried canons of the classical tradition. Given the reliable compositional formula and intensive preliminary work, it is curious to find disjunctions of scale in *La Grande-Jatte*, problems particularly apparent when the painting is seen from a distance. These occur in the figures, not in the landscape. The spectator's attention is regulated by the right-hand couple, the central mother and child, and the three seated figures to left. The spatial disjunctions caused by these crucial groups disturb the picture's cohesion. Accepting that the relationship between the right couple and the mother and child are correct, one senses that the two groups behind and to the left of the latter pair — the wet-nurse and her partner, the woman fishing and

her friend — are too small. Again, there are problems within the left-hand foreground group: the top-hatted man appears either too small, or too near the other man and woman.

Problems of relationships of scale were already present in the *Esquisse d'Ensemble*; the woman fishing at the left is ludicrously small compared to the horn-player or to the soldiers in planes further back. Seurat was clearly aware of this as he painted it. The sketch has in places been reworked to compensate for these flaws; for example, the hat of the woman seated to the lower left was repainted to give the figure more height. But despite the example of the *Esquisse* and the subsequent drawings, spatial problems persisted in *La Grande-Jatte* itself. An explanation for this lies in the fact that in his

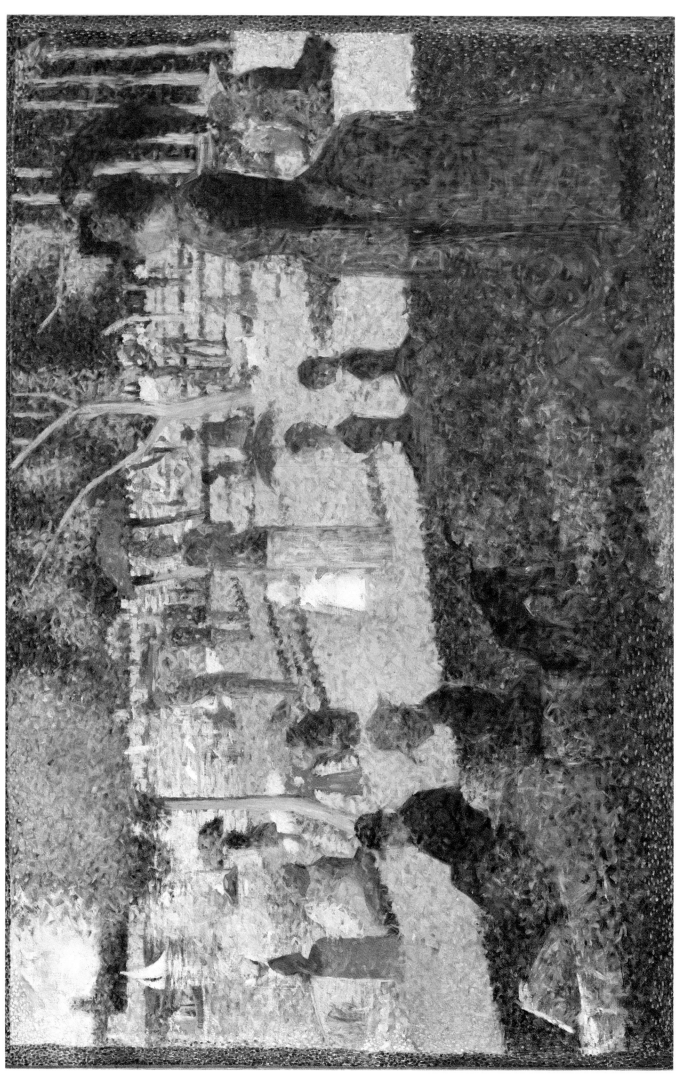

117. Study for *La Grande-Jatte: Esquisse d'Ensemble*. c.1884–5. Canvas, 68 x 104 cm. New York, Metropolitan Museum (DH 142).

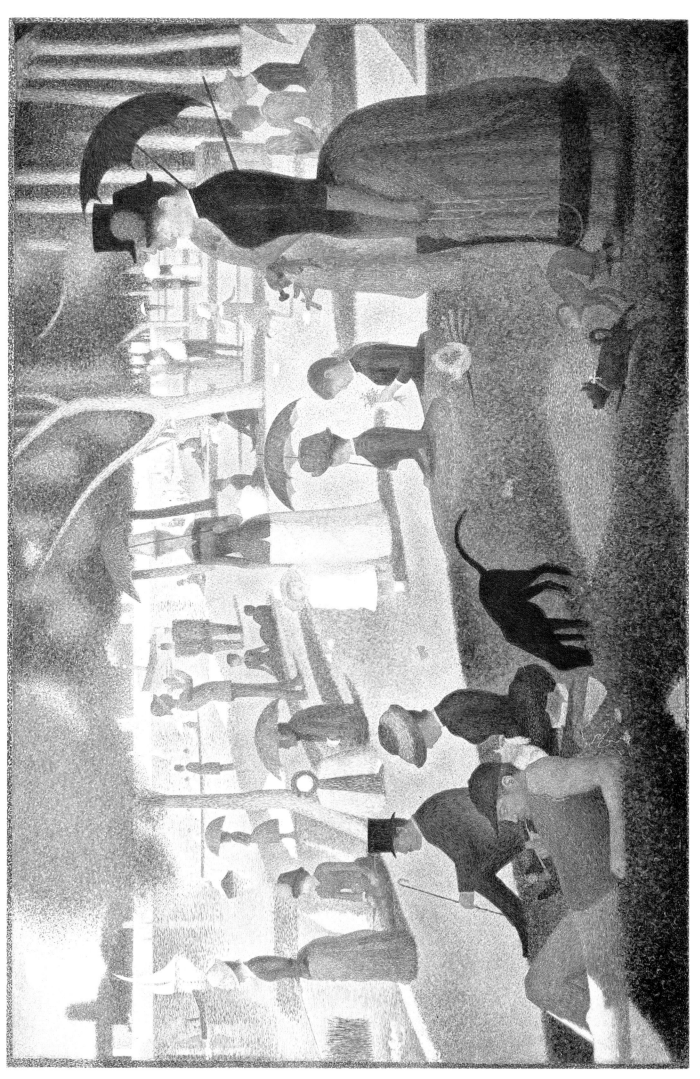

118. *Un Dimanche à La Grande-Jatte* (1884): *Sunday on the Grande-Jatte* (1884). c.1884–6. Canvas, 225 x 340 cm (without later addition of painted border, 207 x 308 cm). Chicago, The Art Institute of Chicago (DH 162).

preparatory work Seurat employed measured squaring only for selected figures or groups, notably for the couple on the right. Other figures he seems to have slotted into the ensemble (whether he had drawings for them or not) on the assumption that once the important figures were fixed the design would work. The figures for which there are drawings — the right-hand couple, the central dark dog (DH 642; Paris, private collection), the seated woman to lower left (DH 632; New York, Stern collection), the wet-nurse, and the woman fishing — coexist in precise relationships of scale. Where a relationship occurs between a drawn figure and one for which there is no (existing) drawing, disjunctions crop up; an instance of this comes between the seated woman and the top-hatted man to the lower left. When relationships of scale and space had not been preconceived in drawings, and when Seurat left these to chance, there were inconsistencies.

It is perhaps significant that Seurat made drawings for all the main figures in the right half of *La Grande-Jatte*; some appear in more than one sheet, or in *croquetons*. The right half was the section of the painting that had been measured, founded on a preparatory canvas squared to correspond to half-metre units on the final painting, and involved the supplementary proportion of the Golden Section, which ran along the upper limit of the foreground shadow. None of these proportions or measurements apply to the left-hand half of the painting, for which there is only a handful of drawings and no equivalent 'cartoon', either painted or drawn, to establish the composition. Thus the majority of the spatial disjunctions and abrupt leaps of scale occur on the left of *La Grande-Jatte*.

A plausible explanation for this would be that Seurat actually began to paint on the left-hand side, an explanation supported by the rapidity with which the shoreline was decided in the early panels, and by the extremely delicate and detailed execution of the woman fishing, which does not tally with the more simplified handling of comparable figures. The discipline imposed on the right half could then be seen as an antidote to the more haphazard approach to the left, applied as the painting progressed. Seurat's youth — he turned twenty-five in December 1884 — and the speed at which he worked on the picture must also have contributed to these flaws. Furthermore, *La Grande-Jatte* was apparently painted in a small studio, and he may not have found it easy to judge the overall effect of the large canvas while he worked. This problem, as well as the suggestion that the small touch was out of key with the painting's size, was articulated as early as February 1887, when *La Grande-Jatte* was exhibited at Les Vingt in Brussels. Signac wrote from there to Pissarro that '... one senses that this large canvas was executed in a small room without space to stand back'.[9] It would be wrong to argue that the perspective and spatial distortions were part of Seurat's deliberate programme for *La Grande-Jatte*.[10] On the contrary, they were the result of accidental, even ex-

ternal, pressures. This is not to say that they were without effect on the nature of the picture, and not just of its design but also of its meaning. For the flaws in *La Grande-Jatte* are intrinsic to its character as a painting made under pressure, a painting demanding constant development and recasting, and these changes involved *La Grande-Jatte's* imagery and signification as much as its painted surface.

The cancellation of the Indépendants show in March 1885 meant that the haste had been in vain. *La Grande-Jatte* was temporarily shelved. During mid-1885 Seurat worked on other, smaller paintings, on the more modest scale of the easel picture. *Lucerne at Saint-Denis* (Plate 62) probably dates from this time, as does *The Seine at Courbevoie* (Plate 100). In addition to these two motifs from the Parisian suburbs Seurat travelled to the Normandy coast during the summer, and from his successful visit to Grandcamp brought back twelve panels and five substantial canvases of marine subjects. 1885 was not a fallow period in Seurat's work. Not only did he begin to discover his extraordinary sensitivity to the subject of the sea, but he also developed an even more sophisticated notation of colour and a more exact handling to accompany it.

Although Seurat's progress was particularly stimulated by his work on the marines — the Grandcamp paintings will be discussed in Chapter 8 — it is evident that his main interest at this time was the refinement of colour and touch. *The Seine at Courbevoie*, for instance, painted from the Grande-Jatte looking towards the suburban villas of Courbevoie, was executed with a variety of small marks, creating an intricate mesh of greens and blues, violets and oranges. To exploit this refinement of vision and touch Seurat returned to *La Grande-Jatte* in October, after his trip to Grandcamp, perhaps in expectation of a forthcoming exhibition. There is no evidence, however, either from Seurat's letters or from examination of the picture itself, that *La Grande-Jatte* was completely reworked between this time and the Eighth Impressionist Exhibition, that is over the winter of 1885–6. In at least two drafts of his 1890 letter to Fénéon[11] his use of the word 'reprise' (taken up again), rather than the more thorough-going 'repeinte' (repainted), suggested that the picture was retouched to accord with his recent progress, and not substantially overhauled as some have asserted.[12]

Internal evidence proves that revisions to the painted surface undertaken at this time were only partial. The surface of *La Grande-Jatte* is matt and dry, though not as chalky as *Une Baignade*. Seurat applied the paint quite thinly, and this is especially apparent where the original layer remains largely untouched, for example in the lower left area of the water, where the weave of the canvas is visible. The stage the painting reached by March 1885 is readily decipherable on close observation of the canvas. The paint was put on in small touches and dabs that varied from passage to passage. The white wall in the background was painted in dry dabs on a light

ground, for instance, while the river was executed in inch- or inch-and-a-half long horizontal marks using a loose system of complementaries; thus the water is predominantly in pale and mid-blues and mid-green, with additions of pale pinks and dull yellows. The grass and the foliage were treated broadly and flatly in local colour, with a light *balayé* overlay that was more pronounced in the trees and shaded grass. At this first stage it would appear that there was little complementary activity in, say, the grass: some very muted oranges and yellows in the lit areas and violets in the shaded patches.

The figures were painted flatly in local colour and then overlaid with a controlled stroke of similar length to the touches in the water. However, the brushmarks in the figures were frequently applied vertically, or at least following the direction of the figure's limbs or drapery, so the trousers of the man reclining to the left are in horizontal strokes, and the sweeping material on the skirts of the main female are in touches that follow their fall. Complementary colours were used in a muted fashion. The skirt of the central woman with a parasol was executed essentially in pink, with blue used in the shadows and some pale olive green mixed with the pink. The skirt of the standing woman to the right was in deep blue-violet, originally with an admixture of pale orange.

In the reworking large areas, in particular the river and foliage, were left unaltered except for small passages. Some patches of grass — to the left of the little girl in white, for example — were also little changed, though much of it was lightly retouched, while the tree trunks and figures were worked over with some thoroughness. The revision was not done entirely with a dotted stroke, or even with marks of equal size or weight. The shaded area of the small tree to the left was retouched in open-spaced *balayé*, the face of the seated foreground woman in small dots, the grass in larger and more openly spaced dots, and the tree trunks in thinly spread dots lightly applied. In order to compensate for the extra visual activity that this reworking required, Seurat had to fill out some of the forms. The edges of the skirts of the woman fishing, the central woman with the parasol and the standing woman to the right were all expanded, and so was the belly of the dark dog.

The retouching of the grass did not add much to the activity of the complementary colours. Around the woman fishing, for example, only a few dots of blue and red were interspersed with the local greens. Complementary relationships were especially enhanced on the figures, where they were already at their most involved. Seurat contributed further touches of red and green to the trousers of the reclining man, where these colours were already present. The skirt of the woman to the right had its orange elements reinforced, and reflections of this orange were incorporated into her trailing arm and on to the man's jacket by her belly. Seurat thus revised *La Grande-Jatte* so that it incorporated his recently developed ideas on colour and the touch pioneered to articulate them.

Félix Fénéon published the first account of these ideas in his review of the Eighth Impressionist Exhibition,[13] and as it seems he first met Seurat at the exhibition itself,[14] he may well have been transmitting the artist's own views directly. Fénéon's article explained the system on which the application of colour outlined above was based. First Seurat applied the local colour to a given area, and then registered on it the effect of coloured light (sunlight) in pure oranges and yellows, the painter's closest approximation. There would be more colour activity in shaded areas, including the much weaker effect of the sunlight and the blue and violet of shadow. The artist also observed the reflection of one colour on to an area of another. Next would come the full interrelationships of complementary colour, with the painter juxtaposing complementaries to exaggerate their differences (simultaneous contrast) and to induce the after-effect in the eye of their colour opposite (successive contrast). By such contrasts, and the irradiating 'haloes' around their borders that these generated in the eye, the artist would be able to lift forms such as figures away from their background. At the same time, owing to the vibration stimulated in the viewer's retina by the colour reactions, he could give as accurate an effect as possible of the natural activity of light as the artifical means of oil paint would allow, and unify the picture by the interplay of colours consistently observed.[15]

The reworking of *La Grande-Jatte* was not done solely with a dotted touch, as we have seen, but Seurat came to favour working with a 'point' — although it might vary in size or weight — because such a stroke facilitated the expression of his increasingly sensitive observation of colour reflections and complementaries. A handling that kept each touch separate ensured that each unit of colour was clean, undiminished by direct mixing with its neighbours — as might occur in a canvas by Monet, for instance — while positively affected by its optical interrelationships. To Fénéon the dot was thus an 'improvement' on the more spontaneous, improvisatory touch of the Impressionist landscape painters, with whose work Seurat would have been more fully acquainted by 1885; he knew Pissarro personally by then, and the Grandcamp paintings display certain knowledge of recent work by Monet.

However, it would be exaggeration to insist that the use of the dot was a logical reaction to Impressionism. Seurat's handling of paint had developed in tandem with his ideas on the application of colour, and these ideas can be traced to his student days. The appearance of the dot on the revised surface of *La Grande-Jatte* was the outcome of a long-rehearsed programme. Small separate touches of paint had been recommended in Charles Blanc's *Grammaire*, and it was a procedure that could be found in Delacroix's painting;[16] both these fundamental sources of Seurat's study of colour had come under his scrutiny long before he knew of Impressionism. By his own account he discovered a dotted touch for the annotation of light in Murillo,[17] and there were other

Old Masters whose work he could have studied at the Louvre who also applied small dots of colour as lights: Vermeer, say, or Canaletto. Scholars have also suggested that awareness of the stippling technique of Japanese woodblock prints and the speckled, almost 'pointillist' surface of contemporary printing techniques (such as the chromotypogravure used in such popular periodicals as *L'Illustration* and *Paris Illustré* in the mid-1880s) may have encouraged Seurat to work with dot-like marks.[18] And it should not be forgotten that the close-knit texture of the paper on which he drew could also give an effect similar to the unified monotony of the pointillist surface. Hence there were multiple stimuli that might have provided Seurat with the dotted touch, and it would be foolish to isolate one.

Seurat's own recorded remarks — found in the 1890 letter to Fénéon — were concerned to establish the priority of his ideas and handling *vis-à-vis* his close associates Pissarro and Signac. He carefully insisted that of the three pointillist canvases Signac exhibited in May 1886, two had been painted within the previous couple of months, and the large painting of a milliner's shop, *Finisher and Trimmer* (Zürich, Bührle collection), had been modified 'in the manner of my technique' (see Appendix I).

If the application of colour was one of the most striking features of *La Grande-Jatte* when it was first exhibited, the other was its simplification of form, especially of the figures. Once more, this was a tendency in Seurat's work from the outset of his career, and one particularly stressed by his choice of a tonal style of drawing, rather than a linear manner better adapted to detail. And some of the early paintings, notably the figures made in 1883 in the vein of Puvis de Chavannes, showed a predilection for economical forms. For a large painting like *La Grande-Jatte*, especially one executed in a tidy touch, it was essential that there should be no intrusive detail, that forms should be ample and disciplined to the ensemble. It was for this ability to control the whole, to find 'la synthèse' (the synthesis), that Blanc admired Delacroix.[19] Seurat's preference for painting simplified, anonymous types demanded a synthetic depiction of the figure, and the reductive quality of his draughtsmanship was as much a part of the technical modernity of *La Grande-Jatte* as was the application of colour he so wished to promote.

In this tendency to 'synthesis,' to slightly awkward but emphatic contours around simplified forms, Seurat paralleled similar initiatives by other artists. Puvis was one. At the 1886 exhibition there were pastels by Degas and drawings by Pissarro showing similar stylistic features; Octave Mirbeau admired Degas's nudes for 'strength of synthesis, abstraction of line'.[20] Gauguin's work was heading in a similar direction, and Seurat had some sympathy for his powerful forms.[21] It was apparently Gauguin who passed on to Seurat, probably in late 1885 or early 1886, a copy of a manuscript ostensibly by the eighteenth-century Persian poet Vehbi

Mohamed Zunbul-Zadé, which, in its prescription of static poses and clarity of contour, gave a strong justification — rather than an inspiration — to a common direction.[22]

Critical reaction at the Eighth Impressionist Exhibition

If *La Grande-Jatte* was complex in its evolution and execution, its meanings were no less involved. Having little evidence about how the general public first reacted to the painting, we can best discover what it signified to contemporaries by turning to the critics, some twenty of whom had their say in May 1886. From their evidence one can begin to ascertain both the devices by which Seurat strived to organize a system of meanings and the extent to which these were comprehended at the time.

The first reviews to be printed, broadly speaking, were by critics in the daily newspapers, mainly professional journalists and people Seurat did not know; later came those in the periodicals and avant-garde journals, often written by friends or acquaintances. There is no doubt that *La Grande-Jatte* came as a shock. Ajalbert's first impression was one of surprise; Henri Fevre and Emile Verhaeren felt they needed to look at the painting a second time.[23] The written reactions were very varied. Some critics expressed instant dislike and incomprehension, such as the two whose reviews appeared the day after the exhibition opened; to Marcel Fouquier in *Le XIXe Siècle* the painting was a 'joke', to Firmin Javal in *L'Evènement*, 'a mistake, a flat pastiche of Miss Kate Greenaway'.[24] A couple — intriguingly enough Roger Marx and Gustave Geffroy — wrote generally appreciative reviews of Seurat's work but did not mention *La Grande-Jatte*.[25] Others immediately saw it as an important picture; Maurice Hermel in *La France Libre* referred to it as a 'manifesto painting' ('tableau-manifeste'), 'the banner of a new school', while Fénéon, explaining its technique, argued that Seurat was 'the first to put forward a complete and systematic paradigm of this new painting'.[26] Some were disconcerted by the picture, a response that must have been exaggerated by the hanging, for *La Grande-Jatte* was apparently hung in a room too narrow for its size.[27]

Most critics found some merit in *La Grande-Jatte*, even if they were ill at ease with it; all expressed considerable admiration for the marines and many commented favourably on the drawings. Several — especially friends in the later reviews — went to some lengths to describe the quality of the new technique's effects. Adam wrote of 'the beauty of the hieratic drawing, the accuracy of the yellow hues', Darzens of 'the effect of an intense and unified light', Ajalbert of 'a uniformity [of touch] in harmony with the method of drawing'.[28] Among such comments there was both recognition that Seurat's technique was able to meet conventional requirements — depth, aerial perspective — and an aware-

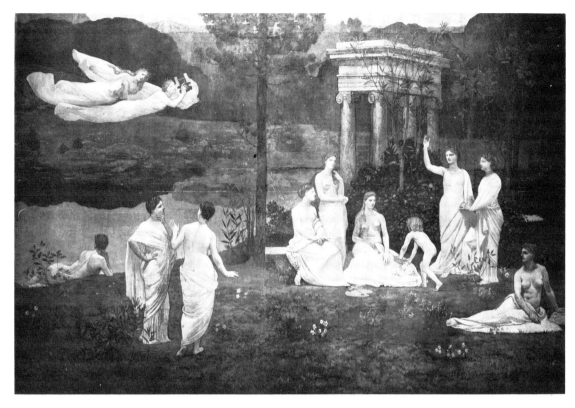

119. Pierre Puvis de Chavannes, *The Sacred Wood* (detail). 1884. Canvas.
Lyons, Musée des Beaux-Arts. Exhibited at the Salon of 1884.

ness of its novel features — synthetic drawing, disciplined lighting, controlled surface. But it was only Fénéon, in the longest and most informed account of *La Grande-Jatte's* colour structure, who claimed that the new method went beyond standard Impressionism, replacing the approach of 'directly painted landscape' with 'a deliberate and scientific manner'.[29]

The critics also addressed themselves to the subject of *La Grande-Jatte*, and a number of them, particularly those writing the later and more considered reviews, noted what they saw as an explicit consonance between the manner of execution and the picture's meaning. In the *Revue de Demain* Fevre, for instance, described his growing comprehension: 'little by little one familiarizes oneself, one guesses, then one sees and admires the great yellow patch of grass eaten away by the sun, the clouds of golden dust in the tree tops, the details of which the retina, dazzled with light, cannot make out; then one understands the starchiness of the Parisian promenade, regulated and stultified, where even relaxation is affected'.[30] The occasional comparison of *La Grande-Jatte* with children's toys and with primitive art — with Egyptian art, with Memling – was rather uncomplimentary in some reviews,[31] but in others sympathetic. Hermel, for one, was particularly acute in his description of the artist's search for 'the ultimate synthesis of the suburban stroller. An angler, an ordinary apprentice seated on the grass, are caught in hieratic stances like an ibis on an obelisk. Promenaders dressed up in their Sunday best in the shade on the Grande-Jatte take on the simplified and definitive character of a cortège of pharaohs.'[32] And Alfred Paulet, arguing in *Paris* that the draughtsmanship of the 1886 exhibition as a whole showed a dangerous tendency to flirt with caricature,

made a similar analogy in his perceptive account of *La Grande-Jatte's* subject: 'The painting has tried to show the toing and froing of the banal promenade that people in their Sunday best take, without any pleasure, in the places where it is accepted that one should stroll on a Sunday. The artist has given his figures the automatic gestures of lead soldiers moving about on regimented squares. Maids, clerks and troopers all move around with a similar slow, banal, identical step, which catches the character of the scene exactly, but makes the point too insistently.'[33] Citing just three critics, it becomes clear that, despite some wariness, intelligent contemporaries recognized that the way *La Grande-Jatte* looked was central to its signification, and their synopses marked much of the painting's range of meanings: the suburbs, Sunday, leisure, habits and behaviour determined by class, the identification of types, the codification of pose and fashion.

'A modernizing Puvis'

For some critics a crucial element of *La Grande-Jatte's* meaning was its overt classicism. Two reviewers recorded a very similar response to its ensemble; for Fevre it was 'something of a materialist Puvis de Chavannes', for Fénéon 'a modernizing Puvis'.[34] The painting probably reminded them of the stately figures and measured pictorial cohesion that Puvis de Chavannes had achieved in such pictures as *The Sacred Wood* (Plate 119), which had been exhibited at the Salon of 1884. Fevre's and Fénéon's response was perceptive — by 1886 Seurat's work was grounded in half a decade's dialogue with Puvis — but *La Grande-Jatte* existed in a more complex

relation to the older painter's work than had previous pictures. In a sense Seurat's modern figures and sub-urban setting were bringing Puvis's Arcadian glades, with their consciousness of classical conventions of design and subject, up to date. There might even have been an element of burlesque in this (as there had been when in 1884 Toulouse-Lautrec and his colleagues at Cormon's studio had dashed off a full-scale spoof of the *Sacred Wood*, with coarse contemporaries infiltrating the sylvan scene).[35] *La Grande-Jatte* might also be seen to improve on Puvis. Critics in the 1880s occasionally re-buked Puvis for oversimplified treatment of light and shade, for failure to incorporate reflected light,[36] and *La Grande-Jatte* was, from one point of view, the ap-plication of a sophisticated system of painted light to Puvisesque composition. Thus Seurat's painting took an ambiguous position of irreverent respect for Puvis: on the one hand caricatural, competitive, even corrective, and on the other adhering to its classical formulae. The remarks of Fevre and Fénéon hint at an understanding of this ambiguity.

One of Seurat's few reported statements was included by Gustave Kahn in his review of the Puvis show held at Durand-Ruel's gallery late in 1887. He quoted 'one of the young Impressionist innovators', who had ambitions to paint in the manner of the Parthenon Frieze: 'The Panathenians of Phidias formed a procession. I want to make modern people ... move as they do on those friezes ...'[37] Interestingly, a comparable undertaking had been made by Hippolyte Flandrin, whose murals in the nave of the Parisian church of Saint-Vincent-de-Paul (1848–53) were commonly known as the 'Christian Pan-athenians', and were still admired in the 1880s for their discipline and symmetry.[38] Just as Flandrin had painted a Christian frieze, so Seurat seems to have seen himself as a painter of 'modern Panathenians', extending the Hellenistic and also the recent classical tradition of Puvis and Flandrin into progressive painting. Whereas the classicism of *Une Baignade* was in many ways an inevit-able reflex after years of academic training, the classicism of *La Grande-Jatte* was a willed contribution to a re-cognizable and still vital tradition in French art, a deli-berate fusion of modern stylistic and classical compo-sitional features.

The title: 'Un Dimanche à la Grande-Jatte (1884)'

The title Seurat gave his painting is not merely descrip-tive, for each of its elements would have been deliberate-ly indicative of specific associations, which we must re-construct in order to understand *La Grande-Jatte* fully. It was entered in the catalogue of the Eighth Impres-sionist Exhibition under no.175 as *Un Dimanche à la Grande-Jatte (1884)* — Sunday on the Grande-Jatte (1884).[39]

1884

He may well have dated the painting '1884' to make clear that the new manner of painting it exemplified was his, to establish priority over Signac and the two Pis-sarros exhibiting with him. This, then, would mark the start of Seurat's public desire for priority and recog-nition of his status. If so the gambit was not wholly successful, for at least one critic — Javal in *L'Evène-ment*[40] — thought that Seurat was a follower of the better-known Camille Pissarro. Of course, 1884 was the year the painting was conceived, and in dating it thus Seurat was perhaps also justifying elements that were no longer up-to-the-minute — some of the fashions, say. It was in fact common practice among contemporary artists to involve a date in a title; Seurat's friend Séon, for example, had exhibited a water-colour at the Salon of 1880 entitled *In 1880*.[41] The device was usually to record a specific, significant event, such as Roll's huge *Four-teenth of July, 1880*, shown in 1882, but it was also used to specify more mundane social observation. One of Raffaëlli's paintings at his one-man show in 1884 was subtitled *Interior of an Elderly Petit Bourgeois Couple's House in 1883*;[42] here was precision about custom and class at a particular moment of modern existence, and it reminds us to see Seurat in terms of social specificity as well as stylistic innovation.

The only known remark of Seurat's directly relating to *La Grande-Jatte* was recorded by Signac fifty years later, when it was used to support the argument that subject was no great concern of Seurat's: 'In another vein I would just as willingly have painted the struggle between the Horatii and the Curiatii.'[43] But this remark might better be interpreted, on the contrary, as stressing the importance of subject-matter. Perhaps its implicit comparison of *La Grande-Jatte* and David's *Oath of the Horatii* (1784; Paris, Louvre) initially came to Seurat's mind because David's famous image had been painted exactly a century before, or because a similar subject — *The Oath of Brutus* — was the set subject for the Prix de Rome in 1884. Seurat seems to have meant that *La Grande-Jatte* belonged to the long tradition of history painting, with its commitment to the moral subject, in which he had been trained. And it may even be that Seurat chose the comparison with David's painting for deliberate ideological reasons, as it was well known that the *Oath of the Horatii* had deep-seated political meaning.[44]

THE GRANDE-JATTE

A vital element of the title was the particularization of the locale, the naming of the Grande-Jatte. Once more, this was hardly unusual, for landscape painters have traditionally identified their sites. This was especially true in the nineteenth century of those whose aim was naturalistic observation, as a glance at Monet's or Pis-sarro's entries in the catalogues of the Impressionist exhibitions shows. But Seurat, as we shall see, was not concerned with the minutiae of topographical accuracy.

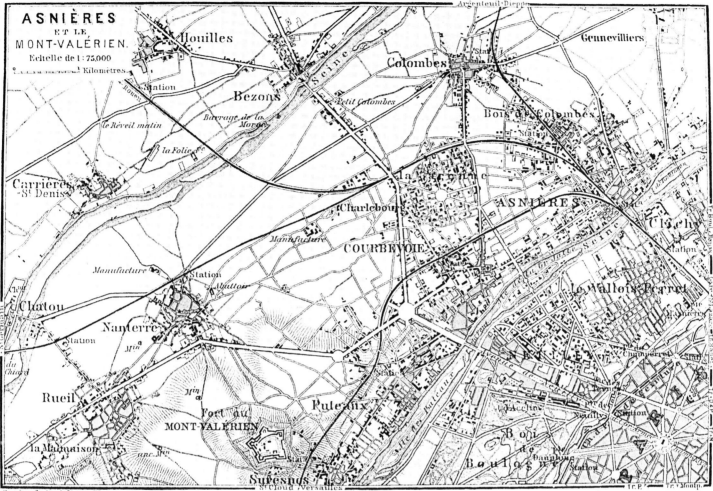

120. Asnières. 1881. From K. Baedeker, *Paris, Handbook for Travellers*, 1881 edn., opp. p.282.

Rather he was drawing attention to the associations that the island, its vicinity and the society which gathered on it would have for contemporary spectators of his painting.

The Grande-Jatte lies in the Seine where the river loops round to the west of Paris (see map, Plate 120). A thin spit some two kilometres long, it faces, on the right bank, Clichy and Levallois-Perret, and on the left, Asnières and Courbevoie. Asnières, depicted in *Une Baignade* and in many canvases by others in Seurat's circle during the 1880s, is situated on the left bank of the Seine to the north-west of the city. By the Second Empire it had won a great reputation as one of the leading centres for 'canotage', or boating, and in the 1860s and 1870s was considered among the favourite suburban haunts of the Parisian pleasure seeker.[45] This was made possible by its proximity to and ease of communication with the centre of Paris. About four kilometres out from the Gare Saint-Lazare, the station at Asnières was opened in 1837, and by 1890 some two hundred trains going to and from the city passed through it daily.[46] The reputation for boating lasted into the 1880s, and in 1886 Louis Barron picturesquely described the place: 'During the week, visitors to Asnières can easily be made out in the streets; it is an amusing spectacle, a motley mixture of correct, clean-shaven gentlemen, obviously actors; of bearded artists, wearing huge hats; of cute women in outlandish clothes; and even the occasional canoeist in a boater, flannels, and striped jersey, the outfit of the freshwater mariner. On Sundays, this fixed population of visitors is joined by a tribe of habitual nomads determined to have a good time. Then the rowing boats, skiffs, yachts, and canoes moored along the banks are untied, and, for the hundredth or thousandth time, it's off to explore Suresnes, Neuilly, the Grande-Jatte and the Ile des Ravageurs'.[47]

But, for all its charm and irony, this was a description almost of an earlier Asnières, for in the 1880s, like other Paris suburbs, it was a town in transition. In 1890 an inhabitant, Edmé Périer, disputed Barron's account, providing instead a more prosaic assessment and listing a population made up largely of people who worked in the city: 'landlords, retired people, Parisian businessmen, employees of the Railway Companies, Banks, civil servants from Ministries and important institutions. There are also many artists, journalists, and workers of all kinds of trade. Little manufacturing, but some market-gardeners and...some poor people.'[48] Asnières's population grew rapidly in the mid-nineteenth century; it stood at 925 in 1846, 5,455 in 1866, 8,278 in 1876, and

14,778 in 1886. It had thus almost doubled in the decade before *La Grande-Jatte* was shown, and by the late 1880s was a town of 3,481 houses and 10 factories.[49] However, Asnières had no heavy industry — its few factories and workshops made greenhouses, boats, mosaics, luggage; there was even a perfumery[50] — and its population was predominantly bourgeois, petit and middle bourgeois at that, rather than proletarian. There were some poor but, as Périer reported of the ragpickers squatting on the route d'Argenteuil, they would have to be moved on, for rising property prices made the land too valuable.[51]

Asnières's neighbouring suburbs seem to have had much the same character. Courbevoie, just upstream, was divided into two distinct sections, a busy commercial zone and, around the church along the Asnières road, smart houses and well-established trees.[52] Bois-Colombes's population was little different from that of Asnières — 'employees, tradespeople, artisans' — but the town itself had grown up recently to accommodate the city's overspill. In 1886 Louis Barron called it 'a vast and flat symmetry, monotonous and dry, with perfectly aligned boulevards, straight streets, regular squares, box-like houses, and carefully walled and railed plots of grass.'[53] Something of the dreary regularity of these *petit bourgeois* estates was accurately captured in Signac's *The Branch Line at Bois-Colombes* (Plate 121), exhibited in May 1886 in the same room as *La Grand-Jatte*.

The contrast between such suburbs on the left bank and those like Clichy and Levallois-Perret on the right was dramatic; as Ajalbert described in a novella published in 1888, the river flowed between 'the smoky factories and blackened docks of one bank and the spacious villas and gardens of the other shore'.[54] Two years earlier Barron's book spoke of 'a violent contrast' between Asnières and, on the opposite bank, Clichy, 'covered with coal dust thrown up by the stevedores unloading barges, lined by workshops plastered in soot, rough wineshops, shanties strewn with rags'; it was a division between the 'gay, carefree, idle and verdant' Asnières and the 'arid, dejected, sombre and hard-working' suburbs across the Seine.

Clichy was 'a big industrial town' with factories making candles, white lead, wax and chemical products, with glass works[55] and the vast gas-tanks of which, again, Signac submitted a painting to the Eighth Impressionist show (1885-6; Melbourne, National Gallery of Victoria). The population was predominantly working class, and

among the workshops and factories of Clichy and Levallois stood the tenement blocks that accommodated it. Indeed, at Levallois were areas of slums and shanty-towns known as the Cité du Soleil, the Cité Foucart, the Cité des Vaches (Plate 122), peopled by the marginal populations of the big city — beggars, ragpickers, street-performers, *déclassés*.[56] The squalor of their accommodation — 'little shacks covered in bituminous paper which the rain penetrates and the wind wrecks', wrote Vallès in 1882[57] — was a matter of public debate and recrimination by the Left.

Immediately between these contrasting suburban zones lay the Grande-Jatte. Being an island it was something of a no-man's-land, between bourgeois propriety and proletarian dereliction, between comfortable housing and filthy tenements, between quiet and tidy streets and the insistent momentum of modern industry. There was not much that could be done to develop the island, for it is only a couple of hundred metres wide at its broadest point. It had long been a boating centre, a port-of-call for picnics, but it was scarcely built up; there were cafés, skittle-alleys and other distractions to cater for the casual visitor. Contemporary illustrations show that it was still partly wooded, and secluded enough for at least one illegal duel to have been fought there in 1886.[58] 'The island of the Grande-Jatte, without being a rural Garden of Eden, offers young Parisians delights which they certainly don't disdain,' wrote Barron that year. 'On holidays and Sundays a dance-hall, whose splendour rivals the glamour of the Elyseé-Montmartre, reverberates with an endless racket; people lay out meals on the bare earth as if they were picnicking on grass, and swings and skittle-alleys flourish where trees used to be.'[59] This is an evocation of ersatz rurality, and the Grande-Jatte's transient population played in a charade,

making the most of sham 'nature' surrounded by the sprawling conurbation of Paris.

SUNDAY

The insistence on a particlar day, Sunday, in the title would have helped the spectator define the painting's population. In an era when the six day week was prevalent Sunday was the only regular day of leisure shared by all classes. During the summer especially, crowds made a weekly exodus to the outskirts of Paris in search of specious rural surroundings. It was a phenomenon frequently commented upon in contemporary bourgeois journalism and fiction, and one descriptive passage from *La Vie Moderne* of 1881 suffices to exemplify the ironic language so often used. 'You should see them, on Sundays, these prisoners of routine. The stations are like over-filled baskets. The pleasure steamers, the trams, every public vehicle that goes beyond the fortifications, is taken over by a swarming, bustling, tumultuous crowd. There's a sort of madness in the joy of this herd let out of the stable. Dragging brats dressed in their Sunday best, sweating from carrying heavy baskets jammed to bursting with bottles and greasy newspaper packets, they scatter at the suburban stations. Down shadowy paths, in the shady glades of parks, in fields covered with flowers which ripple like waves, you find them everywhere, guzzling fresh air and charcuterie, bawling out sentimental songs off-key, and rolling around dishevelled on the grass, which is covered with discarded sea-food and sticky papers.'[60]

The scope of Sunday excursions was inevitably determined by financial and class considerations. Boating, for which Asnières had been and to some extent still was a centre, is a case in point. The owning or even hiring of a boat involved substantial outlay, and with the increasing

121 (opposite). Paul Signac, *The Branch Line at Bois-Colombes*. 1886. Canvas, 33 x 47 cm. Leeds, City Art Gallery.

CITÉ DU SOLEIL (Clichy-la-Garenne)

122. Gustave Fraipont, *Cité du Soleil (Clichy–La Garenne)*. 1886. 13.2 x 9.4 cm. From L. Barron, *Les Environs de Paris*. Paris, 1886, p.36.

123. Ferdinand Heilbuth, *Samedi (Saturday)*. 1886. Location and dimensions unknown. From G. Olmer, Saint-Juirs, *Salon de 1886*, Paris, 1886, opp. p.60.

industrialization of the inner suburban areas it was a pastime pursued more congenially further out of Paris. Thus by the mid-1870s — when Monet worked there — Argenteuil, some seven kilometres beyond Asnières, was a major boating centre, and its clientèle predominantly middle-class.[61] The working classes shared the predilection for escaping from Paris on Sundays, but their means limited what they could do and how far they might go. 'On Sundays the outer *quartiers* – La Villette, La Chapelle, Clignancourt — spill out on to the fortifications and into the suburbs as far as the Ile Saint-Denis and the Grande-Jatte, a whole population *en fête*,' wrote Robert Bernier in his review of Ajalbert's *Sur le Vif* in 1886. 'After a week spent in the heavy, humid atmosphere of the big workshops, in the filth of the boiler-house, in the overwhelming heat of the furnaces, the workers go there to breathe a bit more healthily and to roll in the scanty grass of the *zone*'.[62]

The Parisian Sunday was a frequent subject in the visual arts as well, where the geography of class and leisure was just as scrupulously observed. Caricature dealt with the theme, and Steinlen's comic strip *The Little Delights of Sunday* — a petit bourgeois family outing — printed in *Le Chat Noir* in December 1885[63] is only one of many instances. It also cropped up in paintings at the Salon. In 1885, for example, René Gilbert — an acquaintance of Ajalbert – exhibited *Sunday*, depicting 'the most modest classes of society' and the 'rather crude pleasures of the paupers' promenade,

those who can't afford the railway and whose cravings for rusticity are limited to the slopes of the fortifications'.[64] The following year, at the same time as *La Grande-Jatte* was on show, Heilbuth had his *Saturday* at the Salon (Plate 123). On Saturdays leisure activities did not have to be shared with the working classes, and Heilbuth's painting clearly dealt with bourgeois re-creation: a landscape beyond the reach of the city's margins, the unhurried pace of the smartly dressed women and children, labour making a barely perceptible intrusion — the oarsmen, the laundry-tub — into the pleasures of a summer outing. Sunday could not mean as much to such people as those who had laboured hard for their rest, argued Vallès in 1883: 'One must not compare the Sundays of the working people, who struggle and toil, to the Sundays of those who can afford to be permanently idle or who, by profession, are workers who scarcely work, such as civil servants; ...the modest pleasures of working people affront bourgeois frippery.'[65]

The Sunday that Seurat invoked in his title was part of a contemporary discourse; argued in the press, recognized in the visual arts, and debated in political circles within agitation for the eight-hour day and the broader demand of the Left for increased leisure for the working classes.[66] Thus several critics drew attention to the features of *La Grande-Jatte* that particularly signified Sunday — the people dressed up, the mixture of classes; Ajalbert and Vidal especially stressed Seurat's success in capturing the atmosphere of Sunday in the suburbs.[67]

The Language of the Picture

FASHION

Meaning was also transmitted, as some critics recognized, by Seurat's articulation of his figures and his choice of emblematic imagery. The simplified contours and profile or frontal poses of the foreground figures led several writers to compare them to toy soldiers and to refer to the 'hieratic' qualities of *La Grande-Jatte'* features that are most insistent in the fashionably dressed women. In the Seurat Folio there were cheap printed sheets of toy soldiers, and Herbert has drawn analogies between these and the two soldiers in the painting's middle-ground,[68] reminding us that much of the formal simplicity in Seurat's mature work may have had its roots in his early fascination with popular imagery. There was, for example, the fashion plate (Plate 124). These mass-produced prints could have given Seurat a number of the devices that he used in *La Grande-Jatte*, primarily devices of artifice: reduced use of texture and detail, arbitrary lighting, and exaggerated outline to

124. *Day Dress, 1885*. Print from *La Mode Artistique*, 1885.

stress the essential features of the figure's ensemble. Like the fashion plates, Seurat laid emphasis on the modish bustle. This had been done before — Seurat might have known, for example, Guillaumin's *Quai de Bercy* (c.1881; Geneva, Oscar Ghez collection), which juxtaposed the profile of a lady wearing an ample bustle with a working-class woman wearing more practical clothes — but with less focus on fashion and its significance. In *La Grande-Jatte* Seurat seems to have wanted it noticed, and some critics commented perceptively. Adam spoke of how 'the stiffness of the figures, the stamped-out quality of the forms, contribute to giving the resonance of the modern, the echo of our tight costumes, glued to the body, the reserve of our gestures, the British cant imitated by everyone,' observations with which Ajalbert agreed.[69] Both critics, who belonged to Seurat's circle and were writing after the painting had been on show for a time, after it had been discussed in the cafés, argued that the costume signified; it registered modernity, the up-to-the-minute, and simultaneously hinted at the superficiality of the merely chic.

Costume, of course, is conventionally used to identify class and role, and Seurat used it in this way; a prime instance is the wet-nurse (Plate 113). And yet he also allowed his observation of fashion to act ambiguously. 'Today there is not a lady or a working-class girl who does not have her umbrella, or her satin *en-tout-cas*; it seems that it is the indispensable complement to any *toilette de promenade*,' noted one writer in 1883, while another added the same year: 'first and foremost, the umbrella is the symbol of equality.'[70] In this case an element of costume would not help the spectator; on the contrary, in its ubiquity the umbrella or parasol blurred the class structure, hindered easy identification.

It is no surprise that Seurat's literary friends remarked on the use of fashion, for it was a theme in their own writing. Paul Adam's *Les Demoiselles Goubert*, written in collaboration with Jean Moréas and published in 1886, frequently observed fashion with a curt description analogous to Seurat's synthetic drawing — 'The excess of the latest fashion does mischief to the spines of tall, thin girls. From their backsides dance padded bustles' — and also drew attention to the 'impassive mien' that the heroine Henriette felt necessary to carry off such costume.[71] Adam was sensitive to the caricatural quality of Seurat's treatment of fashion because he had tried similar effects in his writing, but others were offended. According to Signac, the older painter Alfred Stevens paid for his friends to go and jeer at *La Grande-Jatte* on the first day of the exhibition.[72] Stevens was a highly successful painter of elegantly dressed women, specializing in the details of high fashion (Plate 125), and he must have felt that such a painting was a pernicious parody of both his art and his public. The rigid simplicity of Seurat's drawing was surely the cause of his anxieties, and it troubled others. The critic Paulet felt that in their Eighth Exhibition the Impressionists, and Seurat in particular, 'prised from the individual the es-

125. Alfred Stevens, *The Salon of the Painter*. 1880. Canvas, 85 x 114 cm. Private collection.

sential detail which identifies the type', but worried that 'the signification of the drawing scarcely goes beyond caricature'.[73]

TYPES

Five critics — Hermel, Paulet, Christophe, Darzens and Ajalbert — considered it worth while to list some of the types recorded in *La Grande-Jatte*, to identify the island's Sunday population. Hermel wrote of Seurat's 'modern symbolism (*symbolisme moderne*), his schematic wet-nurses, conscripts and oarsmen', linking the treatment of types with emblematic meaning.[74] Christophe saw Seurat 'attempting to seize the diverse attitudes of the epoch, of sex and social class: fashionable men and women, soldiers, nannies, bourgeois, workers', emphasizing the analysis and mixture of class.[75] Seurat had trained himself in his early drawings to convey some of his meanings through types, and he here used the schematic figure to identify the elements in the class structure of a particular time and place, and the critics recognized this — Christophe explicitly. The soldiers,

the hatless girls just in front of them and the nurse would all have been working-class; the top-hatted, well-dressed men and smart women bourgeois. Such a distribution, such a mixture, would have been appropriate for the Grande-Jatte, for — as we have seen — it was a place on the margin between two societies. The frequent assumption that *La Grande-Jatte* depicted only the middle class is incorrect; the argument that it showed a mixture of classes is much nearer the truth.[76]

But Seurat's analysis of the society of the island went deeper than this level of observation. By using types he invoked an imagery common to a broad public: the imagery of the cheap newspaper, the popular illustration and caricature. One example is the wet-nurse, a frequent figure of comment and humour in the popular press. Bertall's drawing of the type (Plate 126), from his well-known *Comédie de notre temps* of 1874, has a caption that makes her class position clear — she is servant to a bourgeois family — and makes the conventional association of nurse and soldier which Seurat hinted at in *La Grande-Jatte*. The important top-hatted figure to the

right was a stock figure in popular imagery too: the smart man-about-town, the *boulevardier*. A caricature of the type drawn by Henri Gray in 1883 (Plate 127) indicated his essential attributes — monocle, top-hat, high collar, cane, moustache — and Seurat identified his figure in the same fashion. The status of the woman accompanying him was not made quite so clear. Only one critic referred to her directly, calling her a *cocotte*, though the monkey was mentioned.[77] A traditional image of lust and promiscuity, the monkey continued to have these associations in France during the 1880s; at the first Salon des Indépendants in 1884, Rupert Carabin showed a wax sculpture of a naked woman playing with a monkey, and the motif occurs in *risqué* prints by Félicien Rops and in drawings by Toulouse-Lautrec.[78]

SLANG AND METAPHOR

With the monkey Seurat's association was verbal as well as visual, for in contemporary slang '*singesse*' (female monkey) meant prostitute.[79] This duplication of meaning was surely deliberate, and the use of both animal imagery and slang was not an uncommon element in contemporary art; in 1886 Aimé Morot exhibited a

watercolour entitled *Deux Coqs et la Poule*, showing two workers fighting over a mistress.[80]

Seurat made linguistic puns elsewhere in *La Grande-Jatte*. The female figure fishing to the left of the painting, so carefully prepared, is on second glance a most unlikely individual: holding a fishing rod, but with no extra tackle to be seen, and dressed to the nines. In contemporary literature the metaphor of the prostitute 'fishing for lovers like one fishes with a rod' was frequent,[81] and the standard pun on '*pêche*' (fishing) and '*péché*' (sin) was often made in popular cartoons too (Plate 128). Seurat's intention was not that this figure should be necessarily naturalistic but that she should carry a particular meaning, that she should be part of his '*symbolisme moderne*'. It is significant that the two key women at *La Grande-Jatte's* flanks invoked contemporary codes for representing the world of prostitution.

Seurat's use of animal imagery also involved the dogs that play such an incongruously lively part in the foreground of *La Grande-Jatte*. These animals' roles were considered and reconsidered as the picture developed; not only did the dark dog once operate as an axial point in a drawing of the ensemble (Plate 105), but Seurat also

126. Bertall, *The Wet Nurse*. 1874. From Bertall, *La Comédie de notre temps*, Paris, 1874, p.205.

127. Henri Gray, *V'lan*. 1883. From *Exposition des arts incohérents. Catalogue illustré*. Paris, n.d. [1884?], p.viii.

123

Dis, Totor, veux-tu... que je pêche?..............

128. 'Leys', *Dis, Totor, veux-tu ... que je pêche?*', 1880. Drawing from *Le Boudoir*, 25 July 1880, p.103.

drew several sheets of dogs and monkeys, adding the small dog after the *Esquisse d'Ensemble* (Plate 117) and moving the monkey closer to the woman who holds its leash. The developing roles of the animals thus give an indication of how meanings became more complex as the painting progressed.

The image of the dog could carry various connotations in late nineteenth-century French art and culture. Different kinds of dog were associated with various classes: pedigree hounds with the aristocracy, terriers with the bourgeoisie, poodles with the *petit bourgeois* or working class, and mongrels with the lowest strata — the marginal city dweller, the criminal, the *déclassé*.[82] The latter gave rise to political associations and metaphors; in 1883 Jean Richepin wrote of mongrels as 'independents, rebels!', and as '*déclassé*', while one of Ajalbert's poems in *Sur le vif* drew an implicit analogy between such animals and the suburban poor in speaking of 'stray dogs, vagabonds, insurgents from the suburbs'.[83] Dogs were also seen as symbols of sexual promiscuity, and hence were frequently associated with prostitutes — the suburban newspaper *Autour de Paris* explained in March 1887 that Parisian prostitutes visiting Asnières could be identified by their lap-dogs, with the pug as a particular favourite.[84] In visual imagery dogs might be used to reinforce scenes of social tension and

class antagonism in representations of prostitution, as in Charles Giron's *The Two Sisters* (Plate 129), exhibited at the Salon of 1883. Here the artist made confrontations between the working-class woman with her family and her flamboyant courtesan sister, between poverty and honesty on one side and wealth and vice on the other, confrontations echoed by the behaviour of the dogs.

Towards an Interpretation of La Grande-Jatte

The meaning of *La Grande-Jatte* hinges on the combination of a specific time and location, particularized by the title, and Seurat's '*symbolisme moderne*'. The northwest suburbs in the mid-1880s, varied in their distribution of class and wealth, were to some extent polarized by the river, and the Grande-Jatte was neutral territory where bourgeois and working-class communities met and mingled. The dogs, rather than the humans, seem to represent the confrontation of classes on the Grande-Jatte. The unaccompanied mongrel serves as the metaphor for the *déclassé*, the suburban poor, the inhabitant of society's margins. The playful, beribboned pug can be identified with the prostitute, the proletarian woman become (superficially) bourgeois through prostitution, the representative of immorally won and easily lost social mobility. Seurat used the animals actively, and their movement invigorates the static foreground, stressing the rigid posing of the people pointed out by Adam and others as a façade of respectability and status. This stiffness might be seen as Seurat's pictorial acknowledgement of the Grande-Jatte on Sunday as a place of tense neutrality, as the meeting place of two societies that had little more in common than geographical location and sexual commerce.

It is no wonder that the codes and emblems of prostitution — the woman fishing, the monkey, the pug — play such a part in the painting's foreground. For the Grande-Jatte, as local newspapers tell us, was known as a place for the adulterous rendezvous, between the *boulevardier* and his wife's maid, say.[85] Promiscuity and prostitution were bridges across the class divide, and localities such as the Grande-Jatte provided opportunities for the shortlived social mobility of the *demimonde*.[86] In Seurat's painting the temporary population of the island literally turn their backs on the realities of the factories and slums of Clichy, facing rather towards the bourgeois comforts of Asnières and enjoying the ephemeral pleasures of Sunday.

These were matters of interpretation that reviewers only hinted at, and we may ask why Seurat's '*symbolisme moderne*', notably his references to prostitution, were not more explicitly interpreted. Some writers, of course, did not bother to address themselves to *La Grande-Jatte*, and poignant absentees were the Naturalist critics; Mirbeau skirted the picture, Roger Marx and Geffroy did not mention it, Huysmans and Alexis failed

129. Charles Giron, *Les Deux Soeurs*. 1883. Canvas, 445 x 650 cm. Location unknown.

to review the show. It seems that the germ of a new aesthetic put them off. Seurat's younger friends wrote acutely about *La Grande-Jatte*, although several of them were not professional art critics. A reference in Adam's review to the fact that the high quality of Seurat's marines was not 'disputed by journalists' suggests that he and his colleagues were aware of initial press antipathy and took the opportunity of their own columns to defend the artist on technical and formal grounds.[87] In their discussion of the subject Adam, Ajalbert, Christophe and others did make shrewd observations and picked up Seurat's trail: Sunday, the suburbs, the types. The element they neglected was prostitution, and this may well have been deliberate. Contemporary censorship could be harsh — Adam had been taken to court and fined for his novel *Chair Molle* in August 1885; the first issue of *La Vogue* in April 1886, including contributions by Fénéon, Kahn and Huysmans, had to be withdrawn because of a *risqué* passage. Seurat's circle probably did not want to disadvantage him. If there is something circumspect and oblique in Seurat's painting, one senses it also in the reviews.

The question remains of *La Grande-Jatte's* relationship to *Une Baignade*. Some writers have taken the view that neither painting carries any social meaning,[88] but this is surely untenable. A more feasible position is the argument that the two pictures form some kind of a pair, with close and deliberate links between them.[89] But there are substantial contradictions to this thesis, concerning both form and subject. The similarity of size could well be coincidental; two metres by three was hardly an eccentric configuration. Not only does *La Grande-Jatte* include some fifty figures to *Une Baignade's* dozen but comparison of the pictures (Plates 97, 118) shows dramatic imbalances in scale and disposition

of the staffage, while the natural features in the paintings, such as the horizons, do not tally. *La Grande-Jatte* and *Une Baignade* have markedly different visual presences. And if Seurat had conceived them as a pair it is curious that the paintings were not (or even intended to be) exhibited together in his lifetime.

The two canvases were not, then, a planned pair, and the attendant argument that they represent the opposition of two classes — *Une Baignade* working-class, *La Grande-Jatte* bourgeois — does not take account of Seurat's development between the two paintings. The figures in *Une Baignade* are frequently taken to be working-class, men from the distant factories.[90] But they are some two kilometres from the Clichy factories and the Asnières bank on which they sit was not itself a heavily industrialized area. Their clothes — bowlers, boaters and elastic-sided boots — do not correspond with those of young labourers such as those described in a contemporary short story by Seurat's friend Maurice Beaubourg, who, bathing nude in the suburban Seine, leave on the bank 'their caps, workers' smocks, cotton trousers, and big hob-nailed boots'.[91] The men in *Une Baignade* are more likely shopkeepers and clerks of petit-bourgeois Asnières rather than the factory workers of proletarian Clichy. If so, Seurat adjusted the social status of the painting's staffage as he proceeded, for early sketches — the Edinburgh *croqueton*, for one (Plate 89) — show figures in the workers' traditional *bleus* washing hauliers' horses, a subject treated by contemporaries such as Guillaumin.[92] *Une Baignade* began as a working picture but became a painting of leisure, albeit snatched lower middle-class leisure. In vital respects it was moderate, uncontentious: the deliberate first major painting, still reliant on academic formulae of pose and design, dealing with a modern subject but with

130. *Regatta on the Seine. c.*1884–5. Conté crayon, 23 x 30 cm. Providence, Rhode Island School of Design (DH 705).

131. Paul Signac, *L'Ile des Ravageurs(?). c.*1884–5. Conté crayon, 20 x 30 cm. Private collection.

a limited consciousness of the suburbs, little variety of types, no subtle codes of meaning.

La Grande-Jatte involved substantially more sophisticated ambitions than *Une Baignade*, adding to the fundamentals of the earlier picture — the planar composition and the suburban subject — degrees of complexity that make direct comparison inappropriate. It represented a very particular society, specified in time and place, and much credit for this critical concentration on the suburban theme in the wake of *Une Baignade* must go to Signac. An inhabitant of Asnières since 1880, Signac was well equipped to develop Seurat's perception of the area, and the evidence of two almost identical drawings of a boating scene (Plates 130, 131) suggests that around 1884–5 they worked together in the western suburbs. During this period Seurat's wider and more challenging circle of friends, writers and painters alike, surely encouraged the more allusive means at his disposal for *La Grande-Jatte*: the simplified visual language of popular

imagery, a refined range of specific types, the punning invocation of argot, and the associations of animal imagery. These were the means that enabled Seurat, after some five years' work in the Parisian *banlieue*, to come to terms with the complex modernity of the suburbs. *La Grande-Jatte* was a picture in which meaning was gravely cultivated, and in this, as well as in its classical configuration, it exemplified Seurat's respect for the traditions of history painting; Charles Blanc's exhortation that 'painting, in its silent eloquence, raises peoples' moral standards'[93] might well apply to this critical picture. If there is something unresolved about *La Grande-Jatte* — as early as 1890 Henri Van de Velde felt it a trifle marred by its hasty gestation[94] — the control, craft and originality of the canvas, as well as its articulation of meaning, immediately gave it a pivotal role in progressive painting. *La Grande-Jatte* was the 'tableau-manifeste' to which in the spring of 1886 the Parisian avant-garde was forced to pay alert attention.

7 *The Front Rank of the Avant-Garde*

Seurat and his circle, 1886–1888

By early summer 1886 Seurat's previously rather isolated position had radically changed, and as the most challenging young painter of the moment he found himself at the centre of the Parisian avant-garde. It is useful to consider the circle in which Seurat moved in the mid-1880s as an avant-garde, a term that formed part of the participants' own parlance. Poets, novelists, artists and critics, all at the early stages of their careers, formed a community of shared ideological and aesthetic interests on the frontiers of contemporary cultural convention. Operating outside, and to some degree against, bourgeois norms, they received support from older artists and from within their own circle: the journalist's defence in his column, say, or the friend's purchase of a picture. But true to the typical pattern of avant-gardes, the stimulus of innovation and interchange, the impetus of rivalry, could not be sustained, and the always shifting constellation finally fragmented.

Seurat developed his position in this avant-garde, and took up the opportunities it offered.[1] He continued to attend the Indépendants' dinners, such as the one held on 8 November 1886 with Signac, Angrand, Dubois-Pillet, Geffroy and Arsène Alexandre present.[2] He put himself out to help friends, storing Lucien Pissarro's canvases after the Eighth Impressionist Exhibition.[3] And he kept in touch by letter, writing to Signac from Honfleur during his stay there in the summer of 1886, and sending news from Paris when Signac was away a year later. But most importantly Seurat made sure that his work — as much of it, and as recent, as possible — was kept in the public eye, and not solely the Parisian public. At the second exhibition of the Société des Indépendants, held from 21 August to 21 September 1886, he showed *La Grande-Jatte* again, two other suburban canvases, three paintings from Grandcamp, and an unfinished picture from the recent trip to Honfleur, as well as some *croquetons*, framing the work in white.[4] Through a friend Pissarro managed to engineer invitations for Seurat, Signac and Lucien to show alongside

Renoir, Gérôme, Sisley and Moreau de Tours at an important exhibition held in Nantes in October and Seurat submitted two Honfleur paintings.[5]

Octave Maus, the energetic secretary of the enterprising Belgian modernist group, Les Vingt, had been impressed by Seurat's work at the Eighth Impressionist Exhibition, and Seurat began a regular association with Les Vingt by showing *La Grande-Jatte* with two Grandcamp and four Honfleur canvases in Brussels in February 1887.[6] The paintings arrived late for the *vernissage*,[7] but had great impact. Signac, who travelled to Belgium with Seurat, reported back to Pissarro: 'An enormous crowd, an amazing fuss, very bourgeois and anti-artist. In sum, a big success for us: Seurat's canvas was invisible, one couldn't get near it the crowd was so enormous.' One of the pictures on show — *Corner of a Dock, Honfleur* (Plate 166) — was already owned by Verhaeren, and *The Beach of Bas-Butin* (Plate 172) was sold to a M. van Cutsem for 300 francs.[8] Seurat had to arrange for several of these paintings to be returned hastily to Paris for the third Indépendants show, held from 25 March to 5 May 1887, at which he exhibited all six completed Honfleur canvases, a new suburban landscape and a foretaste of new projects: a painted sketch of a *Poseuse* and a café-concert drawing.[9] This was the most intense spate of exhibiting in the whole of Seurat's career.

Parallel to Seurat's emergence as a public figure came the status of stylistic initiator, and other young painters followed the example of his work. Signac's *The Dining Room* (Plate 132), exhibited at the Indépendants in 1887, adopted not only the dotted surface prefigured by *La Grande-Jatte* but also its starkly simplified drawing. In later years Signac claimed that *La Grande-Jatte's* subject was chosen to 'tease the Impressionists',[10] an aim more appropriate to his own figure paintings, for *The Dining Room* adopted Seurat's caricatural simplification to parody Caillebotte's painting of the same subject, which he would have seen in the artist's home (Plate 133). Again, Angrand, who had known Seurat since about 1884, came under his sway, and at the same exhibition

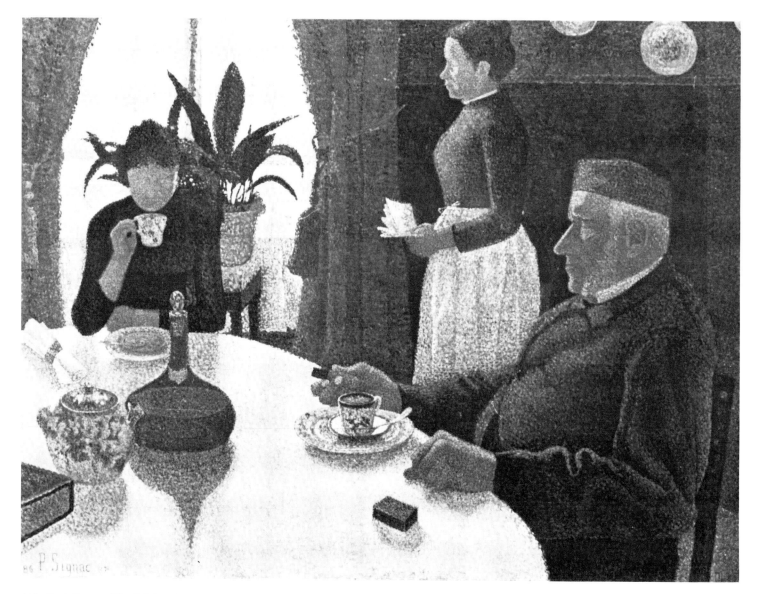

132. Paul Signac, *The Dining Room. c.*1886–7. Canvas, 89 x 115 cm. Otterlo, Kröller-Müller Museum.

showed *An Accident* (Plate 134), a street scene combining naturalistic methods, such as the cut-off figure, with synthetic draughtsmanship and pointillist division of tone. And after the Vingt exhibition of 1887 several Belgian painters followed suit, making Seurat — a year after *La Grande-Jatte* was first shown — the leading artist of a growing group.[11]

If Seurat was the group's artistic leader, Signac was its activist and Pissarro its elder stateman. The dynamic Signac kept the artists and their friends in touch by a voluminous correspondence and via his *soirées*. He saw the advancement of the new painting as a crusade; before the Nantes exhibition he wrote to Pissarro in rousing language: 'There will be a struggle. So much the better; let's hoist our flag above every barricade and open fire!'[12] One of Signac's most important contributions was to serve on the hanging committee of the Indépendants, a position he first won in July 1886, thus enabling the group's paintings to be hung together.[13] He also used his literary connections to advantage. In his account of the 1887 Indépendants exhibition Huysmans,

the art critic of the *Revue Indépendante*, expressed reservations about the new technique, comparing Seurat's colour to 'the harsh notes of a harmonica' and complaining about 'too much method, too many systems, not enough sparkle, not enough life!'[14] Signac agitated for his removal — 'Signac and others haven't yet pardoned me for my reservations about their dottings', wrote Huysmans in October[15] — and by the end of the year he had been replaced by the less experienced but more trustworthy Gustave Kahn.

By the time of the Indépendants exhibition of late summer 1886 there was a recognizable group of painters in close personal contact, moving in a similar stylistic direction, showing their work together and considered as colleagues by supportive critics. Adam, who in *La Vogue* of September that year wrote of Seurat, Signac, Lucien Pissarro, Dubois-Pillet and Angrand together, argued that the exhibition gave 'new assurance that the art of the most recent Impressionists will mark one of the most important moments in pictorial progress'.[16] The same month Fénéon published in *L'Art Moderne*,

133. Gustave Caillebotte, *The Luncheon*. 1876. Canvas, 52 x 75 cm. Paris, private collection.

Les Vingt's journal, his second explanatory article on the new technique, emphasizing its chromatic discipline and painterly procedures and amplifying an argument that he had hinted at earlier in the year: that Seurat's technique developed from, rivalled, reformed and perfected the more improvisatory colour and handling of the Impressionist landscape painters. In this article Fénéon came up with a term to define the new painting, and in writing of 'the Neo-Impressionist method' stressed his own *partis-pris* — the focus on technique and the improvement on Impressionism. He insisted on seeing the group as rivals to the Impressionists, especially Monet, and — as if by extension — seeing Seurat primarily as a landscape painter, preferring *Corner of a Dock* to *La Grande-Jatte*.[17]

The position the Neo-Impressionists themselves took was more fluid and less well articulated. It had, of course, always been Signac rather than Seurat who had cultivated connections with the older Impressionists, but wrangles about the Eighth Impressionist Exhibition of 1886 had already revealed the fragility of amicable relations. Animosity occurred both during the exhibition's organization, as we saw in Chapter 5, and while it was on show. Signac wrote to Verhaeren in May 1886 that

Monet and Renoir were trying to prevent Pissarro showing pointillist paintings with the dealer Georges Petit.[18]

When Pissarro wrote to Lucien a year later that 'Seurat doesn't hesitate a moment in declaring that we're in the right and that the old Impressionists are more and more out-of-date as time goes by,'[19] he was reporting tension and rivalry, to be sure, but no doubt the avant-garde's appetite for modernity also demanded such posturing. The Neo-Impressionists still respected 'these marvellous precursors', as Signac called them, and when he wrote of 'leaving the first generation Impressionists to stray into the arbitrary and the empirical', he added humorously, 'Hmm! you're going a bit far, wretched Néo!', pointing up the semi-serious quality of this jockeying for avant-garde position.[20]

The stance of the new group *vis-à-vis* Monet or Sisley was distant, based on objective stylistic differences, but its relationship with certain erstwhile allies rapidly became peevish and personal. Gauguin and Guillaumin, as old colleagues of Pissarro and Impressionists of longer standing, had expected to benefit from the absence of Monet and others at the 1886 show and to further their own status at the forefront of modern landscape. But they were trumped by Seurat. Guillaumin was particu-

larly incensed when Fénéon's review included Dubois-Pillet, alongside Seurat, Signac and the Pissarros, as one of the 'Impressionist avant-garde' but implicitly excluded himself and Gauguin, and tried to provoke an argument with Seurat, who refused to be baited.[21] A few days later occurred the well-known row when Gauguin, whom Signac had given permission to use his studio while he himself was out of Paris, was refused entry by the misinformed Seurat, a slight that Gauguin never forgot.[22] Seurat was no doubt gauche and officious, Gauguin belittled and irascible. An instance of comradeship — the loan of a studio — instantly became an incident of confrontation, and what in early 1886 had looked like a single new generation of landscape painters under the aegis of Pissarro became antagonistic factions jostling for position. Neither Gauguin nor Guillaumin exhibited at Nantes in October; in December there was an uncomfortable moment at the café de la Nouvelle-Athènes, when they refused to greet Signac and Seurat.[23]

Within a matter of months after the Eighth Exhibition, alliances within the 'Impressionist' community had polarized. Monet and Renoir, increasingly accepted artists, relinquished (temporarily) their links with Pissarro; a coherent, well-supported and organized 'Neo-Impressionist' group emerged; Guillaumin, Gauguin and others belonged to an informal opposition. If these disputes concerned and involved Pissarro and Signac, Seurat's reactions were characteristically objective. He noted disloyalty and avoided confrontation, and concerned himself with his own status.

At this period Seurat's anxieties about his standing as stylistic antecedent began, anxieties to which at first Pissarro, for one, was sympathetic. In September 1886, and again the following April, Fénéon approached the helpful Pissarro rather than the touchy Seurat seeking technical advice for his articles, and Pissarro always stressed his colleague's pioneering position.[24] Seurat's own attitude can only be gauged by the dialogues his friends conducted behind his back, suggesting the distance he kept and the respect he commanded. In June 1887 Pissarro visited his studio and noted that Seurat was preparing a painted frame for Les Poseuses (Plate 146). 'It's absolutely indispensable, my dear Signac,' he wrote. 'We will be forced to do the same,' and adding, 'but I certainly will not show until after our friend Seurat has made known the priority of his idea — it's only fair!'[25] Signac's reply, that his own 'career as a framer will follow later,'[26] was a trifle ironic, a tone he adopted again in his review of the Indépendants exhibition in March 1888: 'This is to certify that Seurat sired the first dotted frame, and Dubois-Pillet the first circular frame — March 1888.'[27] Seurat's quiet officiousness created a climate unwelcome to the collaborative inclinations of his colleagues.

Indeed there were some strains within the Neo-Impressionist group almost from the outset, and the idea of a harmonious avant-garde unit marshalled behind Seurat is untenable. Some tension erupted while Seurat and

Signac were in Brussels in early February 1887 — 'I will tell you what poor Signac has had to endure, and myself, by ricochet,' wrote Pissarro to Lucien — and Seurat refused to see his friend for a while after they returned.[28] The reason for this friction is not known, but Seurat seems to have attempted to deny Signac and others the right to build on 'his' technique. Pissarro complained to his son later in the month: 'Isn't it tiresome that Seurat is so — how can I put it — sick! I don't know how to explain this extraordinary behaviour. It's a ploy if it's not a sickness, and in any case it's foolish, because it will not prevent Signac and others developing their work from the current movement.'[29] Relations obviously recovered after this incident, and Seurat was in regular contact with his colleagues throughout 1887, but the auguries were not good.

The links between Seurat and his painter friends and progressive literary circles that had developed during the period between the exhibition of *Une Baignade* and *La Grande-Jatte* were at their most solid in the couple of years after the Eighth Impressionist Exhibition. As the left-bank brasserie Gambrinus ceased to be a meeting-place in the autumn of 1886 the same literary and artistic clientele shifted to Montmartre, to the vicinity of the boulevard de Clichy, to the painters' *quartier*. From 1886 until at least January 1888 — when the offices moved nearer the city centre — the writers of the *Revue Indépendante*, and also of the *Revue Wagnérienne* and *La Vogue*, met at the Café d'Orient in the rue de Clichy, and there Seurat would have drunk with Kahn, Edouard Dujardin, de Wyzéwa, Adam, Henri de Régnier and Laforgue.[30] It is clear from their letters that the Neo-Impressionists read such journals. They were after all written by friends of theirs, and contained literary, critical and political ideas that had much in common with their own goals.[31]

Seurat was very involved in this community, even in personal ways. In April 1887 he was present when Ajalbert made his début at the bar,[32] and, as he was spending that summer in Paris, he was one of the few able to attend Laforgue's funeral on 22 August, after which he had to depart immediately for his regulation 28 days' military service.[33] Like his artist colleagues, Seurat also made use of his literary connections. One of his drawings was illustrated for the first time in an article by Kahn published in *La Vie Moderne* in April 1887, and a year later he reworked the central figure from *Les Poseuses* into a line drawing modelled in dots (Plate 145) to facilitate its reproduction.[34]

The Symbolist aesthetic

During the course of 1886 and 1887 the literary initiatives of the younger writers began to take concrete form. The arguments for a new departure in literature were voiced first by the poets. On 18 September 1886 Moréas published in *Le Figaro Littéraire* his Symbolist mani-

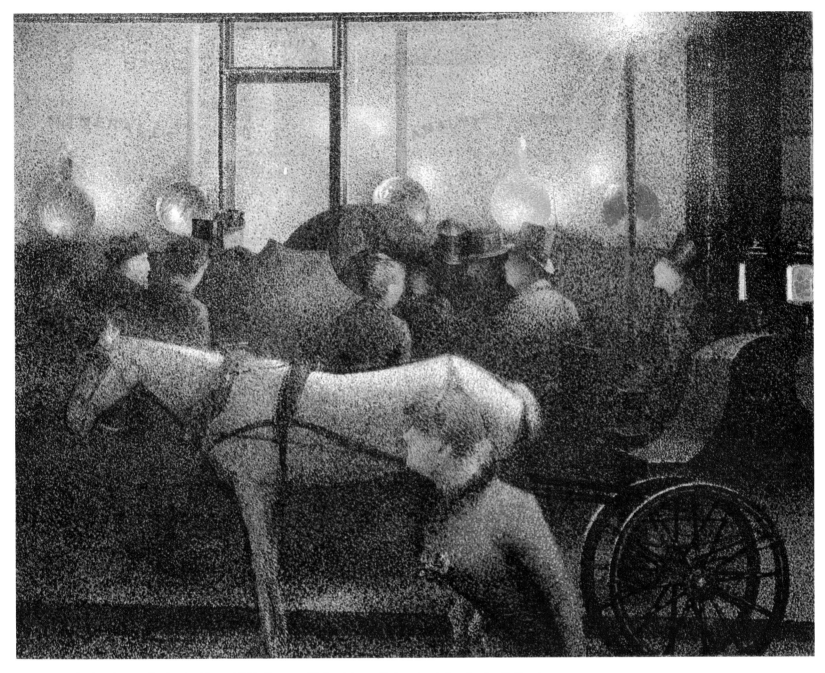

134. Charles Angrand, *An Accident*. 1887. Canvas, 50.6 x 64 cm. Switzerland, Josefowitz Collection.

festo, an appeal against the detail, documentation and crudity of Naturalist literature and for a more tangential, imaginative approach, the evocation of essential emotion rather than the description of exact fact. The aim of Symbolist writing was 'to clothe the Idea in a palpable form which, nevertheless, will not be its goal in itself, but which will remain subservient while serving to express the Idea ... the essential character of symbolic art consists in never going as far as the conception of the Idea itself.'[35]. In *L'Evénément* a few weeks later Kahn amplified this: 'The essential aim of our art is to objectify the subjective (the exteriorization of the Idea) instead of subjectifying the objective (nature seen through a temperament). Wagner's multitonic tone and the most recent Impressionist technique derive from analogous concepts.'[36]

In 1897 Kahn was to argue retrospectively that any aesthetic alliances formed between novelists like Adam, painters like Seurat and poets like himself were simply to give mutual support in the face of opposition, but contemporary accounts show more intellectual cohesion than this.[37] In 1886 Kahn's description of the new verse techniques — an account quoted by Adam in *La Vogue* the next month — spoke of 'the desire to divide the rhythm, to give an approximation of a sensation in the drawing of a strophe', utilizing the terminology of the visual arts, the vocabulary of a Neo-Impressionist.[38] Emile Verhaeren's technical summary of Symbolist verse also deserves to be seen in this light. 'An art of thought, reflection, combination and will. No improvisation', he argued in 1887; 'every word, every sound weighed, scrutinized, intended.'[39] This appeal for discipline rather

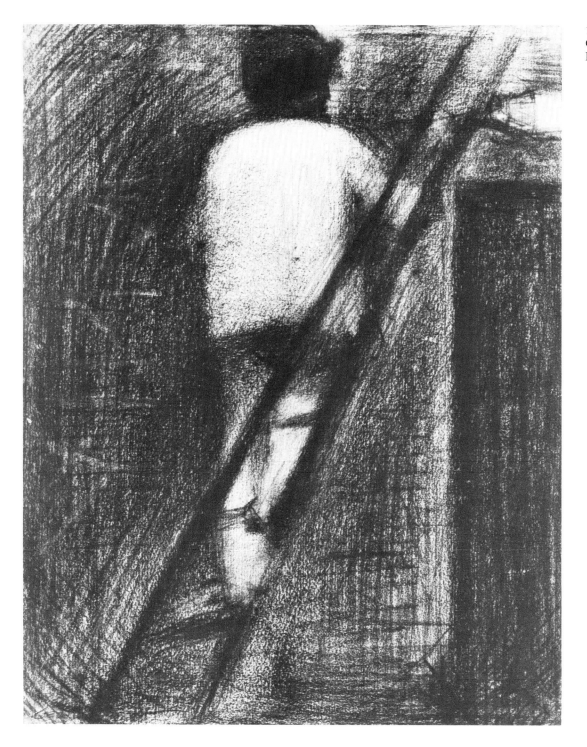

135. *The Roofer.* c.1887–8. Conté crayon, 31 x 24 cm. Paris, Louvre (DH 565).

than virtuosity finds parallels in the art criticism of Fén-éon, and in the contrast between Seurat's and Monet's work. Thus to Kahn in Monet's landscapes 'nature always has convulsions', effects were ostentatiously sought, while Seurat's measured paintings matched the work of 'real poets, those who tax their expression and their ear'.[40] Seurat's later work interweaves with the fabric of Symbolism, a strong aesthetic current of which the Neo-Impressionists were well aware and with which technical and thematic analogies can be traced. In the second half of the 1880s it was the interrelationship between the sophisticated and experimental work of the Symbolist writers and the Neo-Impressionist painters that was at the core of the active Parisian avant-garde.

Metropolitan and suburban themes, 1886–1888

From the mid-1880s Seurat set up a rhythm of work, usually making trips to the Channel coast during the summer to paint marines, and returning to Paris to produce over the autumn and winter months a large-scale figure picture for exhibition in the spring. This was the conventional routine of the Salon painter, and it reflects Seurat's continuing allegiance to the ideology of the Ecole des Beaux-Arts. In the summer of 1886 he painted at Honfleur, and over the following winter started work on *Les Poseuses* — exhibiting a highly finished study for the central figure at the Indépendants in early 1887

136. *Two Workmen on Scaffolding.*
*c.*1887–8. Conté crayon, 31.7 x 23.2 cm.
Paris, private collection (DH 567).

(Plate 144) — and completed canvases from the Honfleur campaign. He did not go to the coast in 1887, perhaps held back by *Les Poseuses*, which was not going well, and by the obligations of temporary military service. Late that year he began *La Parade du Cirque* (Plate 154), and the two paintings, worked on in tandem over the winter, were shown at the Indépendants in 1888 (22 March — 3 May).[41] With them were four drawings of café-concert subjects and four other sheets, all of figures, including the early *Dineur* and the more recent *Sweeper* (Plates 2, 69). The group as a whole testified to Seurat's shifting choice of subject, sidling towards the theme of inner-city entertainment that would preoccupy him for several years to come.

However, it would be wrong to think that Seurat immediately abandoned his earlier concerns. *The Sweeper* and other drawings of this period, such as *The Roofer* and *Two Workmen on Scaffolding* (Plates 135, 136), show that his interest in working-class types persisted. The street scene that had occurred occasionally early in the decade reappeared, too, but with a stylistic character different from that of sheets like *Place de la Concorde* (Plate 65). For example, *The Cab* (Plate 137) of *c.*1887 has a lighter, more even shading typical of other contemporary drawings, and stresses Seurat's current concern for a shallow, almost relief-like space with regimented horizontals and verticals. The design bears similarities to Angrand's contemporaneous *Accident*

133

137. *The Cab. c.*1887. Conté crayon, 23.5 x 30.5 cm. Bern, E.W. Kornfeld Collection (DH 647).

(Plate 134), a canvas that shared Seurat's fascination with the nocturne. *Encounter* is another drawing based on such a configuration (Plate 138), and its planar motif of shop fronts may be a response to the panels of such subjects which Whistler exhibited in Paris at this time.[42] Reproduced as the frontispiece in de luxe editions of the *Revue Indépendante* in August 1887, *Encounter* demonstrates how well the mysterious concision of Seurat's drawings was attuned to the neat evocation of Symbolist writing, to the fastidiousness, say, of Paul Adam's prose

138. *Encounter. c.*1887. Conté crayon, 23 x 31 cm. Location unknown; reproduced as frontispiece to the deluxe edition of the *Revue Indépendante*, Aug. 1887 (DH 477).

in *Les Demoiselles Goubert*: 'In the shops mirrors multiplied the flickering globes of the girandoles. Trams rushed by, behemoths with incandescent eyes. Figures moved around, dragging their shadows along the pavement.'[43]

Seurat's paintings also came increasingly to tally with the measured technique and moods of melancholy and solitude conjured up in Symbolist writing. *Le Pont de Courbevoie* (Plate 139), probably painted over the winter of 1886–7, has such an atmosphere. Its plangent evocation of monotony and alienation in a suburban setting bears comparison with some lines from Georges Rodenbach's *Du Silence*, published in 1888:

'A l'heure délicate où comme de l'encens
Le jour se décompose en molles vapeurs bleues,
Va dans l'abandon noir des quartiers finissants,
Va donc, ô toi dont l'âme est la soeur des banlieues,
Toi dont l'âme est morose et souffre au moindre bruit
A travers le faubourg, comme au hasard construit,
Le faubourg où la ville agonise et s'achève
Dans du brouillard, dans de l'eau morte et dans du
 rêve …'[44]

[At that exquisite hour when the day decomposes/Into soft blue mists like incense,/Go into the dark neglect of the city's furthest outskirts,/Go, you whose soul is the sister of the suburbs,/You whose soul is moody and suffers at the least noise,/Across the haphazardly built suburb,/The suburb where the city peters out and ends/In fog, in stagnant water, and in dream …]

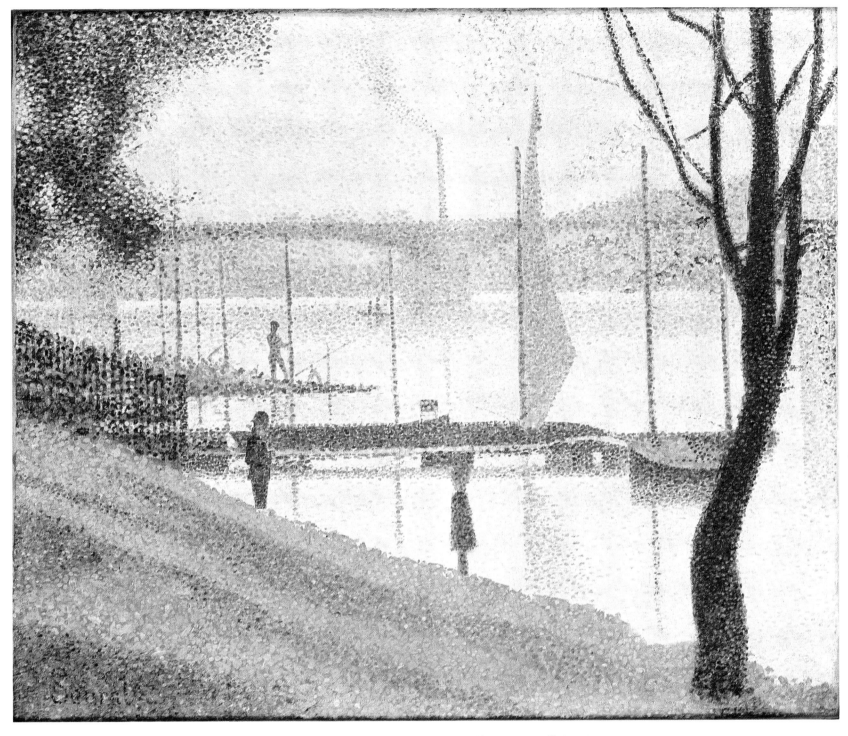

139. *Le Pont de Courbevoie. c.*1886–7. Canvas, 45.7 x 54.7 cm. London, Courtauld Institute Galleries (DH 178).

Le Pont de Courbevoie is an extremely disciplined painting, depth denied by the dying light and rising mist, a grid of verticals and horizontals marking the planes and intervals with an engineer's exactitude. Seurat arrived at such a controlled configuration via a drawing (DH 653; New York, Kettaneh collection) in which he carefully planned bank, jetties and masts. The sheet excluded much of the sky, and in the painting he was forced to rework this area. Pentimenti show that a factory chimney to the rear left and the foliage of the right-hand tree were painted out, Seurat arbitrarily violating natural appearances in favour of an uncluttered horizon and sky,

the better to evoke the claustrophobic void of the *banlièue*. Indeed, with its muted colours and lonely figures it might almost be envisaged as Seurat's response to Puvis's *Poor Fisherman*.

Two other suburban landscapes were painted in 1888. *Banks of the Seine (Island of the Grande-Jatte)* (Plate 140) was made in the spring, and Angrand, who worked alongside Seurat on the motif, left a description of its execution.[45] Also looking out over the Asnières-Courbevoie shore, the painting presents an entirely different mood from that of *Le Pont de Courbevoie*, gay and sprightly. Seurat followed his habit of marking the hori-

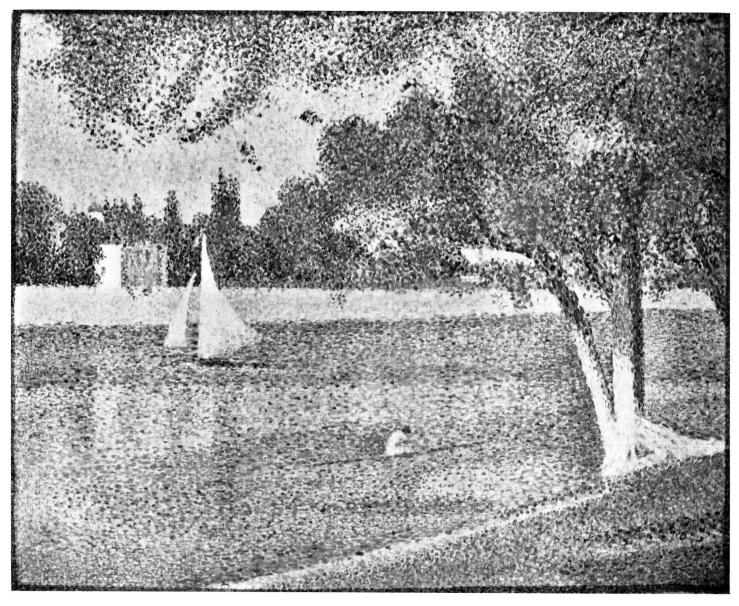

140. *Banks of the Seine (Island of the Grande-Jatte)*. 1888. Canvas 65 x 81 cm. Brussels, Musées Royaux des Beaux-Arts (DH 176).

zontal half-way point — here with the concrete bank — while filling the upper half with tumbling foliage and ordering the lower around gentle diagonals, with the image developed this time from an oil sketch rather than a drawing (DH 175; Paris, Pierre Angrand). *Banks of the Seine* was exhibited at Les Vingt in 1889 with the slightly larger *Dull Weather (Island of the Grande-Jatte)* (DH 177; Philadelphia, Annenberg collection), and these three landscapes indicate that the suburbs continued to interest Seurat after his two major figure paintings on the theme. Nevertheless, sharpness of social observation ceased to be an important objective; the suburbs seem to have reverted to their initial function in Seurat's scheme of things — convenient landscape motifs. This gradual disengagement from the social realities of the suburbs was paralleled by Signac, who in 1887 made his first visit to the Mediterranean sites which would come to dominate his oeuvre. Other Neo-Impressionists, notably Luce and Dubois-Pillet, continued to find significant subjects in the suburbs, but Seurat had begun to concentrate on figure subjects drawn from the life of the city itself.

Les Poseuses: the new painting and the nude

Les Poseuses (*The Models*; Plate 146) was a response to two stimuli. The inclusion of *La Grande-Jatte* in the background was a deliberate ploy, and Seurat probably realized once he had decided on the subject of nude models that such a conjunction could both amplify the meanings of his earlier painting and continue thematic currents that intrigued him. Again, it is possible that a nude subject was stimulated by contemporary critical discourse. In his review of the Eighth Impressionist Exhibition Fénéon had argued that the new technique would be excellent for smooth surfaces, 'notably the nude, to which no one has yet applied it', and other critics — Le Fustec, for example, writing of the Indépendants later in 1886 — had condemned its failure to

adapt to the figure.[46] The purpose of *Les Poseuses* was to put the case for Neo-Impressionism in the most elevated diction of high art: the language of the nude.

It seems likely that planning for *Les Poseuses* began in late 1886 or early 1887, perhaps the latter as Seurat had to spend time completing marines from the Honfleur campaign for his hectic exhibition programme. The initial idea involved a nude standing almost to attention, hands clasped in front of her belly. Seurat explored this in a drawing done from life in his studio (Plate 141), which he supplemented with a small oil study (DH 179; Paris, Renand collection). No doubt he found this pose too unrelaxed, too similar to the rigidity of *La Grande-Jatte's* figures, with which the new painting was to con-

trast, and he altered it. By the spring of 1887 he was able to exhibit at the Indépendants a panel of the resolved pose for the standing nude (Plate 144), more ample and natural, with head tilted and legs casually arranged. This little painting was worked up to a high degree of finish for exhibition, whereas the preparatory panels for the two flanking figures (Plates 142, 143) were less detailed, though no less carefully crafted in their colour structure. Blocked in with *balayé* strokes of flesh tone with a surface in a varied dot predominantly of blues and dull oranges, these figures swiftly established the fundamental poses and chromatic relationships, and also placed the models in approximate settings. Seurat made only two drawings that directly relate to the main canvas, both

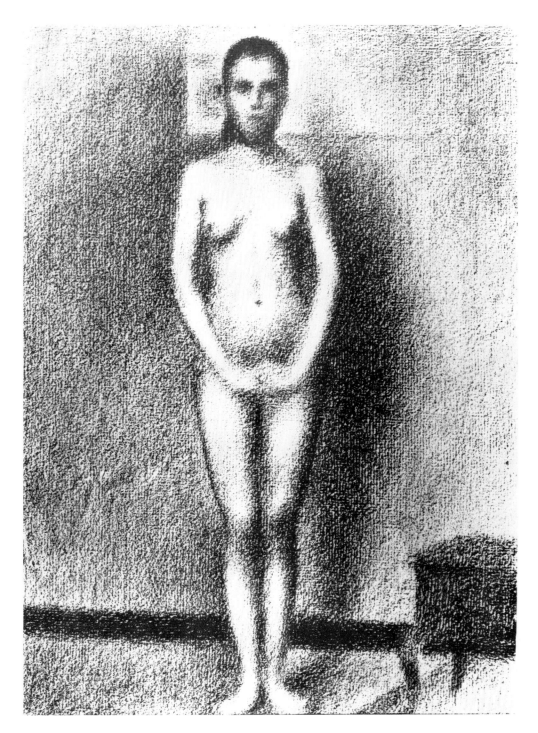

141. Study for *Les Poseuses:
Standing Model. c.*1887. Conté crayon,
29.7 x 22.5 cm. New York, Metropolitan Museum (DH 664).

137

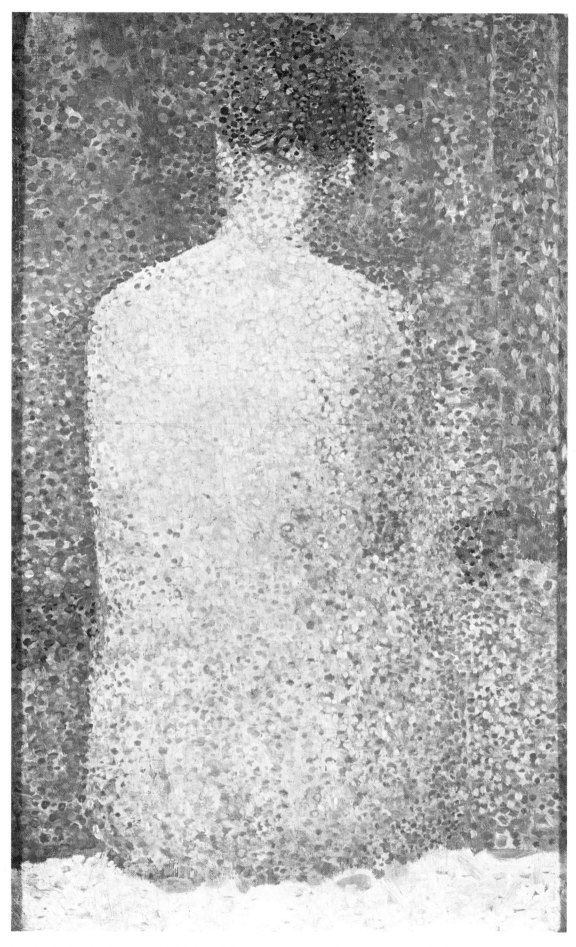

142. Study for *Les Poseuses: Model from Behind. c.*1887–8. Panel, 24.4 x 15.7 cm. Paris, Louvre (DH 181).

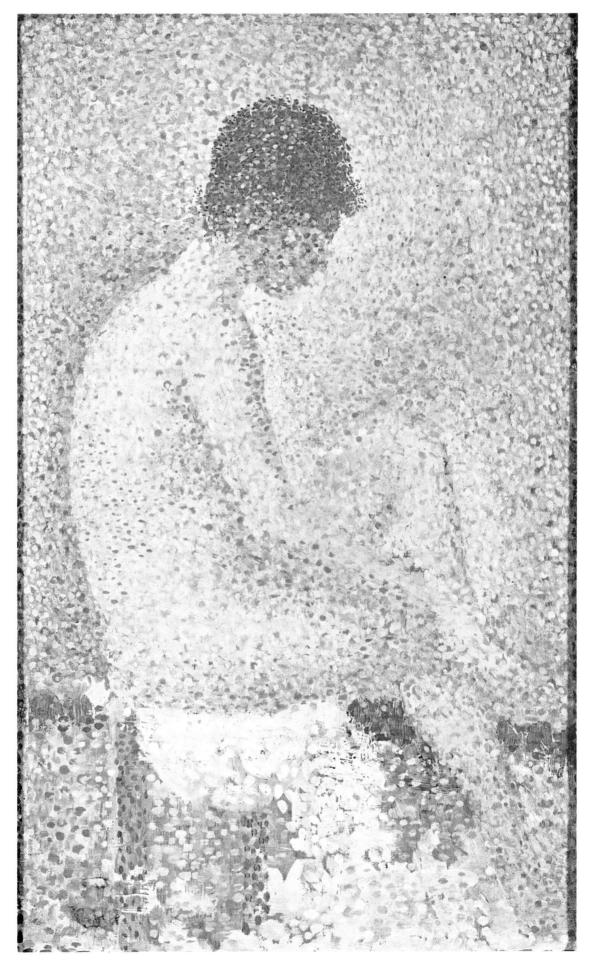

143. Study for *Les Poseuses: Model in Profile. c.*1887–8. Panel 24 x 14.6 cm. Paris, Louvre (DH 182).

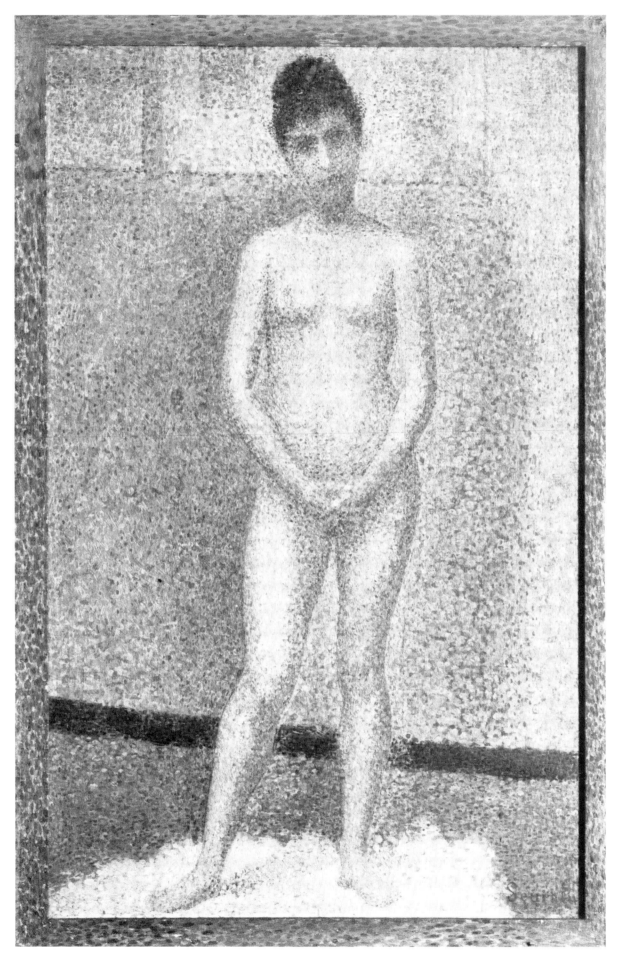

144. Study for *Les Poseuses: Model from the Front. c.*1887. Panel, 26 x 17.2 cm. Paris, Louvre (DH 183).

studies for the still-life elements in the right half of the painting.[47] These sheets would have been made after he had combined his three figures in a panel that established the intervals between them and the studio setting (DH 180; Paris, private collection), once more following his practice of fixing the general composition in colour first and adding the drawn details later. The genesis of *Les Poseuses* was thus shorter and simpler than that of *La Grande-Jatte*.

The execution of the main canvas caused considerable difficulties, however. Writing to Signac in August 1887 Seurat curtly remarked 'Painting on gesso desperate'. The pigments he was using were seemingly deficient, as Signac reported later that month to Lucien Pissarro, and the colours were already changing, a problem not helped by the gesso ground Seurat had chosen.[48] Indeed, it seems that, although Seurat did exhibit the large canvas at the 1888 Indépendants, he painted later a small-scale version which served as a private record of the colour relations he had intended (Plate 147). The exhibited *Poseuses* (regrettably, now difficult to study closely because it is hung so high) was the first major figure subject Seurat had handled from start to finish in the new technique, employing rigorous division of tone and the pointillist touch. It is a cool and refined painting, the models bathed in a studio light that enters from the left and the surface of their bodies treated with close accuracy. The observation of the laws of colour established in *La Grande-Jatte* was applied to *Les Poseuses* in a thorough but unobtrusive fashion. The painting is straightforward and satisfying, with its pyramidal configuration and its tripartite distribution not merely of the models but also of the horizontal planes, cluttered to foreground and rear, bare in the middle. Signac said later that he felt the touch was too small for the size of the canvas,[49] but the painting was widely admired.

Fénéon referred to *Les Poseuses*, as 'the most ambitious effort of the new art', Kahn called it 'a masterpiece'. To Adam and Signac *Les Poseuses* 'attained perfection' and 'established the Neo-Impressionist aesthetic'.[50] Kahn and in particular Fénéon discussed the use Seurat made here for the first time of a painted frame, to mediate between the painting's internal chromatics and its surroundings, one more instance of the artist's restless technical innovation. There were more conservative points to be made, too. At this period, perhaps more than at any other, Seurat's work provoked analogies with the classical tradition. In April 1887 Kahn had compared the character of Neo-Impressionist figure paintings to 'the hieraticism and ... the eternal quality of antique statues', while Jules Christophe had linked Seurat's single *Poseuse* (Plate 144) with Ingres's *La Source* (1856; Paris, Louvre).[51] A year later Kahn summed up Seurat's exhibits at the Indépendants, centred on *Les Poseuses* and *La Parade* (Plate 154), as having 'the simplicity and the majesty of antique art', while Fénéon had spoken of Seurat being as 'in the tradition of the Greek sculptors'.[52]

145. *Model from the Front* (after *Les Poseuses*). c.1887. Pen and ink, 25 x 15.5 cm. Illustrated in *La Vie Moderne*, 15 Apr. 1888, p.229. Los Angeles, Armand Hammer Collection (DH 665).

Such responses to *Les Poseuses* were almost inevitable, for in all three figures Seurat quoted classical prototypes.[53] The left-hand pose surely refers to Ingres's *Valpinçon Bather* (Plate 93), that touchstone of nineteenth-century classicism which Seurat had already invoked in *Une Baignade*. The other two models correspond to the poses of antique sculpture: the central figure to the *Venus Pudica* type, and the right-hand one to the *Spinario*. Such quotations were common in the persistent classical canon of much nineteenth-century French painting. In mid-century artists such as Amaury-Duval and Corot frequently cited the *Spinario* pose, and it occurs during the 1880s in Degas's work.[54] The modest posture of the *Venus Pudica* was also commonly adopted; when Hippolyte Flandrin, painting Eve, wanted a figure that combined the nude with religious seemliness he turned first to such a pose, as did Renoir on occasion.[55] The loose derivation from the *Venus Pudica* type that Seurat utilized in his central figure has

146. *Les Poseuses. c.*1887–8. Canvas, 200 x 250 cm. Merion Station, Barnes Foundation (DH 185).

147. *Les Poseuses (small version)* c.1888. Canvas, 39.4 x 48.7 cm. Private collection (DH 184).

148. Pierre Puvis de Chavannes, *Young Women by the Seashore*. 1879. Canvas, 205 x 154 cm. Paris, Louvre.

precedents in Corot, notably a demure portrait of a bride (*c.*1845; Paris, Louvre), and it was repeated by fellow Lehmann pupils such as Osbert.[56] Indeed, it is possible that the pyramidal composition of the three nudes in *Les Poseuses* was stimulated by the example of Puvis de Chavannes's *Young Women by the Seashore* (Plate 148), which Seurat would have seen first at the Salon of 1879 and then again at Puvis's one-man show held by Durand-Ruel in 1887. *Les Poseuses* was the third successive figure painting by Seurat to evoke comparison with Puvis — in 1890 Henry Van de Velde placed it with 'the most beautiful of Puvis de Chavannes's nudes'[57] — and this repeated response reminds us how closely Seurat was identified with the classical canon in his lifetime. Nevertheless, *Les Poseuses* continued the logical

development of Seurat's classicism, for whereas *Une Baignade* had relied on conventional, even academic formulae, with *La Grande-Jatte* and *Les Poseuses* Seurat worked to marry the classical traditions of French art with avant-garde techniques.

With *Les Poseuses* new theoretical considerations come into play. After their meeting in 1886 Seurat kept in contact with the mathematician, aesthetician and polymath Charles Henry, and he was evidently conversant with Henry's arcane ideas because he acted as 'translator' to less theoretically inclined colleagues like Pissarro.[58] In the mid-1880s Henry was developing ideas on the 'scientific' concordance of colours and lines, ideas known to Seurat's circle and finally published in his *Cercle chromatique ...* of 1888.[59] They have been aptly

summarized by John House: 'Henry associated colours and the direction of lines with moods: warm colours conveyed a happy or dynamogenous mood, cool a sad or inhibitory one; and lines moving upward or to the right a happy mood, downwards or to the left a sad one. He then drew together these two elements, colour and line, and linked particular colours to particular directions — warm colours corresponding to movements upwards and to the right, cool ones downwards and to the left.'[60] Such concepts tallied with those of the Symbolist writers, with their disciplined but oblique evocation of essential emotion, and Henry was a long-standing friend of Kahn and Laforgue.

Fénéon noted that in *Les Poseuses*, 'by a pseudo-scientific fantasy, the red parasol, the yellow parasol and the green stocking are orientated according to the directions that red, yellow and green have on Henry's chromatic circle.'[61] His observation was markedly ironic, and it is likely that Seurat applied Henry's theories only in their generalities. Indeed, John House has pointed out the fatuous results of matching Henry and Seurat in this instance: two happy parasols and a sad stocking.[62] The artist was alert to the latest thinking, as ever, but careful not to allow speculative theories to dominate his painting.

The meaning of the models

Critics made various comments on the painting's meanings. The presence of *La Grande-Jatte* in the background was remarked on by several, including Fénéon, Kahn and Geffroy, and commented on in detail by Adam: 'The people with their rigid Sunday stance are the same size as the models. One woman is fully dressed, on the arm of a proud gentleman; she strolls through the deep perspective of the wooded island that continues the drab perspective of the studio. On the one hand we have figures in the simplicity of nature, with an enigmatic feminine smile on their lips, with their elegant curves, neat, girlish breasts and soft pearly skin. And on the other are figures in their best clothes, stiff and starchy, solemn under the warm summer foliage.' The painting was, Adam argued, 'the synthesis of these two aspects of life'.[63] He immediately recognized the juxtaposition of naked and clothed, a common visual joke in nineteenth-century France. Louis Leroy's humorous *Les Pensionnaires du Louvre* of 1880, for example, included a drawing by Paul Renouard contrasting a woman in modern costume with the nude in Ingres's *La Source* (Plate 149), and a monumental volume on recent French caricature published in 1888 illustrated Dantan's famous statuette of a woman in a crinoline: one side shows the elegant lady in full fig, the other a cross-section revealing the scrawny body beneath.[64] Adam had dwelt on the ostentatious dress of *La Grande-Jatte* in 1886, and he perceived that *Les Poseuses* reinforced retrospectively one of the meanings of the earlier painting, Seurat's con-

149. Paul Renouard, *Couple looking at Ingres's 'La Source'*. 1880. 18.5 x 11.5 cm. From *Les Pensionnaires du Louvre*, 1880, p.67. Private collection.

cept of costume as a pretentious façade. The contrast between naked and clothed was complicated by the classical quotations of his poses: 'after shedding the artificiality of fashion, the models take on the artificiality of Art'.[65]

The juxtaposition of *La Grande-Jatte* and the models also established the polarity of leisure and work. Fénéon and Geffroy both saw *Les Poseuses* in terms of labour, the latter describing 'the slimness and the undernourishment of these thin girls who've reached puberty too rapidly ... the reality of the metropolis and gruelling labour.'[66] And in painting his studio, with his pictures on the wall, Seurat was depicting his own place of work. The subject was a cliché in the 1880s. 'The nude woman shares with the corner of the studio that rare privilege of being on the threshold of every artists' imagination', sniped Jules Vidal, an acquaintance of Seurat, in 1886. 'Often the two are united, the nude woman and the corner of the studio: the one in the other, and the result is called *The Model's Rest*. Isn't it ingenious?'[67] Vidal's

145

150. Salle Estradère, *In the Studio*. 1890. Canvas. From A. Silvestre, *Le Nu au Salon*, Paris, 1890, n.p. Location and dimensions unknown.

sarcasm was well founded, for contemporary Salons included depictions of every likely studio occurrence: the artist at work or having his work criticized, the model resting or being selected by the artist (Plate 150), even a sculptor taking a cast from the model.[68]

Les Poseuses is often taken to be a programmatic exploration of three different positions — front, back, and profile, rather like J.-B. Regnault's *Three Graces* (c.1799; Paris, Louvre) — and with its classical references it was no doubt intended to make an academic point. But it does not show the same model three times, as some have suggested,[69] because there are two pairs of shoes, three parasols and three bonnets. *Les Poseuses* is not merely an artificial arrangement; it is derived from a specific everyday event. Seurat represented three models in his studio: the one on the left half undressed, modestly keeping on skirt and chemise, turning her back to artist and spectator; the central girl standing, holding herself openly but with dignity, chemise at her feet; the right figure dressing, careful not to flaunt herself. This characterization tallies with contemporary accounts of models' behaviour. They were known for their modesty — 'the women who pursue this trade (only the virtuous are involved) are imbued with a very particular modesty', recorded Hugues Le Roux in 1888 — and indeed the reviewer in *La Paix* referred to *Les Poseuses* as 'a very chaste picture'.[70] Seurat may have tried subtly to indicate this by obscuring the monkey in *La Grande-Jatte*,[71] and also gave a clue as to the identity of the models. The many Italian girls working as models in Paris reputedly

removed their chemises over their heads, while a true Parisienne — like Seurat's central figure — allowed her final garment to fall to the floor, forming 'an improvised pedestal' on which she would stand to show off her body. This is what the painting depicts. The women are not actually posing for a picture; one waits, another displays herself, the third dresses. They are showing themselves to the artist, hoping to be hired to pose, and in such circumstances a model would 'discuss herself like a saleswoman discussing her merchandise'.[72] It was a professional, not a degrading, practice, and in painting the hiring of a model Seurat represented a commercial arrangement. He certainly envisaged *Les Poseuses* in such terms. In February 1889 Octave Maus, who knew of an interested collector, wrote to ask the painting's price. Seurat replied that he would charge for a year's work at seven francs a day, by no means a high price for a large painting.[73] Seurat could afford this with his private means, of course, but he was charging much the same as a female model would earn a day; she would receive about five francs for a morning or afternoon *séance*.[74] He might have been aiming just to recoup his costs, or there might have been something egalitarian in his suggestion; perhaps he saw his work as having much the same value as his models'.

It was common for Seurat's literary colleagues to draw wry comparisons between the modern and the classical. Fénéon's stated preference for *Les Poseuses* to 'the nudes of art galleries and mythology'[75] suggested such a contrast and others were frequent in contemporary poetry.

151. J-L. Forain, *The Client*. 1878. Gouache, 25 x 32.5 cm. London, private collection.

Take one example, the first verse of *Réminiscences épiques* by Ephraïm Mikhaël, who Seurat would have met in the Caze circle:

Je préfère aux beautés des Artémis divines
Le corps mièvre et danseur des filles de Paris;
J'aime les yeux rieurs et les voilettes fines,
Les contours estompés par la poudre de riz'.[76]

[I prefer to the beauties of a divine Artemis/The fragile, dancer's body of Parisian girls;/I love the laughing eyes and delicate veils,/The features softened by rice powder.]

Here the body of the Parisienne is promoted over the mythological figures of antique sculpture, and it seems likely that Seurat too was trying to cultivate such parallels. Bringing classical subjects up to date was a tactic to be found in the contemporary visual arts also. He would have been well acquainted with Forain's *The Client*

(Plate 151), which in the 1880s belonged to Huysmans, who hung his Seurat drawings nearby.[77] In this vivid gouache Forain made a modern witticism at the expense of classical mythology; it can be seen as the brothel client choosing a prostitute or as a spoof of the Judgement of Paris. In a similar vein, *Les Poseuses* — in an implicit and thoroughly respectable fashion — dealt with the subject of a woman being selected to do work for a man who will pay her. And it could also be envisaged as a modernized version of the Three Graces, applying the poses of the classical tradition to a contemporary subject. *Les Poseuses* was not a mere academic exercise; it was an image of multiple meanings.

La Parade de Cirque; composition and theory

Late in 1887, with *Les Poseuses* still in progress, Seurat began work on another figure painting, *La Parade de*

147

Cirque (Plate 154). His fascination with the world of saltimbanques and travelling players went back at least as far as 1881, when he had drawn them at Montfermeil, and in 1886 he had shown a drawing of a circus subject at the Impressionist Exhibition. One of the attractions at the annual Foire aux Pains d'Epice (Gingerbread Fair), held in the Place de la Nation during April and May 1887, was the Cirque Corvi, and Seurat chose to represent this circus's *'parade'*: the casual entertainment provided outside the tent by the musicians and performers to entice the public to come in and see the circus proper.[78]

La Parade seems to have been executed quite hastily, both as an antidote to Seurat's frustration with the lagging *Les Poseuses*, and as an experiment with unapplied aesthetic theories. Shown together at the 1888 Indépendants, *Les Poseuses* and *La Parade* share general compositional concerns — frontality, symmetry and shallow space — that mark a departure from the earlier configuration used for *Une Baignade* and *La Grande-Jatte*, which set repeated horizontal planes against diagonals driving into deep space. Seurat's haste, even his confidence, are witnessed by his preparatory work. A drawing for the female spectator third from the left (DH 662; destroyed) may not even have been a direct study for *La Parade*; he might well have taken existing drawings of types and incorporated them in his rapidly developing project. Two other drawings, recently published by Herbert, relate intimately to the painting's genesis: one the placard of the Corvi, the other a sheet of diagrammatic sketches and colour notes.[79] Seurat made three compositional drawings for *La Parade*, all of approximately the same size, 30.5 by 24 cms. The sheets for the left-hand (DH 667; Paris, private collection) and central sections (Plate 152) match the final image quite closely, and the latter has colour notes on the verso which Seurat followed when he painted the trombonist and his surroundings. The drawing for the right side (DH 669; formerly de Hauke collection) represents the figures of clown and ringmaster in larger proportions than they have in the painting, and includes a pony (the Corvi was famous for its animals) between them; these differences suggest that it was the first of the three. Seurat's approach to the composition was thus tripartite, much as with *Les Poseuses*.[80]

Seurat also painted an oil sketch for *La Parade* (Plate 153). The panel was lightly squared in exactly the same way as *La Grande-Jatte*, with the vertical divided into quarters and the horizontal into sixths, the artist thus halving both edges. This sketch established the fundamental chromatic construction of the main canvas, to which it almost exactly corresponds (with the exception of the tree). As Herbert has pointed out, this panel marked a radical departure in Seurat's practice. With the *croquetons* painted *en plein air* Seurat could always return to the motif for revision, but with a nocturnal subject he could not even work direct from his subject. *La Parade*, and especially its colouration, derived from

an intellectual amalgam of theory and memory, abruptly at odds with the essentially naturalistic means of his previous preparatory procedures.[81]

La Parade itself measures almost exactly 100 by 150 cms, dimensions responding simply to the squaring of the oil sketch and the three compositional drawings. The painting broke from the life-size scale of the earlier figure paintings — perhaps because it was executed in some hurry, or because it was experimental in character — but kept to the proportions of both *Une Baignade* and *La Grande-Jatte*: the canvas half as long again as tall. We look over the heads of the crowd queuing for the circus at musicians standing on a temporary platform outside the tent. The green construction to the right juts out towards us, and the public with reserved seats make their way up some unseen steps and past the ringmaster to the box office. The trombonist stands on a plinth to the left of the steps, in front of some more stairs, marked by a banister, which serve the entrance for those without reservations. Behind these stairs is a platform on which the bandsmen stand. The whole scene is set against the provisional presence of the circus tent, decorated with oval placards of the attractions and, behind the trombonist, the prices of entry, all lit by gas-jets from the pipe above and light exuding from the circus itself. This deep pink glow emanating from behind the figures sets them in silhouette and warms the predominantly blue-violet tone of the painting.

Typically, Seurat first blocked in the canvas with broadly painted areas of local colour. The surface layer of *La Parade* was not, however, painted in uniform dots; Seurat's handling was more flexible and less dogmatic than is often thought. The tree, for instance, was executed in little vertical pink dashes over a deep blue underlayer, with varied lighter blue marks at the margins, while the oval to the rear left was painted in quite broad dabbed patches and dots. And the face of the trombonist, handled in small dots of rich pink over dark blue and green, contrasts with that of the ringmaster, executed in larger dots of flesh tone, touched with mid-blues and dull orange. At first glance *La Parade* seems flat and geometric, but in fact it does have depth, provided by contrasts of value and the overlapping of figures. This relief, the sense of separation of audience from performer, is vital to the painting's meaning. The disturbing effect of *La Parade*, at once mesmerizing and daunting, is due to its inherent ambiguities: the bustling crowd reduced to a fossilized formula, the silent scene of noise, the scintillating yet melancholic colour.

In Seurat's lifetime the painting was met with disaffection. He only chose to exhibit it once and he did not mention it in the list of major paintings that he prepared for Maurice Beaubourg the following year.[82] Its reception at the Indépendants in 1888 was lukewarm. Several critics paid it little or no attention. Even to close associates the painting appeared marginal; Signac merely cited a 'nocturne' and Fénéon spoke sceptically of the 'application of a method which aimed at doing scarcely more

152. Study for *La Parade: The Trombone Player. c.*1887. Conté crayon heightened with gouache, 30.5 x 23 cm. Philadelphia, McIlhenny Collection (DH 680).

153. *La Parade: Esquisse. c.*1888. Panel, 16 x 26 cm. Zurich, Bührle Collection (DH 186).

154. *La Parade de Cirque*. c.1887–8. Canvas, 100 x 150 cm. New York, Metropolitan Museum (DH 187).

155. Humbert de Superville, *Schematic Faces*. From *Essai sur les signes inconditionnels dans l'art*, Leyden, 1827–32.

than capturing daylight effects to the nocturne'.[83] *La Parade* seemed an imprudent experimental departure, especially to Fénéon, who insisted on seeing Seurat's work as the logical development of Impressionist landscape painting.

Yet the night-time subject had long interested Seurat; one calls to mind the work by candlelight, a number of early drawings, and the dusk painting (Plate 175) from Honfleur in 1886, and suspects the ambition to better pictures like Angrand's *Accident*. And there is Kahn's evidence that Seurat's fascination with the nocturne was reinforced by Whistler's ideas on the subject, expressed in the *Ten O'Clock Lecture*, a translation of which was published by Mallarmé in the *Revue Indépendante* in May 1888.[84]

If *La Parade's* nocturnal subject forced Seurat away from a more direct to an increasingly cerebral synthesis of natural appearances and so required a more comprehensively theoretical approach than his earlier work, this was in line with much contemporary Symbolist theory. Henry's ideas on the visual arts were paralleled by similar 'scientific' initiatives in literature, such as René Ghil's *Traité du verbe* of 1886, which attempted to equate colours and the sounds of words. *La Parade* is perhaps the most intimately connected of Seurat's paintings with this climate of ideas, the artist's most thorough attempt to control the spectator's emotions subconsciously by the disciplined devices of his art. The sheet of diagrams and notes Seurat made as he formulated his ideas for the painting proves that he planned its geometric structure with reference to Henry's mathematical ideas. He listed numbers that correspond to the proportions of the windows to the right, for instance, and one of the diagrams relates to the Golden Section, which he utilized in *La Parade*, notably for the balustrade in front of the musicians. As Herbert has pointed out, on this sheet there are quotations about the necessity to investigate new scientific ideas in order to arrive at new aesthetic concepts which come from Henry's *Introduction à une ésthétique scientifique* (1885), indicative of Seurat's interest in his friend's researches.[85]

It would, however, be unwise to see *La Parade* purely in terms of innovative ideas, for like much of Seurat's work it combined the radical and the conventional. It must have been about the time that he was working on the picture that Seurat made the remarks which Kahn quoted in January 1888: 'I want to make modern people, reduced to their essential characteristics, move as they do on those friezes [by Phidias], and to place them in canvases arranged in chromatic harmonies, by means of tones ordered into directions that are in harmony with the direction of the lines, with line and colour arranged in accordance with one another.'[86] This statement clearly reflects his recent acquaintance with Henry's ideas, and refers to the arbitrary arrangement of *La Parade* rather than the more naturalistic disposition of *La Grande-Jatte*, but it is important to remember that Seurat would have read about the emotional and associative qualities of line and colour early in his career. Blanc had discussed the direction of line as emotionally significant — horizontals, for example, stimulated feelings 'of solemn repose, peace, and endurance' — and Sutter the moral value of colour: orange the image of pride and vanity, say, or blue of modesty and candour.[87] Once again, Henry's work mentioned Humbert de Superville's research of earlier in the century which established with schematic drawings of the human face how the direction of lines dictated the spectator's perception of emotion (Plate 155), and another of the diagrams on Seurat's sheet reproduced de Superville's schema. These ideas had been discussed, and the faces illustrated, in Blanc's *Grammaire*.[88] Henry's theories were thus based on concepts of which Seurat was already aware; nevertheless, in the later 1880s he provided an undoubted intellectual stimulus, both consolidating and complicating ideas that intrigued artist and writer alike. Much the same com-

156. Anonymous (Bertall?), *Champs Elysées. Fête Sunday*. 1840s. Wood engraving. From: Anon., *Parisian Sights and French Principles*, New York, 1852, p.101.

157. J-J. Grandville/A. Desperet, *Zin! Zin! Baoum ...* 1833. Lithograph, 34.5 x 41 cm. Paris, Bibliothèque Nationale.

bination of old and new can be found in *La Parade's* design, which looks so unrepentantly modern. Seurat's liking for symmetrical compositions might be traced to copies he made as a student, after Poussin's *Ordination*, Ingres's *Apotheosis of Homer* or Raphael's Chigi Chapel frescoes, while the emphatic frontality referred back to drawings of saltimbanque subjects made in the early 1880s, such as the *Clowns and Pony* (DH 668; Washington, Phillips collection), and is indeed the conventional mode of representation for parade imagery.

The imagery of the 'parade'

The theme of the *parade* was common in nineteenth-century French popular imagery, and many cheap prints depicted the crowd of onlookers in front of the musician or saltimbanque, inviting the viewer to identify the types in the audience and look over their heads to the performers (Plate 156). Seurat would undoubtedly have known of such pictorial traditions, perhaps via his father's collection, which included woodcuts of rows of rigid soldiers similar to the musicians in *La Parade*.[89] He must also have been aware, too, that the *parade* subject made a perfect and frequently used vehicle for political caricature. In 1826 an album of ten caricatures was published under the title *Les Parades*, each parodying one of the different political régimes since 1789; Grandville's *Zin! Zin! baoum ...* of 1833 (Plate 157) ridiculed contemporary government ministers like Guizot and Thiers by envisaging them as saltimbanques and charlatans; in 1848 Bertall's *La Foire aux Idées* depicted for the readers of *Le Journal pour Rire* the leading socialist thinkers — Proudhon, Cabet, Considérant — touting their ideas to a milling crowd.[90] Seurat's subject — a travelling circus at the Foire au Pain d'Epice — thus utilized a popular imagery with inescapable political associations.

The Place de la Nation where the fair was held lies to the far east of Paris, less than a kilometre from the Porte de Vincennes, in the 12th arrondissement. This area,

between Bercy and Ménilmontant, was a working-class and *petit bourgeois* vicinity, but the crowds who visited the annual fair came from all over Paris. Thus in *La Parade* Seurat was painting a temporary population as in *La Grande-Jatte* and, although he depicted an urban scene within the fortifications, his challenge was once more to make a synopsis of the fluid populace on the margins of the city. Such fairs fascinated writers and artists in the 1880s, and Seurat's painting needs to be considered within a complex and contradictory web of polemics and mythologies. Descriptions of the *parade* itself can be found in poems by contemporaries as different as Ajalbert and Jean Lorrain.[91] Jules Vallès planned a novel, *La Dompteuse*, that would deal with the life of the fairs, and although it was never completed a substantial amount of the factual material he had gathered was incorporated in a series of articles which appeared in *Gil Blas* during April 1882.[92] The *parade* continued to be treated in popular illustration — a drawing by Charles Maurin, published in *La Vie Moderne* in 1882, can stand as a recent example — and was not uncommon as a subject for painting; Raffaëlli exhibited two *parade* subjects at his one-man show in 1884, and young Emile Bernard tackled the saltimbanque theme in 1887.[93]

Something of the irregular character of Seurat's painting comes into focus when one compares it to a passage of Ajalbert's prose, precisely contemporary, on exactly the same subject. 'They arrived at the sideshows. The bass-drums boomed. The racket of trombones and cornets interwove with the patter of the clowns, and the crowd settled down in front of the *parades* ... Above the grating of the whirligigs and the hurly-burly of the bands, rifles cracked in feeble fusilades and squibs exploded, their smoke sullying the bluish sky of suburban August, swarming with stars.'[94] Ajalbert's naturalistic description is one of noise, excitement, jostle, vulgarity; by contrast Seurat's painting is silent, anti-climactic, petrified, fastidious. The accepted myth of these fairs saluted the mutual gaiety of all classes. In 1884 Paul Hervieu wrote of the 'perfect harmony' of the summer fair, and three years later Albert Samain recorded in his diary a scene that might well describe the left side of *La Parade*; watching three musicians one night on the outer boulevards, 'in front of me I had the pretty napes of two Parisian girls, a blonde and a brunette, with their hair worn up and showing their young necks, enjoying the mawkish ballad ... That's the heart of lower-class Paris, sentimental and good-natured'.[95] Even Vallès could wax lyrical. 'The *parade* begins', he wrote in 1883, 'and there is the lad from the scruffy suburbs as happy as the rich man's son in front of the golden glitter and the sight of these merry farces'.[96]

Behind this mythology lay a more complex reality; the fair was political, it refused to be assigned to the margins of society. At one level its performances could be overtly satirical of contemporary politicians; 'under M. Thiers, the plump dwarf had his heyday, under Mac-Mahon people wanted him with a moustache,' reported

Vallès in one of his articles for *Gil Blas*.[97] At another the factions within the fairgrounds themselves made a metaphor for society as a whole. The larger outfits — such as the Cirque Corvi — were putting the traditional travelling player under pressure. 'Rich saltimbanques do not want poor saltimbanques; the proprietors of circuses with monkeys and ponies do not want to have around those who only have a Munito, six rats or a few fleas to earn their daily bread,' argued Vallès in radical socialist vein. 'The fun of chance is disappearing. The schemes of the fancy large shows are killing it ... It's the Social Question argued out in the fairground to the noise of the big bass drum!'[98] At least one painter dealt directly with the unenviable hardships of the poor saltimbanque in 1888. That year Fernand Pelez exhibited at the Salon his *Grimaces et Misère* (Paris, Musées de la Ville de Paris), a highly naturalistic representation of exhausted, poorly nourished acrobats, clowns and musicians going through their *parade* routine — once more the Salon painter and Seurat in parallel. It was a painting with which the conservative art press would not come to terms. The *Revue des Deux-Mondes* refused to take its composition seriously; the *Gazette des Beaux-Arts* shrugged it off: 'Today we dedicate as much canvas to the evocation of physiological, social and moral misery as Veronese did to the celebration of Venetian festivals ... That, one might say, is a sign of the times.'[99]

Seurat did not approach the *parade* subject with the intense naturalism of Pelez; he inserted meaning into his painting by different methods. In *La Parade* he paid careful attention to the audience, identifying each type and expecting the spectator to do the same. Herbert has argued that the audience represents 'a cross-section of society':[100] the worker in his cap, three bare-headed *filles du peuple*, bowler-hatted *petit bourgeois*, and middle-class gentlemen in their top hats accompanying elegant women wearing fashionable conical bonnets. Further than this, Seurat divided his classes, placed a gap between them, put them — as it were — to the left and right of his painting. In a sense this was a likely, if approximate, division: the wealthier visitors taking the more expensive reserved seats, the less well-off queuing for the places at 50 centimes. The disposition of line and colour suggests that in his representation of the audience Seurat applied Henry's principles. Henry characterized lines moving downwards and to the left with blue-violet, blue and blue-green as inhibitory or sad; this corresponds to the lower left of *La Parade*, the banister leading to the cheap seats, the proletarian section of the audience. And he characterized lines moving upwards and to the right with red, orange and yellow as dynamogenic and happy; this tallies with the upper right of the painting, the bourgeois queue moving up towards the box office.[101] Seurat thus continued the political associations of *parade* imagery, applying his new theoretical means to his purpose, quietly contradicting the myth of class harmony at the fair that prevailed in the 1880s.

La Parade differs from the conventional presentation

158. Honoré Daumier, *The Parade at the Fair.* c.1860. Watercolour, pen and wash, 26.6 x 36.7 cm. Reproduced in Arsène Alexandre's monograph on Daumier (Paris, 1888, p.169). Paris, Louvre.

of the performers in much saltimbanque imagery. Seurat's figures are deadpan, in contrast to, say, Daumier's, who sullenly express their alienation or hysterically plead for attention (Plate 158). He would have known Daumier's images, via Champfleury's *Histoire de la Caricature Moderne* perhaps, or his acquaintance Arsène Alexandre, who published the first book on the artist in 1888.[102] Seurat's conception was not demonstrative, but rather metaphorical. He must have been aware of the close contemporary association of artist and saltimbanque. In the preface of his novel about the circus, *Les Frères Zemganno* (1879), Edmond de Goncourt referred to the famous acrobats the Hanlon-Lees as true artists;[103] indeed, the two acrobats around whom the novel revolves were a metaphor for the Goncourt brothers themselves. And Camille Pissarro in 1887 compared his struggle for sales to a street-singer: 'Ah bah! It's like being a street-singer, the bourgeois turns his back on you when he ought to reward you for so much effort.'[104] In 1888, after the exhibition of *La Parade*, Huysmans reminded readers of *La Cravache* of an image he remembered from the first Indépendants in 1884,

depicting clowns performing in a spectral, twilit circus, and asked who the mysterious artist — Wagner — was.[105] The following month Signac replied that Théo Wagner had been at the Ecole des Beaux-Arts with Seurat, and was both a painter and an amateur trapeze artist.[106] *La Parade* may have owed a pictorial debt to Wagner's lost work, but what is important here is that Seurat knew someone who actually lived the artist-performer metaphor.

The compositional configuration Seurat chose to encapsulate this metaphor corresponds not only to popular imagery but also to one of Rembrandt's etchings, *Christ Presented to the People* (Plate 159). As we have seen, Seurat greatly admired Rembrandt's prints; he both owned and had access to reproductions of them.[107] This particular print was praised in Blanc's *Grammaire* as one of Rembrandt's masterpieces[108] and *La Parade* is reminiscent of its roughly symmetrical design, with figures on the dais, crowd in front, and stairs to the right. But the analogy of subject is more important here than similarity of composition. Seurat was well acquainted with the New Testament incident when Pilate left the

159. Rembrandt, *Christ Presented to the People*. 1655. Drypoint, third state, 35.8 x 45.5 cm. New York, Metropolitan Museum.

decision to crucify Christ to the crowd; about 1875–6 he had made a drawing from the life in the pose of the bound Christ, and the sheet is inscribed with the appropriate reference in St Matthew's gospel.[109] The reference — conscious or unconscious — in *La Parade* to the Ecce Homo theme could hardly have been more apt; both subjects confront the crowd and the individual, both involve the judgement of one on the other.

In this respect the contemporaneous *Les Poseuses* and *La Parade* are linked in theme, for both are scenes of judgement before a transaction. At a fundamental level both paintings represent the hiring of labour. Indeed, in the mid-1880s both artists' models and saltimbanques were forming trades unions to protect their interests as workers.[110] In *Les Poseuses* the hiring takes place in the privacy of the studio, in the unseen presence of the artist alone, while *La Parade* includes its audience and shows money changing hands; it is an openly public and commercial image. There is an approachable naturalistic quality to *Les Poseuses*, setting it apart from the more

forbidding, intimidating *La Parade*, which uses a different vocabulary of meaning. *La Parade* utilized popular imagery, but not in the direct, even emblematic, fashion of *La Grande-Jatte*. Seurat made reference to the frontal configurations and political associations of *parade* imagery, but steered clear of the allegorical method of bringing social criticism into his pictorial language, as for example Willette did in his stained-glass window for the Chat Noir cabaret (Plate 213). Seurat animated *La Parade* with critical meaning by metaphorical means: the colour and direction of lines orchestrated to prompt subdued, melancholic feelings at odds with the mythology of the subject but appropriate to its realities, the figures regimented to conjure up the alienation of the performer from his audience and the failure of the fair to disguise the divisions of society. *La Parade* was Seurat's first thoroughgoing attempt to produce a major canvas combining the language of popular imagery with the idiom of progressive painting that was coherent in style and articulate in meaning.

8 The Marines

The paintings

Seurat's marines are central to his oeuvre. He obviously thought so; he worked on his paintings of the sea and seaports in concentrated campaigns and frequently exhibited groups of his pictures of Channel-coast sites, sometimes alongside figure paintings, sometimes alone. Seurat was clearly ambitious to be acknowledged as both a landscape painter and a figure painter. His motives for painting marines can be deduced from his first group of marines, executed in 1885: he needed to distance himself from Paris, either because progress on Parisian projects had stagnated or because he wanted to work in a fresh, contrasting environment; he wished to concentrate temporarily on landscape motifs, for which he had a temperamental affinity; and he had to come to terms with the most advanced in landscape painting, which at that time meant the work of Monet. The hint of competition with Impressionism — which should not be exaggerated — diminished as Seurat's marines gained in confidence and individual identity.

The importance to Seurat of his marines came to be based on a number of factors, not least that as modestly scaled pictures he could produce them more readily than figure compositions and regularly have a group ready for exhibition, and that they were more easily appreciated by the public than his figure paintings. Again, after *La Grande-Jatte*, as Seurat's figure pictures turned towards more artificial environments, the marines sustained his interest in landscape, for which the Neo-Impressionist technique had been devised. Seurat's commitment to painting landscapes annually was lifelong and consistent, from the early market garden and suburban paintings, via the sketches for *Une Baignade* and *La Grande-Jatte*, to the later Seine-side canvases and the Channel campaigns. In the year after a major summer campaign Seurat would not produce a figure subject, concentrating instead on fully resolving and then exhibiting the previous year's marines; this happened in 1887 with the Honfleur and 1889 with the Port-en-Bessin paintings. Thus a group of marines should be seen as having the same status as a major figure picture.

Grandcamp, 1885

The first group of marines were painted in 1885 at Grandcamp in Normandy, some twenty kilometres to the north-west of Bayeux. Seurat's procedure was standard. He used the orthodox oil sketch practice — producing twelve *croquetons*,[1] and making no drawings — to get acquainted with the area, scout for motifs and plan paintings. Sketches survive, some approximate but some matching exactly, for all five finished canvases that resulted from the Grandcamp visit. Seurat's choice of motif in these paintings was limited. Two look directly out to sea — *Fishing Boats, Low Tide* (DH 155; London, Lefevre Gallery) and *The Roadstead at Grandcamp* (Plate 162) — while two others look along the shore — *Fort Samson* (DH 157; location unknown) and *Grandcamp, Evening* (DH 161; New York, Museum of Modern Art).

The flat and dreary littoral of Grandcamp gave the artist little scope, and to break from this monotony Seurat walked two or three kilometres east, up on to the cliffs, to the famous landmark of the Bec du Hoc. The painting of this site (Plate 161) is the clearest example of the importance of Monet for Seurat at this time. At the Impressionist exhibition in 1882 Monet had shown several cliff paintings, and these had an immediate impact on other artists. The young Signac, for instance, who worked regularly in Normandy during the early 1880s, painted at least one dramatic crag in response to Monet's example.[2] In his paintings (Plate 163) Monet used the scale and presence of the Normandy cliffs to give a stirring sense of nature's power and to investigate spatial effects, suggesting the void between brink and shore without actually representing it. Seurat adopted this effect in his *Bec du Hoc*, without sacrificing the extravagant natural drama of Monet's motifs. And even the more mundane *Roadstead at Grandcamp* seems to have been a response to Monet, in particular to his device of masking off the central area of the picture to give a more naturalistic, glimpsed effect, as in *Sea Coast at Trouville* (1881; Boston, Museum of Fine Arts).

However, Monet's importance — as a rival, as a

160. Study for *Bec du Hoc, Grandcamp*, 1885. Panel, 16 x 25 cm. Private collection (DH 158).

touchstone of quality — was essentially compositional. Seurat's touch in, say, the *Bec du Hoc*, was much more controlled than in Monet's equivalent marines. Both grass and sky were executed in the *balayé* stroke, the sea in horizontal dashes overlaid with dots, and there was a more direct use of secondaries than in previous canvases, for instance the mixture of blues, purples and oranges in the shadows. Seurat's greens were much blonder, more subdued, than in contemporary Monets; at the 1886 Impressionist exhibition *The Roadstead at Grandcamp* reminded Mirbeau of Cazin rather than Monet.[3]

There is no exact evidence about Seurat's working procedure on his marines, but the strong likelihood is that he did not follow the Impressionist practice of painting all, or almost all, the canvas *sur le motif*. It is much more probable that he followed the orthodox pattern, with an oil sketch and perhaps the initial work done in front of the motif, and all the rest in the studio. This is supported by the instance of the *Bec du Hoc*. The *croqueton* (Plate 160) was painted at low tide, with the rocks exposed. This cluttered the space and reduced the effect of void that Seurat wanted, a problem resolved in the canvas by stepping back from the cliff and painting a

higher tide. Such a solution suggests an arbitrary adaptation of the motif, as does the addition at a very late stage of the white sail on the horizon as an indicator of depth. For all that the Grandcamp paintings were to some extent tentative, the artist's disciplined procedures stabilized the results. The *Bec du Hoc* and *The Roadstead at Grandcamp* were considered successful enough to be shown twice in 1886, at the Impressionist Exhibition and at the Indépendants in the autumn, and the *Bec* appeared again at Les Vingt in 1887, and even as late as February 1888 in a small hang at the offices of the *Revue Indépendante*.

Honfleur, 1886

The following summer Seurat worked at Honfleur, in eastern Normandy on the estuary of the Seine. There he produced seven canvases, his largest number from a single campaign and the first group planned from the outset to be executed in the new technique. Honfleur was the biggest port at which Seurat painted, and the one with the strongest artistic links. In the mid-nine-

161. *Bec du Hoc, Grandcamp*. 1885. Canvas, 66 x 82.5 cm. London, Tate Gallery (DH 159).

teenth century it had become a magnet for painters, developing an informal tradition of which Seurat must have been aware as the place's popularity continued; Cals had four pictures of the port at the 1879 Impressionist Exhibition, and at his one-man show in 1884 Raffaëlli included a 'Suite de Six Peintures sur Honfleur'.[4]

Thanks to the letters he wrote to Signac we know a good deal about Seurat's work in Honfleur. He arrived on 20 June, and wrote in a later letter that he would leave on 13 August.[5] He stayed with M. Hélouin, a customs official, perhaps a contact of his father's. Whether lodging with a family friend or at a small hotel – as one assumes he did at the other ports — Seurat probably had few facilities for painting. He wrote his first letter on 25 June: 'I hope I'll soon be able to get on with my canvases seriously. Up to now I've only done sketches to get acclimatized.'[6] After the initial reconnaisance Seurat began to work, and his letters chart his sensitivity to weather conditions. 'Wind and as a result clouds have spoilt the last few days for me,' he wrote in early July;

'the stability of the first days should be coming back.' But he was clearly enjoying himself: 'let's go and get drunk on light again; that's a consolation.'[7]

On the evidence of the surviving work Seurat's preparatory practice varied. One canvas, *The Harbour Entrance* (Plate 168), was done directly from a drawing (DH 657; New York, Sandblom collection) with little change, while another, *End of a Jetty*, has a related but not identical drawing (Plates 164, 165). Three canvases were worked up from quite precise oil sketches, *The Hospice and the Lighthouse*, *The Seine Estuary, Evening*, and *The Beach of Bas-Butin* (Plates 167, 175, 172).[8] The final couple of canvases, the large sketch *Corner of a Dock* and *The 'Maria'* (Plates 166, 176) apparently had no preliminary research.

Just before he left Honfleur Seurat systematically listed his progress to date in a letter to Signac. He considered the *Corner of a Dock* completed as a large-scale sketch, 'the motif having long since dispersed'; the two beach scenes well advanced but not finished; the canvas of the jetty covered but in need of more work; *The*

162. *The Roadstead at Grandcamp*. 1885. Canvas, 65 x 81.2 cm. Private collection (DH 160).

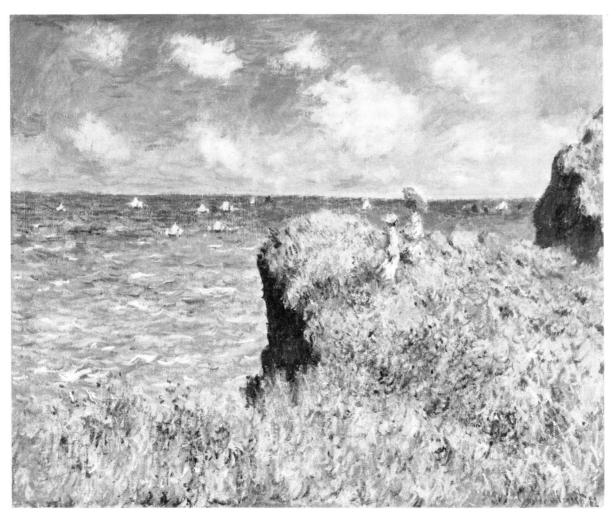

163. Claude Monet, *Promenade on the Cliffs, Pourville*. 1882. Canvas, 65 x 81 cms. Chicago, The Art Institute of Chicago. Exhibited in March 1883 at the Durand-Ruel Gallery, Paris.

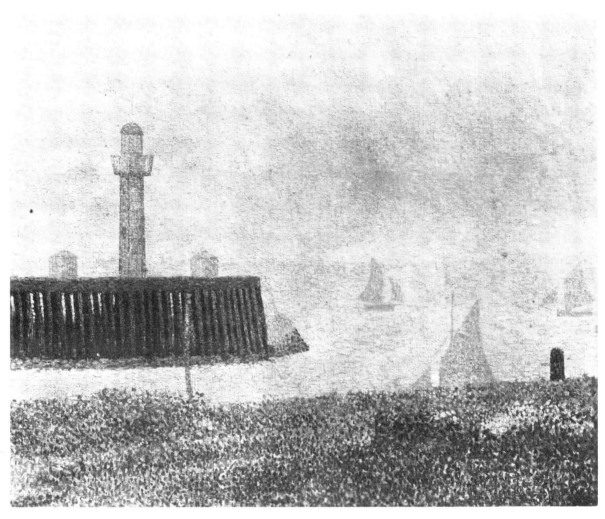

164. *End of a Jetty, Honfleur*. 1886. Canvas, 46 x 55 cm. Otterlo, Kröller Müller Museum (DH 170).

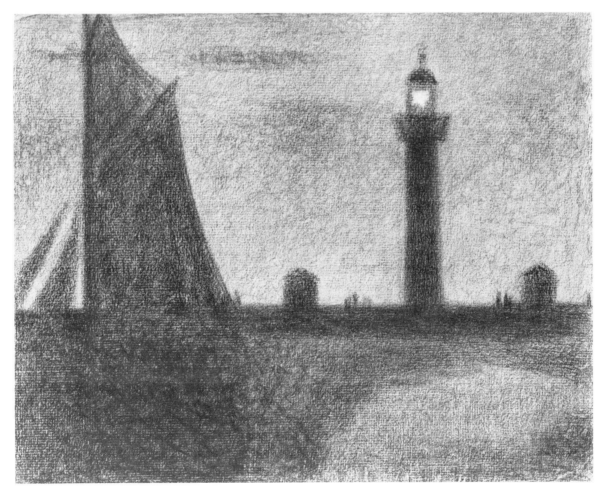

165. *Lighthouse, Honfleur*. 1886. Conté crayon, 24 x 30.7 cm. New York, Metropolitan Museum (DH 656).

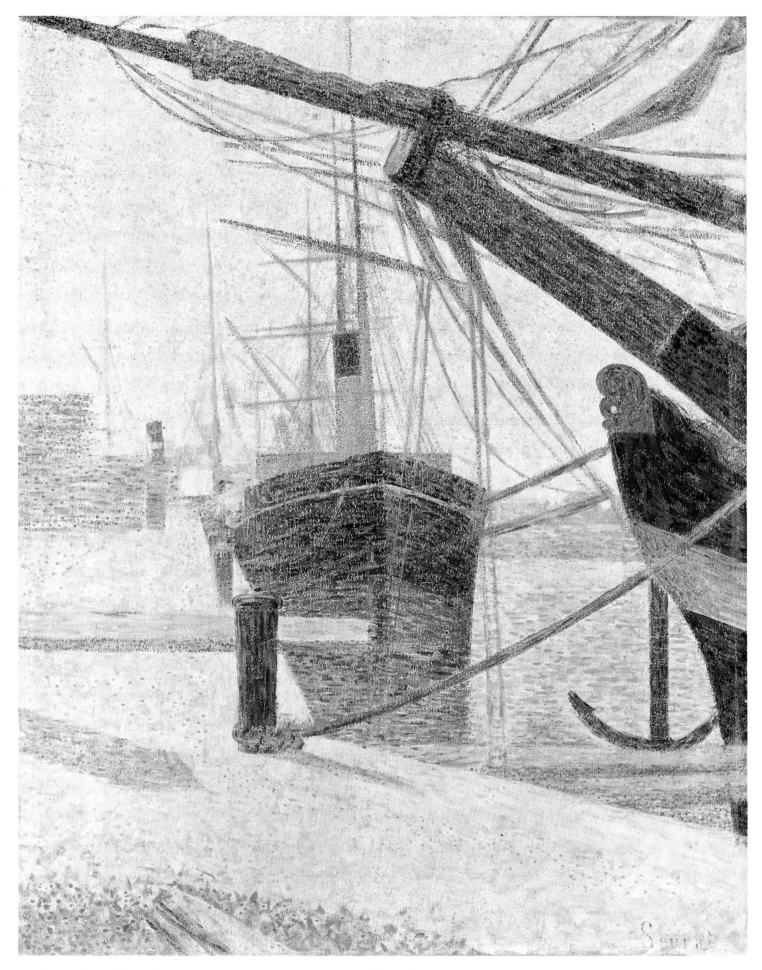

166. *Corner of a Dock, Honfleur*. 1886. Canvas, 81 x 65 cm. Otterlo, Kröller-Müller Museum (DH 163).

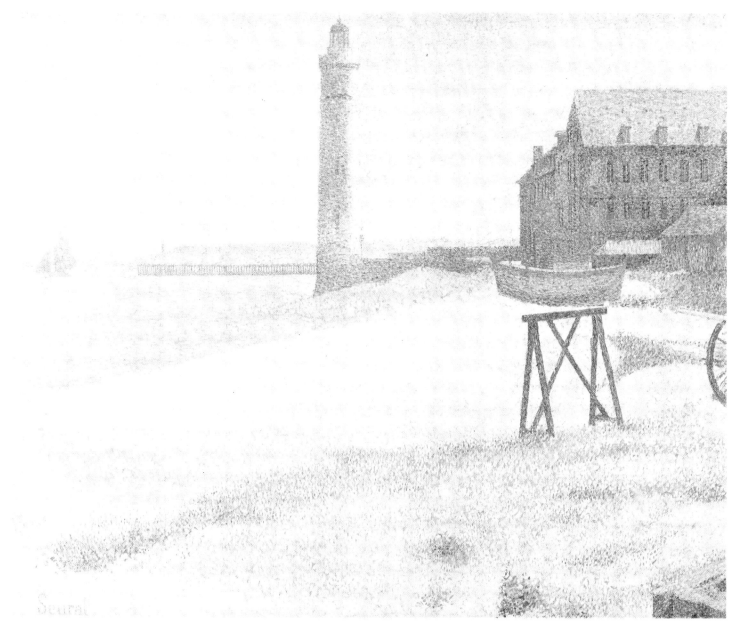

167. *The Hospice and the Lighthouse, Honfleur.* 1886. Canvas, 65 x 81 cm. Washington, National Gallery of Art (DH 173).

Hospice and the Lighthouse and *The Harbour Entrance* merely sketched in.[9] Thus much remained to be done on his return to Paris, and the sequence in which the Honfleur paintings appeared in exhibitions both shows their order of completion and throws light on Seurat's methods. He was prepared to exhibit the *Corner of a Dock* as 'a large oil sketch' — it was made in a week, he told Verhaeren[10] — at the second Indépendants which opened on 21 August. For the Nantes show in October Seurat had ready *The Beach of Bas-Butin* and *The Hospice and the Lighthouse*, the latter the work of two-and-a-half months,[11] while at Les Vingt in February 1887 he exhibited these three paintings with the nocturne, *The Seine Estuary*. In other words, the canvases that Seurat was able to bring on quickly were the ones with oil sketches. For the next Indépendants in March Seurat dropped the *Corner of a Dock* and showed all the resolved Honfleur canvases, now including *The Harbour*

Entrance, the *End of a Jetty* and *The 'Maria'*. It seems to have been the paintings with preparatory drawings that came along more slowly in Paris, and it may be that *The 'Maria'* was done from a drawing now lost; if not it was Seurat's first finished experiment with a marine painted directly on to canvas.

Inevitably Seurat's selection of motifs included sites that had previously attracted artists. The view of the entrance to the harbour, looking over the estuary towards Le Havre, had been frequently treated by artists such as Boudin, Lebourg and Jongkind (Plate 169).[12] And the large lighthouse to the west of the harbour (Plate 167) had attracted — in the 1860s alone — Lépine and Monet as well as Boudin and Jongkind once more.[13] Indeed, Camille Pissarro owned a Jongkind watercolour of this motif which Seurat might have seen when he visited the older painter's Eragny home in 1886.[14] But such repetition could well have been coincidental, the

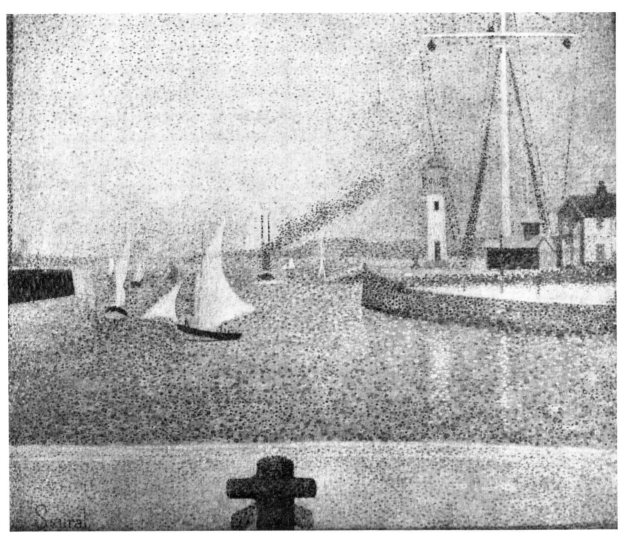

168. *The Harbour Entrance, Honfleur*. 1886. Canvas, 54 x 65 cm. Merion Station, Barnes Foundation (DH 171).

169. Johan-Barthold Jongkind, *The Harbour Entrance, Honfleur*. 1866. Canvas, 42.5 x 56.5 cm. Paris, Louvre.

170. Hiroshige, *Yui. c.*1833–4. Woodblock print. No.17 of *53 Stages of the Tokaido*.

171. Hokusai, *Coast of the Seven Leagues in Sōshū Province. c.*1827–30. Woodblock print. From the set of *Snow—Moon—Flowers*.

172. *The Beach of Bas-Butin, Honfleur*. 1886. Canvas, 67 x 78 cm. Tournai, Musée des Beaux-Arts (DH 169).

lure of the obvious, for at Honfleur Seurat did his best to work in and around the harbour rather than the picturesque town. He used three types of composition: the view along the beach with a shallow diagonal reminiscent of *La Grande-Jatte* and the Grandcamp paintings, a sharp diagonal down the quay for the two canvases of moored shipping, and in *The Harbour Entrance* a flatter, more planar configuration that looked forward to the drawings of 1887 and *La Parade*. With *The Harbour Entrance* in particular, one of the last Honfleur canvases to be completed, it becomes clear that Seurat's disciplined stylization was increasingly independent of the Naturalist tradition exemplified by Jongkind's paintings of the same motif.

The growing individuality of Seurat's landscapes is apparent from a comparison of Monet's *Cliffs at Petites Dalles* of 1880 and *The Beach of Bas-Butin* (Plates 172, 173). The Monet is typical of what Pissarro called 'ro-

mantic' Impressionism, with its exploration of atmospheric effects by means of virtuoso handling and its restless touch, the brushwork trying to approximate the movement of clouds or waves. The varied marks even include casual dots of colour distributed across the cliff-face, where complementary relationships are used to enliven non-prismatic greys and earth tones. Monet's painting has an agitated character, Seurat's has complete control and utter calm. *The Beach of Bas-Butin*, with its regulated touch surreptitiously responding to the slightest change of tone, is a record of light uninterrupted by any intrusively personal accent. The comparison throws into relief the aims of Seurat and his colleagues: to produce landscapes that were 'Impressionist' in their search for accurate effects of light and atmosphere, but to achieve this goal in a more measured and 'scientific' fashion. As Camille Pissarro wrote in July 1886, his own Neo-Impressionist pictures were 'calm and simple, they

173. Claude Monet, *Cliffs at Petites Dalles*. 1880. Canvas, 60 x 80 cm. Boston, Museum of Fine Arts.

"sit", in contrast to the romantic disorderliness' of his earlier work.[15]

The stark simplicity of some of Seurat's marines, which first came to the fore in the Honfleur paintings, may have owed something to the study of Japanese woodblock prints, although there is no direct evidence of any enthusiasm for such prints on his part, as there is with so many other contemporary artists.[16] The controlled planar configuration of *The Beach of Bas-Butin* has consonances with such prints as Hiroshige's *Yui* (Plate 170), but Seurat's acute eye for the observation of light never allowed the unmodulated areas one finds in Japanese prints, and he was careful not to clutter his motifs with unnecessary, accessory linear effects. The monochromatic effect of *The Seine Estuary, Evening* might have been stimulated by the single-toned printing of some Japanese landscapes; Hokusai's *Coast of the Seven Leagues* (Plate 171), for instance, consists solely of various shades of blue. Again, the lucid planar design and even the stippled technique might have justified Seurat's own use of these devices, but it is injudicious to seek for emphatic stylistic initiatives on negligible evidence.

The Honfleur paintings were not, in fact, executed entirely in the novel dotted touch. The beach in *The Hospice and the Lighthouse*, for one, was painted in tightly woven *balayé* strokes of close-valued colour, and the sea in horizontal marks with sparse dots on the surface. And the dry *balayé* layer is even clearer in the uncompleted *Corner of a Dock*; on top of it Seurat began to work varied marks, dots and dashes of differing length and weight, leaving the canvas with a hesitant, even experimental quality. *The 'Maria'*, on the other hand, painted late in the group, was executed entirely in the dot, evidence of Seurat's growing confidence. In general, the Honfleur canvases are characterized by a

scrupulous attention to unity of tone and surface, the legacy of the new technique. Seurat was well aware that these qualities, especially with the near uniform surface, could give rise to a cramped and claustrophobic space, and he consistently, if unobtrusively, inserted *repoussoir* devices into all the paintings. It was perhaps in the Honfleur group that Seurat achieved his first maturity as a landscape painter, marrying his remarkable eye for effects of light and atmosphere to his formidable conceptual faculties as a pictorial architect.

Port-en-Bessin, 1888

Seurat's next visit to the Channel coast took place in 1888 when he worked at Port-en-Bessin, north of Bayeux. Signac had worked there each summer from 1882 to 1884, and it may well have been he who recommended the little fishing port to Seurat.[17] The stay was probably quite lengthy; we know that Seurat went there in August and, according to Théo Van Gogh, was not back in Paris by mid-October.[18] Six canvases resulted from the Port-en-Bessin campaign; as far as we know Seurat made no preliminary drawings or *croquetons* and internal evidence suggests that the paintings were executed directly on to the canvas. In *Port-en-Bessin, Sunday* (Plate 180), for instance, slight pentimenti and *craquelure* around the left side of the harbour entrance indicate adjustment and alteration that preparatory work would probably have avoided. No doubt the paintings were completed in Paris over the following winter, and the set of six was exhibited as a group at Les Vingt early in 1889.

Cumulatively the Port-en-Bessin pictures represent Seurat's most thorough charting of a single location. The topography is simple and symmetrical. The small river Dromme makes a break in the cliffs, and the town and inner harbour are strung out along the valley. The two cliffs to each side of the town — the Falaise de Huppain to the west and the Falaise du Castel to the east — provide some shelter for the harbour, enhanced by the long arms of two outer jetties. Seurat painted two views of the inner harbour, one looking towards it from a quay in the outer anchorage (Plate 174), the other from a dock looking out to sea (Plate 180). Three canvases show views from more or less the same spot on the Falaise de Huppain: *Les Grues et La Percée* looks west towards the Cotentin peninsular, *The Entrance to the Outer Harbour* directly north across the Channel, and *The Outer Harbour, High Tide* east to the Falaise du Castel (Plates 181, 182, 183). This precise panoramic mapping of the view from a single standpoint, creating an informal triptych, shows Seurat at his most methodical (Plate 184). The sixth painting, *The Bridge and the Quays* (Plate 188), represents the harbour front, looking east–west along the shoreline towards the Falaise de Huppain.

The Port-en-Bessin paintings are more open, expansive pictures than Seurat's earlier landscapes. At first sight they appear very naturalistic — in parallel to the systematic selection of motifs — and yet they are the result of conscious arrangement consistent with Seurat's recent figurative work. The paintings all imply a position for the spectator in the tacitly insistent fashion of *La Parade*: atop a cliff, behind a balustrade, on a quayside. And the regulated horizontal zoning of the motifs and the artist's distribution of colour once more recall *La Parade*, nowhere more so than in the relief-like *Outer Harbour, Low Tide* (Plate 174).

If the *Bec du Hoc* had been to some extent an effort to match Monet, *Les Grues et La Percée* was an innovatory, decorative treatment of the cliff motif. Seurat organized the painting with utmost deliberation, halving the canvas between the stolid coast and the open expanse of sea and sky. It was handled overall in a regular dot that was increasingly applied in a directional fashion, following the contours of forms and the margins of colour zones. This quasi-decorative initiative enhanced the emphasis on surface, which in turn could come to hinder the illusion of depth for which Seurat still strove. In Monet's cliff paintings, implied space provided depth. In *Les Grues et La Percée* Seurat failed to get the midground to sit; he showed a spit of rock in order to fix that area, but nevertheless the handling of the nearby water rides up to the surface. Again in *The Outer Harbour, High Tide* the canvas is somewhat scumbled and overworked where the sea meets the beach beyond the far jetty. Flat, horizontal configurations and close values made the articulation of space a problem; Seurat had the boats zigzag slightly to help counteract the emphatic planes and the repetitive cliff–quay motif.

These were niggling difficulties that may well have been caused by Seurat's confident preparedness to operate without preliminary work. Taken together, the Port-en-Bessin pictures constituted a very substantial achievement: encapsulating the port's topography in a methodical selection of motifs, adapting the rigorous formality and increasingly decorative touch of his recent figure painting to his landscape practice.

Le Crotoy, 1889

The following year, 1889, Seurat made his shortest and least productive trip to the Channel coast, resulting in only two canvases. He based himself at Le Crotoy, a small fishing port on the north bank of the Somme estuary, near Abbeville, further up the Channel than he had worked before. Le Crotoy was an obscure choice, though painters had worked there previously, for instance Roll in 1881.[19] Seurat does not seem to have stopped long — perhaps he was called back by Madeleine Knobloch's pregnancy, for their son was born in February 1890[20] — and the visit may have been earlier in the year than usual. Certainly both paintings were ready by early September 1889, when they were shown at the fifth Indépendants. They reappeared at Les Vingt in 1891, once more shown as a pair; this group identity — one

174. *Port-en-Bessin, The Outer Harbour, Low Tide*. 1888. Canvas, 53.5 x 65.7 cm. Saint Louis, City Art Museum (DH 189).

looks upstream, the other down — and the absence of preparatory work links them to the Port-en-Bessin work.

Le Crotoy. Upstream (Plate 191) is the more successful painting. The arcs in the foreground lead the eye towards the solid shapes of the town, organized parallel to the picture plane, and the contrasts are subtler than in its partner. In *Le Crotoy. Downstream* (Plate 192) there is a clever balance of colour, with the stronger value contrasts and warmer colours gathered at the centre, but the painting is weak on the right-hand side. The fishing boats setting out into the Channel catch the eye, but the seaway itself is uncomfortably flat, an effect not helped by the broad touch used for the central beach, so the boats themselves read like silhouettes.

A new departure marked the Le Crotoy paintings, for they were the first pictures for which painted borders were planned from the very initial stage (borders on pre-1889 canvases were applied after the completion of the painting). As Fénéon explained in his review of the fifth Indépendants show: 'The two Crotoy pictures are separated from their large white frames by a border painted on to the canvas itself: such an arrangement does away with the strips of shadow [cast by the frame] which would give a sense of depth and allows the frame to be coloured as the painting is executed.' Although he was responsive to this innovation Fénéon's attitude to the Le Crotoy canvases hints at an increasing lack of sympathy for Seurat's work. He was ironic about Seurat fastidiously signing on the picture's border — 'to perfect the paintings' toilette' — and sceptical of the associative shapes Seurat had imposed on the clouds, comparing them to a mushroom or a jellyfish in *Le Crotoy. Upstream* and to shells in its pair.[21] Perhaps Fénéon, who had always considered Seurat as primarily a landscape painter, was disconcerted by the stylization of these

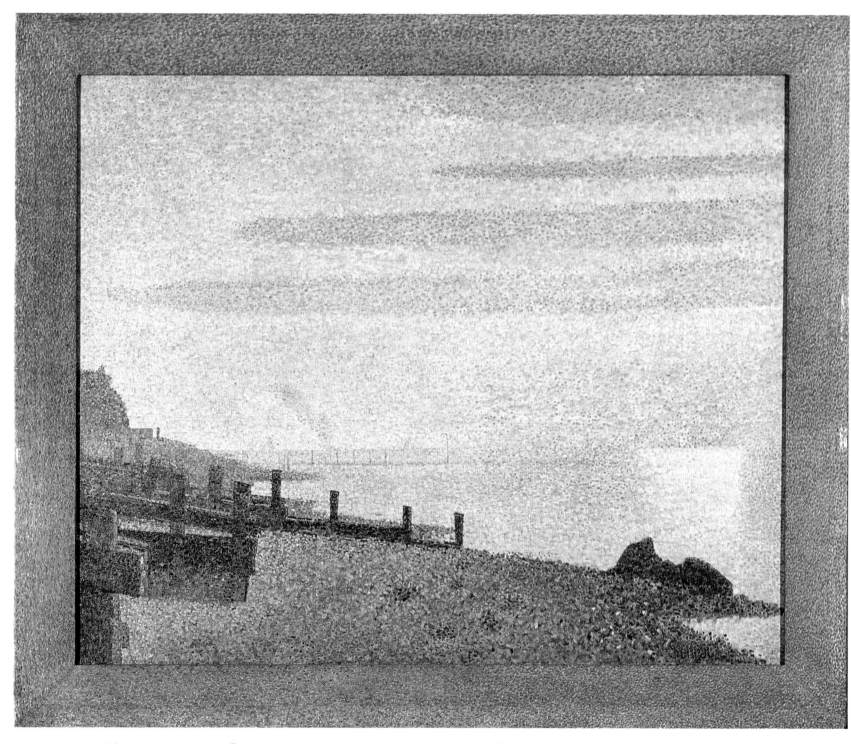

175. *The Seine Estuary, Honfleur, Evening.* 1886. Canvas, 64.2 x 80 cm. New York, Museum of Modern Art (DH 167).

recent marines. Perhaps Seurat, alert to the metaphor and allusion prevalent in contemporary literature, was attempting visual equivalents to poems such as Félicien Champsaur's *Les Nuages*, published in a collection of 1887, which began:

> Les nuages parfois ont des formes charmantes,
> faites avec du blanc, faites avec du bleu.
> Le poète les suit, et, s'amusant au jeu,
> dans ces desseins d'azur reconnaît des amantes.[22]

[Clouds sometimes have charming shapes,/made in white, made in blue./The poet follows them, and, enjoying the fancy,/sees lovers in these azure drawings.]

For there is an element of the metaphorical, the chimerical, in Seurat's later work.

Gravelines, 1890

In 1890 Seurat travelled to Gravelines, a port in the flat dune lands between Dunkirk and Calais, not far

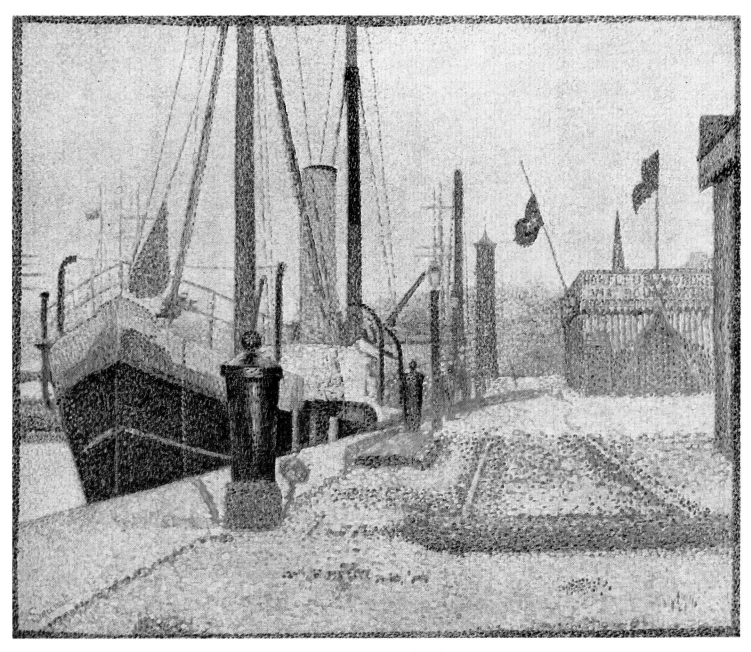

176. *The 'Maria', Honfleur*. 1886. Canvas, 54.5 x 64.5 cm. Prague, Museum of Modern Art (DH 164).

from the Belgian border. This campaign saw a return to the varied preparatory procedures shelved since 1886. Indeed, the genesis of the Gravelines paintings seems to have been the most complex of all Seurat's groups of marines; six *croquetons* and eight drawings went towards the execution of four canvases.

Four of the oil sketches were made independently of the resolved paintings,[23] and it is impossible to establish whether with such highly finished *croquetons* as the one in the Courtauld collection (Plate 189) Seurat was simply getting his eye in or whether he intended them to be worked up later into completed canvases. Again, Seurat drew four sheets that bear no direct relation to any of the paintings;[24] these were perhaps for a picture of the outer channel of the harbour which he never started. Ultimately, and without involving the whole motif, he raided these drawings for specific elements; their

boats appear in *The Gravelines Canal. Evening* and *The Gravelines Canal. Seawards Direction* (Plates 198, 177).

Two of the canvases — *The Gravelines Canal. Grand Fort-Philippe* (Plate 197) and *Seawards Direction* — involved no preparatory work; the other two — *Petit Fort-Philippe* (Plate 196) and *Evening* — resulted from both oil sketches and drawings, the only occasions on which Seurat used these twin preliminary procedures in the marines. *Petit Fort-Philippe*, like the figure paintings, gave drawing a role between *croqueton* and canvas. The oil sketch (Plate 195) established the general design and the chromatic range clearly enough, but Seurat chose to remove the nearby boat and concentrate the shipping in the middle ground of the painting. In the main canvas a bollard fixes the frontal plane, forcing the eye to travel the sweeping length of the quay into broad space, towards the moored boats, one of which Seurat added

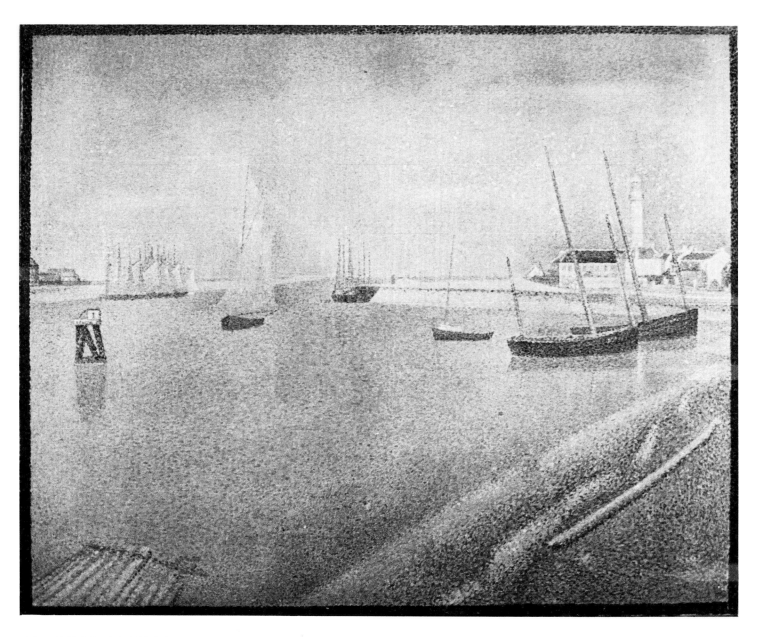

177. *The Gravelines Canal.
Seawards Direction*. 1890. Canvas,
73 x 93 cm. Otterlo, Kröller-Müller
Museum (DH 206).

178. Study for *The Gravelines
Canal. Petit Fort-Philippe: The
Clipper*. 1890. Conté crayon,
23 x 31 cm. New York, Guggenheim
Museum (DH 703).

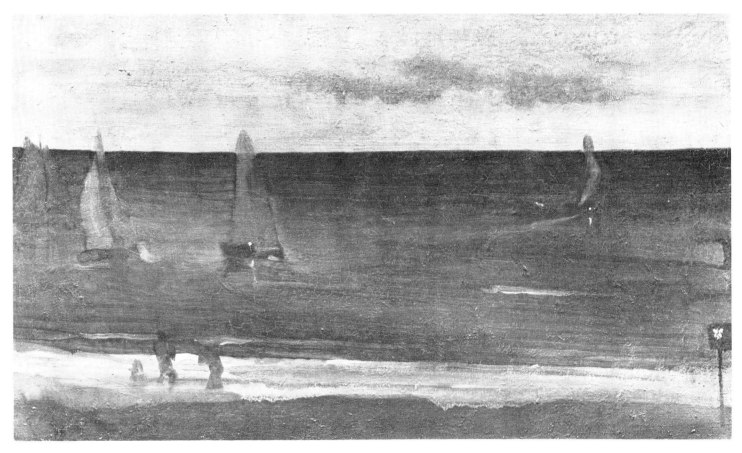

179. J.A.M. Whistler, *Nocturne: Blue and Silver — Bognor.* c.1871–6. Canvas, 50.3 x 86.2 cm. Washington, Freer Gallery. Probably exhibited in 1888 at the Durand-Ruel Gallery, Paris.

from a drawing (Plate 178). This boat, like the little girl in *La Grande-Jatte*, follows Corot's advice to include a light accent in the centre. The arcing quayside of *Petit Fort-Philippe* both recalls *Le Crotoy. Upstream* and prefigures the curving ring of *Le Cirque.*

Petit Fort-Philippe, Grand Fort-Philippe and *Seawards Direction* were all painted in a pale tonality which captures the watery light of the Channel coast on a sunny day with mastery. Yet, despite the absence of drastic colour relationships or value contrasts, the paintings are still encumbered with passages of spatial incongruity. In *Grand Fort-Philippe*, for instance, the central area is firmly fixed, while the muddled use of directional brushwork to the lower left adds a disconcerting element. These are minor difficulties, however, and the paintings are perhaps Seurat's freshest and most harmonious marines, unified in atmosphere and without the almost antinaturalistic stylization of his recent work.

The development of *The Gravelines Canal. Evening* involved an early drawing (DH 697; present location unknown), a *croqueton* (DH 209; Saint-Tropez, Musée de l'Annonciade), and then two detailed drawings (DH 696, 698; Paris, private collection) before Seurat began work on the canvas. The highly simplified planar configuration, the subdued nocturnal tonality and the measured intervals of *Evening* are quite at odds with the Impressionism of Monet that had served as one of the initial stimuli for Seurat's marines. Here Seurat was much closer to Whistler, whose work was regularly exhibited and increasingly appreciated in Paris during the 1880s. The example of the minimal motifs of Whistler's sparse nocturnes was important to Neo-Impressionist painters seeking a synthetic and yet evocative approach to landscape; Angrand's *The Seine at Dawn* (1889; Geneva, Modern Art Foundation) and Pissarro's *L'Ile Lacroix*, Rouen (1888; Philadelphia Museum of Art) stand witness to this. *Evening* would seem to be a response to the nocturnes Whistler exhibited at Durand-Ruel's in 1888 — such as *Nocturne: Blue and Silver — Bognor* (Plate 179) — and at the Salon of 1890. And as a night scene it indicated the breadth of Seurat's capacity as a painter of marines after only five years' experience, rounding off the successful Gravelines group that was shown together at Les Vingt and the Indépendants in 1891.

The marines do have an intimate technical relationship with Seurat's figure paintings. At times they served as the laboratory for experiment, with the dotted touch, directional brushwork, the painted border. They also shared the general compositional concerns of the moment, as we have seen. And the use of symmetrical axes, sometimes at right angles to the Golden Section, again corresponds to some of the figure paintings. Thus the *End of a Jetty, Honfleur* and *Port-en-Bessin, The Outer Harbour, High Tide* (Plates 164, 183), for example, are divided along precise horizontals, *The Gravelines Canal.*

173

180. *Port-en-Bessin, Sunday*. 1888. Canvas, 65 x 81 cm. Otterlo, Kröller-Müller Museum (DH 191).

181. *Les Grues et la Percée, Port-en-Bessin*. 1888. Canvas, 64.7 x 81.5 cm. Washington, National Gallery of Art (DH 190).

Petit Fort-Philippe (Plate 196) along the bisecting vertical axis.[25] Such devices were part of Seurat's concern to control the landscape, to order the artist's sensations into a unified canvas, to preordain the spectator's emotions. It was in the tightly controlled and decoratively construed Port-en-Bessin paintings, executed hard on *La Parade*, that such considerations seem to have been at their most dominant. By 1890, with Seurat's figure paintings increasingly arbitrary and synthetic, the marines had largely returned to a naturalistic vocabulary, by way of compensation.

The imagery of harbour and ocean

THE PORTS

If the marines interweave with the technical and compositional directions of Seurat's other work, we need to ask how they relate to his acute and critical social observation. His habitual choice of ports on the Channel coast as his motifs was typical of his unswervingly consistent temperament; every single canvas is a marine, on no campaign did he turn inland and paint meadows or farmland. That stretch of coast gave him varied shorelines and characteristic climate, which he learnt to record superbly; unlike Signac, the Mediterranean held no attraction for him. And each summer spent in a specific port provided Seurat with the opportunity to particularize the place.

The locations Seurat chose were very different in character. Grandcamp had a quite substantial fishing fleet but poor facilities. There was no proper anchorage, and the boats were forced to beach on the shore's bare rock. By the mid-1870s an increasing number of seaside villas were being erected, and the little town's identity began to change.[26] Yet Seurat showed no interest in the summer society of a small resort. At Grandcamp he was tackling a new genre, and there he painted his most conventionally picturesque motifs — the Bec du Hoc, beached fishing boats — and paid no attention to fisherfolk or holidaymakers. Seurat was deliberately setting himself up as a painter of uncluttered marines, not of Grandcamp's fishing industry or the temporary summer society of the seaside.

Honfleur was the most immediately attractive port at which Seurat worked, but he made no attempt to paint historical buildings such as the Lieutenance or the church of Sainte Catherine. Rather, his conscious effort was to represent the busy outer harbour, which had been largely rebuilt in the 1830s and 1840s, and had undergone more recent improvements.[27] The signal mast on the end of the East jetty, at the entrance to the harbour, and the large lighthouse next to the hospice had started operation in 1857,[28] and Seurat painted them both (Plates 168, 167). His view of the harbour entrance, showing the port's typical traffic of fishing boats and coasters, looking north over the Seine estuary, was taken from the end of the Jetée du Transit, rebuilt between

1865 and 1868. From almost the same spot, but turning south-east, Seurat painted the view down the jetty to show the working port (Plate 176). In *The 'Maria'* he depicted one of the packet-boats of the London and South-Western Railway, bringing in wood, coal and cast iron from Britain and exporting the agricultural produce of Normandy.[29] This painting raises disconcerting problems. On the one hand it represents a very specific commercial reality, or at least the means of commerce: warehouse, railway track, coaster. On the other it ignores both commodities and labour: no livestock or produce, no sailors or stevedores. Perhaps painting the canvas in Paris Seurat had no sketches for these elements; perhaps he did not want to disturb the equilibrium of his deserted picture. Whatever the reasons, there was equivocation in his representation of the working port.

It seems to have been at Port-en-Bessin in 1888 that Seurat's observation of these maritime communities was at its closest. He had gained appropriate experience in earlier campaigns, the topography was easily assimilable, and Port-en-Bessin itself was a straightforward fishing port with a growing population — culled from the less well-equipped Grandcamp and other neighbouring places — and recently improved facilities.[30] Seurat stayed a long time, the paintings came easily, and perhaps nowhere in the marines did his acquaintance with local life manifest itself so clearly as in *Port-en-Bessin, Sunday* (Plate 180). The Port-en-Bessin fishing fleet customarily sailed on Monday and returned home on Saturday, when the catch was unloaded and the craft repaired and refitted. On Sunday the boats were decked out with flags; the population went to mass, and relaxed.[31] Seurat accurately caught the atmosphere of a subdued Sunday — the flags flung out in a gusting west wind, the unmanned boats, some villagers unhurriedly crossing the swing-bridge over the mouth of the inner harbour.

The Bridge and the Quays, Port-en-Bessin (Plate 188) must be considered here. It is something of a rogue, not an integral unit in the charting of the port as the other five canvases were, and it includes insistent and identifiable figures. It may have been the last of the group to be executed, an experiment in combining appropriate types with the port scene. The painting probably represents a weekday; there are no craft in port, the fish market is quiet. *The Bridge and the Quays* was painted from the Pollet side of Port-en-Bessin, the quarter of the fishing community, and shows a customs officer, a child, and a woman carrying a basket (there was fishing for eels on the rocks at low tide).[32] Seurat seemed pleased with the painting — it was exhibited at both Les Vingt and the Indépendants in 1889 — but at the latter show Fénéon found the figures 'improbable'.[33] Indeed, given the incisive specificity of the Parisian figure paintings, *The Bridge and the Quays* seems an uncomfortable essay in the combination of Channel coast types and locale.

Seurat made no further attempt to penetrate local society in his marines. From his paintings of Le Crotoy

one would not know that it was a declining port, silting up and losing its traffic to nearby Saint-Valéry-sur-Somme.[34] Seurat painted it from a distance, treating it — especially in *Le Crotoy. Upstream* (Plate 191) — as a site rather than a community. Much the same is true of his work at Gravelines. This was a flourishing port with a substantial population and an impressive traffic, importing coal from Britain and wood from Norway.[35] In fact, Seurat painted neither the town nor the port of Gravelines. Instead he worked at the outlying hamlets of Petit and Grand Fort-Philippe on either side of the canalized exit of the river Aa, which linked the port with the sea via a channel through the dunes. In a pair of canvases, both the same size, he took as his main motif the lighthouse, built in 1837–8 at the beginning of the north-east jetty;[36] one painting — *The Gravelines Canal. Seawards Direction* (Plate 177) — looked up the canal, the other – *Petit Fort-Philippe* (Plate 196) — faced back inland, down the canal, and was painted from the opposite jetty. Another pair, again identical in size, were made of the view from the quay in front of the lighthouse, looking south-west (Plates 197, 198). Both these canvases show the signal mast at Grand Fort-Philippe situated half-way up the canal to indicate the tides.[37] Seurat's restricted campaign was thus almost as methodical as the charting of Port-en-Bessin, but his paintings gave scant indication of the busy traffic of Gravelines itself.

SYMBOLISM AND THE SEA

At first glance the marines seem to adhere to fundamentally Naturalist principles, in their generally scrupulous attention to light and atmosphere, say, or in the painstaking charting of a site, as at Gràvelines and Port-en-Bessin. But they were painted during a period of shifting aesthetic attitudes and belong to a discourse questioning Naturalist and promoting Symbolist concepts. This is evident from the first occasion Seurat exhibited marines; at the 1886 Impressionist Exhibition some critics admired the light effects, others the mood of '*mélancolie*' that the paintings provoked.[38] The marines were received by, and even came perhaps to be deliberately painted for, an élite audience attuned to Symbolist ideas.

Symbolism used oblique, suggestive means — the selection and arrangement of vocabulary, imagery, metaphor — to express emotion, to evoke mood. In the eyes of Paul Adam Seurat's earlier paintings did not achieve this. In September 1886, reviewing the Indépendants, at which the marines were essentially represented by three Grandcamp canvases, Adam chided the Neo-Impressionists' submission: 'However, it is regrettable to see no place for the Idea there. Their technique does not concern itself with the suggestive. They remain pure landscape painters.'[39] But by 1887 Seurat's marines were beginning to be assessed in thoroughgoing Symbolist terms. Fénéon, for example, remarked of the Honfleur pictures: 'Horizontal lines co-operate to establish their serene character', while in 1889 Jules Christophe spoke

of the Le Crotoy canvases as 'those suave pictorial andantes'.[40] Fénéon's words, with their bow to Henry's theories about the calm of the horizontal, recall the insistence by Verhaeren and others that Symbolism's technical means be delicately adjusted to conjure up appropriate emotions, while Christophe echoed the Symbolists' preoccupation with equating music and the other arts.

Even Seurat's repetitive representation of sites can be considered within a Symbolist ambit. Gustave Kahn's characterization of a Symbolist poem, published in February 1888, defined a creative method paralleled by the paintings Seurat made at Port-en-Bessin later in the year: 'a poem evolving organically, presenting every facet of a subject, each one treated in isolation, but strictly linked by the bond of a single idea'.[41] Seurat himself consciously stressed his similar approach by exhibiting his marines in their interrelating groups and by identifying the 'facets' of his subjects in the catalogue entries. Titles such as *The Seine Estuary, Honfleur, Evening* or *Port-en-Bessin, The Outer Harbour, Low Tide* almost directly mirror the subdivisions of François Poictevin's *Normandie. Eté*, which appeared in the *Revue Indépendante* in October 1887. Poictevin divided the prose pieces on Honfleur, for instance, into sections such as 'From the pier, morning, low tide' and 'From the pier at ebb tide, evening'.[42] Indeed, so closely did Symbolism relate the aims of writer and painter that Kahn once compared Poictevin to an Impressionist in his eye for 'the intimate qualities of objects and the variations of their colour'.[43]

The imagery of sea, coast and port was widely treated by painters and writers of various complexions in the 1880s and carried a broad range of meanings. For Zola its associations were pessimistic; in the notes he made for his novel *Joie de vivre*, published in 1884 and based on the coast between Grandcamp and Port-en-Bessin, he envisaged 'the little village devoured by the sea' as 'the image of the world's collapse'.[44] A similar sense of man's impotence in the face of nature is transmitted by the dull-toned, heavy-skied motifs of rough Channel fishing villages that Cazin frequently painted at this time, and by Pelouse's pictures of Grandcamp in the mid-1880s, with women scurrying back from shrimping to their drab dwellings before the storm breaks (Plate 185). By contrast, on visits to Brittany Odilon Redon, an acquaintance of Seurat via the Indépendants, painted informal, rather ethereal oil-sketches for his own satisfaction (Plate 186), while entries in his journal tackled equivalent subjects. 'Gentle, lovely boats, tossed softly by the eternal waves, you float in the friendly port. Your long, angled masts and their fragile rigging stand out against the background of a foggy sky — and the breeze and the rhythm of the waves soothe the spirit like a mellow harmony,' he wrote euphorically in June 1885.[45]

Seurat's own attitude seems to have fallen between these extremes of pessimism and eulogy. Responses to his marines often spoke of serenity and calm, and perhaps a parallel can be drawn between them and the

182. *The Entrance to the Outer Harbour, Port-en-Bessin*. 1888. Canvas, 54.8 x 64.5 cm. New York, Museum of Modern Art (DH 192).

poetry of Henri de Régnier, whom Seurat knew well and who in later years wrote a long poem in his memory. A common theme in de Régnier's verse was the polarity of city and sea-coast, one signifying venality, the other peace for the world-weary. The poem *Heures Marines*, published in 1886, closed:

Dans la nuit sonne un bruit de lointaines enclumes;
C'est la mer basse qui gémit son chant puissant;
Et voici le sommeil qui vient, assoupissant
Les souvenirs cuisants et chargés d'amertumes
Des dolentes cités où longtemps nous vécûmes.[46]

[The noise of distant anvils sounds in the night;/It is the deep sea moaning its powerful song;/And then sleep comes, allaying/Stinging memories, charged with bitterness,/Of the painful cities where for so long we lived.]

Seurat had a curious lack of interest in the people of the ports; he was an outsider, and the communities remained substantially beyond the powers of his perception. He was more concerned in his marines with evoking a sense of solitude, of self-imposed alienation that was both true to his temperament and consistent with the Symbolist climate. A growing number of paintings in the 1880s were on the surface naturalistic but in essence evocative. Such is the case with Cazin's *Ville Morte* (Plate 187), praised by Redon in 1883: 'Here there is all the silence of an abandoned land, the isolation of a rural

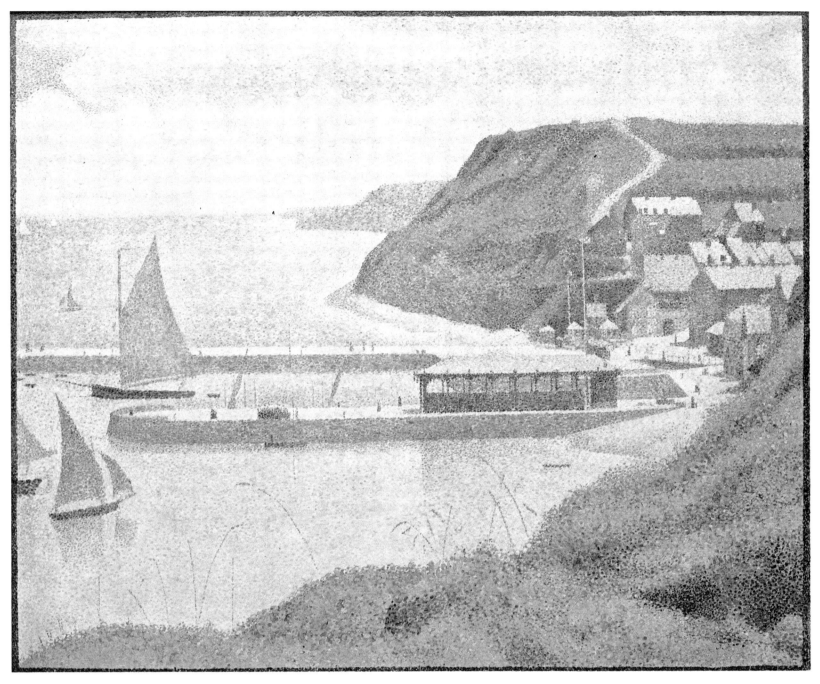

183. *Port-en-Bessin, The Outer Harbour, High Tide*. 1888. Canvas, 66 x 81 cm. Paris, Louvre (DH 193).

184. Photographs taken from the same spot on the Falaise de Huppain, 1982; (a) west towards the Cotentin peninsular; (b) north out to sea; (c) east—Port-en-Bessin with the Falaise du Castel behind.

185. Léon-Germain Pelouse, *The Beach at Grandcamp*. 1886. Oil on canvas, 131 x 163 cm. Location unknown.

186. Odilon Redon, *Village by the Sea in Brittany*. c.1880–5. Canvas, 25 x 32.2 cm. From the collection of Mr and Mrs Paul Mellon.

187. J-C. Cazin, *La Ville Morte. c*.1882. Canvas. Location and dimensions unknown. Exhibited at the Exposition du Cercle de la rue Volney, Feb. 1883. The town represented is Montreuil, in the Pas-de-Calais.

evening, the gloomy, torpid immobility.'[47] Much the same could be said about Redon's own paintings of unpeopled ports, and the image of the deserted town haunted Symbolist literature, most notably in the poetry of Georges Rodenbach. It is in such equivocal company that Seurat's marines belong.

The use of metaphor in the marines can also be considered Symbolist. Many of them emphasize the man-made features of the ports more than natural elements; jetties and quays control the seas, the dock-sides are treeless, the landscape is structured by shaped stone and cement. And yet the ports are populated by tiny, distant figures or entirely deserted. As an ironic compensation for man's absence Seurat used human equivalents, for example in the Honfleur pictures; in *The Seine Estuary* and *The Beach of Bas-Butin* (Plates 175, 172) he substituted the posts of breakwaters for holidaymakers, in *The 'Maria'* and *Corner of a Dock* (Plates 176, 166) bollards stood in for stevedores. On other occasions his tacit metaphors were almost clichés. Zola had compared the fishing boat's sail to a wing in *Joie de vivre*, and as he painted the birds in the *Bec du Hoc* (Plate 161) Seurat may have had this in mind, or recalled Jacques Madeleine's poem published in *Basoche* in 1885:

Blanches ailes de barques frêles,
Vois ces taches d'un ton plus clair
Sur le vert sombre de la mer:
Sont-ce des voiles ou des ailes?[48]

[White wings on frail ships,/Look at those marks of a lighter tone/On the sombre green of the sea:/Are they sails or wings?

Seurat also made play with the polarity of day and night. *The Seine Estuary* and *The Beach of Bas-Butin* almost form a pair, looking in different directions at different times of day, and among the Gravelines paintings *Grand Fort-Philippe* and *Evening* (Plates 197, 198) depict the same site in sun and at twilight. Once again Seurat was not alone; Signac divided a fan painting into night and day (c.1886, Japan; private collection), and one recalls the subdivisions of Poictevin's *Normandie. Eté*. Seurat was surely making conscious application of such literary and Symbolist devices, both in his use of latent metaphor and in orientating his marines towards the evocation of moods of calm or reverie.

The fundamental initiative of Seurat's marines was, alongside the accurate representation of atmospheric effects, to orchestrate natural elements into harmonies suggestive to the Symbolist imagination, rather than to explore social realities that he could only inadequately assimilate. The social disengagement that one senses in the marines stems from the same instinct as de Régnier's sympathy for the sea: the longing or nostalgia for the ocean's wide, untarnished horizons, in contrast to the crowds and corruption amongst which the city-dweller lives.

188. *The Bridge and the Quays, Port-en-Bessin.* 1888. Canvas, 67 x 84.5 cm. Minneapolis, Institute of Arts (DH 188).

189. *The Beach and a Boat, Gravelines*. 1890. Panel, 16 x 24.7 cm. London, Courtauld Institute Galleries (DH 204).

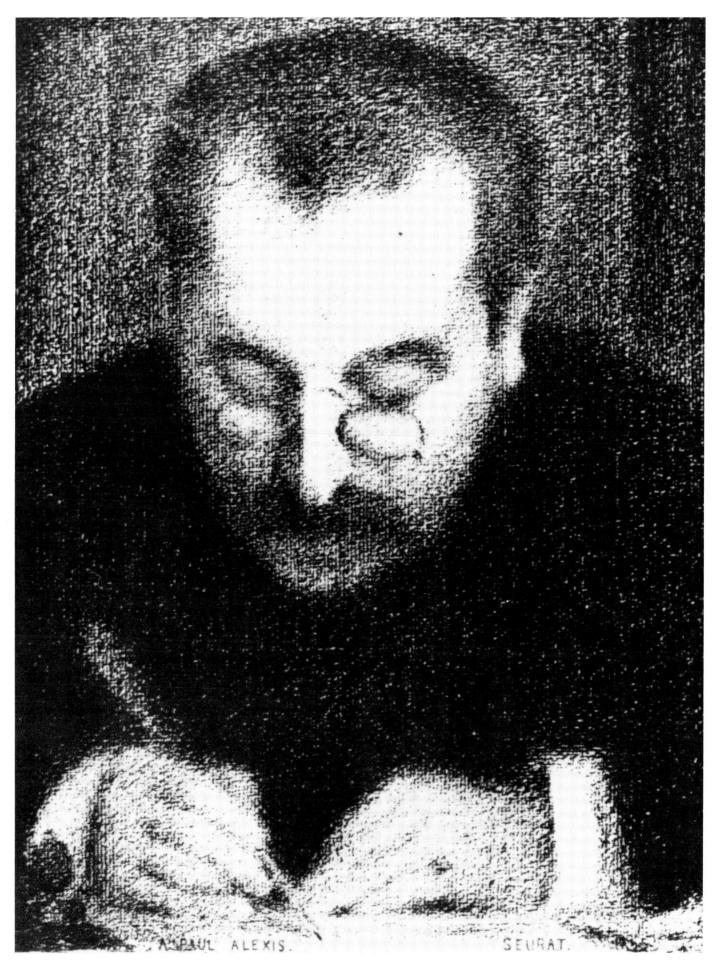

190. *Paul Alexis*. 1888. Conté crayon, 30 x 23 cm. Present location unknown (DH 691). Reproduced in *La Vie Moderne*, 17 June 1888, p.376.

9 The Modern City and the Critical Metaphor

Friction in the Avant-Garde, 1888–1891

By about 1888 the intensity and solidarity of the Parisian avant-garde community began to falter. It did not immediately fragment or fundamentally change in direction, but new developments and new talents, coupled with increasing polarization of opinion over political matters, inevitably involved shifts of personal position, aesthetic orientation or critical status. Seurat did not lose his rank as one of the leading avant-garde painters whose stylistic initiatives had to be watched, and he was still considered to be in alliance with the Symbolist writers, but gradually changing circumstances were no longer so much in his favour. He made sure in his quiet way that he still belonged at the centre of progressive circles in the visual arts. Early in 1889 he travelled to Brussels for the opening banquet of Les Vingt, where *Les Poseuses* was shown, and in February 1890 he attended the annual dinner of the Société des Indépendants with Signac, Luce, the caricaturist Adolphe Willette, and his former colleagues from the Lehmann studio, Séon and Osbert.[1] Indeed, Seurat seems to have cared about the internal politics of the Indépendants, for in 1888 he added his name to efforts to end the Société's continuing quarrel with the rival Groupe des Indépendants.[2]

On several occasions around the turn of the decade Seurat and the Neo-Impressionists were seen as working in parallel with the literary Symbolists; as Fénéon wrote in December 1889, 'M. Gustave Kahn and M. Paul Adam, striving to convert the everyday into a logical dream, cautious about more complex rhythms, concerned for precise and efficient means of expression, saw analogies with their own researches in the work of the Neo-Impressionists.'[3] Seurat certainly kept up his literary contacts. Alexis, whose portrait by Seurat was illustrated in *La Vie Moderne* in June 1888 (Plate 190), published in April that year an account of the *Revue Indépendante*. The journal had just moved from Montmartre to the central rue de la Chausée d'Antin (in itself an indication of the changing face of the avant-garde community), and he described its staff and their circle:

the writers Edouard Dujardin, Ajalbert, Kahn, Adam, Poictevin, Hervieu, the critics Fénéon, Christophe, Henry, the artists Seurat, Signac, Luce, Pissarro.[4] Again, in February 1891, only a few weeks before his sudden death, Seurat attended a banquet in honour of Jean Moréas with writers such as Stéphane Mallarmé, Félicien Champsaur, Samain and de Régnier, artists such as Redon, Gauguin, Signac and Félicien Rops.[5]

Seurat was also an *habitué* of Antoine's Théâtre Libre, which opened in 1887 at small premises in the Passage de l'Elysée des Beaux-Arts, and where some of his work was casually hung;[6] a drawing of a cramped theatre scene, dating from this time, may record its little stage (Plate 194). Seurat was also listed among the many artists who visited the by then famous cabaret of the Chat Noir in the rue Victor Massé, where the remarkable shadow plays of Henri Rivière and Caran d'Ache were mounted; in 1888 the regulars included Salon painters such as Puvis de Chavannes, Jean-Léon Gérôme, Pelez and Henri Gervex as well as independents — Degas, Renoir, Monet and Rops.[7] On the surface Seurat was still in the midst of a varied and flourishing artistic environment, but there is evidence that his participation was increasingly distant, that certain friendships no longer so close.

One reason for this was new commitments in his personal life. He had taken up with Madeleine Knobloch in 1889, perhaps even earlier, and in February 1890 their son was born. Seurat acknowledged paternity and gave the child his own names in reverse: Pierre Georges. Presumably to cater for his mistress and unborn child, he had moved, apparently late in 1889, from the boulevard de Clichy studio, where *Les Poseuses* and *La Parade* had been painted, to new accommodation in the Passage de l'Elysée des Beaux-Arts, further up the Montmartre slopes, near the rue des Abbesses and close to the Théâtre Libre. Here, however, the studio was very small, a mere five metres square.[8]

The slight sense of alienation that one suspects in Seurat's career at the turn of the decade may also have been due to tensions within the Neo-Impressionist group. Minor personal difficulties reached flashpoint in

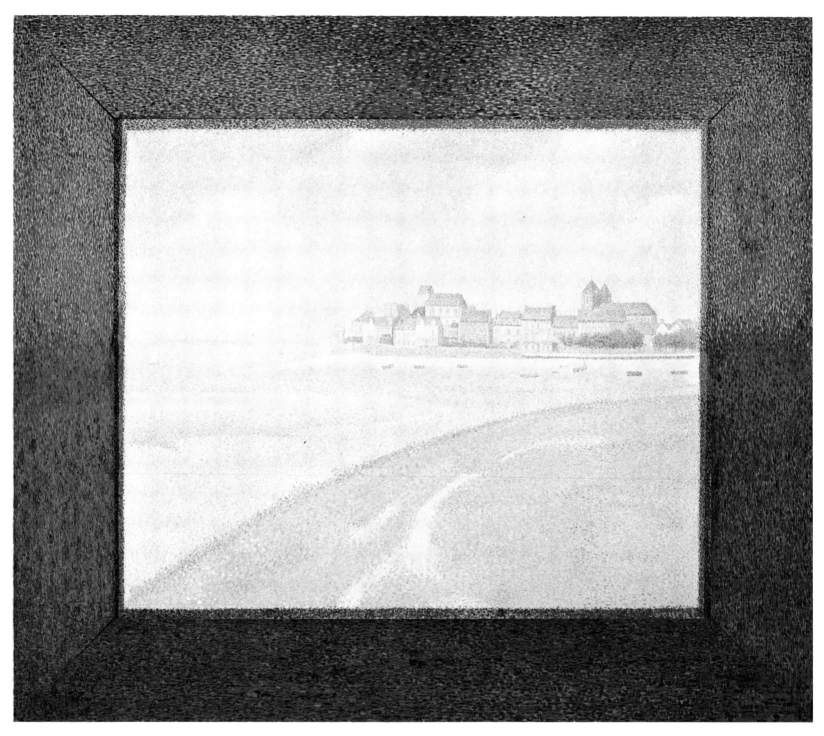

191. *Le Crotoy, Upstream*. 1889. Canvas, 70.5 x 86.3 cm. Detroit, Institute of Arts (DH 194).

1888, after publication of an article on Neo-Impressionism by Arsène Alexandre in the paper *Paris* on 13 August. This began by giving an inaccurate account of the divisionist technique and spoke ironically of the pointillist touch: 'Seurat, the true apostle of the lentil, the one who planted it, who watched it germinate, sees his paternity of the theory contested by poorly informed critics or unscrupulous colleagues.'[9] When Signac read this he was livid, writing to Pissarro on 24 August that this slur on his friends was one 'which casts aspersions on our honesty and which I cannot let go by. I'm writing to Seurat to ask if it was he who prompted Arsène to write that. I am asking for a FRANK reply ...'[10] Seurat replied two days later: 'All I know of this article is the

sentence quoted in your letter ... I have never said anything to him [Alexandre] except this, which I have always thought: the more of us there are, the less original we shall be, and the day everyone uses this technique it will no longer have any value, and something new will be searched for, as has happened already.' He added that it was at least a year since Alexandre had visited him and that he would hardly exhibit with Signac if they were not friends, concluding: 'I do not see the personalities, only fact.'[11]

Still put out, Signac wrote to Pissarro again on 7 September: '... what petty jealousy emerges from this letter. The best thing is to treat his hypocritical and jealous personality as a negligible element and only to pay at-

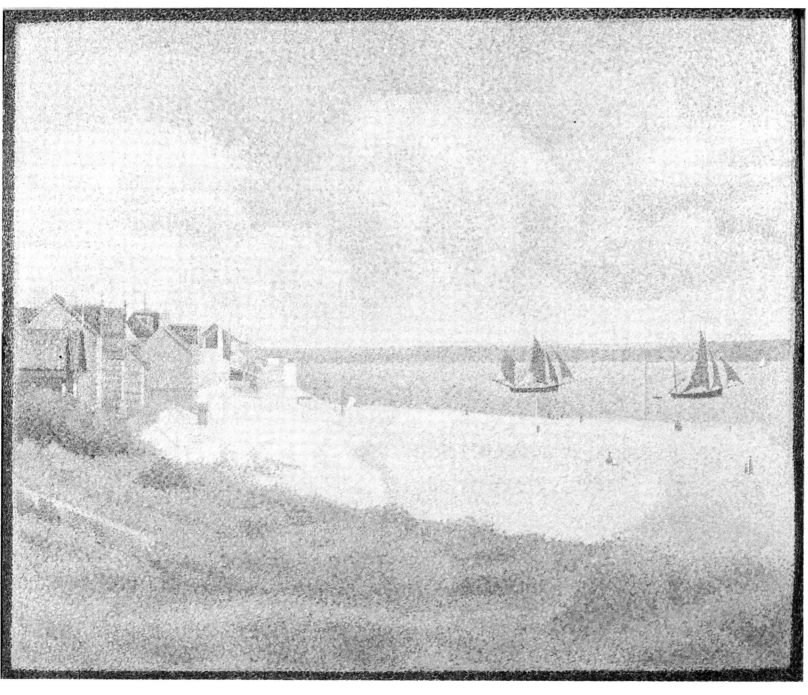

192. *Le Crotoy, Downstream*. 1889. Canvas, 70.2 x 86.3 cm. Stavros Niarchos Collection (DH 195).

tention to his work ... I will not give my friendship to a *huissier* of his kind.'[12] 'Really, if Seurat is the instigator of the article that you've pointed out to me, one's got to believe he's lost his head,' the sagacious Pissarro replied; would it not be wrong for 'all of those who are involved in the new painting to leave Seurat with all the glory of having been the first in France to have had the idea of applying scientific principles to painting? Today he'd like to be its sole proprietor!' Pissarro was worried about what he saw as the excessively 'scientific', academic attitude of Seurat: 'for the future of our "Impressionist" art it is absolutely essential to avoid the academic influence of Seurat. You yourself saw it coming, after all. "*Seurat belongs to the Ecole des Beaux-Arts*",

he's impregnated with it ...'[13] The crisis blew over, but something had been lost. Never again would the relationships be the same, although the friendships were patched up; Seurat drew his colleague's portrait, and it was used to illustrate Fénéon's brochure on Signac in the *Hommes d'aujourd'hui* series in 1890 (Plate 193), while after Seurat's death Signac was a tower of strength for his family and remained a tireless champion of his posthumous reputation.

Signac's earliest anxieties about Seurat's Ecole background were voiced in a letter to Pissarro written in September 1887, at a time when Seurat was working on *Les Poseuses*, increasingly interesting himself in more purely figurative paintings without landscape elements

187

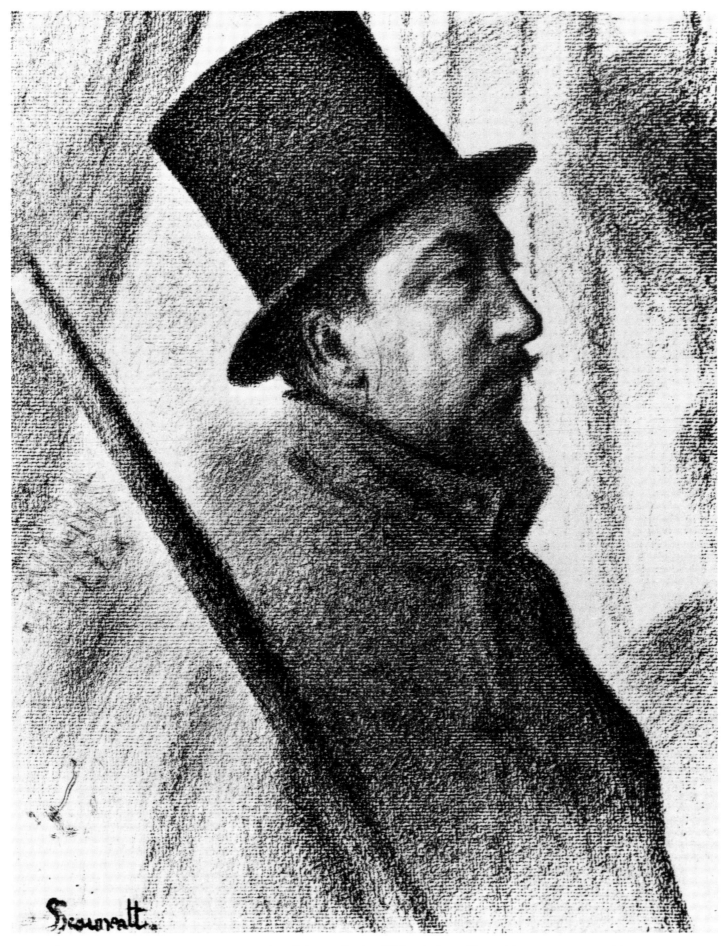

193. *Paul Signac. c.*1889–90. Conté crayon, 34.5 x 28 cm. Private collection (DH 694). Cover illustration to Fénéon's pamphlet on Signac in *Les Hommes d'aujourd'hui*, no.373, Paris, 1890, p.1.

and in abstruse theoretical ideas; Signac perceived that Seurat was taking Neo-Impressionism in a direction he was reluctant to follow. In the same letter he told Pissarro that he understood his problems with the new technique and the elder painter's inclination to return to his previous handling.[14] A year later the same problems still troubled Pissarro, and he articulated them in a letter to Lucien: 'I think a great deal ... about a method of working without the dot. I hope to get there, but I haven't yet been able to resolve the question of dividing the pure tone without harshness ... How can one combine the qualities of purity and simplicity that the dot has with the amplitude, suppleness, spontaneity, freshness of sensation of our Impressionist work? That's the question; it preoccupies me a lot, because the dot is meagre, without consistency, diaphanous, more monotonous than simple, even in the Seurats, above all in the Seurats ...'[15]

By the end of the decade Pissarro's painting had renounced the regimentation of the dot, though he retained a small touch and loosely applied divisionism; his gradual defection, entirely amicable and based on technical and aesthetic rather than personal problems, was followed by Lucien's. Hayet left the Neo-Impressionist camp disillusioned, writing regretfully to Signac in early 1890; 'I have seen this group that I took for an experimental élite divided into two camps: some experimenting, others arguing and sowing discord.'[16] By 1890 the camaraderie and excitement that has made the Neo-Impressionist group a coherent force had splintered. Nowhere is this clearer than in an unpublished letter from Signac to Lucien, written in January: 'You ask me for my news, but dear friend, I don't see anybody, anybody, anybody. Seurat's moved, ... Kahn married to the girl of his dreams, Luce rarely around and Dubois in Le Puy ... So I've got nothing to tell you.'[17]

From the late 1880s Seurat seems to have gravitated back to the company of those he knew from Lehmann's studio, and he attended the atelier's annual reunion dinners from 1887 onwards.[18] Apparently Séon was a particularly important friend at this time. Angrand recalled that they were to be seen at the Café Guerbois together, and around 1889 they were seemingly inseparable, as Dubois-Pillet complained in a letter to Signac.[19] They shared an interest in theory, but Séon criticized Seurat for what he saw as aesthetic deficiencies,[20] perhaps because Seurat's modern subject-matter was at odds with his own mythological and fantastic themes. Séon's ideas were purveyed in particular by the critic Alphonse Germain; one of the most important was the concept that colours and lines could 'symbolize physical or spiritual states and abstract ideas. Each colour had a meaning: white for purity, orange for sadness, violet and blue for melancholy, and so on. The horizontal line stood for serenity, the vertical for spiritual evolution.'[21] The two painters had much in common.

There was a noticeable decline in critical enthusiasm for Seurat's work at the end of the decade, compared

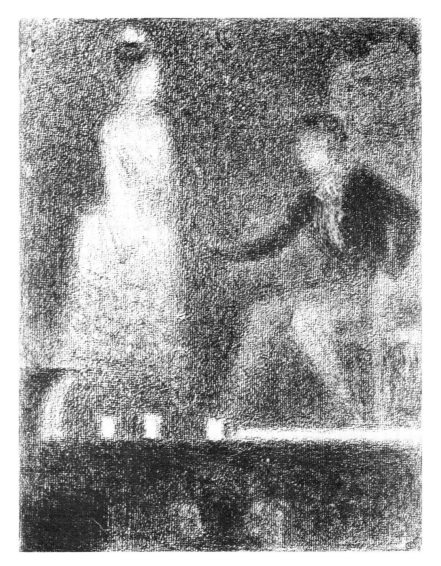

194. *Theatre Scene.* c.1887–8. Conté crayon, 31 x 21.5 cm. Paris, Louvre (DH 683).

with, say, 1886, when so many writers had their say about the Impressionist Exhibition. Reviews by earlier defenders such as Kahn, Adam and Ajalbert became sporadic or ceased to appear. Even Fénéon, too often considered Seurat's consistently loyal mouthpiece, wavered in his support. He did not review the 1890 Indépendants — and thus said nothing about a painting as important as *Le Chahut* — and produced the *Hommes d'aujourd-'hui* brochure on Signac, not Seurat, whose piece was written by Jules Christophe. Fénéon's doubts may well have been based on his view that the Neo-Impressionist method had been developed for and was best suited to landscape; other critics felt that paintings like *Le Chahut* and *Le Cirque* were interesting at an experimental rather than a resolved level.[22]

Not only was Fénéon now apparently closer to Signac than to Seurat — in January 1890 Gauguin referred to him as 'Signac's man'[23] — he was also sufficiently undogmatic to recognize other important artistic departures when they occurred. Gauguin had spent much of 1888 out of the capital, sniping at the well-connected

195. Study for *The Gravelines Canal. Petit Fort-Philippe*. 1890. Panel, 16 x 25 cm. Private collection (DH 207).

196. *The Gravelines Canal. Petit Fort-Philippe.* 1890. Canvas, 73 x 92 cm. Indianapolis, Museum of Art (DH 208).

Paris-based Neo-Impressionists, who, he claimed to Emile Bernard in a letter late that year, had begun 'a campaign (with the *Revue Indépendante* as the base for their propaganda) against us others'.[24] By mid-1889 Gauguin and his 'Groupe Impressionniste et Synthétiste' were able, almost in guerrilla fashion, to make an assault on the city; they staged a show actually inside the site of the crowded Universal Exhibition, held to celebrate the centenary of the French Revolution, and staked a claim as the new avant-garde. Fénéon wrote shrewdly and fairly about their show, recognizing that Gauguin 'was moving towards an analogous goal [to Neo-Impressionism], but by other methods'.[25] By 1891 critics were writing regularly that advanced painting now had two trends, 'Seurat and his friends' and 'the partisans of Paul Gauguin'.[26] Seurat's priority as the leading avant-garde painter in Paris had been successfully challenged.

In the face of what he must have seen as mounting setbacks Seurat endeavoured to shore up his position. He was especially perturbed by Fénéon's *Hommes d'aujourd'hui* brochure, which referred to Signac as 'the youthful glory of Neo-Impressionism', and did not mention Seurat once by name; it used his portrait of Signac (Plate 193) as the cover and yet on the back irreverently reproduced a patchy black blob — apparently the result of 'the collaboration of Henry and the bottom of a sauce-pan' — that might well have appeared to Seurat as a sarcasm at the expense of his theories and drawing style. However, Seurat was most concerned by the brochure's suggestion that the Neo-Impressionist technique was developed about 1885 by 'a few young painters'.[27] On 20 June 1890 he wrote to Fénéon, pedantically spelling out his early interests, dryly charting the development of his art and contradicting certain of the article's assertions the better to defend his prior status. Fénéon replied with polite insolence (see Appendix I).

It was at this time, in the light of fluctuating support and rival claims to attention, that Seurat chose to publicize his own aesthetic position. Appended to Christophe's biography in *Les Hommes d'aujourd'hui* was a statement Seurat had written. But even this outline did not satisfy him fully and he redrafted it, sending the new version to the writer and critic Maurice Beaubourg on 28 August 1890 (see Appendix II). As Homer has pointed out, Seurat's letter concurs with several of Henry's ideas, but in essence these were continuations of theories put forward by writers such as Blanc and de Superville with which Seurat had long been acquainted. In 1890 Seurat still made associations between colours and upward- or downward-moving lines, but he did not follow Henry's further distinction about movement to left and right, and he laid greater stress on the calm of the horizontal. Seurat's commitment to Henry's ideas, close in *La Parade*, seems to have dwindled; 'a modernized version of the academic concept of communication through rationally determined pictorial modes' was what the letter to Beaubourg simply and tersely articulated.[28]

Political polarization at the turn of the decade

By the late 1880s the increasing polarization of French politics was a potent pressure on the avant-garde community. The now-established Republic's commitment to social reform had been viewed with suspicion by the Left since early in the decade, and by its end the weaknesses of middle-of-the-road Republicanism had been cruelly exposed. In December 1887 President Grévy was forced to resign after the disclosure that a close relation had been involved in the trafficking of honours. Financial destabilization also contributed to the disruption of the Republic: in March 1889 a leading financier, Denfert-Rochereau, committed suicide, and the Banque de France had to step in to prevent a run on the nervous Stockmarket. The popular ex-Minister of War, General Boulanger, rose rapidly in public estimation as a charismatic figure who might fill what seemed to be a power vacuum, and elements of both Left and Right rallied behind him in a curious and temporary alliance. Boulanger unexpectedly fled the scene in April 1889, having brought the country to the verge of a *coup d'état*. For all that Boulanger was ultimately a flash-in-the-pan, he did arouse considerable support. Paul Adam, for one, stood as a Boulangist candidate in 1889, on a platform of social reform.[29]

Between the Decazeville miners' strike of 1886 and the assassination of President Carnot in 1894 there was mounting unrest in France, with the Left clamouring for social legislation such as the minimum wage and a shorter working week. But the Left was no more united. By 1890 the extreme Left, even Guesdists, were prepared to accept collaboration with bourgeois parties and seek election to parliament. The anarchists, on the other hand, operated outside the party system, with papers such as Grave's *La Révolte* and Emile Pouget's *Père Peinard* (founded in 1889) putting forward their arguments: that capitalism was corrupt, central government overbearing, contemporary régimes represented the interests of the bourgeoisie to the detriment of the people, and that the urban orientation of modern society encouraged the suppression and degeneration of the working classes.[30]

Anarchism drew support not only from proletarian demands for direct action but also from intellectuals, which caused Guesde to condemn it as 'the Socialism of the bourgeois'.[31] It was attractive to artists and writers because it entailed commitment to radical ideology without party allegiance, and because its emphasis on individual freedom could be equated with their aesthetic aims. 'Symbolism ... can be translated literally by the word Liberty and, for those of violent disposition, by the word Anarchy,' argued Rémy de Gourmont in 1892.[32] Indeed, anarchists promoted links with literature and the visual arts. This was particularly true of Grave, but as early as 1885, in *Paroles d'un révolté*, Kropotkin had urged artists: 'Show the people the ugliness of real

life, and make us put our finger on the causes of that ugliness; tell us what a rational life could be, if it didn't collide at every step with the ineptitudes and ignominies of the present social order.'[33]

There can be no doubt that by the turn of the decade there was widespread politicization of the arts in France, and that the Neo-Impressionist circle was intimately involved. The Club de l'Art Social, founded in 1889, mixed artists and writers — Pissarro, Rodin, Ajalbert, Lucien Descaves — with political activists like Grave and Louise Michel.[34] And the language of art criticism increasingly carried Leftist associations; in 1890 Octave Mirbeau, due to write the preface for a Pissarro exhibition, was referred to as 'the official introducer of revolutionary artists', while the year before Luce was directly compared to Vallès.[35] By about 1890 the political affiliations of certain Neo-Impressionist painters had become clear. Pissarro knew both Grave and Pouget by 1890,[36] and used quotations from *La Révolte* as captions for *Turpitudes sociales*, an album of drawings he made in 1889, virulently attacking capitalist Paris from an anarchist standpoint. Meanwhile Luce was regularly called, by critics such as Fénéon, 'the anarchist Luce';[37] Signac's drawing (1890; New York, Altschul collection) depicted him reading *La Révolte*, and by 1891 he was contributing drawings to *Père Peinard*.

There is no direct evidence about Seurat's political position, and it would be injudicious to attach him too closely to anarchism, arguing by extrapolation from his colleagues. In fact, the period of their closest association with anarchism was during the heyday of its agitation and repression, in the mid and late 1890s, when Seurat was dead; Signac, for example, did not begin to publish in *La Révolte* until 1891 or to correspond with Grave till the following year, and the Neo-Impressionists only started regularly to contribute propagandist images from 1896.[38] Although Seurat missed the full flood of Anarchist commitment, there is no doubt that the political polarization at the turn of the decade stimulated him to concentrate his art, to develop his early inclinations of critical social observation towards the choice and articulation of imagery consistent with the ideology of the radical Left.

Jeune Femme se poudrant

At the sixth Salon des Indépendants, which opened on 20 March 1890, Seurat showed five Port-en-Bessin marines, the two recent Grande-Jatte landscapes and two figure paintings, *Jeune Femme se poudrant* and *Le Chahut* (Plates 202, 208). The *Jeune Femme* was probably painted before *Le Chahut*; it may well have been begun in the first half of 1889 (Signac thought possibly late 1888), before the Le Crotoy trip, but it was not ready for the Indépendants in September that year, when the newly completed marines were shown. Seurat probably finished the *Jeune Femme* during the autumn, as work

started on *Le Chahut*, and the two paintings have elements in common.

It seems likely that *Jeune Femme se poudrant*, which is approximately half life-size, was painted directly on to the canvas with no preparatory drawings, although a sheet of a reclining nude (DH 660; formerly Félix Fénéon collection) is usually considered to represent the same sitter, Madeleine Knobloch.[39] Seurat designed the painting around a comparatively simple system of three prominent horizontals, still visible under the surface. One bisects the canvas, running through the edge of the bodice and especially visible to the left of the raised hand. Equidistantly spaced above and below this division one line passes through the ear and over the top of the eyes, while another is apparent to the left of the table, just below the lip of its surface. There seem to be no vertical marks.

Seurat's use of the dot was not systematic, ranging from small points to oval dabs, and in passages the touch was ordered in directional sweeps that look forward to the arcing distribution of marks in the Gravelines marines and *Le Cirque*. This mannerism, combined with Seurat's arbitrary application of an upward-rising, 'happy' pattern reminiscent of his diagram in the letter to Beaubourg (see Appendix II) and the rather unresolved treatment of the skirt (under which there seems to be only a single knee), gives the canvas a decorative, unnaturalistic quality. This character is enhanced by the colour range — the mid-blue background, subdued yellow skirt and flesh tone giving a relaxed and compact value structure, with an unobtrusive but piquant use of complementaries in the darker areas — the overall effect of which is quite pale and muted, Seurat's nearest flirtation with pastel tones.

Both the title *Jeune Femme se poudrant* and the image itself encourage one to classify the picture as a genre subject, which is misleading. Perhaps the secretive Seurat did not want to identify Madeleine Knobloch, and so stressed genre over portrait elements. The frame on the background wall once held a portrait of Seurat — X-rays indicate a head — but prior to exhibiting the picture he replaced it with a vase of flowers. *Jeune Femme* has been seen as almost a parody of the sitter — described variously by Roger Fry as 'this impossible woman', by John Russell as 'the impeccable podge'[40] — and it is true that in contemporary literature full-breasted women were often treated in quasi-comic fashion; Taton-Néné in Zola's *Nana* (1880) and Tétons de Bois in Catulle Mendès's *La Première maîtresse* (1888) are cases in point. But in a document explaining her position over the *partage* after Seurat's death, probably dating from 1891, Madeleine Knobloch referred to *Jeune Femme de poudrant* as 'mon portrait'.[41] She would hardly have so acknowledged, or wanted to keep, a painting that ridiculed her, and she appears to have considered it an acceptable likeness, for all its gentle irony. The painting is not merely an instance of Seurat's own growing interest in portraits at this time, as evinced in his drawings, but

197. *The Gravelines Canal. Grand Fort-Philippe*. 1890. Canvas, 65 x 81 cm. Cambridge, Fitzwilliam Museum (on loan from the Trustees of the late Lord Butler) (DH 205).

198. *The Gravelines Canal, Evening*. 1890. Canvas, 65.2 x 81.7 cm. New York, Museum of Modern Art (DH 210).

199. Heidbrinck, 'Il était un corsage ...'. Pen and ink from *Le Courrier Français*, 4 November 1888, p.5. Paris, Bibliothèque Nationale.

belongs to a wider concern for portraiture among his colleagues; Aman-Jean exhibited a portrait of his wife at the Salon of 1891 (Cleveland Museum of Art) and Henri-Edmond Cross of his at the Indépendants that year (Paris, Musée d'Orsay), alongside Signac's important portrait of Fénéon (New York, private collection).

It is such elements — the decision to give the portrait a pose with narrative connotations, the construction and colour range of the painting — that define the meanings of *Jeune Femme se poudrant*. The juxtaposition of woman and mirror, the woman often shown in revealing costume, surrounded by cosmetics and trinkets, has had long associations with Vanitas imagery, indicating the transitory nature of human beauty and earthly delights; one thinks of sixteenth- and seventeenth-century images such as Jacques de Gheyn II's engraving of the subject.[42] This tradition continued in the nineteenth century; Nana became frightened at the sight of her naked body in the mirror, and a poem by Charles Cros — who merited a fulsome obituary from Fénéon when he died in 1888 — took up the same theme:[43]

> Mais la psyché pourtant, Madame,
> Vous dit: 'Ce corps vainement beau,
> Caduc abri d'un semblant d'âme
> Ne peut éviter le tombeau.

[But the mirror, Madame,/Says to you: 'This vainly beautiful body,/Crumbling disguise for a semblance of a soul,/Cannot avoid the tomb.]

The subject was still treated in the visual arts, and Seurat must have known this, for a figure on one of the sheets of notes he took after Delacroix (Plate 31) seems to be a copy of his *Le Lever* (1850; formerly David-Weill collection), a painting of a nude dressing her hair before a mirror with deliberate Vanitas associations, including the cut flowers that Seurat introduced into *Jeune Femme se poudrant*.

The curiously Rococo quality of *Jeune Femme se poudrant* — its full, fleshy forms and pastel colouring — seems uncharacteristic of Seurat, but we should remember that this period saw a great revival of interest in eighteenth-century French art, a trend exemplified by the publication of scholarly monographs and by exhibitions such as the large show of paintings of this period held at the Galérie Georges Petit over the winter of 1883–4. Contemporary Salon painters made conscious references to this luxurious era and its art; for example, Alfred Stevens's watercolour *La Toilette* (1888; Bryn Mawr, Smith collection) depicted two women in eighteenth-century dress and in 1887 the Salon regular Emile-Pierre Metzmacher painted *The Broken Pot*, a deliberate modernization of Greuze's famous painting.[44] This taste for the Rococo was to be found in Seurat's circle, for Fénéon wrote an appreciative review of the Petit exhibition, while during the course of the decade Charles Henry published Cochin's *Mémoires* and Caylus's hitherto unknown biography of Watteau.[45] Seurat's cultivation of a Rococo character for his painting thus had a context; indeed, the concept of *Jeune Femme se poudrant* could have developed as well from engravings after toilette scenes by Boucher[46] as from recent Salon offerings such as Accard's *Comment me trouvez-vous?* of 1886 and contemporary illustrations like Heidbrinck's titillating *Il était un corsage* (Plate 199).

Perhaps Seurat conjured up Rococo features to rival chic Salon revivalism or to please his mistress, but one should be aware of other associations, other levels of meaning. The accepted view of Rococo art stressed its erotic elements — to Fénéon 'a chaste eighteenth-century' was 'an incomplete eighteenth century'[47] — and this emerged forcefully in the overt sexual connotations of such paintings as Metzmacher's and poems like Verlaine's *Amour*, published in *La Vogue* in 1886, which compared his lover to a Boucher nude.[48] There was an implicit licentiousness in Seurat's ordering of *Jeune Femme se poudrant*. The mirror is directed towards the woman's cleavage, which she is powdering, and the central horizontal axis and a vertical Golden Section intersect exactly between her breasts.[49] This tacitly voyeuristic trick of drawing the spectator's attention to the exposed flesh of the bosom was not new; it can be found in similar eighteenth-century images such as Greuze's *The Broken Mirror* (Plate 200), in which the dishevelled bodice is displayed at dead centre. But the implicit eroticism of *Jeune Femme se poudrant* was essentially private; indeed, the gentle and self-absorbed demeanour of the woman, the window-like picture on the wall (where

200. Jean-Baptiste Greuze, *The Broken Mirror. c.*1763.
Canvas, 56 x 46 cm. London, Wallace Collection.

Seurat's head had once appeared), and the dominant pale blue tonality — a colour associated by Sutter with modesty and candour but traditionally with the Virgin Mary — might almost lead one to construe the painting as an ironic version of the Annunciation, a not inappropriate allusion given Madeleine Knobloch's pregnancy.[50]

Jeune Femme se poudrant has an independent position in Seurat's oeuvre. As an exhibition picture it functioned within the context of the toilette scenes, at times with eighteenth-century associations, that were so common in contemporary French art. As a genre painting it played up the luxurious fripperies of female fashion, perhaps with a subtle reference to the long-standing and moralistic Vanitas tradition. And yet Seurat constructed the picture with a delicate eroticism, keeping this the more private by painting himself out, disguising the portrait within the anonymity of the genre scene, and depicting the woman alone, her own audience.

The café-concert: stalking the subject

The other figure painting that Seurat exhibited at the Indépendants in 1890 was *Le Chahut* (Plate 208), a picture that both consolidated old concerns and broke

new ground. The painting was an important one for Seurat: it was the first large-scale, multi-figure work that he had shown for two years, and it came at a time when his status in the avant-garde was under pressure. It continued both the theme of the café-concert, approached early in his career, and interests prefigured in *La Parade*, such as shallow space and artificial lighting. Yet *Le Chahut* introduced novelties, too, notably experiment with the representation of vigorous movement.

The painting's subject was taken from popular culture. The café-concert, like the circus, was one of those arenas of public vulgarity, of brash entertainment commonly enjoyed and easily understood, where bourgeois and proletarian jostled each other, a teeming, exciting microcosm of contemporary existence suited to Seurat's metaphorical and ironic imagination. The subject of the café-concert had first interested Seurat about 1880–1, when he made a number of coloured crayon drawings of entertainers such as the *Chanteuse* (DH 676; New York, Kramarsky collection). It reappeared in 1887. At the Indépendants in the spring that year he exhibited a drawing of the *Eden-Concert* (DH 688; Amsterdam, Van Gogh Museum), which was reproduced alongside an article by Kahn in *La Vie Moderne* that April.[51] Two café-concert drawings were shown informally in the offices of the *Revue Indépendante* during January 1888,[52] and a few weeks later at the Indépendants four were exhibited, including *A la Gaîté Rochechouart, Au Concert Européen* and *Au Divan Japonais* (Plates 205, 201, 210), with *Les Poseuses, La Parade*, and some other drawings. Seurat seems to have envisaged an almost communal identity for his café-concert drawings. At Les Vingt in 1889 he exhibited two café-concert sheets with specific titles — *A la Gaîté Rochechouart* and *Au Concert Européen* once more — alongside particular sets of paintings, the six Port-en-Bessin canvases and the two recent Grande-Jatte landscapes.

In these drawings, made during 1887 and early 1888, Seurat chose to depict sites — one assumes his titles were accurate, though his record of detail was deliberately restricted — that were close to his studio in the boulevard de Clichy; the Divan Japonais was in the rue des Martyrs, the Gaîté Rochechouart in the boulevard of that name. Yet again he kept clear of the centre of the city and the smarter café-concerts there, places to which he was not attuned, preferring the outlying *quartiers* where frontiers of class were more fluid. The observation of types and the codification of class by their costume was often as succinct in these drawings as in *La Parade*; *High C* (DH 684; Paris, Rehns collection) juxtaposes women's smart bonnets and bare heads, the sheet in the Cleveland Museum of Art (DH 687) different kinds of male headgear.

All these drawings of the café-concert have in common a general configuration, whereby the artist places the spectator firmly within the auditorium, looking over the heads of the audience or orchestra towards the entertainer on stage. As we have seen with *La Parade*, this

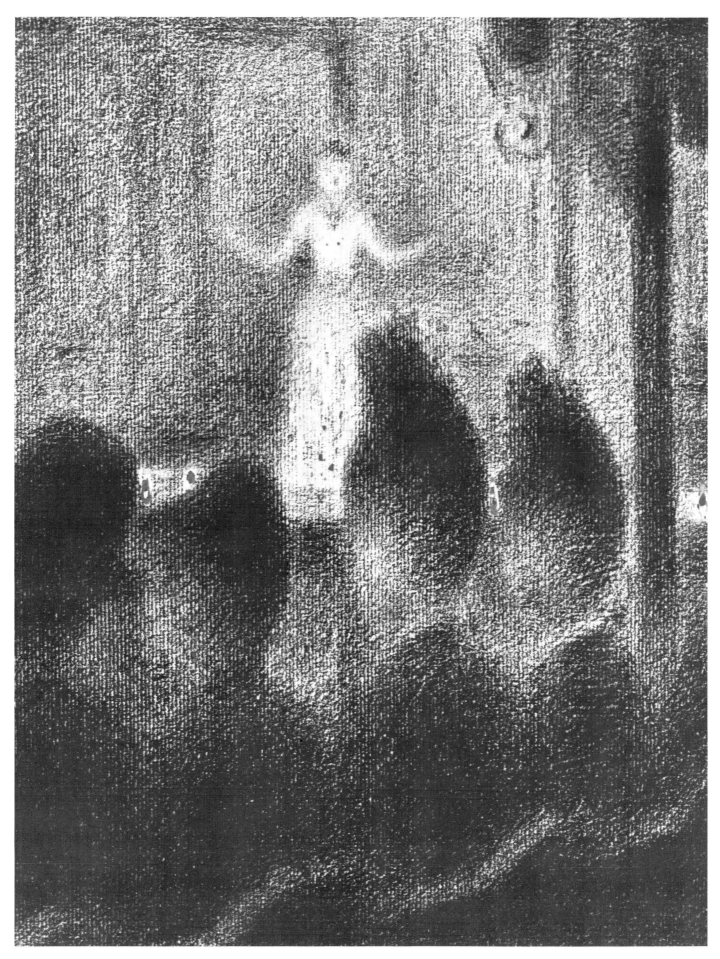

201. *Au Concert Européen. c.*1887–8. Conté crayon, 31.2 x 23.7 cm. New York, Museum of Modern Art (DH 689).

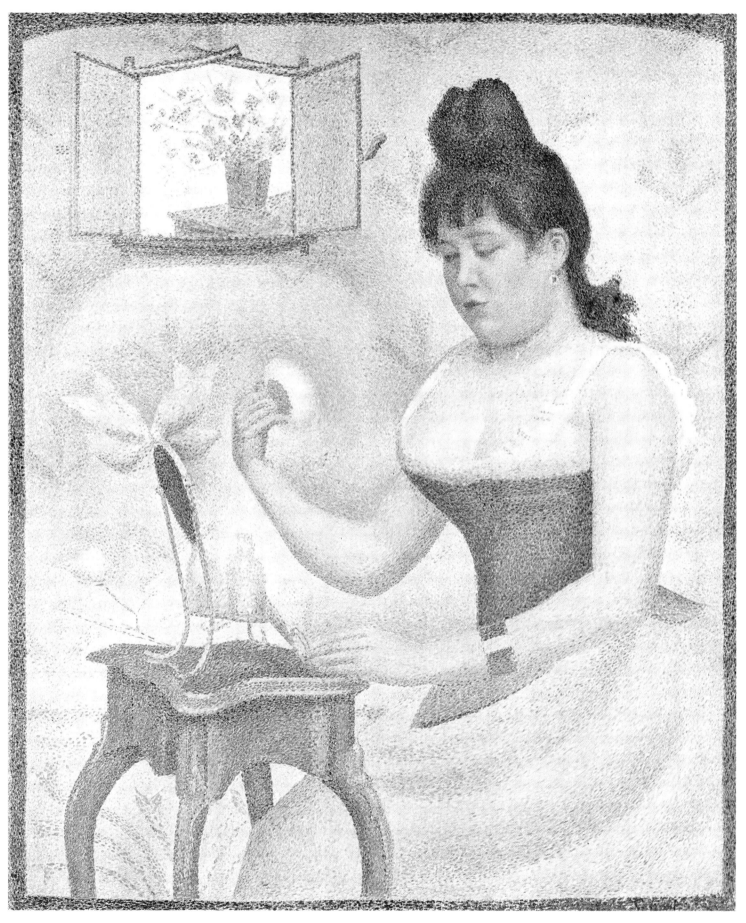

202. *Jeune Femme se Poudrant. c.*1889-90. Canvas, 94.2 x 79.5 cm. London, Courtauld Institute Galleries (DH 200).

203. Charles Levy, *Concert-Européen*. c.1880–5. Coloured lithograph, 58 x 43.5 cm. Paris, Musée de la Publicité.

204. Job, *Café-Concert Singer*. 1884. From *La Caricature*, 1884.

was a device that had deep roots in popular imagery, and by Seurat's day was an utter commonplace in illustration (Plate 204). But whereas Degas, when he used this configuration in ballet or café-concert scenes during the 1870s, gave scrupulous individual identity to the intermediate figures — twisting heads, shaping ears, sloping shoulders — in order to give the spectator a sense of physical presence in the crowd, Seurat adopted a different attitude. His drawings were orchestrated to make us perceive an alienation between audience and performer. Nowhere is this more evident than in *Au Concert Européen* (Plate 201), where the audience look away from the singer they have paid to enjoy. Here the singer's arms are raised in a direction of gaiety — according to Seurat's theories — and yet the rhythms of the foreground seats and the figures fixed in their catatonic anonymity face in the opposite, inhibitory way. In these studious drawings — not sketches, but carefully composed in the atelier — Seurat was rehearsing a trenchant, melancholy irony at odds with his brash and vulgar subject.

Seurat applied himself to these drawings with great sophistication. J.H. Rubin has pointed out the intricate interrelationship between two almost identical sheets (Plates 205, 206) representing the Gaité Rochechouart.[53] Both were drawn on paper cut to precisely the same size, the images composed with mathematical control. In both the profile of the singer's skirt lies on a vertical, and the line of footlights on a horizontal Golden Section, for example, but one sheet — now in the Fogg Art Museum (Plate 205) — is more correct in matching geometry and image, with niceties such as the junction of conductor's baton, horizontal bisection and vertical Golden Section. Rubin argues from this that the Fogg drawing must have been the second, more resolved sheet and, especially as it has been signed, the one Seurat chose to exhibit. This extravagant exactitude, combined with remarkably delicate light effects, gives these two sheets a disciplined, disturbing quality characteristic of all Seurat's café-concert images. The drawings served, as had the *croquetons* and drawings for the suburban

subjects, as his reconnaissance of the theme, his period of assimilation and exploration of technical problems. This achieved, Seurat was able to tackle an exhibition painting in which such material could be combined with a system of meanings so as to constitute a synthetic image of the subject.

Le Chahut: movement and image

The germ of *Le Chahut* was in these drawings. In particular, the sheet known as *Au Divan Japonais* (Plate 210), exhibited early in 1888, formed the basis of the painting completed two years later. This drawing included the fundamental elements of the painting: the central bass player, flanked by conductor and — here — a female spectator, with the all-important dancer (perhaps two) behind. The composition seems to have lain dormant for many months, until Seurat decided that it would serve well for his planned picture. Late in 1889 he must have begun to consider a large canvas, and two oil sketches show his progress. The *croqueton* in the Courtauld collection (Plate 207) got little further than the

drawing; the individual figures came more into focus — now with three dancers — but the general disposition remained the same. This panel, however, with its hastily applied, small and irregular dot, gave some sense of the swirling effect Seurat would later use to produce an atmospheric haze in the background of his canvas. The second painted study (Plate 209), this time on canvas, served as the resolved preparatory sketch. A fourth dancer was added, as well as further details such as the flautist to lower left and the shadows cast by the performer's feet, and the ensemble was pushed further back into the picture space. Even at this stage Seurat made scant effort to specify the types in the audience; their identities, and the meanings they carried, could be established later.

The colour structure of *Le Chahut* itself (Plate 208) is delicate, arbitrary and sophisticated. Essentially the painting is founded on warm and cool tones, oranges and blues, and Seurat orchestrated a subtle oscillation between the two polarities. The warmer passages are moderated by pale blues and yellows, while the cooler areas are activated by touches of orange (to represent the play of gaslight), reds and greens. Seurat introduced

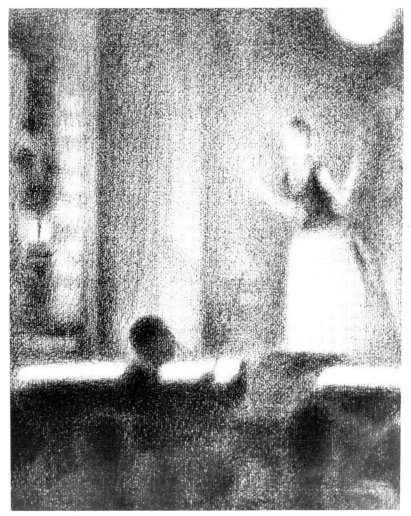

205. *A la Gaîte-Rochechouart. c.*1887–8. Conté crayon heightened with gouache, 30.5 x 23.3 cm. Cambridge, Fogg Art Museum (DH 686).

206. *A la Gaîte Rochechouart. c.*1887–8. Conté crayon heightened with gouache, 30.5 x 23.3 cm. Providence, Rhode Island School of Design (DH 685).

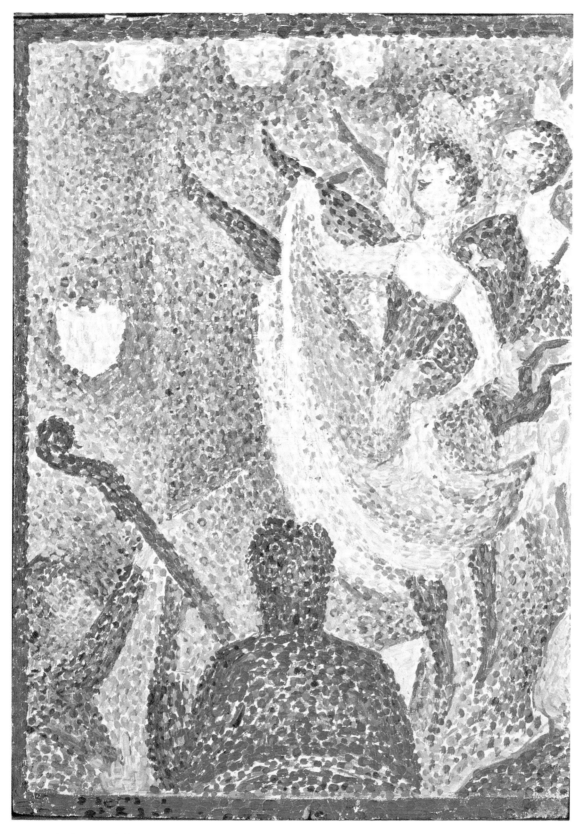

207. Study for *Le Chahut*. *c.*1889-90. Canvas, 21.5 x 16.5 cm. London, Courtauld Institute Galleries (DH 197).

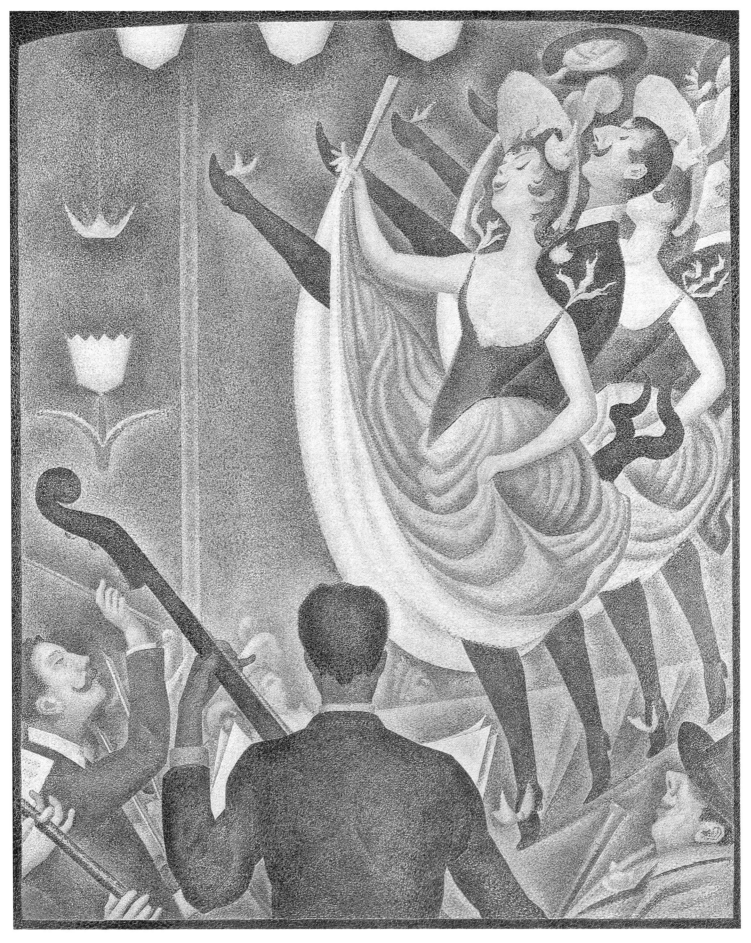

208. *Le Chahut. c.*1889–90. Canvas, 171.5 x 140.5 cm. Otterlo, Kröller-Müller Museum (DH 199).

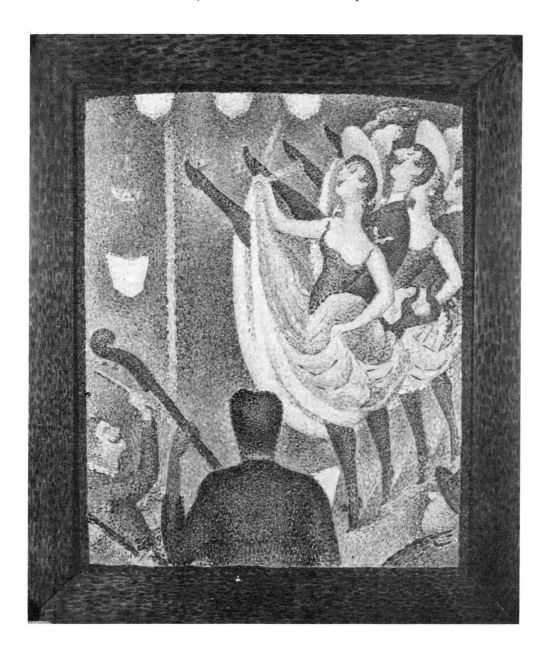

209. Study for *Le Chahut*. c.1889-90. Canvas, 55.7 x 46.2 cm. Buffalo, Albright-Knox Art Gallery (DH 198).

210. Study for *Le Chahut*: '*Au Divan Japonais*' c.1887-8. Conté crayon, 30.5 x 23 cm. Paris, Louvre (DH 690).

haloes — the device of irradiation — around the lighter, warmer zones such as the lamps, pillar and petticoats, and these serve simultaneously to give a sense of relief and to enhance the harmoniously decorative unity of the picture surface.[54] This enforced cohesion gives *Le Chahut* an uncanny, alienating, almost fantastic quality, a sense of disquiet enhanced by the impersonal caricatures of the dancers' faces — once more indebted to de Superville's diagrams — and the rigidly repetitive rhythm of their dance.

The innovative individuality of *Le Chahut* is to be found in its drawing. The angular, rather clipped handling of line was more emphatic than in previous paintings. Since the *Divan Japonais* drawing Seurat had developed in the oil sketches an increased linear crispness which he transferred to the final canvas, with blue lines providing scaffolding for legs and clothes, green outlining areas of flesh. This sharp linearity, at odds with the fuller forms of paintings from 1889 such as the Le Crotoy marines and *Jeune Femme se poudrant*, was thus

launched over the winter of 1889–90, significantly at the same time that a major retrospective exhibition of the celebrated artist Jules Chéret was held in Paris. Chéret, who after an apprenticeship in Britain in the techniques of colour lithography had started his career in France during the late 1860s, had by the eighties established a virtual monopoly over the nascent art of decorative colour poster design.[55] There is no doubt that Seurat admired Chéret's posters. In his obituary Verhaeren recorded that Seurat 'wanted to establish their means of expression and intercept their aesthetic secrets'; the artist collected them and persuaded his mother to do so as well.[56]

Le Chahut seems to have been the first instance in which Seurat made a stylistic bow to Chéret. The painting's debt to the poster designer was not primarily compositional, as the fundamental design was established in the drawing made prior to any apparent interest in Chéret. But as Seurat particularized his configuration, he may well have had recourse to the poster for *La Foire de*

Seville (Plate 211), published in 1889, in which Chéret articulated exactly those elements – the subsidiary relationship of musician and audience, the shadows cast by the dancers — that Seurat needed in order to sharpen detail in *Le Chahut*. Above all, Seurat took from Chéret a brisk, sharp linearity, as effective as the more rounded manner of *La Grande-Jatte* for the synthetic simplification he wanted, and easily adapted to his new concern for energetic movement.

It has been argued that the dynamic repetition that gives the sense of movement to *Le Chahut* was derived from the recent experimental 'chronophotographs' by Etienne-Jules Marey, but despite Seurat's curiosity about certain scientific developments there is no evidence of any particular interest in photography.[57] His staccato duplication of shapes may have had its origins in his reading of Blanc, whose *Grammaire* praised Ancient Egyptian art for 'the persistent repetition which makes a procession from every step, a religious emblem from every movement, a sacred sign from every gesture'.[58] However, both the colour range and the flat repetitive figures of *Le Chahut* recall Hellenistic Black- and Red-Figure vases, and it is probably no coincidence that at this time Henry, with Signac's collaboration, was interesting himself in the Bibliothèque Nationale's collection of such objects.[59] But if *Le Chahut* overlapped with Henry's activities in this respect it was no longer so close to his ideas as *La Parade* had been, for Seurat's

211. Jules Chéret, *Nouveau Cirque. La Foire de Seville*. 1889. Coloured lithograph, 112 x 82 cm. Paris, Musée de la Publicité.

205

distribution of colour does not slavishly correspond to Henry's linear theories. In fact Seurat's own less specific views — that all lines above the horizontal express gaiety — apply to *Le Chahut*,[60] while the important young critic Alphonse Germain suggested in an article published in mid-1890 that the painting's use of colour and line to preordain mood was 'almost identical' to the recent work of Séon, whom he ultimately favoured over Seurat.[61] Nor should one forget that calculatedly repetitive effects were one of the techniques of Symbolist writing. A passage from Adam and Moréas's *Les Demoiselles Goubert* of 1886, describing the Eden-Concert, almost tallies, in sophistication and subject, with the repetition of *Le Chahut*: 'Pink and green, the luminous depth of the scenery, lined by the can-can girls. On their faces incarnadine smiles; in their hollow eyes — a glint. Pink and green, the luminous depth. The taut, indigo legs of the dancers, the taut legs in a row, beyond the round gas lamps.'[62]

Sophisticated technical procedures were applied in the execution of *Le Chahut*, and this was recognized by contemporaries. Theo Van Gogh, for instance, reporting on the Indépendants to his brother Vincent in Provence, was aware that Seurat was trying 'to express things by means of the direction of lines' and admired the impression of movement, but finally found the painting 'curious'.[63] The Belgian Henry Van de Velde, at this time painting in the Neo-Impressionist style, stated categorically that 'the intention [of *Le Chahut*] is to succeed in expressing gaiety by the consistent direction of lines',[64] but such a simplification only hints at the complex meanings embodied in *Le Chahut*. To unravel these we need to look closely at its subject, at the type of contemporary entertainment Seurat represented, and its place in contemporary discourse.

The reality of dancer and public

Since its first flowering in the 1860s, the café-concert had stimulated much debate, which continued vigorously throughout the time Seurat was painting. By 1890 it was firmly entrenched as the main form of popular entertainment in Paris. The café-concert catered for broad sections of the population, both bourgeois and proletarian, as well as for tourists. The original outdoor café-concerts, with seats and tables gathered round a stage and catering for the summer clientéle, still survived, but new buildings were coming into use based on the standard theatre format, establishing the café-concert as a permanent fixture in metropolitan show business (Plate 203). Programmes were very varied, with performances from singers, comedians and acrobats, as well as the staging of more ambitious operettas and pantomimes.[65]

There were several divergent attitudes to the café-concert. As T.J. Clark has pointed out, for the Right the crass triviality of much of its material and the moral laxity apparent in both performers and public seemed threatening to an insecure bourgeois culture, while in the opinion of the Left the café-concert distracted the working classes from pressing social issues.[66] To some conservative commentators the phenomenal success of the café-concert was symptomatic of the weakness and egalitarianism of the Third Republic, to others the popularity of its slang songs and cheapjack stars subverted conventional theatre.[67] But in an article published in *Le Gaulois* in 1886 Octave Mirbeau defended the café-concert: 'There one discovers the great pace and bewilderment of modern life, all the joking, all the disrespect, the whole contemporary show, it all pours from the unthinking lips of a singer in an ominous shorthand which stirs the intellectual's reflections and the artist's imagination';[68] for him it was a microcosm of modern society. And, indeed, the café-concert fascinated Seurat's circle: in a letter to Kahn of 1886 Laforgue referred to Henry as 'the man of science who goes to the Divan Japonais'; Lucien Pissarro showed a group of drawings of cafés and café-concerts at the 1888 Indépendants; the year before Ajalbert published a poem on the *chahut*.[69]

Seurat elected to operate on the *boulevards extérieurs*, as we have seen. For the painting he opted to represent dancers rather than the singers who had featured in the drawings — a significant choice — and to show them on the stage of a café-concert rather than on the floor of a dance-hall, a *bal* like the Elysée-Montmartre or the Moulin de la Galette. The places identified in the titles of the drawings — the Gaîté-Rochechouart, the Concert Européen — were reputed as places for 'the popular element', though they would have had a stronger mix of bourgeois clients than the rougher dance-halls.[70] The *chahut* itself was a specific dance, with particular movements and suggestions. Defined in a contemporary slang dictionary as 'Can-can pushed to its furthest limits, dance taken to the point of hysteria', it was also known as the *quadrille naturaliste*.[71] It had developed from the can-can quite recently, and apparently began about 1885–6 at Le Jardin de Paris, a *bal* that boosted attendances by staging a showpiece; the skill and lasciviousness of the performers, above all the infamous La Goulue, made the new dance catch the popular imagination. Its two main moves — *le grand écart* and *le port d'armes* — were based on the high kick; both involved the dancer doing the splits while she remained standing on one leg. The *chahut's* whole *raison d'être* was immodest display; it was in essence a repetitive signal of sexual availability.[72] 'Ah! what an expressive pantomine: black stockings, well pulled up, allow one to see a thin strip of pink flesh; tight-fitting pants let one make out the roundness of the thighs; the dress plastered around the haunches indicates to enthusiasts opulent hindquarters; the cleft of the bodice is cleverly arranged for the eye to plunge in easily and explore its depths,' wrote the spuriously outraged Charles Virmaître in 1893; 'And that's only the *hors-d'oeuvres*; the *pièce de résistance* is the quadrille, when these women — without any inhi-

bitions, because they're paid to do it — raise their leg, without any knickers if you please, up to eye-level.'[73]

The *chahut's* sexual connotations were rapidly seized upon by popular illustrators, especially those working for *Le Courrier Français*, a Montmartre-based weekly which included drawings by artists Seurat knew, such as Lucien Pissarro and Willette. A drawing signed 'Desportes' appeared in April 1886, showing *chahut* dancers with rabbits, using an animal image from Parisian argot to make a lewd innuendo, while in 1891 Willette published a drawing representing Pierrot watching a high-kicking dancer and commenting: 'She's right. It's more proper and more profitable to sell her ... than her heart or her wits!'[74] Popular illustration and its audience was well aware of the nature of the *chahut*, of the economic realities that underlay it, and had begun to produce a visual vocabulary to convey this.

The compositional genesis of *Le Chahut* makes it clear that Seurat also strove to match the structure of his painting to the facts of the dance. In both the *Divan Japonais* drawing and the Courtauld *croqueton* (Plates 210, 207) the spectator to lower right is an almost negligible presence, while the conductor's baton points at the foreground dancer in an obscene fashion. In the subsequent Buffalo oil-sketch (Plate 209) Seurat gave the spectator a more identifiable — and male — role, and altered the baton from its suggestive angle. In the final painting the conductor remained the same, and the spectator took on a particular character, with his prurient leer and the addition of the prominent cane, a phallic symbol commonly used by contemporary illustrators.[75] *Le Chahut* was in fact ordered in a similar way to *Jeune Femme se poudrant*, to indicate implicitly the eroticism of the subject, for the exact horizontal halfway line and a vertical golden section coincide at the front dancer's sex.[76] For all its appropriate precision Seurat kept this structure tacit, and it seems that he was cautious about publicizing the painting's erotic elements. The expectations of the café-concert insisted that female performers show 'a great deal of bosom'.[77] Hasty repainting indicates that Seurat was uncertain what to do about the main figure's bust; pentimenti show that he flattened the breasts but overpainted an original outline to shift her neckline slightly lower. Even such minor modifications suggest anxieties about the presentation and reception of his image, and these instances of suppressed or oblique sexual features may possibly owe their circumspection to an active censorship; in January 1889 two illustrators on *Le Courrier Français*, Legrand and Zier, had been fined for publishing obscene drawings, one an allegory of prostitution.[78]

Seurat's attitude to the *chahut's* public expression of promiscuous sexuality is to be found in both the painting's subject and its means of representation. His motive for invoking Chéret in his picture, for example, was not simply to represent a scene drawn from popular culture via the vocabulary of popular imagery. Chéret was not only seen by contemporaries as the most effective and florid poster designer of the day, but also as democratic and egalitarian. Fénéon, for one, spoke in 1888 of his ubiquitous posters as 'masterpieces for the ragpickers', while another critic, reviewing Chéret's retrospective, praised his work as 'a young, living, vibrant art, made for the crowd'.[79] While listing Chéret's great decorative qualities, comparing him to Watteau and Fragonard, critics still found it necessary to identify him as a satirist and comment on his canny mixture of taste and vulgarity, to regard his work as 'a caustic, mocking satire' on the Parisienne, 'rightly letting fly at the cupidity or licentiousness of those money-grabbers and spoilt fruits'.[80] It is quite possible that with *Le Chahut*, as he began to enter Chéret's thematic territory and appropriate his formal language, Seurat too hoped to stimulate such reactions, and to draw public attention to his chosen target.

For the *chahut* was an ideal subject for scathing satire. Central to discourse about the dance was the argument that its blatant eroticism was keyed to financial gain. 'Without wanting to push the moral problem too far, couldn't directors [of the café-concerts] alert themselves to what is being planned and prohibit it if it is offensive?' asked Chadourne in 1889. 'For example, could one not beg them in the name of art and even of pleasure to get rid of these frightful exhibitions of women,... these Goulues, the Grilles d'Egout, who dance on the French stage steps unknown to the crudest savage. I know that big takings are a powerful attraction; but, quite apart from the short duration that such a success can have, does it not bring down shame and discredit on these establishments?'[81] The Left certainly saw such spectacles in these terms. Writing in *La Révolte*, shortly after Seurat's death, Signac explained the ideological position of the Neo-Impressionists' imagery. By painting scenes of working-class life, 'or, better still, the pleasures of decadence like dance-halls, *chahuts* and circuses — as the painter Seurat did, who had such a vivid perception of the degeneration of our transitional era — they will bring their evidence to the great social trial that is taking place between workers and Capital.'[82]

In 1888 anarchists even took action against a particularly licentious café-concert in Lyons, into which a bomb was lobbed in the small hours. The police thought this was a consequence of an article published a few months earlier by *Le Droit Social*, an anarchist paper, which had pointed a finger at the place: 'You can see there, especially after midnight, the fine flower of the bourgeoisie and of commerce ... The first act of the social revolution must be to destroy this den.'[83] Spectacles like the *chahut* were, on the surface, frivolous entertainments; in their equation of obscenity and profit, in their exploitation of working-class women for the pleasure and pocket of a predominantly bourgeois public, they were also the terrain of class conflict.

From the many contemporary texts that describe the *chahut* we gain a clear picture of the society that surrounded the dance. Huysmans' *Certains*, published in

212. A. Brouillet, *Suzanne*. 1890. Location and dimensions unknown. From L. Enault, *Paris-Salon 1890*, Paris, 1890, opp. p.5.

1889, contained a description of a drawing of a *quadrille* by Raffaëlli, in which the artist represented 'the female of the species, cast out of the suburbs to make a living on the stage, and satisfy the voyeuristic lusts of people from the rich *quartiers*; and beneath the carnival tinsel, beneath the cosmetics, beneath the extravagance of these exposed bellies and heaving tits, he has discovered the boozed vulgarity of gesture and the mercenary lewdness of every eye.'[84] Charles Quinel's poem *Danseuse* appeared in *Le Courrier Français* in January 1891:[85]

Dans les bals de Montmartre, elle danse, les soirs
Entre des calicots, des gommeux et des grues:
Femmes en grands chapeaux, hommes en habits noirs;
Messieurs du dernier chic ou roulures des rues.
Sans gaîté, sans plaisir, pour gagner ses cent sous
Elle danse et son rire est quelque peu morose
Tandis que le public cherche dans ses dessous
De dentelle et de soie un morceau de chair rose.

['In the evenings she performs at the Montmartre dance-halls/ Amongst apprentices, tarts, and men-about-town:/ Women in large hats, men in dark suits,/Dandies and streetwalkers./ Without gaiety, without pleasure, to earn her hundred sous,/ She dances, and her laughter is somewhat morose/As the public search her lace and silk underwear/For a morsel of rosy flesh.]

Both texts describe the calculated voyeuristic eroticism of the dance and, although Quinel's account of a varied public was accurate, in his final verse he set the dancer off against the 'bourgeois living on a comfortable in-

come', establishing a similar class distinction to Huysmans's between working-class suburb and wealthy *quartier*. The social reality of the *chahut* was complex, but both writers chose to reduce it to its essential polarity of proletarian *chahuteuse* and bourgeois spectator.

Le Chahut was not the only contemporary painting to respond to the same synthesis — Signac's confrontation of workers and Capital, if you will. Brouillet's *Suzanne* (Plate 212) was exhibited almost simultaneously to *Le Chahut*, at the Salon of 1890. Brouillet's picture, while a modification of an Old Testament theme and a representation of the audience rather than the performance, nevertheless envisaged the *chahut*'s environment in much the same way as Seurat: a place of overt sexual and implicit financial exchange, where the top-hatted, cane-carrying bourgeois is juxtaposed with the readily available working-class woman.

Critics immediately recognized the satirical meaning inherent in Seurat's representation of both sides of this polarity. George Lecomte wrote of his dancers, describing how 'while performing their libidinous acrobatics, the *chahuteuses* keep their upper bodies impeccably rigid, heads held high, and, from beneath eyelids that speak of their conquests, they cast a glance over the temptations they have unleashed'.[86] Seurat depicted the dancers' faces according to de Superville's schema for gaiety (Plate 155), but their smiles, like their movements, are regimented and artificial. The caricatural drawing of their features and the piston-like precision of the dance combine to expose the *chahut* as a staged event of bogus frivolity. This representation of the dancers — doll-like, unindividualized — seems alert to the exploitation of women in the dance-halls, the indecent display traded

213. Adolphe Willette, *Te Deum Laudamus*. 1886. Pen and ink. From *Le Courrier Français*, 28 Mar. 1886, p.3. This illustration by Willette does not include the Latin inscriptions identifying the allegorical motifs that were incorporated in the original stained glass (now lost).

for wages, that was central to the discourse surrounding the *chahut*.

Kahn's sharply critical awareness of the polarity particularly chastised the audience: 'As a synthetic image of the public, observe the pig's snout of the spectator, archetype of the fat reveller, placed up close to and below the female dancer, vulgarly enjoying the moment of pleasure that has been prepared for him, with no thought for anything but a laugh and a lewd desire. If you are looking at all costs for a "symbol", you will find it in the contrast between the beauty of the dancer, an elegant and modest sprite, and the ugliness of her admirer; between the hieratic structure of the canvas and its subject, a contemporary ignominy'.[87]

Kahn drew attention to the way Seurat had characterized his typical spectator, isolated to lower right, as a pig. Writers regularly referred to the public of the *chahut* in this way — the *Courrier Français* talked of the clients of the Jardin de Paris as 'pigs after garbage' as early as 1886 — and no doubt Seurat adopted the metaphor because it was appropriately common parlance.[88] It was also an image central to a work of art Seurat must have known, a motif whose configuration bears analogy with both *La Parade* and *Le Chahut*: Willette's stained glass window for the Chat Noir (Plate 213). Titled *Te Deum Laudamus*, the window was an allegory of modern society, with a monarchical pig as symbol of bourgeois domination, and images of poverty, promiscuity and revolt. Similar symbolic means were used by other artists in the late 1880s as vehicles for social comment or criticism. For instance, in 1889 Lunel drew an illustration (Plate 214) welcoming visitors to the Universal Exhibition in which he depicted the new Eiffel Tower as a pertinent image of contemporaneity, but dwarfed it by a *chahuteuse*, with the implication that she was a more potent symbol of modern Paris.

There was, then, a modern, critical imagery, operating via allegory, available to Seurat. His Ecole training had made him aware of painting's long-standing tradition of didactic, moralizing subjects, and in early paintings such as *Truth Emerging from the Well* (Plate 11) he had rehearsed allegorical subjects. Nevertheless, in *Le Chahut* Seurat did not revert to the cumbersome conventions of allegory, by which each motif carried specific meaning. Rather the painting is a finely tuned harmonization of formal means — the ordered direction of rising lines, the use of the golden section as a suggestive axis, the angular mannerisms of the common poster — and metaphorical or associative elements — the dance itself, highly publicized and hotly debated, the porcine spectator, the accessories that mark him both lascivious and bourgeois. Albeit a less ambitious painting, *Le Chahut* produced a smoother synthesis of form and meaning than *La Grande-Jatte*. By the end of the decade Seurat had learnt to coordinate his efforts more, to isolate a specific target, and no doubt the tenser political climate contributed a more acute, critical edge to his work. *Le Chahut*, hanging at the Indépendants in 1890 with *Jeune Femme se poudrant* (contrasting images, one might say, of public and private sexuality), appeared strikingly unusual, with its uncompromisingly unnaturalistic ordering of pictorial means to convey meaning, the technical sophistication of its chromatic structure, and the combination of hieratic, even primitive, repetition and its poster-like presence.

The Eiffel Tower as emblem

The small panel of the Eiffel Tower (Plate 215) shows, like *Le Chahut*, how by the end of the decade Seurat's paintings of Parisian subjects were founded on an increasingly iconic system of representation rather than on

214. F. Lunel, *Salut à la Province et à l'Etranger*. 1889. Pen and ink. From *Le Courrier Français*, 12 May 1889, p.1.

215. *The Eiffel Tower*. 1889. Panel, 24 x 15.2 cm. San Francisco, Fine Arts Museum (DH 196).

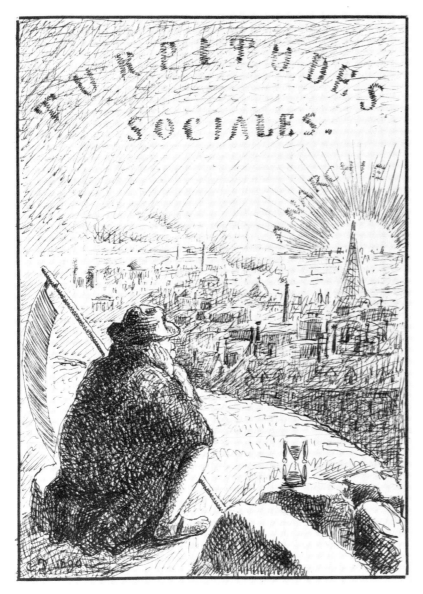

216. Camille Pissarro, *Anarchie*, cover of *Turpitudes sociales*. 1889. Pen and ink, 31.5 x 24.5 cm. Geneva, Skira Collection.

naturalistic appearances. The *Eiffel Tower* is another instance of Seurat's realization — seen previously in such pictures as the *Ruins of the Tuileries* (Plate 65) — that the city's public buildings might carry emblematic meanings. Probably executed in early 1889, the painting depicts the Tower at a similar stage of completion to that in a picture by Paul Delance, *The Champ-de-Mars, Paris, in January 1889*, shown at the Salon that year.[89] Seurat was by no means the first to respond to the modernity of this monumental structure. *La Vie Moderne*, for example, had illustrated a drawing of one of the four basic pillars under construction as early as October 1887, and in February the following year a drawing by Hayet showing the Tower completed only up to the first stage.[90] The structure itself had caused great public up roar. On 14 February 1887 *Le Temps* published a letter, signed by members of the cultural establishment such as the painters Gérôme, Léon Bonnat, Bouguereau and Meissonier and the writers Dumas *fils*, Pailleron and Leconte de Lisle, objecting virulently to the erection of

'the useless and monstrous Eiffel Tower', claiming that the great architectural monuments of the city would be dwarfed by little more than 'a gigantic, black factory chimney'.[91]

But there were others who were prepared to accept the Tower within the pale of a new aesthetic. In a riposte to this letter of protest Laforgue justified it with the slogan 'Place aux Jeunes!' 'It will acquire its own beauty like the other machines in Paris.'[92] Another of Seurat's circle, Antoine, director of the Théâtre Libre, wrote in his diary in 1889 that in due course 'people will perceive the grandeur of this first realization of the aesthetic of iron. There are days when, in the Parisian climate, the Tower takes on an admirable lightness and elegance.'[93] Seurat surely belongs in such company. In a lighthearted way his representation of the Eiffel Tower continued the ironic, anthropomorphic interchangeability of figure and object that we have seen elsewhere in his work, and this has parallels in the whimsy of contemporary satire, such as the caricature of Eiffel as his tower, published in *Le Figaro* in 1889.[94] It was Meyer Schapiro who first drew analogies between *The Eiffel Tower*, the trombonist of *La Parade* and the central figure of *Les Poseuses*,[95] and all three motifs witness the effectiveness with which Seurat could manipulate the symmetrical form into an emphatically emblematic, even heroic, image.

For all that *The Eiffel Tower* has an almost human presence, Seurat was also conscious of its technological modernity, carefully charting the shifts of tone in the special weatherproof encaustic with which the construction was coated.[96] But this attention to chromatic nicety coincided with Seurat's own theories of formal signification, for both the thrusting rise of the Tower and its warm bright colours generate the mood of gaiety.[97] For Seurat, then, the Eiffel Tower would seem to have had specific meaning. To Lunel (Plate 214) and Seurat the Tower symbolized contemporary Paris, the Paris of the 1889 Universal Exhibition. The cover illustration of Pissarro's *Turpitudes sociales* (Plate 216), drawn that year, represented the figure of Time watching the sun of Anarchy rise over contemporary Paris, identified by the Eiffel Tower, which is unable to disguise the new dawn.[98] Pissarro used the Tower to signify his horror of the bourgeois régime and the corruption of the modern city, whereas for Seurat it was the image of the future, of technological progress. And while in his caricature Lunel envisaged the dancer as the dominant delight of the Universal Exhibition, for Seurat the image of the *chahut*, rather than the tower, signified his indignation towards contemporary society.

L'Homme à Femmes

The initial allegiance to Chéret that had commenced with *Le Chahut* became more overt in 1890, notably in the cover Seurat designed for a novel, Victor Joze's *L'Homme à Femmes* (Plate 217). Chéret's reputation,

founded largely on his posters but also on his work in other areas of the applied arts such as book covers, was as the creator of public art for public consumption, and this was consistent with the more extrovert character Seurat was now seeking in his monumental figure painting and also in much of his other work.

Other members of the Neo-Impressionist circle had earlier made drawings derived from the Naturalist novel — Signac from Huysmans's *Les Soeurs Vatard* (*c.*1885; Paris, private collection) and Van de Velde from Zola's *L'Oeuvre* (1889; Otterlo, Kröller-Müller Museum). In illustrating the cover of Joze's book Seurat not only strengthened his literary links but also followed his

colleagues' initiatives towards the availability, even the democratization, of their work, for such sympathy towards the applied arts was by no means without ideological connotations; both Signac and Van de Velde were also men of the Left. With *L'Homme à Femmes* Seurat took himself deliberately into the new arena of commercial art. As Kahn insisted in 1888, Chéret proved the possibility 'of striking and elegant industrial art, with genuinely pleasing lines':[99] in other words, the combination of new procedures — not without commercial, technological associations — and a new canon of beauty.

Kahn's remark was made in a review of a book by Félicien Champsaur, *L'Amant des Danseuses*, for which

217. *L'Homme à Femmes*. 1890. Pen and ink, 25.7 x 16.5 cm. Geneva, Galerie Jan Krugier (DH 695).

213

218. Study for *Le Cirque: L'Ecuyère. c.*1890–1. Conté crayon, 30 x 30 cm. Private collection (DH 707).

Chéret had designed the poster (Plate 219). Seurat, unused to the demands of cover design, relied on Chéret's image, notably in the juxtaposition of the dark figure of the rakish Parisian dandy against the paler backdrop of flirtatious women.[100] The drawing has the svelte but muscular contours typical of Seurat's adaptations of Chéret, enlivened not by the strict dot of the earlier illustrative drawing derived from *Les Poseuses* (Plate 145) but by morse-like marks. And the torsion of some of the figures is more akin to the poster designer's work than the staid solidity of Seurat's previous profiles.[101]

Seurat's cover, as Georges Lecomte recognized in his review of the book,[102] identified the central characters of Joze's novel, representing them as types: Charles de Montfort, Naturalist writer, 'the ladies' man' himself; the shop-girl Louise Berton whom he seduces and disastrously takes up; the anonymous streetwalker with whom he is first unfaithful to Louise; the lewd café-concert singer Alice Lamy, his partner in a passionate affair; and the baronne de Scheidlein, wife of the man who keeps Alice and who becomes de Montfort's long-term mistress. Seurat's drawing stayed true to his theoretical procedures, for he utilized his de Superville-derived formulae for the faces, contrasting the 'rising' features of the promiscuous characters with the 'calm' ones of the virtuous Louise: once more an example of the equation of the literal and symbolic in his work.

The book's rambling and inconsequential narrative is unimpressive, and *L'Homme à Femmes* is only of interest because it is a *roman à clef*. The novel starts almost as an account of avant-garde life on the boulevard de Clichy in the late 1880s; Paul Alexis and Oscar Méténier appear as themselves, 'Edouard Normand' is a barely disguised Edouard Dujardin, 'Osip Mazourine' is Téodor de Wyzewa, and so on. But of salient interest is de Montfort's closest friend, Georges Legrand. Legrand, aged twenty-nine, is 'cold, correct, taciturn', speaking in 'laconic phrases', living on private means of 400 francs per month, an Impressionist painter who has executed many small oils and several large compositions:[103] 'Georges Legrand' is obviously Georges Seurat. Nowhere does this become clearer than in Joze's account of Legrand's current painting, which bears a striking similarity to *Le Chahut*: 'a strange quadrille, the stage of some café-concert or other; two coarsely beautiful *chahuteuses*, with provocative gestures, kicking their legs into the air; and their partners, opposite them, with bent knee and raised head, looking at the womens' petticoats in a kind of ecstasy; in the audience a varied public — men-about-town, tarts, villains, bourgeois, workers'.[104] How apt it was that Seurat should appear as a fictional character in the novel which saw his début as designer of book covers; how apt that he should emerge half-disguised as he strove to give his art a more public presence.

Le Cirque: the poster and the grand manner

A similar world of cheap entertainment and urban types was the setting for Seurat's next important composition. On 10 March 1891 the Indépendants opened, and Seurat showed *Le Cirque* (Plate 224) alongside the four Gravelines marines. The painting was not entirely finished (though quite resolved enough for display), the artist perhaps anxious publicly to assert his new initiative and not to let another year slip by without showing a major figure picture. *Le Cirque* met with little critical enthusiasm. Fénéon, who devoted a paragraph of his review to Signac, merely listed 'other Neo-Impressionists, let's see: Seurat, a circus …;' while Julien Leclercq asked rhetorically: 'can this geometry be called art?'[105] The tendency was to see the painting simply as a continuation of *Le Chahut's* researches into linear direction, and only infrequently were critics prepared to look more closely for its ambitions and meanings.

Seurat himself clearly planned it as a major work. *Le Cirque* is a large painting — the image much the same size as *Le Chahut*, the painted border making the ensemble slightly bigger — and the foreground clown is lifesize. He prepared it, as he had the Gravelines pictures, with more preliminary studies than had been his recent practice; there is a carefully planned oil study on canvas and six drawings. Of these drawings three, all in the standard *conté* medium, gave a start to the mid- and background zones that would be at the spectator's eye-level (the procedure used in *La Parade*). The left drawing shows horse, rider and leaping clown (Plate 218), the centre a section of audience and portal (DH 711; New York, private collection), the right the ringmaster (DH 708; New York, private collection). Three other draw-

219. Jules Chéret, *L'Amant des Danseuses*. 1888. Colour lithograph, 114 x 86 cm. Nice, Musée Chéret.

220. Study for *Le Cirque: Le Clown et Monsieur Loyal.*
*c.*1890–1. Blue crayon and watercolour on tracing paper,
30.5 x 35.2 cm. Paris, Louvre (DH 710).

ings, including a watercolour (Plate 220), rare in Seurat's oeuvre, concerned themselves with the clown in the forefront. The watercolour, in fact, is on the same scale as the oil study (Plate 223), to which it is directly related. Although this painting differs from the final canvas in important respects — it includes only twenty-eight figures, for instance, and has two clowns in the foreground — it served to ratify the drawing's proposed design and rehearse the colour range. Heavily primed in white and worked in a dash rather than a dot, the oil study established that *Le Cirque* would be dominated by the three primaries, red, yellow and blue, with only a subsidiary role for the intermediate colours.[106]

The main picture was painted over a grid of both rectangular and diagonal lines, which is still visible in places beneath the paint surface.[107] However, Seurat used this geometrical scaffolding as an approximate rather than a definitive structure. He made informal use of the grid when, for example, he needed to place a new figure such as the bowler-hatted man to the left of the rider's wand. Seurat's figure painting had long since ceased to be ordered according to naturalistic regulations, and *Le Cirque's* broad blue border emphatically removes the fictive scene from its real surroundings. His loosely Henryesque theories have full rein in the painting: the play of local colours responds to his chromatic circle, and diagonal and vertical lines are gathered above the horizontal to express gaiety.[108] In essence it was the painting's entrenched anti-naturalism that stirred contemporaries' misgivings — Angrand provoked a passionate response from Seurat when he expressed theoretical reservations; critics were irritated by the painted border[109] — and although this quality is clear in the caricatural figures and sharp outlines it is most apparent in the overtly artificial handling of colour.

Le Cirque shows that by the winter of 1890–1 the direction of Seurat's figure painting had dramatically, if logically, changed. Gone was the consciously monumental, hieratic presentation — profile or frontal — of his earlier canvases, overtaken too was the fossilized concupiscence of *Le Chahut. Le Cirque* deals with full-blooded, uninhibited dynamism. The arc of the ring and the clown's long streamer enclose the practised gymnastics of the circus; the cantering pony, the prancing bare-back rider, the tumbling clown. It no longer seems plausible to argue that Seurat's painting was indebted to Toulouse-Lautrec's *Au Cirque Fernando* (1888; Chicago, Art Institute) — although, hanging in the foyer of the Moulin Rouge, Lautrec's painting would have alerted Seurat to the possibilities for displaying progressive art in the public forum — for *Le Cirque* responded to more complex compositional conventions, involved more sophisticated initiatives.[110] Once more it is important to recall Seurat's training. Much of the advanced schooling at the Ecole des Beaux-Arts was orientated towards the composition of large-scale decorative paintings. A strong strand in the mural tradition, dating back to the Renaissance, generated compositional excitement by the incorporation of vertiginous, anti-gravitational figures into the design. This idiom was still strong in nineteenth-century French decorations; indeed, among Ingres's major pupils Henri Lehmann was the leading protagonist. His *Oceanides* (Plate 8), for example, was specifically selected for the 1889 Universal Exhibition, and there — with its soaring central sylph and the demonstrative gestures of the subsidiary figures — might have served as a reminder to Seurat of this still effective convention for conveying a sense of dynamism, with its inevitable connotations of 'La Grande Peinture'.

Delacroix had also been a great exponent of such com-

221. Eugène Delacroix, *Heliodorus Expelled from the Temple*.
*c.*1854–61. Oil and wax on plaster, 751 x 485 cm. Paris, Church of
Saint-Sulpice.

222. Jules Chéret, *Persivani and Vandervelde*. 1875. Colour
lithograph, 80.5 x 62 cm. Paris, Musée de la Publicité.

positions, nowhere more so than in his murals for Saint-Sulpice, which in the later 1880s Seurat brought Kahn and his literary friends to admire.[111] It therefore comes as no surprise to recognize in *Le Cirque* distant but distinct echoes of one of these murals, Heliodorus *Expelled from the Temple* (Plate 221). The setting of vigorous action against a firm architectural back-drop, the observers looking down on the spectacle, the turbulent juxtaposition of careering horse and flying figure, the presence of gesticulating onlookers to the right: all these features are shared. In an important article published in *Art et Critique* during October 1890, just when Seurat was beginning work on *Le Cirque*, Alphonse Germain lavished praise on Delacroix's use of colour, insisting that Impressionism's goal of accurate light effects 'can only in fact give rise to works that are dissimilar to those of the creator of *Heliodorus Expelled from the Temple*, who, in opposition to nature, never altered his dominant [colours].'[112] Germain set up Delacroix, and the Saint-Sulpice paintings in particular, as a touchstone of quality, and stressed that the power of his colour lay in its independence from strict naturalism. Here was both a challenge and a justification for *Le Cirque*; one might almost see in the painting a response to Germain's words, even an attempt by Seurat to reanimate flagging critical support.

Advanced art critics recognized by 1890 that there were currently two major stylistic initiatives in French decorative painting; one derived from Puvis de Chavannes, the other from Chéret.[113] In his preface to the Chéret exhibition catalogue in 1889 Roger Marx had even demanded that he be given commissions for decorative paintings, a plea for an accommodation between modern popular style and traditional idiom.[114] Chéret's presence can be felt strongly in *Le Cirque*: in the angular drawing, the tensile energy of the figures, and in the strikingly artifical use of a primary colour range. Seurat was obviously so well acquainted with Chéret's (rather repetitive) repertoire of poses that one could make myriad comparisons. The bareback rider was surely founded on such figures as the pirouetting ballerina of the poster for *L'Amant des Danseuses* (Plate 219), and the acrobatic clown performing a 'souplesse en arrière' on the similarly contorted type established by Chéret as early as the *Persivani and Vandevelde* poster of 1875 (Plate 222).

Le Cirque, following its oil study, is founded on the primaries. The space of the circus ring itself is defined by the red clown in the foreground and red balustrades to the rear; the acrobatic spectacle centres on the yellow performers; blue ordains the shadows and the stiller, subsidiary figures. There is scant use of secondaries.

217

223. Study for *Le Cirque. c.*1890–1. Canvas, 55 x 46 cm. Paris, Louvre (DH 212).

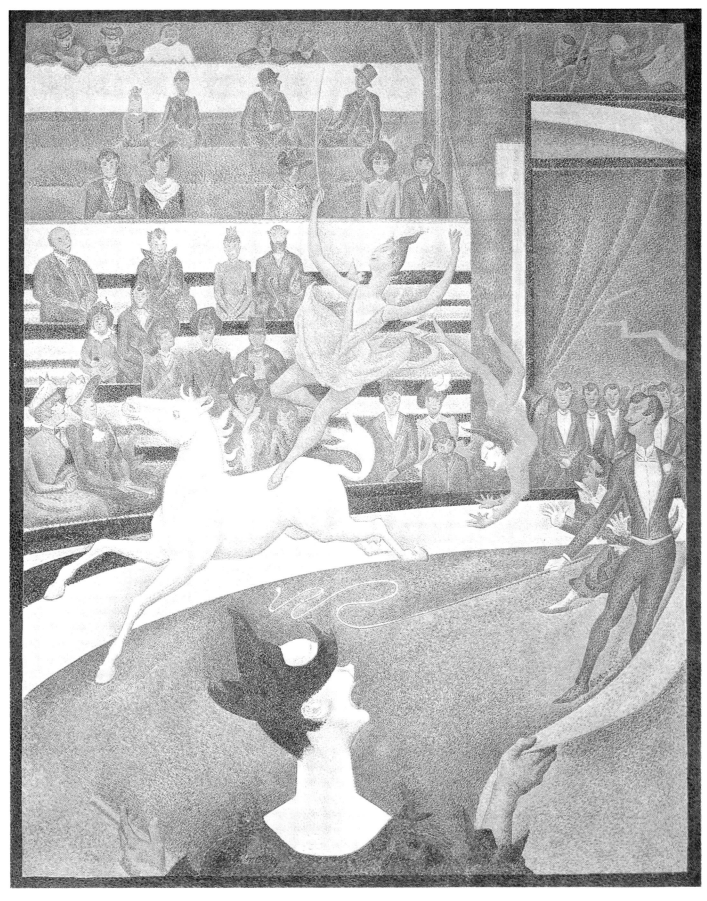

224. *Le Cirque.* c.1890–1. Canvas, 185 x 150 cm. Paris, Louvre (DH 213).

Dark green plays a part in the aura around the foreground clown, to lift him from the surface; flesh tone is respected; and there are some casual records of reflected light — no longer a central commitment — as in the yellow marks on the horse's back. The paint, applied in almost oval marks more ample than the touch of canvases like *La Parade*, is no longer seeking to give a correct illusion of artifical light but conjured into pulsing and swirling passages the better to serve *Le Cirque's* decorative purpose. Both the reliance on prominent primaries and the shifting dissemination of tone through arbitrary zones had been pioneered by Chéret.

Such direct interrelationships between Seurat's painting and Chéret's work surely mean that, at one level, he intended *Le Cirque* to take on much the same signification as a poster. The formal ambitions of the painting were thus complex, daring and even contradictory, combining three elements: the most recent formulation of his own Neo-Impressionist principles, Chéret's stylistic vocabulary for the modern poster, and the grand traditions of mural painting, exemplified in particular by Delacroix. These were to coalesce in a single coherent pictorial form to create a modern and democratic decorative painting.

Contemporary radical writing on the arts backed such a populist initiative. Gustave Geffroy attacked the cloistered approach of many Ecole des Beaux-Arts graduates, who detested 'the passing omnibus, the passerby, poster designs and newly printed books'.[115] And Guyau's important recent book on art and sociology argued that 'great art is not that which confines itself to a small circle of initiates, of professionals or collectors; it is that which has an effect on a whole society'.[116] *Le Cirque* endeavoured to break down the élitism of both avant-garde painting and the history painting tradition by borrowing Chéret's egalitarian legibility.

The arena of society

Seurat's chosen subject of the circus was once more a theme of public and popular entertainment, and again one already common in the imagery of the period. During the 1880s the circus had cropped up in the visual arts in the work of Salon painters such as James Tissot and John Lewis Brown, in popular illustration like Jules Faverot's drawings for *Le Courrier Français*, and in progressive circles; Suzanne Valadon had painted a circus scene in 1889 (Cleveland, Museum of Art) and the same year Hayet had produced a series of such subjects.[117] The circus was also admired by Seurat's literary colleagues, for Fénéon regularly reviewed the events of the big top in the *Revue Indépendante*, and Ajalbert's *Paysages de femmes* included a poem on a bareback rider.[118]

Seurat's painting represents the Cirque Fernando, identifiable by its cast-iron columnar structure, which was situated on the corner of the boulevard Roche-chouart and the rue des Martyrs, the artist's beat in the later 1880s. The Cirque Fernando's audience was mixed. Usually it was 'frequented by numerous *petit bourgeois* families and local tradespeople', one journalist reported in 1889, while another writer added that one night a week the clientele was more chic; the Cirque dedicated Wednesdays to 'high-life *soirées*'.[119] Georges Lecomte's review of the *Le Cirque* was unusual in that it drew attention to class distinctions in Seurat's audience. He saw that the painting contrasted the feverish performers with the 'absolute passivity' of the spectators. 'They have characteristic attitudes and faces, representative of types and classes; the figures on the upper benches lean on their elbows in a weary, uninhibited way.'[120] Seurat identified types and their class obviously, matching social rank to seats of appropriate status and expense, nearer to or further from the ring. The spectators all face the performance, their features firmly fixed in 'gaiety'. The salient exceptions are the tipsy bourgeois, top-hat askew and conspicuously out of place, and the bowler-hatted neighbour who observes him; social displacement is made to catch our attention. Although the crowd consists of suitably varied types, all are schematized, and the overall effect of row upon row of ridiculous faces is reminiscent of Daumier's notorious caricature *The Legislative Belly* (1834). Lecomte elected to pick out the slumped workers, but he might equally have indicated their counterparts at the other end of the social scale, the men-about-town loitering near the entrance to the ring. These men attended the circus out of chic, and also to form liaisons with the female performers; they were staple fodder for caricature.[121] Yet again Seurat's assessment of a specific place's public was acute and critical, revealing a consciouness of class polarization and of patterns of prostitution within Parisian society.

We have already noted (see pp.155-6) how common the analogy between alienated artist and clown was to contemporaries. Seurat used the same metaphor in *Le Cirque*. It may be no coincidence that Alexis and Méténier's dramatization of *Les Frères Zemganno* was staged at the Théâtre Libre in February 1890, reminding Seurat of the poignant parallel.[122] The metaphor fascinated Naturalists and Symbolists alike — 'I ought to have been a clown, I've missed my destiny', wrote Laforgue to a friend in 1882.[123] Indeed, in *Le Cirque* the tumbling clown actually points towards a painter — a gesture made less explicit in the final painting than in the sketch — for the bearded figure in the front represents Angrand.[124] But the metaphor had other meanings, and the clown was not always envisaged as the victim of derision. One poem published in 1890 saw him as a critical observer of the audience:

Au milieu de la piste ... son oeil de chouette
Se fixe, triste et rond, sur les bourgeois sereins,'

[From the centre of the circus ring ... his owl-like eye/
Sad and round, fixes on the unconcerned bourgeois.]

225. Adolphe Willette,
Ave-Alphonse-Imperator.
1886. Pen and ink. From *Le Courrier
Français*, 31 Jan. 1886, pp.4-5.

while another from the following year described a smug clown gratified by his own clever performance under the public gaze, ending:

Le clown sur ses trétaux, c'est l'homme dans la vie?[125]

[The clown on his boards, isn't he man in the midst of life?]

In his role as performer the artist or clown had an outsider's view of society, a position which enabled him to analyse and to parody it; he was something of a subversive. And in *Le Cirque* the foreground clown seems to play such a role; as much a part of the audience as the action, he looks on at both public and performance. He is the intermediary between spectator and image — a putto has a similar function in Correggio's *The Vices* (Paris, Louvre) — who alerts us to illusion, metaphor and meaning.

Perhaps to understand fully the critical content of *Le Cirque* we should pursue a further parallel. It was common at the time to compare contemporary Paris and ancient Rome, with debauchery the common factor, especially in the climate of 'Decadent' literature in the mid-1880s; one of the Decadent's chief organs, *Lutèce*, was titled after the Latin name for Paris.[126] Such comparisons frequently involved the modern circus and the Roman amphitheatre. An example of this is Willette's caricature (Plate 225) of Gérôme's *Ave Caesar, Morituri Te Salutant* (1859; Yale University Art Gallery), published in *Le Courrier Français* in 1886. Willette kept the amphitheatre setting, substituting Parisian for Roman types — a pimp for Caesar, stuffy bourgeois for senators, the contemporary prostitute in various guises for gladiators — and changing the statue of a lion into the promiscuous pig. In an article for *La Revue Illustré* of the previous year Félicien Champsaur, discussing the Cirque Molier, envisaged Couture's famous *Romans of the Decadence* (1847; Paris, Louvre) recast as a circus: 'Aristocrats, the wealthy and the talented, prostitutes, youth and beauty, would all be brought together in this work, ... a synthesis of the comedy of Parisian life'.[127] Such parodies of history paintings likened Parisian to Roman corruption. Envisaging the place of entertainment as a microcosm of contemporary Paris — as Joze did in *L'Homme à Femmes*[128] — provided a moralizing metaphor for modern society.

Caricature, of course, was a long-standing interest of Seurat and other Neo-Impressionists. At the Exposition des Arts Incohérents in 1889 Angrand had exhibited a parody of his own work, and Signac's *Un Dimanche Parisien* (1890; Paris, private collection) once more took off Caillebotte.[129] *Le Cirque*, too, owes much of its meaning to caricature. Its representation of the audience exposes the rigid inequalities of social rank; the clown signifies the beleaguered position of the artist in the face of public incomprehension, and also the artist's function as satirist or commentator. If *Le Cirque* is not a direct modernization of a history painting, its discreet similarities to Delacroix's *Heliodorus* cannot be counted as entirely respectful, and Seurat's fusion of the moral grandeur of the mural tradition and Chéret's democratic immediacy was surely intended to create a vehicle for a critical, satirical metaphor about contemporary Parisian society. *Le Cirque's* more diffuse associations denied it the poignant accuracy of *Le Chahut* or *La Parade*. With its high-spirited energy and vivacious colour it marked new and complicated ambitions, both ideological and aesthetic, in Seurat's work, ambitions that he was unable to fulfil.

Conclusion

A few days after the opening of the 1891 Indépendants, with the unfinished *Le Cirque* on view, Seurat suddenly fell ill. It seems that he was the victim either of an infectious angina or acute meningitis.[1] Rushed from his cramped quarters in the Passage de l'Elysée des Beaux-Arts to his mother's apartment in the boulevard de Magenta, he died there on 29 March 1891, after a few days of delirium. Not long afterwards his baby son died of the same illness.

His artistic colleagues were desolated. Pissarro sent the 'frightful news' to Lucien in London: 'you can understand the distress of all those who followed him or who were interested in his artistic projects. It's a great loss to art'.[2] Verhaeren recalled how he received the news from Théo Van Rysselberghe in silent disbelief, angered by the unpredictable cruelty of death.[3] Seurat's sudden loss was widely regarded with deep regret in the progressive artistic circles of Paris; even Stéphane Mallarmé, the senior Symbolist poet and only a slight acquaintance of the dead painter, sent a note of condolence to the family.[4]

There was a concensus among many art critics, both in their obituaries and in their reviews of the retrospectives held in 1892 at the Indépendants and at Les Vingt, that although Seurat's work was impressive and important there remained an element of the unresolved and experimental about it. Arsène Alexandre, Jules Antoine and Téodor de Wyzewa, for example, all wrote of Seurat with great respect, but finally considered that his theoretical initiatives had not achieved full realization.[5] Verhaeren, in more positive vein, argued that Seurat's work had been marching determinedly towards the ambitious goal of grand decoration.[6] Whatever degrees of caution or enthusiasm were expressed about Seurat's capacity to resolve his theories in his canvases, there was general agreement that in a short working life he had posed central questions about painting. De Wyzewa and Verhaeren both believed that his rigorous and systematic analyses of colour and line, his search for finite rules of visual expression, were of great value to modern art.

Critical writing during Seurat's lifetime occasionally perceived a logical, consistent pattern in his work, and assessments since his death, beginning with immediate obituaries, have invariably found that any survey of his *oeuvre* reveals a disciplined, logical, almost pre-programmed evolution. Seurat's compositional and theoretical progress was indeed regulated. The path from *Une Baignade* and *La Grande-Jatte* to *Le Chahut* and *Le Cirque* involved first the modernization of the classical configurations in which he had been trained, the exhaustion of an orthodox academic formula, before the artist could pass on to the more radical ambition of marrying advanced colour theory with the vibrant immediacy of the contemporary poster. It was deliberate progress, as formal problem led to formal problem: the first two major figure paintings horizontal and planar in construction, *Les Poseuses* and *La Parade* frontal and planar, *Le Chahut* a dynamic frieze, *Le Cirque* pitching energetic forms into deeper space. In step marched the theories concerning colour and line. First came the pointillist touch and the system of division of tone to control the distribution of colour, then the orientation of line and colour within a coordinated scheme. Both these departures shared the aim of applying the rules of painting to his work — and ambition initially stimulated by reading Blanc as a student — and the later harmonization of line and colour was consistent with the implicit preordination of emotion inherent in the Symbolist aesthetic. That Seurat was confident in his technical achievements is apparent from a remark he made to Angrand; writers and critics, he said, 'see poetry in what I do. No, I apply my method, and that's all.'[7]

The meaning of Seurat's images developed in close relation to his aesthetic and theoretical concepts. *La Grande-Jatte* was not only the application of a more complex internal structure, handling of paint and chromatic system to the basic configuration of *Une Baignade*, but it also involved the insertion of new codes of representation and meaning. His greater sophistication from mid-decade onwards was due to a wider range of contacts, to new friends, new ideas, new politics. For all

La Grande-Jatte's undoubted importance as the flagship of a burgeoning avant-garde in 1886, for all its grandeur of scale and audacious execution, the picture lacks a certain unity of conception in its pictorial structure and its system of meanings. Seurat's two greatest figure paintings came later, after further reflection and exposure to advanced aesthetic and ideological notions. *La Parade* and *Le Chahut* integrate formal mechanics and social critique with exceptional efficiency and intensity, and it is no coincidence that they are the product of years of increasing social friction and political instability, of communal but competitive avant-gardism, and great intellectual energy.

Seurat's subjects do revolve around certain consistent themes. All the major figure paintings, with the exception of the preliminary *Une Baignade*, deal with people acting out their roles in modern society. All depict these 'performers' in a cramped, even stage-like, space — the island of the Grande-Jatte, the circus, the café-concert, the crowd at the Foire aux Pain d'Epice. Just as the early drawings of Homeric themes were divided into factions so in the late paintings Seurat ordered his images of increasingly critical charge around the opposition of audience and performer. For Seurat the roles people played in contemporary Paris were not candid or relaxed, but posed and artificial; society's casting was arbitrary, inflexible, antagonistically divisive. Another regular feature of his subjects is the dominant objectivity. Figures are customarily reduced to types, most notably the working-class figures. For all his likely ideological sympathy with the Left he kept his distance from the proletariat, unlike Luce, say, or Steinlen. Seurat did not trespass beyond his limited knowledge, accepting the frontiers of his circumspect bourgeois existence. This did not lessen the critical force of his paintings, although the social meaning of his work has been obscure to twentieth-century eyes, accustomed to overtly caricatural or realistic treatment of such themes, and misled by formalist criticism. Unlike his colleagues Pissarro and Signac, whose ideologically motivated images veered from the propagandist drawing or print to idyllic paintings of anarchist utopias, Seurat chose a more incisive approach. Paintings like *La Parade* and *Le Chahut* combined an acute comprehension of social reality with the synthetic force of Seurat's objective vision and his sophisticated infiltration of the stock associations of popular imagery and culture.

Seurat's training at the Ecole des Beaux-Arts had instilled in him from the outset the idea that painting was the product of pictorial intelligence and practised dexterity. His early belief that paintings should be thought through and subject to cogent rules, rather than merely the result of observation, set him outside the Naturalist aesthetic. Even his marines, for all their superficial similarity to Impressionist canvases, were the result of regulated configurations and chromatic structures coordinated not so much to record natural effects as to evoke mood, in the Symbolist vein. Seurat's rigorous powers of conceptualization, as well as his consummate skill as painter and draughtsman, brought him to early prominence, even in the competitive Parisian avant-garde of the 1880s. As a theoretician of major significance, as a landscape painter of subtle sensitivity, but above all as one of the greatest image-makers of the modern city, Seurat well deserves the esteem in which he was held by contemporaries.

Appendices

APPENDIX I

This exchange of letters between Seurat and Fénéon is reproduced in facsimile in de Hauke, vol.I, pp.xxi-xxiii.

Paris, 20 June 1890

My dear Fénéon,

Allow me to point out an inaccuracy in your biography of Signac[1] — or rather, so there's no room for doubt, allow me to specify.

'It seduced ... around 1885', p.2, par.4.

The evolution of Pissarro's and Signac's style, begun in [blank], was more gradual. I object and can determine to within about a fortnight the following dates:

The 'priority of the spectral element being the cornerstone of the technique', which You were the first to establish.

Searching ever since I could hold a brush for an optical formula on that basis, 1876–1884.

and with that end in view having read Charles Blanc as a student and knowing Chevreul's laws and Delacroix's precepts,

having read the articles by that same Charles Blanc on that same painter (*Gazette des Beaux-Arts*, vol.XVI, if my memory is correct)

knowing Corot's ideas about tone (from a copy of a private letter dated 28 October 1875) and some of Couture's teachings on the subtlety of tints (at the time of his exhibition)[2]

having been struck by the intuition of Monet and Pissarro

sharing certain of Sutter's ideas about classical Greek art that I thought over carefully at Brest (Journal *l'Art*) March and February 1880

having had Rood introduced to me by an article of Philippe Gibb's *Figaro* 1881 I am keen to establish the following dates which prove my prior paternity

1884 *Grande-Jatte* study Indépendants exhibition [and the discussions that I had]

1884-5 *Grande-Jatte* composition

1885 studies at the Grande Jatte and at Grandcamp

took up the *Grande-Jatte* composition again 1886 October[3]

1886 January or February a little canvas by Pissarro, divided and pure, shown at Clozet's, the dealer in the rue Chateaudun.

Signac definitely convinced and having just modified his *Milliners* executed — at the same time as I was finishing the *Jatte* – in the manner of my technique:

1. The *Passage du Puits Bertin*, Clichy, March-April 1886

2. The *Gasometers at Clichy*, March-April 1886

(catalogue of the indépendants For these reasons

Frosty relations with Guillaumin who had introduced me to Pissarro and whom I saw due to his long-standing friendship with Signac.

You will acknowledge that there is a nuance here and that if I was unknown in 85 I nevertheless existed, I and my vision which you have just described supremely well, apart from one or two details, without mentioning my name.

Already Mr. Lecomte has sacrificed me to Charles Henry who we didn't know before the rue Laffitte (error pointed out)[4].

It was at Robert Caze's place that we were put in touch with several writers from *Lutèce* and *Le Carcan* (*Petit Bottin des arts et des lettres*)

Pissarro came there with Guillaumin.

Then You brought me out of the shadows, with Signac who had benefitted from my researches.

I count on your loyalty to communicate these notes to Mr. Jules Christophe[5] and Lecomte.

I shake your hand loyally and cordially — Seurat

23 June 1890

Your little tale, so well documented, my dear Seurat, has taught me nothing essential: I do know that the technique of optical painting was established by you, and, as you have the graciousness to recall yourself, I put it in print long ago.

If I had had the honour of writing your biography, as Jules Christophe did, I would have published it again.

I have no need to reread my article to be sure that it contains nothing liable to confuse the public on the origin of this technique which the old Impressionists received badly and which seduced more recent painters, in 1885.

I simply, and deliberately, excused myself from giving the reader information about this, judging that it was not the place to go into this secret.

As you desired it so, Messrs. Christophe and Lecomte have received communication of your letter of the 20th.: the former on the 21st., the latter on the 22nd. Also on the 22nd., at 29 minutes past 5, I presented myself at your studio, with Mr. Lecomte, and left a card to mark the uselessness of my visit. Not knowing when I could come and see you again nor whether you would soon be leaving Paris, I am writing to you – which allows me to offer you my most cordial compliments and to dispel your anxieties, my dear Seurat.

félix fénéon.

Tuesday 24 June 90

My dear Fénéon,

Out of the 30 articles calling me an innovator I count you six times, so it was not this that made me write.

If you had written my biography and had asked my advice I would have asked you not to give too much importance to technique. That's what I did with Mr. Christophe, giving him a simple note on the aesthetic followed by a general line on technique (which I regard as the spirit and the flesh of art). The two original elements.

Signac must suffer as much as me from the vulgarisation of the technique. He was of my mind two months ago.

People who have read you take pity on me doubtless they don't fully understand such condolences are very disagreeable for me [sic].

They consider me damaged. That's the reason why I make my position very clear and why I am telling you what I think without any bitterness.

In 1885, seeing you want to push things on several months, 'it seduced' an old artist Pissarro and a young man Signac. I don't think that's the right order, and I mention it as I'm the one who loses out.

Your friend Seurat.

I'm going to the North round about Calais?

1 'Signac', *Les Hommes d'Aujourd'hui*, no.373, 1890.
2 A large Couture retrospective was held in Paris in 1880.
3 Despite Seurat's determination to be precise, here he meant October 1885, as another version of the letter makes clear (D/R, p.xxvii, n.34).
4 'Rue Laffitte' is a reference to the 8th. Impressionist exhibition, held in that street (May-June 1886).
5 Christophe had already published his 'Seurat', *Les Hommes d'Aujourd'hui*, no.368, 1890.

APPENDIX II

Seurat's letter to Maurice Beaubourg, 28 August 1890

Aesthetic
Art is Harmony. Harmony is the analogy of contrary and similar qualities in *tone*, *colour* and *line*, considered with reference to a dominant and under the influence of a scheme of lighting in happy, calm or sad combinations.

The contraries are:

In *tone*, a (more luminous/lighter) against a darker.
In *colour*, the complementaries; that is, a particular red set against its complementary, etc. (red-green; orange-blue; yellow-violet).
In *line*, those that form a right angle.
Gaiety of *tone* results from a luminous dominant; of *colour*, from a warm dominant; of *line*, from angles above the horizontal.

Calmness of *tone* results from a balance of dark and light; of *colour*, from a balance of warm and cold; of *line*, from a horizontal.
Sadness of *tone* results from a dark dominant; of *colour*, from a cold dominant; of *line*, from angles below the horizontal.

Technical
Assuming the phenomena of the duration of a light-impression on the retina.
Synthesis necessarily follows. The means of expression is the optical mixture of tones and colours (local colour and the colour of the source of illumination: sunlight, lamplight, gaslight, etc.), that is of lights and reactions against light (shadows), in accordance with the law of *contrast*, gradation and irradiation.
The frame is in a harmony that opposes those of the tones, colours and lines of the picture.

Notes

Full references for works cited by name and date only will be found in the Selected Bibliography. The following abbreviations have been used in the notes:

C.P. *Archives* – *Archives de Camille Pissarro*, Paris, Hotel Drouot, 21 November 1975.

C.P. *Lettres* – C. Pissarro, *Lettres à son fils Lucien* ed. J. Rewald, Paris, 1950.

DH – C. de Hauke, *Seurat et son oeuvre*, 2 vols., Paris 1961. The *catalogue raisonné* of the paintings and drawings.

D/R – H. Dorra/J. Rewald, *Seurat, L'Oeuvre peint, Biographie et catalogue critique*, Paris, 1959. A *catalogue raisonné* of paintings and related drawings only.

Fénéon – F. Fénéon, *Oeuvres plus que complètes*, 2 vols., ed. J.U. Halperin, Geneva, 1970.

Chapter ONE: *The Seurat Family*

1 For the biographical details mentioned below see: Coquiot, 1924, pp.13, 16, 18, 28; Perruchot, 1966, pp.11-13; Sutter, 1970, p.13.
2 Letter from Signac to Félix Fénéon (23 Oct. 1934), quoted in Rewald, 1948, p.108
3 Verhaeren, 1891, p.198.
4 Coquiot, 1924, pp.38, 43.
5 Sutter, 1970, p.20.
6 For the anecdotes about Seurat's character see: Coquiot, 1924, pp.30, 40-3; D/R, p.lxi.
7 Anon., *L'Art Moderne*, 2 Mar. 1890 (quoted from Faunce, 1980, p.55).
8 Coquiot, 1924, p.30.
9 D/R, p.lv.
10 Herbert, 1962, p.7.
11 Kahn, 1928, p.v; Kahn, 1924, p.13.
12 For Seurat's appearance see: Kahn, 1924, p.13; Coquiot, 1924, pp.26, 43, 48.
13 R.L. Herbert, 'City versus Country: The Rural Image in French Painting from Millet to Gauguin', *Art Forum*, 8, Feb., 1970, p.44.
14 Joze, 1890, p.15; Lebon/Pelet, 1888, p.230. For the relationship between Seurat and Joze's novel, see Chapter 9, pp.212-14.
15 D. Pinkney, *Napoleon III and the Rebuilding of Paris*, Princeton, 1958, pp.64-5. See also T. Zeldin, *France, 1848-1945*, I, *Ambition, Love and Politics*, Oxford, 1973, pp.553-4.
16 E. Zola, *L'Assommoir*, Paris, 1877 (quoted from Emile Zola, *Oeuvres complètes*, 3, ed. H. Mitterand, Paris, 1967, p.915).
17 Barron, 1886, p.121.
18 Lebon/Pelet, 1888, p.34.
19 Coquiot, 1924, p.28.

Chapter TWO: *The Education of the Artist*

1 Sutter, 1970, p.13.
2 DH 214; Herbert, 1962, pp.10, 175, n.4 (not in DH).
3 For Lautrec's childhood drawings see R. Thomson, 'Henri de Toulouse-Lautrec: drawings from 7 to 18 years', in *Six Children Draw*, ed. S. Paine, London, 1981, pp.38-48.
4 Herbert, 1962, pp.13, 166, n.7.
5 DH, II, repr. p.303 (Addenda).
6 See letter of 14 January 1887, in C.P. *Lettres*, pp.126-7; Herbert, 1962, p.9.
7 'Liste Officielle des Membres du Jury des Récompensés de l'Exposition Universelle de 1889', *L'Exposition de Paris de 1889*, no.46, 23 Oct. 1889, p.47.
8 Herbert, 1962, pp.14-15; Sutter, 1970, p.13. D/R, p.xxxiii, state that Seurat left school at sixteen.
9 According to D/R, p.xxxiii. Herbert, 1962, p.15 records that Lequien's 'only known activity was to exhibit twice at the Salon, in 1875 and 1876'.
10 Aman-Jean, 1970, pp.10-13. The reminiscences of Aman-Jean's son are not always reliable.
11 Aman-Jean, 1970, pp.28-9; DH 287.
12 Boime, 1971, p.24.
13 Herbert, 1962, p.177.
14 DH 284; Herbert, 1962, p.177.
15 Herbert, 1962, pp.26-9. Herbert identifies 11 after Ingres, 4 after Raphael, 3 after Poussin, 2 each after Holbein and Ghiberti, and one each after Michelangelo, Perugino, Bellini, Pontormo and Titian.
16 Herbert, 1962, p.26.
17 Not recognized by DH as from the Parthenon frieze. For this identification see R. Ross Holloway. 'Seurat's copies after Antique sculpture', *Burlington Magazine*, 105, no.723, June 1963, p.284.
18 e.g., DH 244, 245; 253, 254; 299-301.
19 DH 249, 292, 294, 295, 298. J. Richardson has suggested that these were taken from the Louvre's marble copy (inventory no.564) of the 'Farnese Antinoüs in the Naples Museum' (Richardson, 1978, p.11). Herbert, 1962, pp.175-6 and Holloway, loc. cit., would seem to be corrected by Richardson. For this drawing I concur with Herbert's dating of 'no later than 1876' (p.16) rather than Richardson's 1877.
20 DH 272; Herbert, 1962, p.176.
21 R. Rey, *La Renaissance du sentiment classique dans la peinture française à la fin du XIX^e siècle*, Paris, 1931, p.101; D/R, p.xxxiii; Homer, 1964, p.266, n.2). Sutter, 1970, p.13, suggests that Seurat may have taken some lessons at the Ecole as early as 1876, but gives no evidence to support his claim.
22 Information on Lehmann from Henri Lehmann, 1978 and 1983.
23 For the full history of this painting see *Le Musée du Luxembourg en 1874*, Paris, Grand Palais, May-Nov. 1974, no.155.
24 D. Carter, 'A Symbolist Portrait by Edmond Aman-Jean', *Bulletin of the Cleveland Museum of Art*, 62, no.1, January 1975, p.10,

n.19.

25 For the evidence that Seurat knew Théo Wagner at the Ecole des Beaux-Arts see Signac's letter of 19 Sept. 1888, published in *La Cravache*, 22 Sept. 1888, n.p.

26 J.-L. Debauve, 'Laforgue romancier. Une tentative avortée: Un raté', *Revue des Sciences Humaines*, 50, no.178, Apr.-June 1980, pp.130-8. See also D. Arkell, *Looking for Laforgue*. Manchester 1979, pp.35-6.

27 Lehmann, 1983, pp.38-9.

28 J. Lethève, *The Daily Life of French Artists in the Nineteenth Century*, New York, 1972, p.21.

29 Fournel, 1884, pp.311, 320; Coquiot, 1924, p.27.

30 Rosenthal, 1911, p.65; Aman-Jean, 1970, p.14.

31 DH 1 (England, private collection). It has been claimed (*Ingres*, Paris, Petit Palais, October 1967-January 1968, no.108) that Seurat made his two copies after one of Ingres's preliminary oil studies for Angelica (Paris, Louvre). This is incorrect. Both Seurat's copies include details (such as the manacle and the braid in the hair) which are not present in the study but appear in the final painting. It is most unlikely that Seurat knew of the oil study, which was in private collections throughout his lifetime.

32 Debauve, 'Laforgue romancier ...', p.134.

33 Fournel, 1884, p.320.

34 Debauve, 'Laforgue romancier ...', p.134.

35 Coquiot, 1924, p.27.

36 Kahn, 1928, p.vii.

37 C. Blanc, *Grammaire des arts du dessin. Architecture, sculpture, peinture*, Paris, 1867, pp.14, 513.

38 Lehmann, 1983, pp.134-5.

39 DH 233, 234, 261, 262, 264, 310.

40 Herbert, 1962, pp.27, 166, n.14; Russell, 1965, pp.12-13. For instance Degas and Besnard. See T.Reff, *The Notebooks of Edgar Degas*, Oxford, 1976, I, pp.95, 96; C. Mauclair, *Albert Besnard. L'Homme et l'oeuvre*, Paris, 1914, p.6.

41 DH 262; *Odyssey*, Book 19.

42 DH 234; *Iliad*, Book 1. I am grateful to Dr. Tom Rasmussen for identifying this subject. DH 264, *The Lyre*, and 310, *The Sleeping Shepherd*, await correct identification in classical literature or mythology.

43 In 1880, for example, the subject was *Ulysses Recognized by Telemachus*. For the winning painting by Doucet see C. Simond, *Paris de 1800 à 1900*, III, *1870–1900. Troisième République*, Paris, 1901, p.217.

44 Debauve, 'Laforgue romancier ...', p.135.

45 Rops, frontispiece to H. Monnier, *Les Bas-fonds de la société*, Paris, 1864 (repr. Félicien Rops. *L'Oeuvre graphique complète*, ed. J.-F. Bory, Paris, 1977, p.100); Chevalier, *Vérité* (repr. *Paris à l'Eau-Forte*, no.58, 17 May 1874, between pp.44-5); Chapu, *Vérité (Monument à Flaubert)* (see *The Romantics to Rodin*, ed. P. Fusco, H.W. Janson, Los Angeles County Museum of Art, 1980, no.57).

46 See the review by Henry Houssaye, *Revue des Deux Mondes*, pér.3, no.38, 1 Mar. 1880, pp.198-9. The same painting was exhibited at the Salon of 1882.

47 Rosenthal, 1911, p.66.

48 Sutter, 1970, p.13; *Explication des ouvrages de peinture, sculpture ... exposés au Palais des Champs-Elysée*, Paris, 1879, p.329; ibid., 1880, p.193.

49 Sutter, 1970, p.13. For the regulations see Lebon/Pelet, 1888, pp.166-7.

50 Lebon/Pelet, 1888, p.230.

51 Sutter, 1970, pp.153-4.

52 Sutter, 1970, p.13. Coquiot (1924, p.33) claimed that during this period Seurat visited a number of Channel locations, but gave no evidence to support his assertions.

53 Boime, 1971, p.35.

54 DH 326, 329, 340.

55 DH 333, 341, 345, 356.

56 DH 319, 346, 364, 366, 371.

57 DH 321, 355.

58 Sutter, 1970, p.13; *Explication des ouvrages de peinture, sculpture ... exposés au Palais des Champs-Elysées*, Paris, 1881, p.274.

59 Coquiot, 1924, p.131; Sutter, 1970, p.13.

Chapter THREE: *The Early Drawings and Paintings, 1880–1883*

1 Rewald, 1948, p.28; D/R, p.xxxviii.

2 Herbert, 1962, p.44.

3 Signac, 1899, p.97.

4 DH 391, 392, 390, 398, etc.

5 DH 409, 422.

6 Herbert, 1962, pp.47-8.

7 Such as *View at Pompeii*, 1840; see *Nineteenth Century French Drawings*, London, Hazlitt, Gooden and Fox, June-July 1981, no.29. Lehmann apparently showed his own drawings to students; see Debauve, 'Laforgue romancier ...' (see Ch.2, n.26), p.136.

8 Herbert, 1962, p.177.

9 Goldwater, 1941, p.120, n.8.

10 Jamot, 1911, p.177.

11 Herbert, 1962, p.24.

12 Herbert, 1962, pp.128, 130-1, dates the two *Promenoir* drawings 1887–8, a possibility surely obviated by the main figure's dress, which is in the fashion of the early years of the decade.

13 See n.16 below.

14 This collection was found and first published by Professor Herbert. See: Herbert, *Burlington Magazine*, 1958, p.146, n.8; Herbert, 1962, pp.60, 63, 65, 166, n.6, 167, n.19. The Seurat Folio contained, as well as the thirteen reproductions of Rembrandt's etchings from *Le Figaro* and at least one other, two prints by Cham and reproductions after Millet and Ingres. There were also 61 items of *imagerie populaire*, as well as 18 life drawings and 29 copies after classical sculpture by Seurat himself.

15 H. Havard, *La Peinture hollandaise*, Paris, 1881, pp.83-4.

16 Broude, 1976, pp.155-60. The Rembrandt reproductions that Seurat cut out of the Figaro article are listed p.160, n.5.

17 For example the sale of Millet's studio (10-11 May 1875) and the sale of 95 pastels from the Gavet collection (11-12 June 1875).

18 For Bonvin and Lhermitte's drawings see: G.P. Weisberg, *Bonvin: La Vie et l'oeuvre*, Paris, 1979; M.M. Hamel, *Léon Lhermitte, 1844–1925*, PhD. thesis, Washington University, St. Louis, 1974.

19 *Catalogue de la 4me Exposition de Peinture ...*, Paris, 10 April – 11 May 1879, no.130.

20 It is interesting that Seurat seems to have shown no interest in printmaking, despite the suitability of his drawings for conversion into printed images and the enthusiasm of several of his close colleagues, such as Camille Pissarro, Luce and Signac, for producing prints.

21 It is not known whether Seurat visited the major Daumier retrospective, held at the Durand-Ruel Gallery from April to June 1878, at which paintings, drawings and lithographs were shown. For the exhibition see: J. Cherpin, 'Autour de la première exposition des peintures de Daumier', *Gazette des Beaux-Arts*, pér.6, vol.51, May – June 1958, pp.329-40.

22 C.Blanc, 'Eugène Delacroix', *Gazette des Beaux-Arts*, vol.16, Feb. 1864, p.106; E. Zola, *Oeuvres complètes*, ed. H. Mitterand, Paris, 1966, vol.I, p.520.

23 D. Sutter, 'Les phénomènes de la vision', *L'Art*, 20, 1880 (quoted from H.R. Rookmaaker, *Gauguin and Nineteenth Century Art Theory*, Amsterdam, 1959 (1972 edn., p.91).

24 Chevreul's findings were originally published as *De la loi du contraste simultané des couleurs et de l'assortiment des objets colorés*, Paris, 1839; see n.22 above.

25 O. Rood, *Théorie scientifique des couleurs*, Paris, 1881.

26 See especially Homer, 1964, and R.L. Herbert, 'Seurat's Theories', in Sutter, 1970, pp.23-42. The following account is substantially indebted to the work of these two scholars.

27 Homer, 1964, p.30.

28 Herbert, 'Seurat's Theories', p.24.

29 Ibid.

30 Homer, 1964, pp.39-40, 275, n.73.

31 For a further consideration of Sutter's influence on Seurat see Prak, 1971, pp.367-78.

32 Coquiot, 1924, pp.30, 33; Signac, 1899, p.97; Kahn, 1928, p.viii.

33 Blanc, 'Eugène Delacroix', p.106 and pp.100, 122.

34 These notes are given in full in Fénéon, 1922, pp.154-8. Fénéon suggested that the notes were made from memory.

35 *Extraits des souvenirs de mes bonnes et interessantes causeries avec M. Corot, année 1869, à Méry-sur-Seine*, J. Aviat, 27 Octobre 1875. Quoted in full in Signac's diary of 16 November 1898 (*Journal de Paul Signac*, 1952, p.284.

36 *Méthode et entretiens d'atelier*, Paris, 1867; *Paysage. Entretiens d'atelier*, Paris, 1869.

37 A. Boime, *Thomas Couture and the Eclectic Vision*, New Haven/London. 1980, p.491.

38 For Puvis's critical fortunes see R. Goldwater, 'Puvis de Chavannes: Some Reasons for a Reputation', *Art Bulletin*, 27, no.1, Mar. 1946, pp.33-43.

39 See M.-C. Boucher, *Catalogue des dessins et peintures de Puvis de Chavannes*, Musée du Petit Palais, Paris, 1979, pp.70, 72.

40 Aman-Jean, 1970, p.18; Herbert, 1959, p.29.

41 Ph.-H. de Valenciennes, *Elements de perspective pratique ... suivis de réflexions et conseils à un élève sur la peinture et particulièrement sur le genre du paysage*, Paris, 1799–1800 (2nd, enlarged edn., 1820); Boime, 1971, pp.136-9.

42 See Chapter 2 above. For examples of Lehmann's landscape *études* see Lehmann, 1978, no.31, and of Puvis's see *Puvis de Chavannes, 1824-1898*, Paris, Grand Palais, Nov. 1976 – Feb. 1977, no.89. There are several other such studies in the Musée des Beaux-Arts, Lyons.

43 This painting has also been known as *L'Invalide*, a misleading title as the building in the background is not Les Invalides and Seurat was never given to such anecdotal or sentimental titles.

44 Cited in E. Fahy, F. Watson, *The Wrightsman Collection*, V, *Printings, Drawings, Sculpture*, New York, 1973, pp.210-11; for a discussion of the related drawings, see p.209.

45 Sutter, 1970, p.14; Carter, 'A Symbolist Portrait...' (see Ch.2, n.24), p.10, n.20: (evidence from François Aman-Jean (letter of 26 Dec. 1973)).

46 Herbert, 1968, p.101.

47 Homer, 1963, p.284; Herbert, 1968, p.101.

48 DH 15, 16, 18, 20, 37, 44, 46, 59, 60, 103.

49 D/R 13; DH 75.

50 Fénéon, 1922, p.155.

51 Signac, 1899, p.97. Kahn, whose evidence is not always reliable, noted the influence of Monet and Renoir on Seurat's early painting, but he did not substantiate his views (Kahn, 1928, p.vi). For the alleged visit to the 1879 Impressionist exhibition see Rosenthal, 1911, p.66.

52 D. Wildenstein, *Claude Monet. Biographie et catalogue raisonné*, II, *Peintures 1882–1886*, Lausanne/Paris, 1979, nos.730, 733, 734 are particularly close.

53 Homer, 1964, p.60.

Chapter FOUR: *Rehearsing the Subject*

1 Lebon/Pelet, 1888, p.34. These figures are taken from the official census of 30 May 1886.

2 O. d'Haussonville, 'La Misère à Paris. I. La Population indigente et les quartiers pauvres', *Revue des Deux Mondes*, pér.3, vol.45, 15 June 1881, p.827.

3 J. Vallès, 'Les Boulevards. I. De la Bastille au boulevard Montmartre', *Gil Blas*, 2 Feb. 1882 (from Vallès, 1971, p.36).

4 R. Tombs, *The War against Paris*, 1871, Cambridge, 1981, p.3.

5 Ajalbert, 1938, p.13.

6 Lebon/Pelet, 1888, p.34. See n.1 above.

7 d'Haussonville, 'La Misère ... I', p.829.

8 R. Bernier, 'Un poète impressionniste. Jean Ajalbert', *La Revue Moderne*, no.25, 20 Jan. 1886, p.9.

9 R. Ginisty, *Paris à la loupe*, Paris, 1883, pp.388-9.

10 E. Benjamin, H. Buguet, *Coulisses de bourse et de théâtre*, Paris, 1882, p.63.

11 Ajalbert, 1938, p.38.

12 R. Caze, 'Lettre', in J. Ajalbert, *Sur le vif. Vers impressionnistes*, Paris, 1886, pp.6-7.

13 J. Laforgue, *Lettres à un ami, 1880–1886*, ed. G. Jean-Aubry, Paris, 1941, p.35.

14 Coquiot, 1924, p.29; Rich, 1935, p.16 and n.4; Kahn, 1928, p.viii.

15 E. and J. de Goncourt, *Germinie Lacerteux*, Paris, 1865 (1889 edn., pp.v-viii).

16 J.-K. Huysmans, 'La Bièvre', in *Croquis parisiens*, Paris, 1880 (quoted from *Oeuvres complètes de J.-K. Huysmans*, VIII, Paris, 1929, p.87).

17 Ibid., pp.105-8.

18 J.-E. Blanche, *Propos de peintre. De Gauguin à la Revue Nègre*, Paris, 1928, p.37, n.1.

19 C. Bigot, 'L'Exposition des Indépendants', *La Revue Politique et Littéraire*, 2me sér., 28 Apr. 1877, p.1046.

20 J.-K. Huysmans, 'L'Exposition des Indépendants en 1880', in *L'Art Moderne*, Paris, 1883 (quoted from 1919 edn., pp.114-5).

21 F. Javel, 'L'Art autour de Paris', *Autour de Paris*, 5 Dec. 1886.

22 O. Mirbeau, J.-F. Raffaëlli, *L'Echo de Paris*, 8 May 1889 (quoted from *Des Artistes*, I, Paris, 1922, p.82).

23 Barron, 1886, pp.117, 125.

24 G. Geffroy, 'Maison de Campagne', *La Justice*, 22 Aug. 1885, quoted from *Notes d'un journaliste*, Paris, 1887, pp.90-1.

25 Barron, 1886, pp.118, 124.

26 Barron, 1886, p.123; O. d'Haussonville, 'La Misère à Paris. II. La Population nomade, les asiles de nuit et la vie populaire', *Revue des Deux Mondes*, pér.3, vol.47, 1 Oct. 1881, p.637.

27 d'Haussonville, 'La Misère ... I', p.828.

28 J.-K. Huysmans, *Les Soeurs Vatard*, Paris, 1879 (quoted from *Oeuvres complètes de J.-K. Huysmans*, III, Paris, 1928, p.120).

29 J. Lorrain, *Nu*, Paris, 1888, p.98.

30 R. Darzens, *Nuits à Paris*, Paris, 1889, p.65.

31 See, for example, Félicien Champsaur's 'Effet de neige', in *Parisiennes*, Paris, 1887, p.15.

32 J. Vallès, 'Fraternité', *La France*, 7 July 1882 (quoted from Vallès, 1971, p.129).

33 The ruins were razed between December 1882 and September 1883 (see Y. Christ, *Le Louvre et Les Tuileries*, Paris, 1949, p.129).

34 Bertall, *La Comédie de notre temps*, II, Paris, 1874, pp.239-77.

35 '"Tout-Paris", Les Impressionistes', *Le Gaulois*, 2 Apr. 1880.

36 *Notes de l'Inspecteur Général des Ponts et Chaussées ... à l'appui de budget de l'exercice 1874*, Paris, 1873, p.133.

37 G. de Maupassant, 'Servantes: rubans et tabliers', *Les Types de Paris*, no.3, Paris, 1889, n.p.; H. Le Roux, 'Les Nourrices', in *L'Enfer parisien*, Paris, 1888, p.104.

Chapter FIVE: *Une Baignade and its Aftermath, 1884–1886*

1. Roger Marx, *Le Progrès Artistique*, 15 June 1883 (quoted from Rewald, 1948, p.28).

2. Jamot, 1911, p.178.

3. Roger Marx, 'La Décoration de la Mairie de Courbevoie', *Le Voltaire*, 8 Dec. 1884.

4. See, for example, an anonymous drawing of Jean-Paul Laurens, dated 1888 (Nineteenth-Century French Drawings, London, Hazlitt, Gooden and Fox, June-July, 1980, no.66).

5. I agree with DH in rejecting the painting reproduced in D/R (no.84 bis) as a genuine work; it is not by Seurat. DH 592 is not, in my opinion, a direct study for Une Baignade.

6. See, for example, Lövgren, 1959, p.4.

7. Herbert, 1960, p.368; 1962, p.182.

8. Herbert, 1968, p.108; Cooper, n.d. [1946], p.12; Lövgren, 1959, p.5.

9. Compare, for example, Lépine's *The Seine*, exh. Marlborough Gallery, June, 1950 (44). Peto Coll.

10. D/R, p.xlii.

11. I am most grateful to Richard Brettell and Susan Wise for permission to inspect the panel in July 1982.

12. D/R, pp.lxxxiii-lxxxiv.

13. *Journal Inédit de Paul Signac*, 1949, p.114. Une Baignade was retouched in 1887 on return from exhibition in New York.

14. Trublot (P. Alexis), 'A Minuit. Les Indépendants', *Le Cri du Peuple*, 17 May 1884.

15. Blanc, 1867, p.10.

16. For example in Boime, 1965.

17. See, for instance, G. Marconi's *Nu feminin assis*, c.1865–70, in *Mid Nineteenth Century French Photography*, Edinburgh, Scottish Arts Council, Aug.-Sept. 1979, no.40.

18. For the creation of the Indépendants see (Fénéon, I, p.53); Signac, 1934, pp.49-52.

19. Rewald, 1948, p.46.

20. Fénéon, I, p.53. For Dubois-Pillet see especially the essay by Bazalgette in Sutter, 1970, pp.89-98, and her *Dubois-Pillet, sa vie et son oeuvre (1846–1890)*, Paris, 1976.

21. Fénéon, I, p.53.

22. J. Antoine, Dubois-Pillet, *La Plume*, no.57, 1 Sept. 1891, p.299.

23. R. Marx, *Le Voltaire*, 10 Dec. 1884; R. dos Santos, 'Exposition des artistes indépendants', *Moniteur des Arts*, no.1569, 19 Dec. 1884, p.418, mentioned nine studies in one frame.

24. Anon., 'Petite Gazette', *Journal des Artistes*, 16 Jan. 1886, p.6.

25. Rosenthal, 1911, p.179, n.1.

26. Sutter, 1970, p.47. For Signac see also Signac, Paris, Louvre, Dec. 1963-Feb.1964; Cachin, 1971.

27. Homer, 1964, pp.130, 288, n.23.

28. Cachin, 1971, pp.16, 18.

29. A. Tabarant, *Pissarro*, Paris, 1924, p.51, states that Guillaumin introduced Seurat to Pissarro in early 1885; Sutter, 1970, p.48, claims Seurat met Pissarro in October 1885.

30. Coquiot, 1924, pp.38-9.

31. Sutter, 1970, pp.107-8.

32. 'Une trouvaille', *Le Chat Noir*, 11 Feb. 1882; 'Une crevaison', ibid., 25 Mar. 1882.

33. Coquiot, 1924, p.38.

34. J. Christophe, 'Symbolisme', *La Cravache*, 16 June 1888, n.p.

35. Sutter, 1970, p.16.

36. Ajalbert, 1938, pp.117, 119.

37. See *inter alia* P. Stephan, 'Naturalist Influences on Symbolist Poetry, 1882–1886', *French Review*, 46, no.2, Dec. 1972, pp.299-311.

38. See J.-K. Huysmans, *Lettres inédites à Emile Zola*, ed. P. Lambert, Geneva, 1953, p.51, n.12.

39. For the Left at this period see E.W. Herbert, *The Artist and Social Reform. France and Belgium, 1885–1898*, New Haven, 1961, pp.1-9; T. Zeldin, *France 1848–1945*, I, *Ambition, Love, Politics*, Oxford, 1973, pp.725-57.

40. F.W.J. Hemmings, *Emile Zola*, 2nd edn., Oxford, 1966, p.276.

41. Anon., 'Courrier social', *La Vogue*, no.1, 4 Apr. 1886, p.28; Editorial 'Programme pratique', *Revue indépendante*, no.7, Mar. 1885, pp.361-71.

42. *Petit Bottin des lettres et des arts*, Paris, 1886, p.29.

43. Trublot (P. Alexis), *Le Cri du Peuple*, 1 May 1885 (quoted from 'Naturalisme pas mort'. *Lettres inédites de Paul Alexis à Emile Zola, 1871–1900*, ed. B.H. Bakker, Toronto, 1971, pp.15-16).

44. Quoted from Rewald, 1948, p.94.

45. Ajalbert, 1938, pp.118, 112.

46. Alexis contributed from Oct. 1883 to Aug. 1888 (Bakker, op.cit., p.258, n.1).

47. Trublot (P. Alexis), 'Mon Vernissage', *Le Cri du Peuple*, 2 May 1886 (quoted in Bakker, op.cit., p.501). These were two panels painted at Grandcamp in the summer of 1885 (DH 152, 153) and an earlier one of the rue St.-Vincent under snow (DH 70).

48. Quoted in Cachin, 1971, p.30.

49. Kahn, 1924, p.9.

50. Cachin, 1971, p.29; C.P., Lettres, p.169 (5 May 1888); Herbert, 1968, p.70.

51. C.P., *Lettres*, p.30 (20 Feb. 1883); ibid., pp.51-2 (5 July 1883).

52. C.P. *Archives*, no.143 (12 Dec. 1885).

53. Ibid., no.78.

54. C.P., Lettres, pp.100-1, (Mar. 1886).

55. For a fuller account of the organization of the show see J. Rewald, *The History of Impressionism*, 4th edn., London, 1973, pp.518, 521-4.

56. Signac, 1934, p.52.

57. Verhaeren, 'Georges Seurat', *La Société Nouvelle*, Apr. 1891 (quoted from *Sensations*, Paris, 1927, p.196).

58. *1886. Catalogue de la 8me Exposition de Peinture...*, Paris, 1886, p.16.

Chapter SIX: *La Grande-Jatte, the 'Manifesto Painting'*

1 Rich, 1935, p.10.

2 D/R, p.xxvii.

3 It is not possible to be absolutely specific about the number of preliminary panels and drawings. Some of the panels are often counted as preparatory works but, although definitely executed c.1884, do not correspond directly to *La Grande-Jatte* (e.g. DH 108; location unknown: DH 115; Plate 107); another may have been painted after the main canvas (DH 116; New York, Bernhard Collection); one more I suspect may not be by Seurat (DH 110; Washington, National Gallery). As for the drawings, DH lists several (615, 618, 621) that have only distant relationships to the *Grande-Jatte* project.

4 Panels that might be considered as belonging to this early stage include DH 109 (Paris, Louvre), 111 (France, private collection), 112 (Paris, Renand collection), 119 (Merion, Barnes Foundation), 122 (Paris, private collection), 125 (Buffalo, Albright-Knox Gallery), 126 (Paris, private collection), 140 (Paris, formerly Jacques Rodrigues-Henriques).

5 Herbert, 1958, p.151.

6 D/R, p.lxxxvii.

7 DH 636 (New York, Metropolitan Museum); 637 (New York, Guggenheim Museum); 638 (Providence, Sharp collection); 639 (Paris, Louvre); 640 (Zürich, Feilchenfeldt collection). For the improbable idea that Seurat's conception was based on Pisanello see Boime, 1969, pp.79-81.

8 Homer, 1964, p.157.

9 *C.P. Archives*, no.172; also *Journal Inédit de Paul Signac*, 1949, p.114 (29 December 1894).

10 Lövgren (1959, p.54) has argued that perspectival distortions 'are brought together without synchronization in order to visualize a discontinuous reality,' for example.

11 See Appendix I; D/R, p.xxvii.

12 Homer, 1964, p.115; *Post-Impressionism*, 1979-1980, p.132.

13 'Les Impressionnistes en 1886: VIIIe Exposition Impressionniste', *La Vogue*, 13-20 June 1886, pp.261-75 (*Fénéon, I*, pp.35-7 on Seurat).

14 D/R, p.xlvii.

15 For detailed accounts of these principles see Homer, 1964, pp.133-7 and Herbert, in Sutter, 1970, pp.28-9.

16 Homer, 1964, pp.32, 144.

17 Kahn, 1924, p.15.

18 See Dorra, 1970, and Broude, 1974, passim.

19 C. Blanc, 'Eugène Delacroix', *Gazette des Beaux-Arts*, xvi, Feb.1864, p.100.

20 'O. Mirbeau, Exposition de Peinture. 1, rue Laffitte', *La France*, 21 May 1886.

21 Kahn, 1924, p.16.

22 Herbert, 1958, p.151.

23 J. Ajalbert, 'Le Salon des Impressionnistes', *La Revue Moderne*, 30, 20 June 1886, p.392; H. Fevre, 'L'Exposition des Impressionnistes', *Revue de Demain*, May-June 1886, p.149; Verhaeren, 1891, pp.196-7.

24 M. Fouquier, 'Les Impressionnistes', *Le XIXe Siècle*, 16 May 1886; F. Javal, 'Les Impressionnistes', *L'Evénement*, 16 May 1886. See also Mirbeau in *La France* (see n.20); ' ''Labruyère'', Les Impressionnistes, II', *Le Cri du Peuple*, 28 May 1886.

25 R. Marx, 'Les Impressionnistes', *Le Voltaire*, 17 May 1886; G. Geffroy, 'Hors du Salon. Les Impressionnistes', *La Justice*, 26 May 1886.

26 M. Hermel, 'L'Exposition de Peinture de la Rue Laffitte', *La France Libre*, 28 May 1886; Fénéon, I, p.36 (*La Vogue*, 13 June 1886).

27 Verhaeren, 1891, p.198.

28 P. Adam, 'Peintres Impressionnistes', *Revue Contemporaine*, 4, Apr.-May 1886, p.550; R. Darzens, 'Chronique Artistique. Exposition des Impressionnistes', *La Pléiade*, I, May 1886, p.89; Ajalbert in *La Revue Moderne* (see n.23).

29 Fénéon, I, p.35.

30 Fevre in *Revue de Demain* (see n.23).

31 Mirbeau in *La France* (see n.20); A.Paulet, 'Les Impressionnistes', *Paris*, 5 June 1886.

32 Hermel in *La France Libre* (see n.26).

33 Paulet in *Paris*, (see n.31).

34 Fevre in *Revue de Demain* (see n.23), p.150; Fénéon, I, p.37.

35 M.-G. Dortu, *Toulouse-Lautrec et son Oeuvre*, New York, 1971, II, p.232.

36 For example, P. de Boutard, 'Le Salon de 1886', *La Nouvelle Revue*, 40, May-June, 1886, p.607.

37 G. Kahn, 'Exposition Puvis de Chavannes', *Revue Indépendante*, n.s.6, no.15, Jan.1888, pp.142-3.

38 Fournel, 1884, p.270.

39 *1886. Catalogue de la 8me. Exposition de Peinture...*, Paris 1886, p.16.

40 Javal in *L'Evénement* (see n.24).

41 *Explication des Ouvrages de Peintures, Sculpture...exposés au Palais des Champs-Elysées*, Paris, 1880, no.5837.

42 *Catalogue Illustré des Oeuvres de Jean-François Raffaëlli, suivi d'une Etude du Beau Caractériste*, Paris, 1884, no.68.

43 P. Signac, 'Les besoins individuels et la peinture', *Encyclopédie française*, XVI, 1935 (quoted from *D'Eugène Delacroix au néo-impressionnisme*, 1964 ed., p.154.

44 L. Viardot, , *Les Merveilles de la peinture*, 2nd ser., Paris, 1872, p.313; J.L. Jules David, *Le Peintre Louis David. 1748-1825. Souvenirs et Documents Inédits*, Paris, 1880, p.31.

45 E. de Labédollière, *Histoire des environs du nouveau Paris*, Paris, 1861, pp.135-7; L. de Vallières, *Nouveau guide complet des promeneurs aux environs de Paris*, n.d. (c.1871), pp.20-1.

46 E. Périer, , *Notes sur la ville d'Asnières*, Asnières, 1890, pp.11, 38.

47 Barron, 1886, pp.39-40.

48 Périer, *Notes sur...Asnières*, pp.61-2, 11. See also J. Petit, *Asnières*, Nanterre, 1939, p.70.

49 Périer, *Notes sur...Asnières*, pp.9, 36.

50 Périer, p.50; Petit, *Asnières*, p.70; *Dictionnaire Géographique et Administratif de la France et de ses Colonies*, ed. Paul Joanne, Paris, 1890, vol.I, A-B, p.181.

51 Périer, *Notes sur...Asnières*, p.7.

52 Barron, 1886, p.29.

53 Barron, 1886, p.63.

54 J. Ajalbert, 'Le P'tit', *Revue Indépendante*, n.s.6, no.15, January 1888, p.105.

55 Barron, 1886, pp.38, 40.

56 Barron, 1886, pp.37-8, 41.

57 J. Vallès, 'Le Petit Mazas', *Gil Blas*, 4 May 1882 (quoted from Vallès, 1971, p.104).

58 For Fraipont's illustration see Barron, 1886, p.30 and for the duel between Georges Duval and Dubut de Laforest, *Autour de Paris*, 24 Oct. 1886.

59 Barron, 1886, p.30.

60 'Coqhardy', 'Chronique', *La Vie Moderne*, 25 June 1881, p.402. See also, *inter alia*, 'Bernadille' (V. Fournel), *Esquisses et croquis Parisiens. Petite Chronique du temps présent*, Paris, 1879, pp.289-93; R. Marx, 'Dimanches de Paris', *Les Types de Paris*, 1889, pp.94-6.

61 P. Tucker, *Monet at Argenteuil*, New Haven/London, 1982, pp.105-8.

62 R. Bernier, 'Une Poète Impressionniste. Jean Ajalbert', *La Revue Moderne*, 25, 20 Jan. 1886, pp.10-11.

63 *Le Chat Noir*, 26 Dec. 1885, p.619.

64 Ajalbert, 1938, p.38; H. Havard, *Salon de 1885*, Paris, 1885, p.38.

65 Vallès, 'Le Dimanche', *La France*, 18 May 1883 (quoted from Vallès, 1971, p.362).

66 See Zeldin, I, 1973, p.669, and for Kropotkin's anarchist arguments Medlyn, 1975, pp.59-60.

67 Ajalbert in *Revue Moderne*, (see n.23), p.392; J. Vidal, 'Les Impressionnistes', *Lutèce*, 239, 29 May-5 June 1886.

68 Herbert, 1962, pp.111,113.

69 Adam in *Revue Contemporaine*, (see n.28); Ajalbert in *Revue Moderne*, (see n.23).

70 O. Uzanne, *L'Ombrelle. Le Gant. Le Manchon*, Paris, 1883, p.61; P. Ginisty, , *Paris à la loupe*, Paris, 1883, p.178.

71 P. Adam/J. Moréas, , *Les Demoiselles Goubert*, Paris, 1886, p.16.

72 Signac, 1934, p.55.

73 Paulet in *Paris* (see n.31).

74 Hermel in *La France Libre*, (see n.26). The use of the word 'symbolisme' here would be in its conventional sense, and not linked to the Symbolist literary movement launched later by Moréas's manifesto in *Le Figaro Littéraire*, 18 Sept. 1886.

75 J. Christophe, Chronique. Rue Laffitte, No.. *Journal des Artistes*, 13 June 1886, p.194.

76 Rich, 1935, p.7; M. Roskill, *Van Gogh, Gauguin and the Impressionist Circle*, London, 1970, p.87. And Russell, 1965, p.146.

77 Anon., *The Bat*, 25 May 1886, p.186. The writer was probably George Moore (I am grateful to Anna Greutzner for this suggestion).

78 *L'Oeuvre de Rupert Carabin, 1862-1932*, Paris, Galerie du Luxembourg, 1974, no.50; *Félicien Rops*, Düsseldorf, Städtische Kunsthalle, Feb.-Mar. 1979, no.104; Dortu, *Toulouse-Lautrec* (see n.35), VI, E.20.

79 L. Rigaud, *Dictionnaire d'argot moderne*, new edn., Paris, 1888, p.349.

80 H. Vinayde, 'Chronique artistique', *La Pléiade*, 1, Mar. 1886, p.22.

81 *Le Soir*, from Nina de Villars, *Feuillets parisiens*, Paris, 1885, n.p. See also *Paris à l'Eau-Forte*, 66, 12 July 1874, pp.108-9.

82 Thomson, 1982, pp.323-37.

83 J. Richepin, *Le pavé*, Paris, 1883 (quoted from 1912 edn., pp.234-5, 237); J. Ajalbert, *Sur le Vif. Vers Impressionnistes*, Paris, 1886, p.47.

84 'Lablainie', 'Chronique. La Banlieusarde', *Autour de Paris*, 12, 20 Mar. 1887; A. Scholl, 'Plaidoyer pour les chiens', in *Paris à Cent Coups*, Paris, n.d. [c.1890], p.202.

85 Anon., 'Canton de Courbevoie. Asnières', *Autour de Paris*, 29, 17 July 1887.

86 For a fictional account of social mobility at Asnières see A. Daudet, *Froment Jeune et Risler Aîné*, Paris, 1874.

87 Adam in *Revue Contemporaine*, (see n.28), p.550.

88 Prak, 1971, p.375; Richardson, 1978, p.47.

89 Medlyn, 1975, pp.54-6; House, 1980, pp.346-7.

90 Nicolson, 1941, p.146; Medlyn, House (see n.89).

91 M. Beaubourg, 'Les Ames de Verre', *Revue Indépendante*, n.s.4, no.11, Sept. 1887, p.337.

92 See his *Quai de Bercy*, c.1885 (repr. C. Gray, *Armand Guillaumin*, Chester, Conn., 1972, pl.99).

93 Blanc, 1867, p.513.

94 Van de Velde, 1890, p.122.

Chapter SEVEN: *Seurat and his Circle, 1886-1888*

1 For more general surveys of this avant-garde see Rewald, 1978, chap.3, and Lövgren, 1959, chap.I.

2 Anon., 'Diner du Rouge et du Bleu', *Journal des Artistes*, 14 Nov. 1886, p.382.

3 C.P. *Lettres*, p.104.

4 D/R, p.liv.

5 D/R, p.li, n.20; C.P. *Archives*, no.2; D. Delouche, 'L'animation artistique, 1825–1890', *Arts de l'Ouest*, 4, Feb. 1978, pp.33-4.

6 *Les XX, Bruxelles. Catalogue des dix expositions annuelles (1884–1893)*, Brussels, 1981, n.p. For Les Vingt, see: J. Block, 'Les XX: Forum of the Avant-Garde', in *Belgian Art, 1880-1914*, Brooklyn Museum, 1980, pp.17-40.

7 Letter from Signac to Maus, 1888, see Chartrain – Hebbelinck, 1969, no.4, p.61.

8 D/R, p.lviii; Herbert, 1959, p.321.

9 D/R, p.lix.

10 Signac, 1899, p.154.

11 For neo-Impressionism in general see Herbert, 1968, and Sutter, 1970.

12 C.P. *Archives*, no.165.

13 See his unpublished letter to Lucien Pissarro, 24 July 1886 (Ashmolean Museum, Oxford).

14 J.-K. Huysmans, 'Chronique d'Art. Les Indépendants,' *Revue Indépendante*, n.s.3, no.6, Apr. 1887, pp.54-5.

15 J.-K. Huysmans, *Lettres inédites à Arij Prins, 1885–1907*, ed. L. Gillet, Geneva, 1977, pp.96-8.

16 P. Adam, 'Les Artistes Indépendantes,' *La Vogue*, 2, no.8, 6-13 Sept. 1886, p.267.

17 F. Fénéon, 'L'Impressionnisme aux Tuileries', *L'Art Moderne*,

19 Sept. 1886 (Fénéon, I, pp.53-8).

18 Herbert, 1959, pp.317-8.

19 C.P. *Lettres*, p.149 (15 May 1887).

20 Néo [P. Signac], 'IVe Exposition des Artistes Indépendants', *Cri du Peuple*, 29 Mar. 1888.

21 Fénéon, *La Vogue*, 13-20 June 1886, (Fénéon, I, p.49); letter from Seurat to Signac, 16 June 1886 (D/R, pp.xlviii, xlix).

22 Letter from Seurat to Signac, 19 June 1886 (D/R, pp.xlix, l).

23 C.P. *Lettres*, pp.112-3 (3 Dec. 1886).

24 C.P. *Lettres*, p.110 (15 Sept. 1886); letter from Pissarro to Signac, Apr. 1887 (quoted in Rewald, 1948, p.113). See also Pissarro's letter to Durand-Ruel, 6 Nov. 1886 (see L. Venturi, *Les Archives de l'Impressionisme, II, Paris, 1939, p.24).

25 Rewald, 1948, p.113.

26 C.P. *Archives*, no.175 (30 June 1887).

27 'Néo' in *Cri du Peuple* (see n.20).

28 C.P. *Lettres*, p.133 (4 Feb. 1887); letter from Signac to Pissarro, Feb. 1887 (C.P. *Archives*, no.172).

29 C.P. *Lettres*, p.134 (23 Feb. 1887).

30 E. Raynaud, *En Marge de la mêlée symboliste*, Paris, 1936, pp.20-1.

31 See, for example, letter from Signac to Pissarro concerning *Le Symboliste*, summer 1886 (C.P. *Archives*, no.167).

32 Ajalbert, 1938, p.262.

33 F. Fénéon, 'Les Poèmes de-Jules Laforgue', *L'Art Moderne*, 9 Oct. 1887 (Fénéon, II, p.580); Arkell, *Looking for Laforgue*, 1979, pp.235-6. Seurat's military service lasted from 22 Aug. to 18 Sept. 1887 (see Perruchot, 1966, p.108).

34 G. Kahn, 'La Vie Artistique', *La Vie Moderne*, 9 Apr. 1887, p.232; ibid, 15 Apr. 1888, p.229.

35 J. Moréas, 'Le Symbolisme', *Le Figaro Littéraire*, 18 Sept. 1886 (quoted from *Les Premières Armes du Symbolisme*, Paris, 1889, pp.33-4).

36 G. Kahn, 'Réponse des Symbolistes', *L'Evénement*, 28 Sept. 1886 (quoted from Lövgren, 1959, p.65).

37 G. Kahn, *Premiers Poèmes*, Paris, 1897, p.21.

38 Kahn in *L'Evénement* (see n.36); P. Adam, 'Le Symbolisme', *La Vogue*, 2, 4-11 Oct. 1886, p.399.

39 E. Verhaeren, 'Le Symbolisme', *L'Art Moderne*, 24 Apr. 1887 (quoted from *Impressions*, 3rd series, Paris, 1928, p.116).

40 Kahn, Vie Moderne, 9 Apr. 1887, p.229.

41 D/R, p.lxiii.

42 For example *Chelsea Shops* (c.1880-5; Washington, Freer Gallery of Art), probably exhibited at the Galerie Georges Petit, Paris, May-June 1887 (no.208).

43 Moréas/Adam, *Les Demoiselles Goubert*, 1886, p.101.

44 G. Rodenbach, *Du Silence. Poésies*, Paris, 1888, p.32.

45 Coquiot, 1924, pp.39-40.

46 Fénéon, I, p.37; J. Le Fustec, 'Exposition de la Société des Artistes Indépendants', *Journal des Artistes*, 34, 22 Aug. 1886, p.282.

47 DH 661 (Paris, Louvre); DII 663 (New York, Metropolitan Museum). Homer (1960, p.229) has rightly pointed out that DH 662 (destroyed) is a drawing for *La Parade*.

48 D/R, p.lxi; and pp.lxi-lxii (letter of 29 Aug. 1887).

49 Journal of Paul Signac, 1952, pp.270-1, (28 Dec. 1897).

50 F. Fénéon, 'Le Néo-Impressionnisme à la IVe Exposition des Artistes Indépendants', *L'Art Moderne*, 15 Apr. 1888 (Fénéon, I, p.84); G. Kahn, 'Peinture: Exposition des Indépendants', *Revue Indépendante*, n.s.7, no.18, Apr. 1888, p.161; P. Adam, 'Les Impressionnistes à l'Exposition des Indépendantes', *La Vie Moderne*, 15 Apr. 1888, p.229; 'Néo' [Signac] in *Cri du Peuple* (see n.20).

51 Kahn, *Vie Moderne*, 9 Apr. 1887, p.232; J. Christophe, *Journal des Artistes*, 24 Apr. 1887 (see D/R, p.210).

52 Kahn in *Revue Indépendante* (see n.50); Fénéon in *L'Art Moderne*, 10 July 1887 (Fénéon, I, p.81).

53 These references have been previously quoted in Rich, 1958, p.16; Herbert, 1962, p.128; House, 1980, p.350.

54 See Amaury-Duval's *Antique Bather* (c.1860–70; Rouen, Musée des Beaux-Arts), versions of Corot's *Eurydice Wounded* (c.1868–70: A. Robaut, *L'Oeuvre de Corot. Catalogue Raisonné et Illustré*, vol.III, Paris, 1965, nos.1999-2001), and Degas's *The Thorn* (c.1885: P.-A.Lemoisne, *Degas et son Oeuvre*, Paris, 1947-9, no.1089).

55 Fournel, 1884, p.272; see Renoir's *Baigneuse* (1888; private collection).

56 For instance in his *Vision* (1892; Paris, Mlle. Yolande Osbert).

57 Van de Velde, 1890, p.122.

58 G. Lecomte, *Camille Pissarro*, Paris, 1922, p.75.

59 C. Henry, *Cercle chromatique présentant tous les compléments et toutes les harmonies de couleurs avec une introduction sur la théorie générale du contraste, du rythme et de la mesure*, Paris, 1888. For Henry see J.A. Argüelles, *Charles Henry and the formation of a Psychophysical Aesthetic*, Chicago/London, 1972, and Dorra, 1969.

60 House, 1980, p.351.

61 Fénéon, I, p.84-5).

62 Dorra, 1969, p.351; House, 1980, p.351.

63 Fénéon, I, p.84; Kahn in *Revue Indépendante* (see n.50); G. Geffroy, 'Pointillé-Cloisonnisme', *La Justice*, 11 Apr. 1888; Adam in *La Vie Moderne* (see n.50).

64 L. Leroy, *Les Pensionnaires du Louvre*, Paris, 1880, p.67; J. Grand-Carteret, *Les Moeurs et la caricature en France*, Paris, 1888, p.347. Huysmans made such a conjunction in *L'Art Moderne*, Paris, 1883 (see House, 1980, pp.350-1).

65 House, 1980, p.350.

66 Geffroy in *La Justice* (see n.63).

67 J. Vidal, 'Le Salon. 104e Exposition des produits de l'Industrie', *Lutèce*, 238, 22-9 May 1886, pp.2-3.

68 See, for example, C.-H. Pille, *L'Ami Vayson (Salon de 1887. Catalogue illustré*, Paris, 1887, p.241); E. Dantan, *Un Moulage sur Nature* (ibid., p.249); L. Picardet, *Etude dans l'atelier (Salon de 1888. Catalogue illustré*, Paris, 1888, p.83); G. Roussin, *Endormie* (A. Silvestre, *Le Nu au Salon 1889*, Paris, 1889, n.p.); P. Sinibaldi, *Un avis* (A. Silvestre, *Le Nu au Salon 1890*, Paris, 1890, n.p.); Salle Estradère, *A l'atelier* (ibid.); Marshall, *Le repas du modèle* (ibid.).

69 D/R, p.xci; Prak, 1971, p.377; Richardson, 1978, p.67.

70 H. le Roux, 'Les Modèles, in *L'Enfer Parisièn*, Paris, 1888, p.76; Anon., 'L'Exposition des Indépendants', *La Paix*, 4 Apr. 1888 (D/R, p.217).

71 Russell, 1965, p.206.

72 H. Detouche, *Propos d'un peintre*, Paris, 1895, pp.45-6; P. Dollfus, *Modèles d'artistes*, Paris, 1888, pp.73-4.

73 Signac, 1934, p.58 (17 Feb. 1889).

74 Dollfus, *Modèles...*, p.137; Le Roux, 'Les Modèles...', p.74.

75 Fénéon, I, p.85.

76 *Oeuvres de Ephraïm Mikhaël. Poésie. Poèmes en prose*, Paris, 1890, p.8. See also *Chair*, in *Oeuvres Posthumes de G.-Albert Aurier*, ed. R. de Gourmont, Paris, 1893, p.97, and Laforgue's *Moralités légendaires* (1886–7).

77 J. Huret, *Enquête sur l'évolution littéraire*, Paris, 1891, p.185; Dx, 1932, p.188. See also Marie Bracquemond's *The Three Graces of 1880* (1880; Chemillé, Mairie), a version of which seems to have been shown at the 1886 Impressionist exhibition (J. Isaacson, *The Crisis of Impressionism, 1878–1882*, Michigan, 1980, p.66).

78 For the identification of the Cirque Corvi see Kahn in *Revue Indépendante* (n.50); Herbert, 1980, pp.9-10.

79 See Herbert, 1980, figs.3, 12.

80 I do not believe that the dotted drawing, reputedly 'after' *La Parade*, is by Seurat (DH 681; Lexington, Kentucky, Gaines collection).

81 Herbert, 1980, p.12.

82 Herbert, 1980, p.9 and p.20, n.2 (letter of 28. Aug. 1890).

83 'Néo' in *Cri du Peuple*, (see n.20); Fénéon, I, p.84.

84 Kahn, 1928, pp.vi-vii.

85 Herbert, 1980, pp.12-13. See also Herbert, 1958, p.152 and D/R, pp.xciii-xciv.

86 Kahn in *Revue Indépendante*, Jan. 1888, p.143.

87 Blanc, 1867, p.532; Sutter, *Phénomènes* (quoted from Homer, 1964, p.44).

88 Blanc, 1867, p.36.

89 I am grateful to Sally Medlyn for pointing this out to me.

90 Grand-Carteret, *Les Moeurs et la caricature*, 1888, p.187, 297; *The Cult of Images. Baudelaire and the Nineteenth Century Media Explosion*, University of California, Santa Barbara, Apr.-May 1977, p.45.

91 Ajalbert, 1886, pp.25-7; J. Lorrain, *Modernités*, Paris, 1885, p.3.

92 For the unfinished text of the novel see J. Vallès, *Oeuvres complètes*, vol.4, ed. L. Scheler/M.-C.Banquart, Paris, 1970, pp.322-529, and for the articles (*Gil Blas* 6, 13, 20, 27 Apr. 1882); Vallès, 1971, pp.83-103.

93 *La Vie Moderne*, 21 Jan. 1882, p.45; *Catalogue Illustré des Oeuvres de Jean-François Raffaëlli*, 1884, nos.78, 79; for Bernard's painting see B. Welsh-Ovcharov, *Vincent van Gogh and the Birth of Cloisonism*, Toronto/Amsterdam, 1981, p.293.

94 J. Ajalbert, 'Le P'tit'. *Revue Indépendante*, 6, no.16, Feb. 1888, pp.256-7.

95 P. Hervieu, 'Fêtes Foraines' in *La Bêtise Parisienne*, Paris, 1884, p.100; A. Samain, *Carnets intimes*, Paris, 1939, pp.37-8 (1 Oct. 1887).

96 Vallès, *La France*, 23 Mar. 1883 (Vallès, 1971, p.317).

97 Vallès, *Gil Blas*, 6 Apr. 1882 (Vallès, 1971, p.84).

98 Vallès, *La France*, 11 May 1883 (Vallès, 1971, pp.355, 358).

99 G. Lafenestre, 'Le Salon de 1888. I. La Peinture', *Revue des Deux-Mondes*, pér.3, no.87, 1 June 1888, p.663; A. Michel, 'Salon de 1888', *Gazette des Beaux-Arts*, 38, 1888, p.139. For Pelez's work see: R. Rosenblum, 'Fernand Pelez, or The Other Side of the Post-Impressionist Coin', in *Art the Ape of Nature. Studies in Honour of H.W. Janson*, New York, 1981, pp.707-718.

100 Herbert, 1968, p.119.

101 For a diagram of Henry's ideas see Homer, 1964, p.206.

102 Champfleury, *Histoire de la caricature moderne*, 3rd ed., Paris, 1885, p.189 illustrates a *parade* scene by Daumier; A. Alexandre, *Honoré Daumier: l'homme et l'oeuvre*, Paris, 1888: watercolour *The Parade* (Plate 158) repr. p.169.

103 E. de Goncourt, *Les Frères Zemganno*, Paris, 1879, p.xi. See Medlyn, 1975, p.130.

104 C.P. *Lettres*, p.136 (27 Feb. 1887). See Russell, 1965, p.216.

105 J.-K. Huysmans, 'Trois Peintres. I. Cézanne, II. J.-J. Tissot, III. Wagner', *La Cravache*, 4 Aug. 1888, p.2.

106 Signac, *La Cravache*, 22 Sept. 1888, p.2.

107 *Christ Presented to the People* was repr. in E. Michel, *Rembrandt*, Paris, 1886, p.73, *inter alia*.

108 Blanc, 1867, p.678.

109 Herbert, 1962, p.176, repr. no.13 (DH 275; Paris, private collection).

110 Dollfus (see n.72), p.126; Le Roux (see n.70), pp.79-82; Vallès, *La France*, 11 May 1883 (Vallès, 1971, p.354); H. Le Roux, *Les jeux du cirque et la vie foraine*, Paris, 1889 (English edn., 1890, pp.25-7).

Chapter EIGHT: *The Marines*

1 DH 141-3, 145-6, 148, 150, 152, 154, 156, 158, 165. In the ensuing accounts of the preparatory procedures Seurat adopted for his marines I have followed the general assumption that his related drawings and *croquetons* have come down to us more-or-less intact. There is no evidence that Seurat destroyed or discarded such preparatory material.

2 Signac, *The Normandy Coastline* (Paris, Palais Galliéra, 10 June 1971, no.289.

3 O. Mirbeau, 'Exposition de Peinture. 1, rue Laffite', *La France*, 21 May 1886.

4 Isaacson, *The Crisis of Impressionism*, 1980, (see chap.7, n.77), p.208; *Catalogue Illustré des Oeuvres de Jean-François Raffaëlli*, 1884, no.58.

5 D/R, pp.l, li, p.lii.

6 D/R, p.l.

7 D/R, pp.li-lii.

8 DH 172, 166, 168.

9 D/R, p.lii (letter of early Aug. 1886).

10 Herbert, 1959, p.322 (letter of late Feb. or early Mar. 1887).

11 Ibid.

12 For example, Boudin, *Honfleur, The Jetty* (c.1863-4; private collection); Lebourg, *Entrance to the Port of Honfleur, Low Tide* (1882; New York, private collection).

13 Lépine (1869; private collection); Monet (1864; Los Angeles County Museum; Boudin (c.1864-6; private collection)

14 *Collection Camille Pissarro*, Paris, Galerie Georges Petit, 3 Dec. 1928, no.67; letter from Signac to Pissarro, 1886, C.P. *Archives*, no.168).

15 C.P. *Lettres*, p.109 (30. July 1886).

16 See Dorra/Askin, 1969, pp.81-94 and Dorra, 1970, pp.108-13.

17 Sutter, 1970, p.47.

18 Letter from Theo to Vincent Van Gogh (19 Oct. 1888), *Vincent Van Gogh. The Complete Letters*, III, London, 1958, pp.530-1.

19 A.-F. Hérold, *Roll*, Paris, 1924, p.87.

20 D/R, pp.lxviii-lxix.

21 Fénéon, '5e. Exposition de la Société des Artistes Indépendantes', *La Vogue*, Sept. 1889 (Fénéon, I, pp.164-5).

22 F. Champsaur, *Parisiennes*, Paris, 1887, p.113.

23 DH 201-4.

24 DH 699-702.

25 D/R, pp.xciv-xcv; Prak, 1971, p.372.

26 M. Gouton, 'Port de Grandcamp', *Ministère des Travaux Publics. Ports maritimes de la France. II. Du Havre au Bequet*, Paris, 1876, pp.517-26.

27 V.-A. Malte-Brun, *Calvados. Géographie-Histoire. Statistique, Administration*, Caen, 1882, pp.37-8; M. Arnoux, 'Port de Honfleur', *Ministère des Travaux Publics, II*, pp.293-6.

28 Arnoux, n.27, op.cit., p.314.

29 Arnoux, pp.302, 319-20.

30 M. Gouton, 'Port de Port-en-Bessin', *Ministère des Travaux Publics. II*, pp.489-515; Malte-Brun, *n.27, op.cit., p.26*; L. Aubourg, *Notice sur Port-en-Bessin*, Caen, 1894.

31 Aubourg, n.30, op.cit., pp.11-12.

32 Aubourg, p.13.

33 Fénéon, I, p.165. For another interpretation of the painting see Homer, 1957, pp.17-41.

34 M. Geoffroy, 'Port du Crotoy', *Ministère des Travaux Publics. Ports Maritimes de la France. I. De Dunquerque à Etretat*, Paris, 1874, p.343.

35 A. Plocq, 'Port de Gravelines', *Ministère des Travaux Publics. I*, pp.168, 184.

36 Plocq, pp.144, 152.

37 Plocq, p.153.

38 Ajalbert, *Revue Moderne*, 20 June 1886, p.393; Hermel, *La France Libre*, 28 May 1886, p.2 spoke of light. Auriol, *Le Chat Noir*, 22 May 1886, p.708; 'Labruyère', *Le Cri du Peuple*, 28 May 1886; Geffroy, *La Justice*, 26 May 1886, praised the "mélancolie pénétrante."

39 P. Adam, 'Les Artistes Indépendantes', *La Vogue*, 2, no.8, 6-13 Sept. 1886, p.267.

40 Fénéon, 'Le Néo-Impressionnisme', *L'Art Moderne*, 1 May 1887 (Fénéon, I, p.75); J. Christophe, 'L'Exposition des Artistes Indépendantes', *Journal des Artistes*, 29 Sept. 1889, p.304.

41 G. Kahn, 'Les Livres', *Revue Indépendante*, n.s.6, no.16, Feb. 1888, p.290.

42 F. Poictevin, 'Normandie. Eté, *Revue Independante*, n.s.5, no.12, Oct. 1887, p.51-3.

43 G. Kahn, 'Chronique de la Littérature et de l'Art', *Revue Indépendante*, n.s.6, no.16, Feb. 1888, p.284.

44 E. Zola, *Les Rougon-Macquart*, ed. H. Mitterand, Paris, 1964, p.1755.

45 O. Redon, *A soi-même. Journal (1867-1915)*, Paris, 1961, p.88 (12 June 1885).

46 H. de Régnier, *Apaisement*, Paris, 1886 (quoted from *Premières Poèmes*, 11th edn., Paris, 1920, p.79).

47 Redon, *A soi-même*, p.153 (Feb. 1883).

48 Zola, *Les Rougon-Macquart*, p.1198; J. Madeleine, 'Sur la Plage', *Basoche*, 1, no.3, Jan. 1885, p.120.

Chapter NINE: *The Modern City and the Critical Metaphor*

1 Rewald, 1948, p.130; Anon., 'Beaux-Arts', *Art et Critique*, 36, 1 Feb. 1890, p.78.

2 Coquiot, 1924, p.149.

3 F. Fénéon, 'Certains', *Art et Critique*, 14 Dec. 1889 (Fénéon, I, p.172); also G. Vanor, *L'Art symboliste*, Paris, 1889, p.42.

4 'Trublot' [P. Alexis], 'Visite à la *Revue Indépendante*', *Cri du Peuple*, 14 Apr. 1888 (see '*Naturalisme pas mort*', ed. Bakker, 1971, pp.513-4).

5 R.G., 'Echos divers et communications', *Mercure de France*, Mar. 1891, pp.190-1.

6 Lugné-Poë, *La Parade, I. Le Sot du Tremplin. Souvenirs et Impressions de Théâtre*, Paris, 1930, p.104.

7 C. Virmaître, *Paris-Palette*, Paris, 1888, pp.63-4.

8 F. Fénéon, 'Precisions concernant Seurat', *Bulletin de la Vie Artistique*, 15 Aug. 1924 (Fénéon, I, p.468); D/R, p.lxx; Sutter, 1970, pp.19-20.

9 A. Alexandre, 'Le Mouvement Artistique', *Paris*, 13 Aug. 1888.

10 C.P. *Archives*, no.179.

11 D/R, p.lxv.

12 C.P. *Archives*, no.180.

13 Rewald, 1948, p.115.

14 C.P. *Archives*, no.176.

15 C.P. *Lettres*, pp.177-8 (6 Sept. 1888).

16 Rewald, 1948, p.116.

17 Ashmolean Museum, Oxford.

18 Sutter, 1970, p.22.

19 Coquiot, 1924, p.44; *French Symbolist Painters*, London, Arts Council, 1972, p.145.

20 Coquiot, 1924, p.44.

21 *French Symbolist Painters*, n.19, p.145.

22 A. Alexandre, 'Le Salon des Indépendants', *Paris*, 20 Mar. 1891; R. Sertat, 'Artistes Indépendants', *Revue Encyclopedique*, 1 June 1891, p.549.

23 A. Alexandre, *Paul Gauguin*, Paris, 1930, p.102.

24 *Lettres de Gauguin à sa femme et à ses Amis*, ed. M. Malingue, Paris, 1946, letter lxviii, p.136.

25 F. Fénéon, 'Autre Groupe Impressionniste', *La Cravache*, 6 July 1889 (Fénéon, I, p.157).

26 J. Antoine, 'Critique d'Art. Pavillon de la Ville de Paris, Exposition des Artistes Indépendants', *La Plume*, 49, 1 May 1891, p.157.

27 F. Fénéon, 'Signac', *Les Hommes d'aujourd'hui*, 8, no.373, 1890 (Fénéon, I, pp.174-9).

28 Homer, 1964, pp.185-6, 198-217; quotation from p.212.

29 J.A. Duncan, *Les Romans de Paul Adam*, Berne/Frankfurt/Las Vegas, 1977, pp.16-19.

30 For Anarchism see, *inter alia*, R.L./E.W. Herbert, 1960, I; E.W. Herbert, 1961; J. Joll, *The Anarchists*, London, 1964; J. Monférier, 'Symbolisme et Anarchie', *Revue d'Histoire Litteraire de la France*, 2, Apr.-June 1965, pp.233-38.

31 'Trublot' [P. Alexis], 'Mes anarchistes', *Le Journal*, 17 Nov. 1892 (see '*Naturalisme pas mort*', ed. Bakker, 1971, p.263, n.8).

32 R. de Gourmont, 'Le Symbolisme', *Revue Blanche*, June 1892, p.321.

33 P. Kropotkin, *Paroles d'un révolté*, Paris, 1885 (quoted from 1978 edn., p.67).

34 E.W. Herbert, 1961, p.23, n.28.

35 Anon., 'Beaux-Arts', *Art et Critique*, 36, 1 Feb. 1890, p.78; F. Fénéon, '5e Exposition...des Artistes Indépendants', *La Vogue*, Sept. 1889 (Fénéon, I, p.166).

36 R.L./E.W. Herbert, 1960, p.477.

37 F. Fénéon, 'Artistes Indépendants', *Le Chat Noir*, 21 Mar. 1891 (Fénéon, I, p.182).

38 R.L./E.W. Herbert, 1960, p.477 and n.16.

39 An oil sketch (Houston, Museum of Fine Arts), catalogued by D/R (no.174) but not DH, has only a recent provenance and may not be by Seurat.

40 Fry/Blunt, 1965, p.16; Russell, 1965, p.244.

41 DH, p.xxviii.

42 See *Printmaking in the Age of Rembrandt*, Boston, Museum of Fine Arts, Oct. 1980 – Jan. 1981, no.11.

43 E. Zola, *Oeuvres complètes*, vol.4, *Nana*, ed. H. Mitterand, Paris, 1967, p.286; F. Fénéon, 'Feu Cros', *La Cravache*, 18 Aug. 1888 (Fénéon, II pp.596-600); *Paroles perdues* (1873; quoted from *Oeuvres complètes de Charles Cros*, ed. L. Forstier/P.Pia, Paris, 1964, p.91).

44 Sold Sotheby's, 31 Mar. 1982, no.200.

45 F. Fénéon, 'L'Art du XVIIIe Siècle', *La Libre Revue*, 1 Jan. 1884 (Fénéon, I, pp.17-18); C. Henry, *Mémoires inédites de Ch.-Nic. Cochin...*, Paris, 1880; *Vie d'Antoine Watteau*, Paris, 1887. An *Exposition de l'Art Français sous Louis XIV et Louis XV* was held at the Ecole des Beaux-Arts in 1888.

46 For instance G.-E. Petit's *Le Matin* (see P. Jean-Richard, *L'Oeuvre gravé de François Boucher dans la Collection Edmond de Rothschild*, Paris, 1978, no.1, 456).

47 Fénéon, I, p.18.

48 P. Verlaine, 'Amour', *La Vogue*, 2, no.5, 16-23 Aug. 1886, pp.148-9.

49 D/R, p.xcvi.

50 I owe this suggestion to Jayne Sullivan.

51 *La Vie Moderne*, 15, 9 Apr. 1887, p.232.

52 Fénéon, 'Calendrier de Janvier. III. Exposition de la Revue Indépendante', *Revue Indépendante*, Feb. 1888 (Fénéon, I, p.94).

53 Rubin, 1970, passim.

54 For an excellent account of the painting see Callen, 1982, pp.146-9.

55 See L. Broido, *The Posters of Jules Chéret*, New York, 1980; E. Maindron, *Les Affiches illustrées, 1886-1895*, Paris, 1896.

56 Verhaeren, *Société Nouvelle*, Apr. 1891 (from *Sensations*, 1927, p.200); Herbert, 1958, pp.156-8.

57 Scharf, 1968 (1974 edn., pp.229-31); Homer, 1962, pp.391-2.

58 Blanc, 1867, p.468.

59 I am grateful to Mike Burles for this suggestion; Fénéon, 'Signac' in *Les Hommes d'aujourd'hui*, no.373, 1890 (Fénéon, I, pp.177-8).

60 Homer, 1964, pp.223-6.

61 A Germain, 'Du Symbolisme dans la Peinture', *Art et Critique*, 58, no.5, July 1890, p.418.

62 Adam/Moréas, 1886, p.167.

63 *Complete Letters of Vincent van Gogh*, III, London, 1958, T.29, p.565 (19 Mar. 1890).

64 Van de Velde, 1890, p.123.

65 See, *inter alia*, A. Chadourne, *Les Cafés-concerts*, Paris, 1889.

66 T.J. Clark, 'The Bar at the Folies-Bergère', in *The Wolf and the Lamb Popular Culture in France*, ed. J. Beauroy/M. Bertrand/ E. Gargan, Saratoga, 1977, pp.233-52.

67 Chadourne, *Les Cafés-concerts*, p.7; J. Lemaitre, 'Les Cafés-Concerts', *Impressions de Théâtre*, 2me. Série, Paris, 1888, pp.287-94.

68 F. Cachin, 'Un défenseur oublié de l'art moderne', *L'Oeil*, 90, June 1962, p.55.

69 J. Laforgue, *Lettres à un ami. 1880–1886*, ed. G. Jean-Aubry, Paris, 1941, p.151; Néo, *Le Cri du Peuple*, 29 Mar. 1888, p.3; J. Ajalbert, *Paysages de femmes*, Paris, 1887, pp.69-70.

70 Chadourne, *Les Cafés-concerts*, p.22.

71 L. Rigaud, *Dictionnaire d'argot moderne*, Paris, 1888, p.84.

72 E. Patrick, 'Les Bals de Paris. Le Jardin de Paris', *Le Courrier Français*, 28 Feb. 1886, p.6; E. Rodrigues, *Cours de danse fin de siècle*, Paris, 1892; G. Montorgueil, *Paris dansant*, Paris, 1898, pp.169-96.

73 C. Virmaître, *Trottoirs et lupanars*, Paris, 1893, p.142.

74 *Le Courrier Français*, 4 Apr. 1886, p.6; ibid., 26 Apr. 1891, p.1.

75 See, for instance, Forain's drawing in *Le Courrier Français*, 11 Jan. 1891.

76 See diagram in D/R, p.ci.

77 Chadourne, *Les Cafés-concerts*, p.99.

78 For the trial see *Le Courrier Français*, 20 Jan. 1889, pp.2-17.

79 F. Fénéon, 'Calendrier d'Octobre', *Revue Indépendante*, Nov. 1888 (Fénéon, I, pp.122-3; V. Champier, 'L'Exposition des Affiches Illustrées de M. Jules Chéret', *Revue des Arts Décoratifs*, 7-8, Jan. – Feb. 1890, pp.254-5.

80 R. Marx, *Exposition Jules Chéret. Pastels. Lithographies. Dessins. Affiches Illustrées*, Galeries du Théâtre d'Application, Dec. 1889 – Jan. 1890, pp.v-vi; H. Durand-Tahier, 'Exposition des Oeuvres de M. Jules Chéret', *La Plume*, 20, 1 Feb. 1890, p.24.

81 Chadourne, *Les Cafés-concerts*, p.310.

82 Anon. [P. Signac], 'Impressionnistes et Révolutionnaires'. *La Revolte*, 13-19, June 1891, p.4.

83 *Le Droit Social*, 12 Mar. 1888, quoted in Joll, *The Anarchists* (1979, edn., p.112). See Medlyn, 1975, pp.142-3.

84 J.-K. Huysmans, Raffaëlli, from *Certains*, Paris, 1889 (*Oeuvres complètes de J.-K. Huysmans*, X, Paris, 1929, p.33).

85 *Le Courrier Français*, 25 Jan. 1891, p.4.

86 G. Lecomte, 'Société des Artistes Indépendants', *L'Art Moderne*, 30 Mar. 1890, p.101.

87 G. Kahn, 'Seurat', *L'Art Moderne*, 11, 5 Apr. 1891 (quoted from

Broude, 1978, pp.24-5).

88 Patrick, (see n.72), 1886; see also Virmaître, (n.73).

89 *Salon de 1889. Catalogue illustré*, Paris, 1889, repr. p.111.

90 *La Vie Moderne*, 29 Oct. 1887, p.696; 4 Feb. 1888, p.72.

91 J. Bertaut, *L'Opinion et les moeurs. La Troisième République, 1870 à nos jours*, Paris, 1931, pp.190-1.

92 J. Laforgue, 'Chronique Parisienne', *Revue Indépendante*, n.s., 2, no.5, Mar. 1887, p.345.

93 Antoine, *Mes souvenirs sur le Théâtre Libre*, Paris, 1921, pp. 149-50.

94 Repro. 'Chronique des Arts', *Gazette des Beaux-Arts*, 1236, Jan. 1972, p.33.

95 M. Schapiro, 1964, pp.40-1.

96 Herbert, 1968, p.123.

97 N. Davies, 'Aspects of the Universal Exhibition, 1889', unpublished B.A. dissertation, University of Manchester, 1982, p.39.

98 R. Thomson, 'Camille Pissarro, *Turpitudes Sociales*, and the Universal Exhibition of 1889', *Arts Magazine*, 56, no.8, Apr. 1982, p.85.

99 G. Kahn, 'Chronique de la Littérature et de l'Art', *Revue Indépendante*, n.s., 8, no.22, Aug. 1888, pp.315.

100 Herbert, 1958, p.158; Herbert, 1962, p.153.

101 The author does not consider the 'oil study' for *L'Homme à Femmes* (DH 211) to be in Seurat's hand.

102 Lecomte, 1890, p.87.

103 Joze, 1890, pp.3, 7, 15.

104 Ibid., pp.24-5.

105 F. Fénéon, 'Artistes Indépendantes', *Le Chat Noir*, 21 Mar. 1891 (Fénéon, I, p.182); J. Leclercq, 'Aux Indépendants', *Mercure de France*, 2, May 1891, p.298.

106 For a detailed account of the preparatory work see Pearson, 1977-8, pp.46-8.

107 Repr. D/R, 1959, p.cv.

108 Homer, 1964, pp.229-30.

109 Coquiot, 1924, pp.41-2; Leclercq, n.105; A. Retté, 'Septième Exposition des Artistes Indépendantes', *L'Ermitage*, 5, May 1891, p.294.

110 For the obsolete Lautrec argument see, *inter alia*, my *Toulouse-Lautrec*, London, 1977, p.14.

111 Kahn, 1928, p.viii.

112 A. Germain, 'Delacroix Théoricien', *Art et Critique*, 25 Oct. 1890, p.684.

113 See, for example, H. Mazel, 'La Peinture et la Sculpture en 1890', *L'Ermitage*, 3, June 1890, p.117.

114 R. Marx, *Exposition Jules Chéret*, 1889-90, pp.iii-iv.

115 G. Geffroy, 'Le Bagne de l'Ideal', *Revue Indépendante*, n.s.9, no.25, Nov. 1888, p.179.

116 M. Guyau, *L'Art au point de vue sociologique* (intro. A. Fouillée), Paris, 1889, p.xi.

117 Sutter, 1970, p.110.

118 J. Ajalbert, *Paysages de Femmes*, Paris, 1887, pp.65-6.

119 J. Roques, 'Cirque Fernando', *Le Courrier Français*, 13 Jan. 1889, p.4; A.-J. Dalsème, *Le Cirque à Pied et à Cheval*, Paris, 1888, p.25.

120 G. Lecomte, 'Le Salon des Indépendants', *L'Art dans les Deux Mondes*, 19, 28 Mar. 1891, p.225.

121 See, for instance, A. Robida, *La Grande Mascarade parisienne*, Paris, 1881, p.135.

122 Medlyn, 1975, p.132.

123 *Oeuvres Complètes de Jules Laforgue*, IV, ed. G. Jean-Aubry, Paris, 1925, p.123 (Letter xxviii).

124 F. Fénéon, 'Charles Angrand', *Bulletin de la Vie Artistique*, 15 Apr. 1926, (Fénéon, I, p.481).

125 A. Vincent-Eloy, 'Le Clown', *L'Ermitage*, 7, Oct. 1890, p.360; H. de Braisne, 'Dans le Cirque', *Le Courrier Français*, 28 June 1891, p.8.

126 P. Stephan, *Paul Verlaine and the Decadence, 1882–1890*, Manchester, 1974, pp.10, 114.

127 F. Champsaur, 'Carnet d'un Clown du Cirque Molier', *La Revue Illustrée*, 15 June 1885 (from *Masques modernes*, Paris 1889, p.144).

128 Joze, 1890, p.10.

129 J. Passe, 'Exposition des Arts Incohérents', *Journal des Artistes*, 19 May 1889, p.154; *Gustave Caillebotte*, Houston/Brooklyn, 1976-7, p.140.

Conclusion

1 D/R, 1959, p.lxxiv, n. 58.

2 C.P. *Lettres*, p.221 (30 March 1891).

3 Verhaeren, 1891, pp.195-6

4 S. Mallarmé, *Correspondance, IV, 1890-1891*, ed. H. Mondor, L.J. Austin, Paris, 1973, p.214 (letter mlxxvii). Mallarmé's letter is lost, but the reply, by 'Madame Veuve Seurat', is known (ibid, n.2). The sender was presumably Madeleine Knobloch rather than Seurat's mother.

5 A. Alexandre, 'Un Vaillant', *Paris*, 1 April 1891, pp.1-2; J. Antoine, 'Georges Seurat', *Revue Indépendante*, no.19, April 1891, pp.89-93; T. de Wyzewa, 'Georges Seurat', *L'Art dans les Deux Mondes*, no.22, 18 April 1891, pp.263-4.

6 Verhaeren, 1891, p.203.

7 Coquiot, 1924, p.41.

Selected Bibliography

The following bibliography concentrates mainly on readily available scholarly material published over the last forty years. (For more extensive bibliographic references the reader is directed to the two *catalogue raisonnés* listed below.) Contemporary texts, such as exhibition reviews and literary or socio-political material, have been fully cited in appropriate footnotes, except when they have been frequently quoted.

AJALBERT, J., *Mémoires en Vrac. Au Temps du Symbolisme, 1880–1890*, Paris, 1938.

Souvenir d'Aman-Jean (1859-1936), Paris, Musée des Arts Décoratifs, Apr.– May 1970.

BARRON, L., *Les Environs de Paris*, Paris, 1886.

BLANC, C., *Grammaire des Arts du Dessin. Architecture, Sculpture, Peinture*, Paris, 1867.

BOIME, A., 'Seurat and Piero della Francesca', *Art Bulletin*, 47, no.2, June 1965, pp.265-71.

BOIME, A., 'Studies of the Monkey by Seurat and Pisanello', *Burlington Magazine*, 91, no.791, Feb. 1969, pp.79-81.

BOIME, A., *The Academy and French Painting in the Nineteenth Century*, London, 1971.

BROUDE, N., 'New Light on Seurat's "Dot": Its Relation to Photomechanical Colour Printing in France in the 1880s', *Art Bulletin*, 54, no.4, Dec. 1974, pp.581-9.

BROUDE, N., 'The Influence of Rembrandt Reproductions on Seurat's Drawing Style: A Methodological Note', *Gazette des Beaux-Arts*, pér.6, vol.88, Oct. 1976, pp.155-60.

BROUDE, N. (ed.), *Seurat in Perspective*, New Jersey, 1978.

CACHIN, F., 'The Neo-Impressionist Avant-garde', *Art News Annual*, 34, 1968, pp.54-65.

CACHIN, F., *Paul Signac*, Paris, 1971.

CALLEN, A., *Techniques of the Impressionists*, London, 1982.

CHARTRAIN-HEBBELINCK, M.-J., 'Les Lettres de Paul Signac à Octave Maus', *Bulletin, Musées Royaux des Beaux-Arts de Belgique*, 1969, I-2, pp.52-102.

CHASTEL, A., 'Seurat et Gauguin', *Art de France*, 2, 1962, pp.298-304.

CHASTEL, A., and MINERVINO, F., *Tout l'oeuvre peint de Seurat*, Paris, 1973.

CHRISTOPHE, J., 'Seurat', *Les Hommes d'Aujourd'hui*, 8, no.368, 1890.

COOPER, D., *Georges Seurat. Une Baignade, Asnières*, London, n.d. [1946].

COQUIOT, G., *Seurat*, Paris, 1924.

COURTHION, P., *Georges Seurat*, New York, 1968.

DORRA, H., 'Re-naming a Seascape by Seurat', *Gazette des Beaux-Arts*, pér.6, vol.51, Jan. 1958, pp.41-8.

DORRA, H., and ASKIN, S., 'Seurat's Japonisme', *Gazette des Beaux-Arts*, pér.6, vol.73, Feb. 1969, pp.81-94.

DORRA, H., 'Charles Henry's "Scientific" Aesthetic', *Gazette des Beaux-Arts*, pér.6, vol.74, Dec. 1969, pp.345-56.

DORRA, H., and REWALD, J., *Seurat. L'Oeuvre peint. Biographie et catalogue critique*, Paris, 1959.

DORRA, H., 'Seurat's Dot and the Japanese Stippling Technique', *Art Quarterly*, 23, no.2, 1970, pp.108-113.

DX, L., 'Un Mot contre Huysmans attribué par Peladan à Seurat et démenti par Signac', *Bulletin de la Société Joris-Karl Huysmans*, 6, Mar. 1932, pp.187-8.

FAUNCE, S., 'Seurat and "the Soul of Things",' *Belgian Art, 1880–1914*, Brooklyn Museum, Apr. – June 1980, pp.41-56.

FENEON, F., 'Notes inédites de Seurat sur Delacroix', *Bulletin de la Vie Artistique*, I, Apr. 1922, pp.154-8.

FOURNEL, V., *Les Artistes français contemporains. Peintres – sculpteurs*, Tours, 1884.

FRY, R., and BLUNT, A., *Seurat*, London 1965 (essay by Fry first published 1926).

GOLDWATER, R., 'Some Aspects of the Development of Seurat's Style', *Art Bulletin*, 23, no.2, June 1941, pp.117-30.

GOLDWATER, R., *Symbolism*, New York, 1979.

GOULD, C., *Seurat's 'Bathers, Asnières' and the Crisis of Impressionism*, London, National Gallery, 1976.

DE HAUKE, C., *Seurat et son oeuvre*, 2 vols., Paris, 1961.

HERBERT, E.W., *The Artist and Social Reform. France and Belgium, 1885–1898*, New Haven, 1961.

HERBERT, R.L., 'Seurat in Chicago and New York', *Burlington Magazine*, 100, no.662, May 1958, pp.146-53, 155.

HERBERT, R.L., 'Seurat and Jules Chéret', *Art Bulletin*, 40, no.2, June 1958, pp.156-8.

HERBERT, R.L., 'Seurat and Puvis de Chavannes', *Yale University Art Gallery Bulletin*, 25, no.2, Oct. 1959, pp.22-9.

HERBERT, R.L., 'Seurat and Emile Verhacren: Unpublished Letters', *Gazette des Beaux-Arts*, pér.6, vol.54, Dec. 1959, pp.315-28.

HERBERT, R.L., 'A Rediscovered Drawing for Seurat's *Baignade*', *Burlington Magazine*, 102, no.689, Aug. 1960, pp.368, 370.

HERBERT, R.L. and E.W., 'Artists and Anarchism: Unpublished Letters of Pissarro, Signac and others', I, *Burlington Magazine*, 102, no.692, Nov. 1960, pp.473-82; II, ibid., no.693, Dec. 1960, pp.517-22.

HERBERT, R.L., *Seurat's Drawings*, New York, 1962.

HERBERT, R.L., *Neo-Impressionism*, New York, Guggenheim Museum, Feb. – Apr. 1968.

HERBERT, R.L., ' "Parade de Cirque" de Seurat et l'esthétique scientifique de Charles Henry', *Revue de l'Art*, 50, 1980, pp.9-23.

HOMER, W.I., 'Seurat's *Port-en-Bessin*', *Minneapolis Institute of Arts Bulletin*, 2, 1957, pp.17-41.

HOMER, W.I., 'Seurat's Formative Period', *Connoisseur*, 142, Aug. – Sept. 1958, pp.58-62.

HOMER, W.I., 'Notes on Seurat's Palette', *Burlington Magazine*, 101, no.674, May 1959, pp.192-3.

HOMER, W.I., review of Dorra/Rewald, *Art Bulletin*, 42, no.3, Sept. 1960, pp.228-33.

HOMER, W.I., 'Concerning Muybridge, Marey, and Seurat', *Burl-*

ington Magazine, 104, no.714, Sept. 1962, pp.391-2.

HOMER, W.I., 'Seurat's Paintings and Drawings' (review of de Hauke), *Burlington Magazine*, 105, no.723, June 1963, pp.282-4.

HOMER, W.I., *Seurat and the Science of Painting*, Cambridge (Mass.), 1964 (new edn., 1978).

HOUSE, J., 'Meaning in Seurat's Figure Paintings', *Art History*, 3, no.3, Sept. 1980, pp.345-56.

JAMOT, P., 'Artistes contemporains. Ernest Laurent', *Gazette des Beaux-Arts*, pér.4, vol.50, Mar. 1911, pp.173-203.

JOZE, V. (pseud. for V. Dobrski), *La Ménagerie sociale. L'Homme à femmes. Roman parisien*, Paris, 1890.

KAHN, G., 'Au Temps du Pointillisme', *Mercure de France*, 181, no.619, Apr. 1924, pp.5-22.

KAHN, G., *Les Dessins de Georges Seurat*, Paris, 1928 (new edn., New York, 1971).

KATZ, L., 'Seurat: Allegory and Image', *Arts*, 32, Apr. 1958, pp.40-7.

KOZLOFF, M., 'Neo-Impressionism and the Dream of Analysis', *Art Forum*, Apr. 1968, pp.40-5.

LEBON, A., and PELET, P., *France as it is*, London, 1888.

LECOMTE, G., '*La Ménagerie sociale* de M. Victor Joze – Une couverture de M. Seurat', *Art et Critique*, Feb. 1890, p.87.

Henri Lehmann, 1814–1882. Paris, Galerie Gaubert, Oct. 1978 (cat. by M.-M. Aubrun).

Henri Lehmann, 1814–1882. Portraits et Décors Parisiens. Paris, Musée Carnavalet, June – Sept. 1983 (cat. by M.-M. Aubrun).

LÖVGREN, S., *The Genesis of Modernism. Seurat, Gauguin, Van Gogh and French Symbolism in the 1880s*, Stockholm, 1959.

MEDLYN, S.A., 'The Development of Georges Seurat's Art, with Special Reference to the Influence of Contemporary Anarchist Philosophy', M.A. thesis, University of Manchester, 1975.

NICOLSON, B., 'Seurat's *La Baignade*', *Burlington Magazine*, 79, no.464, Nov. 1941, pp.138-46.

NICOLSON, B., 'Reflections on Seurat' (review of Dorra/Rewald), *Burlington Magazine*, 104, no.710, May 1962, pp.213-15.

PEARSON, E., 'Seurat's *Le Cirque*', *Marsyas*, 19, 1977-8, pp.45-51.

PERRUCHOT, H., *La Vie de Seurat*, Paris, 1966.

Post-Impressionism. Cross-Currents in European Painting, London, Royal Academy, Nov. 1979 – Mar. 1980 (Seurat entries by J. House).

PRAK, N.L., 'Seurat's Surface Pattern and Subject Matter', *Art Bulletin*, 103, no.3, Sept. 1971, pp.367-78.

REWALD, J., *Georges Seurat*, Paris, 1948.

REWALD, J., *Post-Impressionism – from Van Gogh to Gauguin*, New York, 1956 (revised edn., 1978).

REY, R., *La Renaissance du sentiment classique dans la peinture française à la fin du XIXe siècle*, Paris, 1931.

RICH, D.C., *Seurat and the Evolution of 'La Grande Jatte'*, Chicago, 1935.

RICH, D.C., and HERBERT, R.L., *Seurat. Paintings and Drawings*, Art Institute of Chicago, Jan. – Mar. 1958.

RICHARDSON, J., *Seurat. Paintings and Drawings*, London, Artemis S.A., Nov. – Dec. 1978.

ROSENTHAL, L., 'Ernest Laurent', *Art et Décoration*, 3, 1911, pp.65-76.

ROSKILL, M., *Van Gogh, Gauguin and the Impressionist Circle*, London, 1970.

RUBIN, J.H., 'Seurat and Theory: The Near-Identical Drawings of the Café-Concert', *Gazette des Beaux-Arts*, pér.6, vol.76, Oct. 1970, pp.237-46.

RUSSELL, J., *Seurat*, London, 1965.

SCHAPIRO, M., 'Seurat: Reflections', *Art News Annual*, 29, 1964, pp.18-41, 162.

SCHARF, A., *Art and Photography*, Harmondsworth, 1968.

'Extraits du journal inédit de Paul Signac, 1894-1899', ed. J. Rewald, *Gazette des Beaux-Arts*, pér.6, vol.36, July–Sept. 1949, pp.97-128; ibid., vol.29, Apr. 1952, pp.265-84; ibid, vol.42, July – Aug. 1953, pp.27-57.

SIGNAC, P., *D'Eugène Delacroix au Néo-Impressionisme*, Paris, 1899 (new edn., ed. F. Cachin, 1964).

SIGNAC, P., 'Le Néo-Impressionisme. Documents', *Gazette des Beaux-Arts*, pér.6, vol.2, Ja. 1934, pp.49-59.

SUTTER, J. (ed.), *The Neo-Impressionists*, London, 1970.

THOMSON, R., ' "Les Quat' Pattes": The Image of the Dog in Late Nineteenth Century French Art', *Art History*, 5, no.3, Sept. 1982, pp.323-37.

VALLES, J., *Le Tableau de Paris* (ed. M.-C. Bancquart), Paris, 1971.

VAN DE VELDE, H., 'Notes sur l'Art. *Chahut*', *La Wallonie*, 5, 1890, pp.122-5.

VERHAEREN, E., 'Georges Seurat', *Société Nouvelle*, Apr. 1891 (reprinted in *Sensations*, Paris, 1927, pp.195-203).

ZELDIN, T., *France, 1848-1945*, 2 vols., Oxford 1973, 1977.

Since the completion of this book the following articles have been published:

SMITH, P., 'Seurat and the Port of Honfleur', *Burlington Magazine*, 126, no.978, Sept. 1984, pp.562, 564-7, 569.

STUMPEL, J., ' "The Grande-Jatte", that patient tapestry', *Simiolus*, 14, no. 3/4, 1984, pp.209-224.

Index